VISIONS OF SUBURBIA

Suburbia. Tupperware, television, bungalows and respectable front lawns. Always instantly recognizable though never entirely familiar. The tight semi-detached estates of 1930s Britain and the unfenced and functional tract housing of middle America. The elegant villas of Victorian London and the clapboard and brick of 1950s Sydney. Architecture and landscapes may vary from one suburban scene to another, but the suburb is the embodiment of the same desire: to create for middle class middle cultures in middle spaces in middle America, Britain and Australia.

Visions of Suburbia considers this emergent architectural space, this set of values and this way of life. The contributors address suburbia and the suburban from the point of view of its production, its consumption and its representation. Placing suburbia centre stage, each essay examines what it is that makes suburbia so distinctive and what it is that has made suburbia so central to contemporary culture.

Discussing suburbia as a range of practices, images and ideas, dreams, nightmares and realities, *Visions of Suburbia* examines the histories of suburban development and the representation of suburbs in the mass media and popular music. From early colonial development to the ubiquitous bungalow, suburbia reveals itself to be both complex and central to the experience of life in the twentieth century.

Contributors: John Archer, Homi Bhabha, Deborah Chambers, Alison J. Clarke, Gary Cross, James S. Duncan, Nancy G. Duncan, Simon Frith, John Hartley, Anthony D. King, Vicky Lebeau, Andy Medhurst, Lynn Spigel.

Editor: Roger Silverstone is Professor of Media Studies and Director of the Graduate Research Centre in Culture and Communication, University of Sussex. He is the author of *The Message of Television*, *Framing Science* and *Television and Everyday Life*.

VISIONS OF SUBURBIA

EDITED BY ROGER SILVERSTONE

ROUTLEDGE

LONDON AND NEW YORK

First published 1997
by Routledge
11 New Fetter Lane, London EC4P 4EE

Simultaneously published in the USA and Canada
by Routledge
29 West 35th Street, New York, NY 10001

Typeset in Perpetua by Solidus (Bristol) Limited
Printed and bound in Great Britain by
Biddles Ltd, Guildford and King's Lynn

British Library Cataloguing in Publication Data
A catalogue record for this book is available from the British Library

Library of Congress Cataloging in Publication Data
Visions of Suburbia / edited by Roger Silverstone.
p. cm.
Includes bibliographical references and index.
1. Suburbs. 2. Suburban life. 3. Popular culture.
I. Silverstone, Roger.
HT351.V57 96-6379
307.74—dc20

ISBN 0–415–10716–4
0–415–10717–2 (pbk)

CONTENTS

List of figures vii

Preface and acknowledgements ix

Notes on contributors xi

INTRODUCTION 1
Roger Silverstone

1 COLONIAL SUBURBS IN SOUTH ASIA, 1700–1850, AND THE
SPACES OF MODERNITY 26
John Archer

2 EXCAVATING THE MULTICULTURAL SUBURB: HIDDEN HISTORIES
OF THE BUNGALOW 55
Anthony D. King

3 A STAKE IN THE COUNTRY: WOMEN'S EXPERIENCES OF
SUBURBAN DEVELOPMENT 86
Deborah Chambers

4 THE SUBURBAN WEEKEND: PERSPECTIVES ON A
VANISHING TWENTIETH-CENTURY DREAM 108
Gary Cross

5 TUPPERWARE: SUBURBIA, SOCIALITY AND MASS CONSUMPTION 132
Alison J. Clarke

6 DEEP SUBURBAN IRONY: THE PERILS OF DEMOCRACY IN
WESTCHESTER COUNTY, NEW YORK 161
Nancy G. Duncan and James S. Duncan

7 THE SEXUALIZATION OF SUBURBIA: THE DIFFUSION OF
KNOWLEDGE IN THE POSTMODERN PUBLIC SPHERE 180
John Hartley

8 FROM THEATRE TO SPACE SHIP: METAPHORS OF SUBURBAN
DOMESTICITY IN POSTWAR AMERICA 217
Lynn Spigel

9 NEGOTIATING THE GNOME ZONE: VERSIONS OF SUBURBIA IN
 BRITISH POPULAR CULTURE 240
 Andy Medhurst
10 THE SUBURBAN SENSIBILITY IN BRITISH ROCK AND POP 269
 Simon Frith
11 THE WORST OF ALL POSSIBLE WORLDS? 280
 Vicky Lebeau
POSTCRIPT: BOMBS AWAY IN FRONT-LINE SUBURBIA 298
 Homi Bhabha

 Index 304

FIGURES

1.1 'Plan of the Town of Singapore, by Lieut. Jackson', 1823 30

1.2 'Plan oder Grundriss der Stadt und derer Vorstätte, wie auch des Castels
Batavia' 32

1.3 'Plan oder Grundriss der Stadt Batavia, samt der eine Stund weges
umher liegendes Gegend' 36

1.4 'Platte Grond van de Thuyn en Woonhys behoorende Aan den Wel Edele
Gestr. Heer Jan Schreuder', 1755 37

1.5 Johannes Rach, House of Willem Hendrik van Ossenberch, c. 1764–70 38

1.6 'Plan de Madras', 1746, after Paradis 43

1.7 'The environs of Madras. Surveyed in 1814. London: W. Faden, 1816' 46

1.8 'A survey of the country on the eastern bank of the Hughly from
Calcutta to the fortifications at Budgebudge including Fort William . . .
from the Year 1780, till 1784. Mark Wood' 48

1.9 'Map of Calcutta and its environs, from an accurate survey taken in the
years 1792 and 1793, by A. Upjohn' 49

1.10 Henry Salt, View of Calcutta from a House in Chowringhee, 1803 50

2.1 C. F. A. Voysey, Design for a bungalow at 'Bellagio', c. 1885 67

2.2 M. H. Baillie Scott, Design for a bungalow at Douglas, Isle of Man,
1889–90 68

2.3 Charles Edwards, Bungalow at Paterson, New Jersey, 1886 69

2.4 Winning design for 'A Countryside Bungalow' by Mliss, 1893 70

2.5 Winning design for 'A Hill-side Bungalow, a few miles from London, for
a gentleman' by Centaur 71

2.6 Robert A. Briggs, Bungalow design as an alternative to 'the ordinary
suburban villa of a stereotype pattern'. In 1897 this model had been
'lately built in Sussex' (p. xii) 72

2.7 A. Jessop Hardwick, 'Proposed bungalow at Tunbridge Wells, Kent' 73

2.8 G. H. Brewerton, 'Dr Emerson's bungalow at Southbourne' 74

2.9 The Bungalow, Oakwood, Roundhay, Leeds, 1900–1. Architect
 unknown, but designed after R. A. Briggs, *Bungalows and Country
 Residences*, 1891 75
2.10 Percy Robinson, Design for a bungalow built at Bramley, Leeds,
 1900 76
2.11 Colonial space: Blacktown bungalows 78
2.12 Floating signifiers: Chinese, American, Indian, English, Scots,
 Australian . . . 79
2.13 Cultural translation: Bungalow to 'house' 80
2.14 Ambiguous identities in Sydney's multicultural suburbs 81
2.15 Globalization and hybridity 82
5.1 Formal table setting featuring 'Poly-T: material of the future' 136
5.2 'Tupperware, the nicest thing that could happen to your kitchen' 139
5.3 Suburban Tupperware party c. 1956 140
5.4 Tupperware promoted as the ideal barbecue accessory 141
5.5 Brownie Wise, vice-president of Tupperware Home Parties Inc.,
 standing before a mural entitled 'The Evolution of Dishes' in the
 foyer of the corporate headquarters, c. 1953 147
5.6 Invitation to a Tupperware Bridal Shower Party 153
5.7 A group of Hispanic Tupperware dealers honouring a fellow
 'Tupperite' with an embroidered textile for product display,
 c. 1959 155
7.1 *Sex and Sylvania Waters* enter the national community. Sophie Lee
 and Noelene Donaher make their Christmas wishes on behalf of a
 suburban readership 193
7.2 Sophie Lee: The 'frocks pop' 194
7.3 Sophie Lee: Sexualization as popular critique 195
7.4 Sophie Lee: The politics of the glance. 'Telebrity' private lives as
 the (suburban) public sphere 196
7.5 Kylie Minogue sends frock-waves around the world 202
7.6 Popular couture: British and Australian magazines choose the
 same dress (but different meanings) 203
7.7 Popular couture (Australian version) 204
7.8 Kylie Minogue as cover-girl for the sexualization of ordinariness 205
7.9 Suburbia as class war: suburban culture ('our land') abandons the
 city 210
7.10 Suburbia recolonizes the city – with lingerie, consumers and
 hormones 211
11.1 Record sleeve, *The Sound of the Suburbs* 282

PREFACE AND
ACKNOWLEDGEMENTS

I was born and brought up in the suburbs. 21 Brancote Road, Oxton, Birkenhead, Cheshire, England, United Kingdom, Europe, The World, The Universe, The Galaxy, as I wrote on the inside page of my first *Oxford English Dictionary*. And it was the centre of the Galaxy too. It was home – a semi-detached pebble-dashed house in a midwar suburb of a town that was itself (the shipbuilders Cammell Lairds apart) a suburb of Liverpool, that 1960s city throbbing on the other side of the Mersey.

Visions of Suburbia cannot be disconnected from these origins, though it is intended neither as an expiation nor a glorification of them. My relationship to the suburb is my own. The contributors to this volume will also have their own. Our various experiences of the suburban in turn inform our various visions. They can be seen, like suburbia itself, to be both intensely particular and idiosyncratic and at the same time bathetically familiar. Yet through these accounts and visions I want to make the case that the experience of suburbia is central if we are to make sense of our everyday life, at least in industrialized and industrializing societies, in the twentieth century.

The hope is that suburbia, as a geographical, an architectural and a social space, but also as an idea and ideology, as form and content of texts and images and as product of a multitude of social and cultural practices, will emerge as significant through these pages. The hope too is that the various contributions will, however slightly, shift the weight of emphasis in the analysis of modernity and postmodernity away from the city, the trumpeted cauldron of cultural creativity, to those social and cultural spaces on the edge, where everyday values opposed to, or incomprehending of, the harsh realisms of urban creativity are forged. The hope finally is that the collection will stimulate further interest and enquiry into this soft under-belly of the contemporary.

In many ways this is a Sussex book. It is the product of an interdisciplinary

environment that really does work. It would have been inconceivable, at least for me, anywhere else.

Visions of Suburbia is more than usually a product of a collaboration between editor and publisher. Conceived in conversation between the two it has benefited enormously from Rebecca Barden's input and enthusiasm. Her involvement was absolutely essential, so much so that I do not think the book would have emerged without it.

My thanks finally to all the contributors, for their tolerance and their patience, and of course for their commitment and enthusiasm, sympathetic and critical in turn, to a project which in the final analysis can only be my responsibility.

Sussex

January 1996

'Bombs Away in Front-line Suburbia' was broadcast on BBC Radio 4 on 14 July 1995 and originally printed in *The Guardian* newspaper on 8 July 1995.

CONTRIBUTORS

John Archer is a founding member and currently Director of Graduate Studies in the program in Comparative Studies in Discourse and Society at the University of Minnesota. He is the author of *The Literature of British Domestic Architecture, 1715–1842* and articles on Anglo-American architecture and suburbia. His forthcoming works include studies of the eighteenth-century English villa and landscape garden, and of the spatial formation of colonial Calcutta.

Homi Bhabha is the Chester D. Tripp Professor of the Humanities at the University of Chicago where he teaches in the departments of English and Art. His recent books include *Nation and Narration* (Routledge, 1990) and *The Location of Culture* (Routledge, 1994). He is currently working on *A Measure of Dwelling*, about the cultures of global and vernacular cosmopolitanism. He is a contributor to *Art Forum* in New York.

Deborah Chambers is Reader in the Sociology of Communication and Culture at Nottingham Trent University within the department of English and Media Studies. She has lectured and conducted research on the sociology of culture and feminist cultural politics in Australia as well as Britain, written on women's studies and women in higher education, communication and industrial design, and conducted research on the history of the family album.

Alison J. Clarke is Lecturer in Design History and Material Culture in the School of Historical and Critical Studies at the University of Brighton. She is the author of *Tupperware: The Politics of Mass Consumption* (Smithsonian Press, forthcoming) and is currently working on an ethnography of contemporary household consumption.

Gary Cross is Professor of History at Pennsylvania State University and author of *Time and Money: The Making of Consumer Culture* (Routledge, 1993) and *Worktowners at Blackpool: Mass Observation and Popular Leisure in the 1930s* (Routledge, 1990). *Toys and the Making of American Childhood* is forthcoming with Harvard University Press.

James S. Duncan is Lecturer in Geography and Fellow of Emmanuel College, Cambridge. He is the co-editor of *Place/Culture/Representation* (Routledge, 1993) and author of *The City as Text* (Cambridge, 1990).

Nancy G. Duncan is affiliated Lecturer in Geography at Cambridge. She is the editor of *BodySpace: Destabilizing Geographies of Gender and Sexuality* (Routledge, 1996).

Simon Frith is Professor of English at Strathclyde University and Co-director of the John Logie Baird Centre. His latest book is *Performing Rites: The Value of Popular Music* (Harvard and Oxford University Presses, 1996).

John Hartley is Professor of Mass Communication Studies at the University of Wales, Cardiff. His latest book is *Popular Reality: Journalism, Modernity, Popular Culture* (Arnold, 1996). He has lived in suburbia in Australia and Britain and written on popular culture and media for publications there and in the USA.

Anthony D. King is Professor of Art History and of Sociology at the State University of New York at Binghamton. His most recent book is *Re-presenting the City* (Macmillan and New York University Press, 1996); with Thomas Markus, he is co-editor of Routledge's new Archi*text* series.

Vicky Lebeau is Lecturer in English in the School of Cultural and Community Studies at the University of Sussex. She is the author of *Lost Angels: Psychoanalysis and Cinema* (Routledge, 1995) and has published in various journals including *Screen, Camera Obscura* and *Parataxis*. She is also a contributor to the *Year's Work in Critical and Cultural Theory*.

Andy Medhurst is Lecturer in Media Studies in the School of Cultural and Community Studies at the University of Sussex. He has published widely on British cinema, popular culture and the politics of sexuality; he contributes frequently to *Sight and Sound* and to many radio and television arts and current affairs programmes and is currently preparing a book on cultural identity and British comedy.

Roger Silverstone is Professor of Media Studies and Director of the Graduate Research Centre in Culture and Communciation at the University of Sussex. His latest book is *Television and Everyday Life* (Routledge, 1994). He has recently co-edited *Consuming Technologies: Media and Information in Domestic Spaces* (Routledge, 1992), *Communication by Design: The Politics of Information and Communication Technologies* (Oxford University Press, 1996) and *International Media Research: A Critical Review* (Routledge, 1996). He is founding series editor of *Sussex Studies in Culture and Communication* (Routledge).

Lynn Spigel is Chair of the Critical Studies Division at the School of Cinema–Television at the University of Southern California. She is author of *Make Room*

for TV: Television and the Family Ideal in Postwar America (University of Chicago Press, 1992) and has co-edited several anthologies on film and TV, including her forthcoming *The Revolution Wasn't Televised: Sixties Television and Social Conflict* (Routledge, 1996) and *Feminist Television Criticism* (Oxford University Press, 1997).

INTRODUCTION

I

Many people like suburbia.

(Venturi, Brown and Izenour, *Learning from Las Vegas*, 1977)

My dear wife Carrie and I have just been a week in our new house, 'The Laurels', Brickfield Terrace, Holloway – a nice six-roomed residence, not counting basement, with a front breakfast-parlour. We have a little front garden; and there is a flight of ten steps up to the front door, which, by-the-by, we keep locked with the chain up. Cummings, Gowing, and our other friends always come to the little side entrance, which saves the servant the trouble of going up to the front door, thereby taking her from her work. We have a nice little back garden which runs down to the railway. We were rather afraid of the noise of the trains at first, but the landlord said we should not notice them after a bit, and took £2 off the rent. He was certainly right; and beyond the cracking of the garden wall at the bottom, we have suffered no inconvenience.

(George and Weedon Grossmith, *The Diary of a Nobody*, 1892)

Seeing Bromley from the forecourt of Bromley South Station. Through the dust of a high summer's day the High Street curves away right, up the gentle hill towards the new pedestrian precinct and The Glades, the pastelled, decoed, glass elevatored, fully let shopping mall at the north end of town. Lunchtime. School holidays. The street is busy. Young wives and their tiny children. Bare midriffed girls and shaded boys. The elderly on the occasional bench. Chain store jostles with department store, thrift with fast food. Everything seen on television can be bought.

Ahead, a ravaged shopping precinct, by-passed by the glossy mall, stands mostly empty. Next to it a cut-price supermarket. On a wall a sign, faded with age and inattention, reads: *Graffiti Is Vandalism. An Offence For Which You Can Be Fined*

Up To £300 And Be Given A 3 Months Imprisonment Or More Under the Criminal Damage Act 1971 And Also Quite Often Pay For The Repair. A New Video System Is Now Being Installed Within This Area. Deep in the precinct's bowels but heralded by a transfixing collection of assorted junk and pot plants, 'Caligula', Richard Niazi's amazing folly of a restaurant (live opera on Sunday and Monday), a cornucopia of an eating house, whose frontage is decorated with pages torn from the magazine *Understanding Science* as well as the *Collected Works of Walter Scott* (including *The Bride of Lammermoor*) and made over to look like a *fin de siècle* prostitute's boudoir, stuffed to bursting with silks and satins, lampshades, feathers, pearls, toys, birdcages, bottles, dead clocks and china birds, the flotsam and jetsam of suburban fantasy, the whole misassembled as if in a car boot sale in Marrakesh. Outside, next to a cactus growing out of some cast-off industrial machinery and a toy koala bear tied to a tree with a piece of turquoise polyester stands a television with its power wire lying flaccidly on the concrete; an L-shaped pipe sits proudly above the blank screen.

Look left and the road forks one way down Mason's Hill; the other leads to Westmoreland Road. St Mark's Church (nineteenth-century Gothic) can just be seen three-quarters hidden behind the social security and tax offices on the corner of Sandford Road. Sandford Road itself is resolutely residential. Large detached suburban villas, only one of which masquerades as a dental surgery, stand comfortably side by side. No one the same, each pitched and chimneyed, pebble-dashed and porched, paved and glazed in its own way, neither conceived nor inhabited identically, bearing the scars of alternate neglect and regentrification, their bay and bedroom windows open for the heat but masked by flapping nets, their interiors private and protected. Sandford Road leads to the Bromley Lawn Tennis and Squash Club (founded in 1880) (for the middle and the upper middle classes) and the Bromley allotments (for the lower middle). Walk along its shaded length, past the 1970s town houses of Streamside Close, and listen to the sounds of suburbia. The groan of a low-flying light plane, the regular explosion of an airliner on its way from Heathrow to destinations east, the distant hum of traffic and the occasional rattle of the commuter train – the noises of passage – creating a kind of passacaglia with the sparrows, pigeons, blackbirds and the voices of children and neighbours. The houses get smaller and semi-attach. Gardens are, mostly, carefully groomed; slab-paved space created at the front for the second car. Not quite new Fords, Vauxhalls, Rovers and Nissans stand in driveways and against the kerb. Late Victorian gives way to an uneven blend of Edwardian, midwar and 1960s styling.

A footpath leads to the main Hayes Road, past Ravensbourne School (grant-

maintained). On a lamp post at the corner and with due cognizance of earlier notices, find the following: *Jodie woz here 1994 won't come back again.*

Hayes Road leads to Hayes one way, and to Orpington, Chislehurst and Sevenoaks the other. Opposite the school are what look like open fields, horses grazing, and then a string of more suburban houses, detached this time, but grubby from their main-road-side location. Suddenly as if planted entirely for your benefit, in the driveway of number 25A (The Meadows), spot a 1959 pink Cadillac, registration FSK 279. In the front garden a well, a pump and a gas lamp, a stone otter and a stone hedgehog. On the wall of the mock tudor residence a security alarm. The house next door is called The Squirrels.

Suburbia lives.

It never died.

This book is about suburbia. It is about an emergent architectural space, a set of values and a way of life. It is about suburbia as a material environment, as a range of practices and as a slew of images and ideas. It brings together a range of contributions which, though by no means exhaustive, nevertheless aims to address suburbia and the suburban from the point of view of its production, its consumption and its representation. It places suburbia centre stage, unashamedly reifying it, unashamedly revealing the hidden underbelly of modernity in all its tortured, clichéd glory, but also rigorously enquiring into what it is that makes suburbia distinctive, what it is that has made suburbia so central to contemporary culture and what it is that we need to understand if we are to make sense not just of suburbia's past and present but also of its future.

Bromley is a case in point. Half a day's horse ride from London and once a manor of the bishops of Rochester, it was suburbanized, unexceptionally, following the sale in 1841 of Bickley Park. Its population quadrupled in the last forty years of the nineteenth century, following the arrival in 1858 of the railway, which brought the centre of the growing town to around twenty minutes from Cannon Street in the City of London (though cheap fares for the working classes were resisted here as elsewhere by those railway companies serving the genteel suburbs). H. G. Wells was born there in 1866, and so, it might be said, was Mr Polly. Bromley had long been a site for the erection of grand villas by the risen bourgeois for whom a seat in the country indicated their claims for aristocratic status, but, like so many towns and villages of the time and equivalent distance from London, it quickly succumbed to more speculative, underplanned and less ostentatious development. Population expanded beyond the capacity of the local Board initially to provide services, especially effective drains, but proper sanitation did arrive, as did schoools, churches and a cottage hospital. It received

its Royal Charter in 1903 – 'one of the busiest and most progressive of the independent communities within a short distance of the metropolis'.

Seventy years and two world wars later, Bromley achieved notoriety as one of the crucibles for punk rock in the UK and as a setting for the surburban novelists of south London. In between Bromley matured, life went on, properties changed hands, industries declined, its dependence on the metropolis ebbed and flowed. New housing was constructed in boom times. Offices lay and lie empty or incomplete in slump. Suburban culture, struggled for between the wars, secured in the 1950s and then progressively challenged since, is revealed, as well as masked, in all its overblown hybridity, as much in the tattoos and piercings of the suburban young as in the buddleias, lace curtains and shopping trolleys the young both reject and will one day in their turn and in their way reproduce.

Bromley is both unique and entirely typical. In this it is exemplary. Suburbia, the product of the complex and untidy histories and geographies of urbanization and modernization, is just such. Instantly recognizable though never entirely familiar. Ubiquitous but invisible. Secure but fragile. Desired but reviled. Suburbia is neither singular nor unchanging. Architectural and landscape styles vary from one suburban environment to another, from the tight semi-detached estates of the unplanned suburbs of 1930s Britain to the more expansive unfenced tract housing of middle America, from the elegant villas of early Victorian London to the clapboard and brick of 1950s Sydney. Nevertheless in each case the suburb is the embodiment of the same ideal as well as the same practical solution, imperfectly realized in both cases, and arguably unrealizable: the attempt to marry town and country, and to create for middle classes middle cultures in middle spaces in middle America or Britain or Australia.

Suburbia has remained curiously invisible in the accounts of modernity. The suburban is seen, if at all and at best, as a consequence, an excrescence, a cancerous fungus, leaching the energy of the city, dependent and inert and ultimately self-destructive. Marshall Berman's (1982) magisterial analysis of the experience of modernity is grounded in the life of the city, the visible vitality of the street, jumble, jungle, a vitality destroyed and denied by the sweeping redevelopments of freeways, malls and suburbs. The tension between old and new, the creative and destructive impulses, the paradox of ordered disorder, of an accessible, securable safety amidst the tense but creative struggle for the soul of the city – the capacity to make oneself at home in the maelstrom – this is what marked the essence of urban space and modern times. Yet for millions, and mostly by choice, the city was too much to bear. It was a place to leave. And for those millions, throughout the modern period, the experience of modernity was the

experience not of the street, but of the road, not the sidewalk but the lawn, and not the jarring and unpredictable visibility of public spaces and public transport, but the enclosed private worlds of fences, parlours and automobiles. Public. Private. Paradise. Prison. Palpable danger was replaced by hidden dread. Batavia, St John's Wood, Levittown, Crestwood Heights, Crawley New Town, Ramsey Street, Watts.

This search for the perfect marriage of nature and culture, this desire to create a balanced life, the best of all worlds, is one that has a long history. Merchants desirous of leaving behind the physical and cultural pollution of indigenous populations and commercial activity in colonial cities, rising middle classes escaping the noise, dirt and pressures of rapidly and chaotically expanding eighteenth- and nineteenth-century British towns and cities, immigrants to new continents and new coasts, the global upwardly mobile, all have made the suburb their own, claiming physical distance, social distinction and a degree of cultural control, and quick to protect and defend their gains against others who also want a share. This history, dimensions of which appear in the pages which follow, is a complex, often surprising and a crucial one. It is crucial because without it we are in danger of mistaking the suburb, of misreading the physical marginality of suburbia, always on the edge, always defined by what the city and the country are not, for both cultural and political marginality. An understanding of how suburbia was produced, and continues to be both produced and reproduced, is an essential precondition for an understanding of the twentieth century, an understanding above all of the emerging character and contradictions of our everyday lives. And this is the case even in the knowledge that vast populations live in other circumstances, sometimes close enough to be denied access to what they might see as the suburban dream, more often not even in the frame, removed by poverty from access to any kind of permanent dwelling let alone one which they could claim to own.

Running through many of the critical discussions of the character of suburbia and suburban culture is a strong sense of the paradoxes and contradictions that define it. Suburbia is, quite rightly, seen as both an essential product of urban expansion and at the same time an escape from, and a protest against it (Fishman, 1987: 206). The closure that those living within suburbia desire for their private lives and, at least for the males, their leisure time, depended and still depends entirely on the close economic as well as cultural links with the city. Indeed the tensions between work and leisure in suburbia are essentially gendered tensions, as women and men experience suburbia in, typically and conventionally, powerfully and divisively distinctive ways.

But the tensions lie even more deeply, as Robert Fishman notes:

The classic suburb has . . . left a rich legacy. It is first a monument to bourgeois civilisation at its
most prosperous and self-confident, an aesthetic achievement in both landscape and domestic
architecture that commands respect; but it is also a testimony to bourgeois anxieties, to deeply
buried fears that translate into contempt and hatred for the 'others' who inhabit the city.

(1987: 154)

What can be claimed as true of the classic suburb such as that designed by
Frederick Law Olmsted at Riverside, Illinois, can be seen as being of much wider
reference and relevance. Bourgeois suburban culture has become increasingly, as
the present century has matured, the dominant, fanned through the blandishments
of the broadcast media, sympathetically represented in fiction, as Alison Light
(1991) points out in for example the novels of Agatha Christie ('there might be
a body in the drawing room but there is nothing to offend or intimidate the reader
in the lounge' (76)), and only recently becoming vulnerable as a consequence of
both social and technological diversification and fragmentation. Yet suburban
anxieties have, of course, been the stuff of drama and literature. From Ibsen to
Osborne, from Flaubert to Updike, the intensity of bourgeois suburban life has
been subject to deep analysis, a clawing away of the superficial harmony of
domestic order, a revelation of the stresses and the strains of status, a constant
ringing challenge to the patina of barely achieved authenticity.

The suburban household has struggled hard to contain the anxieties generated
by its increasing dependence on, and vulnerability to, the events, both real and
imaginary, which take place beyond its front door: anxieties generated by fears of
public failure on the one hand, and of threats of physical and symbolic violence
on the other. Defences are constructed, against otherness in whatever form, and
rehearsed daily in the public media, as tabloids, soap operas, and confessional talk
shows chew their way through the dilemmas of the day. At the same time, and
from time to time, suburban culture itself erupts, and the lava of mod and punk
flows across its surface scarring skin and clogging pores until it is itself consumed
by the relentless juggernaut of mass commodification.

Yet suburbia is creative. The standardization so bemoaned by modernist critics
is itself, plausibly, quite superficial. Levittown has now become a passable model
of postmodern individuality, as standardized houses have been transformed, trees
and gardens planted, and the basic structure of grid and lot has been overlaid by
other designs and other models of suburban architecture. Spaces, both inside and
outside, are redesigned, reformed into expressions of personal taste and identity.
The shared products of contemporary material and symbolic culture are chosen

or discarded, arranged and rearranged according to desire, itself structured by class or ethnicity. Suburban streets are complex and subtle signifiers, offering, for those who can read the signs, delicate statements of style and status. Gleaming doorsteps, decorated paths, polished cars, weeded gardens, the junk of ages, lopsided caravans, peeling window frames, painted brickwork, double glazing, double garages, all together marks of distinction, and reinforced within the house by the nuances and idiosyncrasies of decoration and material culture. F. M. L. Thompson (1982) noted that if the nineteenth-century suburban dream was a middle-class dream, yet the reality, even then, was a social patchwork. The efforts at social standardization, from landowners, planners, builders and railway owners combined, failed to exert the necessary control. Even if individual suburban spaces betrayed the anticipated social homogeneity, the overall patterns of suburban growth around towns and cities were never less than sociologically and socially varied. The modern suburb is a social as well as a cultural hybrid.

Suburban culture is a gendered culture. Indeed the suburbanization of culture has often been equated by its many critics with a feminization of culture. The suburban home has been built around an ideology and a reality of women's domestication, oppressed by the insistent demands of the household, denied access to the varied spaces and times, the iteration of public and private that marks the male suburban experience and which creates, for them, the crucial distinctions between work and leisure, weekday and weekend. In particular, postwar suburbanization was buttressed by a concerted effort by public policy and media images to resocialize women into the home, and into the bosom of the nuclear bourgeois family (Spigel 1992). In the midst of this, opportunities for empowerment would emerge – Deborah Chambers discusses a number in this volume – as women took what limited occasions there were within the suburban iron cage for sharing activities, which like the Tupperware party, as Alison J. Clarke suggests, offered both conviviality and a measure of economic independence to set against the challenges of childrearing in neighbourhoods and communities that do not often offer enough support to the housebound suburban mother (Richards 1990).

Otherwise liberation of a kind, though barely, has come with what James Flink (1988) has called the refrigerator-automobile complex and the shift away from the relentless, daily, need to shop, cook and clean. But only changes in the public world of work have begun to make possible a fundamental shift in the material, if not the ideological, underpinning of suburbia. New technologies, new services, the instantaneity of what has now become an increasingly insistent phone-food complex (kitchens are beginning to atrophy) are also arguably beginning to disturb

established patterns. Changing demographies too are having their effect. Yet change is slow. It always is.

And whatever the changes in the social and gender dynamics of suburbia, they are framed if not determined by the consumerism that makes suburbia a life of style. Suburban culture is a consuming culture. Fuelled by the increasing commoditization of everyday life, suburbia has become the crucible of a shopping economy. There is an intimate and indissoluble link between suburbia and buying. The commodities that are displayed on shelves, in catalogues, on billboards and television screens, and in the corner shop, the department store, the mall, are all designed to contribute to the creation of suburbia. In a culture which has become increasingly one of and for display, stores, museums and homes have developed alongside each other, linked by the increasingly dilated veins of a commodity system that grows more intensive daily, even in its fragmentation (Sack 1992). The shopping mall, all glass and glister, all climate and quality control, is the latest manifestation of the dialectic of suburban consumption in which the skin of suburbia is somehow turned inside out, revealing the inner workings, the body, of 'commodified selfhood' (Langman 1992), triumphant in the displays of desire, sites for the social, places for seeing and being seen, ersatz locations for a new public exercising its rights and responsibilities in the neon marketplace. Suburbs are now being built around the mall, spatially defined by a symbolic and material dependence on what many have suggested are the cathedrals of our time. All the available variety and difference of late capitalism is displayed beneath dome and atrium, as fountains and fig trees, marble and glass, elevators and escalators, respectively contain, decorate and facilitate the endlessly effortless movement between nature and culture, heaven and hell. Shopping. Shopping.

The hybridity displayed in the shopping mall is a re-representation, a reflection and a revelation, of the hybridity of suburbia. Not nature, not culture; not country, not city; suburbia is a physical embodiment of a mythical solution to an essential contradiction. The melting pot of the city did not melt. Difference was preserved in districts and quarters and in the abrasive display of the juxtapositions of street culture. Yet somehow the suburb managed to impose its own logic. In architecture and landscape essential dualisms, both spatial and temporal, were denied – the garden city, Riverside, Hampstead Garden Suburb, in colonial, or mock tudor or prairie. And buried not far beneath the surface of its apparent uniformity lie distinctions that depend less on origin than on activity, distinctions that have lost their past and are defined only in the present, embodied perhaps in the ghostly images of family albums: the product of *the hybridization of time*. Expressed in the floodlit privacy of suburban yards and car ports, of picture

windows and indoor plants, are identities that both reconcile and deny the essential differences between urban and rural life; soil in the sitting room, machines in the garden: *the hybridization of space*. Those rehoused from urban slums in Britain after the 1939–45 war were offered a bourgeois solution to the problems of the city: a home of one's own and a little garden, both spaces to cultivate. The expectation was that these working-class folk would conform to an ideal, which they did, and lose their class culture, which in the first instance they appeared not to do (Goldthorpe et al. 1968). But the differences grounded in the differences of position in the system of production have gradually been overlaid and replaced by the differences of position grounded in the system of consumption (Bourdieu 1984), and though they arguably remain, they are muted and transformed: the result, *a hybridization of culture*.

Now hybrids, highly valued, difficult to produce yet vigorous, are often sterile. The sterility of suburban culture is much remarked upon, though mostly by those who have left or want to leave it. Likewise popular culture, the Light Programme of the BBC and the Ealing comedy, dance bands, radio soap operas, teen pop, even Hollywood, has equally been dismissed or despised by those who have little time or patience for the mass-produced. And even those who have defended the popular have done so, in recent cultural studies, on the assumption that the popular could be, and must be, authentic if it is to have value, and on the equivalent assumption that such authenticity could not be produced by the ordinary conformities of suburban life. Yet it is precisely in the ordinariness of suburban everyday life, in the rhythms and routines of day and week, commuting and housework, that the particular character and distinctiveness of suburban culture is to be found. And it is in the institutionalization of broadcasting, first in radio, then in television, that the ordinariness of above all suburban life is given its most dramatic and consistent, if also self-destructive, expression.

Suburbia offers a coincidence of the architectural and the televisual. The elective affinity between the two is increasingly being noted. Robert Fishman (1987), for example, writing on the new high technological post-suburbs rapidly growing along the edges of the old, points to the home-centred nature of both physical and symbolic environments, as 'technoburb' and television promote their mutual interests, in their equal dependence on, and encouragement of, decentralization. Both 'technoburb' and television have set their sights against the noise and nausea of the city.

Yet the interrelationship between television and suburbia lies deeper than this, as I have argued elsewhere (Silverstone 1994). It can be seen to have three dimensions. The first is the historical coincidence of the development of postwar

suburbia and the new television service, as heir to radio as a broadcast medium, providing a form of communication which has sustained a dispersing population, claiming through the annual calendar of media events, the schedule of daily and weekly programmes, and the consistency of voice and image an – albeit ideological – version of a national culture. Suburbia, as Raymond Williams (1974) has pointed out, has depended on developments in media technologies, pre-eminently radio, television and the telephone, to compensate for loneliness and distance, as well as to make mobilization possible. Television, above all, offers that route to the global, to an infinity of reach, metronomically playing tunes of alternate threat and reassurance as we watch from the more or less comfortable surroundings of suburban lounge or parlour.

Secondly, television provides in its programmes, especially in soap opera and talk shows, a constant mastication of the abiding dilemmas of (principally) suburban life: problems of sexuality and sexual relations, problems of community and neighbourliness, problems of family and of life and death, problems of childhood and of ageing, problems of physical and moral threat, problems of history and heritage, all of which are played out nightly on our television screens, which then become a kind of Greek chorus on the uncertainties and contradictions of contemporary life. Of course not all the settings for these endless narratives and endless discussions are literally suburban, but my contention is that the morality that informs and guides the narratives and limits their resolution is principally one that is grounded in suburban, bourgeois experience, always contained by the structure of the text, in the same way as they are contained in both the narrative and the experiential structures of everyday life. Indeed this can be pushed further and in two directions. The first is in the structures of the television texts themselves, especially those of soap opera: fragmented, multi-layered, endless and endlessly repetitive, which were created, it has been argued (Modleski 1983), for the domestic schedule of the suburban wife, always busy, always distracted, but always available for both story and advertising. And the second is in both what has been called television's secondary textuality (the discussions of television programmes, their stars and stories, in the pages of tabloid press and weekly magazines) and in the daily talk and chatter, in office, pub and, yes, over the garden fence. Here especially, both the structures and content, the characters and our identifications with them, are rehearsed and moulded to the fantasies and realities of suburban existence.

And finally, television, arguably, acts as an engine of suburban hybridization already discussed as it creates, displays and mythically reproduces all the ambiguities of modernity. This suburban hybridity is at the heart of television

culture, involving as it does the delicate but insistent definition of boundaries around the acceptable but at the same time increasingly refusing to discriminate between fantasy and reality. Television, it has been suggested, creates a hybridity of mixed and uncertain genres and representations. Meanwhile the once protected distinctions between public and private lives and spaces no longer can survive the endless refusal of television (and other media) to acknowledge the bounds of privacy, both of public figures and private citizens. History is merged to the present. Geography is denied by an instant compression of space. Nothing is unavailable. When everything appears to have value, then nothing has.

There is a tension then in television culture between its capacity to support suburban culture and at the same time its tendency to undermine it. This tension which appears elsewhere and which I have discussed elsewhere (Silverstone 1994) has significant implications for suburban politics and for what can be called the suburbanization of the public sphere.

Jürgen Habermas (1989) has bewailed the collapse of what he identified and valued as a public sphere, the product of an enlightened bougeoisie who, albeit briefly, were able, in coffee houses and through the convivial and unconstrained discussion of the issues of the day, to engage publicly in the political life of their society. Discussing the effects of the electronic media, of consumption and indeed of suburbanization, he points to the disintegration of a rational, critical public, denied the necessary distance that the world of letters and, as it were, 'applied' leisure encouraged. Both public and private spheres have lost their specificity and their function. Replacing it, Habermas argues, is a new refeudalized public sphere of display, withdrawal and 'tutelage' as the new media sabotage the privacy of thought, and as potentially potent citizens are turned into chronically impotent consumers. Drawing in William H. Whyte's (1956) seminal discussion of suburbia and making the same error of reading a particular stage of suburban development as if it were either the final or the only one, he too sees a convergence of the televisual and the architectural as together they undermine the vitality of the democratic process.

Suburban architecture and planning have been argued by many to have facilitated the shift both to a new kind of privacy and at the same time to its weakening. Symbolic, for example both for Whyte and Habermas, was the picture window of the ranch-style postwar suburb in the United States (never much of a feature in British suburbia, except in rear patio gardens), which was seen to express the new vulnerability and permeability of the private sphere. Suburban domesticity was a domesticity of ordered display and understated consumption in

which judgements of taste and style defined social position and coincidences of taste and style defined communities.

The politics that has emerged is not without its contradictions and its tensions. However, rather than a refeudalization suburbia offers a new kind of neo-participatory politics based on self-interest and grounded in defensive anxiety. Private property and fresh air. Both inspire on the one hand a version of intermittently moderate conservatism which in Europe goes under the heading of social democracy and in the United States involves a convergence of a sort between the established parties, and on the other an intermittently vicious and reactionary politics, ethnic and racist. Suburbia, as Homi Bhabha suggests in the postscript to this book, is becoming, increasingly, a battleground, both over-attacked and over-defended.

But there is more to suburban politics than party politics or a politics of confrontation. Power for the most part is exercised locally, within the suburb itself, but also from time to time, and when collective interests are threatened, on a wider stage. Equally the political process as a whole has been domesticated, or as John Hartley suggests in this book feminized, offering a politics of pragmatism, a politics of taste, in which transient but potent images replace ideas and ideals. The enlightenment has been suburbanized, and with it suburbanites participate in a different kind of politics, a tactical politics of the person conducted from the couch and on the phone rather than the soap box and dependent on technologically mediated strands of information and illusion. Participation may have been substantially enhanced by the mediation of national and international agendas, by access to the public and private lives of those in power, and by a constant, visible and accessible critique and analysis of the issues of the day, but the terms of that participation and the possibilities for influence are very much in question. Indeed as technologies and delivery systems multiply and fragment even the fragile illusion of a national community of suburbs will have to be rethought.

Indeed many analysts see traditional suburbia coming to an inglorious end as both the practicalities of women's increasing involvement in work undermine the basic supports of bourgeois family life, and the increasing social heterogeneity of suburbia results in a new urbanization, as suburbs become sites for a new integration of high-technology work, mall-based consumption and electronically protected living space. Edge cities (Garreau 1991) have mushroomed at freeway intersections all over the United States. Ideologically suburban, and certainly ex-urban, they nevertheless offer a new kind of hybridity: no longer dependent on the city for jobs, shopping or culture, they provide it all on site, a cocoon of

enmeshing nature and culture at the frontier of social space. Edge cities, architecturally hyperactive and sociologically inert, are the postmodern suburbs. Canary Wharf is potentially one such in the UK: a glistening phallus of a building surrounded by half-empty restaurants and unevenly terraced houses (red brick, hardwood windows and painted metal balconies) in turn clustered round deserted river basins and waiting, hope against hope, for some kind of activity that might disturb the placid surface either of the water or the day.

Does this signal the end, or just another manifestation, of suburbia; yet another metamorphosis in the long history of suburban spaces and lifestyles? Just as analyses of both modernity and modernism have ignored the suburb in favour of the city, so too have the equivalent discussions of the postmodern. De-industrialization and re-industrialization, the ever-changing dialectic of globalization and localization, decentralization and recentralization, increasing segregation and deepening social inequalities, ungovernability and new forms of urban representation together for Edward Soja (1995) define the geography of the postmodern city. Buried beneath these radical restructures suburban spaces are invisibly both reformed and remarginalized. Yet the suburban idea and ideal remains. Is Los Angeles a suburban city or a city of suburbs, or is it something else again?

Suburbia is no longer to be found simply in the landscapes of tract housing or ribbon development, among Victorian villas or in garden cities. It is to be found also, and perhaps increasingly, in the suburban imaginary, a virtual space no longer visible either on the planner's drawing board or on the margins of cities. Suburbia is a state of mind. It is constructed in imagination and in desire, in the everyday lives of those who struggle to maintain hearth and family and in the words of those who still are brave (or mad) enough to define and defend bourgeois values. It has a long history. Maybe it still has a future.

II

Visions of Suburbia brings together a number of studies of suburbia and the suburban. It is multidisciplinary and interdisciplinary. It is intended to provide an opportunity for a consideration, a critique and sometimes a celebration of suburbia from positions and perspectives based in historical, geographical and cultural analysis. Hopefully it will stimulate discussion and research. It raises many more questions than it can hope to answer.

The book is organized loosely into three broad sections, focusing in turn on a significant aspect of the construction of suburbia as a built environment, a social space and an ongoing discourse. As the book develops the focus shifts from the production of suburbia to a concern with consumption and then finally with its representation in film, television and perhaps especially in popular music. This structure is an attempt to define an orientation to the dynamic processes of suburbanization and to the multitudinous variations in both the experience of suburbia and its visible expression. Informing all the contributions, in some more explicitly than others, is a claim of the centrality of suburbia for an understanding of modernity and of the twentieth century. As the century draws to a close, as the unravelling threads of modernity are rewoven into something called the postmodern, the significance of the suburban, in all its contradictions, looms increasingly large. The issues raised are not of course simply academic ones. They relate directly to the way in which we live or might live, to the politics of urban space, to questions of identity, authenticity and security in a world of increasing uncertainty and change. The suburbs are important as the physical and cultural manifestation of a particular (though evolving and never consistent) solution to the problem of providing both house and home for increasing numbers, and increasing numbers of upwardly mobile individuals and families – globally. Never ideal, never perfect, always contentious, suburbs have nevertheless become models of hominess, as bourgeois values have flowed through the increasingly sclerotic veins of the social system.

Representation is the key term, for through it one can explore the ways in which the particular reflexivity of suburban life is expressed. Suburbs represent themselves. They are, both in the broad brush-strokes of landscape and class as well as in the fine detail of distinction, offering a constant commentary on their own emergent aesthetic, on their own rights of existence. Their development has never passed without record or comment. The values that they are presumed to have encouraged and upon which they mostly depend – moral as well as aesthetic – have filtered through into literature, art, cinema, television, music and fashion. They have never been uncontested. Indeed some of the more strident struggles on behalf of high modernism have been fought, as John Carey (1992) documents so well, around the presumed philistinism of suburban life. The suburbs, therefore, are 'represented' in the ways of their production as well as in consumption, and they are also 'represented' in various, and often unashamedly contradictory ways, in the pages of this book.

John Archer opens the book with an account of the creation of the early colonial suburbs, in Batavia, Indonesia by the Dutch and in Madras and Calcutta

by the British. The distinguishing characteristic of the modern suburb of which these were the forerunners is what he calls contrapositionality. Earlier suburbs, and indeed the *kampongs* of Batavia, had grown up or were created outside the city for safety's sake or for ethnically defensive reasons. Indeed such early suburbs, of which there were many in medieval European as well as colonial cities, were almost always unregulated places, deplored, feared and generally avoided by the citizen. What marked these new suburbs was a new relationship to the city which they left behind. Individual villas, and then by a more or less rapid process of accretion, residential districts were constructed beyond the city walls, the fort or the trading centre, but their relationship to it was one of equivalence and equality not one of dependence. The suburbs that matured on the Waterlooplein, the Choultry Plain and in Chowringhee, though architecturally distinctive with respect to each other, established a common form of life, enabling the colonial traders, both the elite of the trading companies and the rising bourgeois and professional classes, to create a residential environment, homogeneous, secure and separate, to which they could retire for peace and leisure at the end of the week or at the end of the day.

From the very beginning, these colonial suburbs came to embody and display class and ethnic identities and cultures, not just with respect to indigenous populations which they increasingly came to ignore geographically and architecturally, but within the frame of the colonial culture itself. Archer points to the attempts by the upper echelons of the East India Company in Madras in 1759 to control the potentially socially disruptive attempts of the less exalted members of their ranks to build their residences away from the city, fearing that such luxury would encourage idleness. This confrontation between versions of, and rights to, a suburban existence presaged not dissimilar confrontations in Britain, especially between the wars, when the lower middle classes left the cities in droves, quite overwhelming the genteel seclusion that the first generations of suburbanites had gained; a moral and aesthetic threat which much disturbed the likes of Evelyn Waugh, Graham Greene and E. M. Forster (Carey 1992).

Morality and aesthetics. Architecture and popular culture. The domestic and the colonial. These conjunctions are rarely separated in the history of suburban development. Anthony King's discussion of the bungalow is exemplary in this respect. King has written widely on the history of the bungalow (1984/1995). In this contribution he traces its thorny relationship to its colonial and imperial past as well as its stormy relationship to the conformities of bourgeois culture. The bungalow, from its first introduction into the UK during in the 1870s, contained powerful and contradictory symbolic charges. It offered a profoundly other kind

of domesticity than was then the norm in British cities. Separate, singular, without the clear internal boundaries between public and private space that the multi-floored town or city house provided, it defined a radical new version of social space which attracted both the prominent architects of the Arts and Crafts movement and the criticism of those who saw engrained within it a challenge to the established proprieties of middle-class domestic life. This challenge was informed, and indeed depended upon, the bungalow's close association with Britain's imperial heritage. It was touched by the exotic. It depended economically (many of the first bungalows were built for returning colonial administrators and entrepreneurs), symbolically (Fred Horner's play *The Bungalow*, of the end of the nineteenth century, dealt with 'narratives of masculinity, sexual transgression, marital infidelity, flirtation, Bohemianism, artistic flouting of social convention, Orientalism, and also racism' (p. 60)), socially (the bungalow was a key architectural component of the suburbanization of time, the weekend) and aesthetically (it was from its first emergence a hybrid of architectual styles) on an otherness that of course quickly became domesticated in the seaside suburban estates between the wars.

Anthony King's account offers a fragment of an otherwise hidden history. It is clearly a particularly British history; the bungalow style has quite different connotations in the United States, for example. But in completing his story King moves to contemporary Australia where the continuing saga of suburban architecture in general, and of the bungalow in particular, is taking another twist in its reappropriation by the new post-colonial immigrants into suburban Sydney and Melbourne. The bungalow has shown itself, like suburbia, to be particularly resilient to, but also expressive of, changes in the global economy and polity and above all in the relationships that have been written, and are continually being rewritten, in global culture.

Sydney is also the site for Deborah Chambers's study of postwar suburbanization. Her history of this rapid, and only belatedly and inadequately, planned suburban development is based on an oral history conducted among the women who participated in it. Their memories are of a kind of two-step suburbanization, the first stage of which involved the creating of plots big enough for the new residents both to build their own houses and to cultivate their own gardens – a new Eden in which these early residents struggled to create a suburban community. It was built on the foundations of urban work for the men and a barter economy among the women, exchanging eggs and tomatoes, dependent on the weekly visit from the grocer and on their own preparedness, for they had neither cars nor public transport, to walk. This was a now romanticized, and inevitably

ephemeral, suburban environment: isolated, rural, but entirely engaging. The women at home were forced into each other's social and economic space, and as a result also into a political space – since many combined to oppose later developments and to force through community schemes. Nevertheless government plans and urban expansion were together unstoppable. The new suburbs were pre-planned, socially and architecturally, and, as a result of the failures of both, what is now remembered as a rural idyll, hard but creative, disappeared under a barrage of bulldozers and brick.

Chambers analyses, through the voices of the women themselves, their experience of this second wave of (mostly immigrant-led) suburbanization: thousands of folk dumped at a railway station; an extra hundred children arriving in school the next day with neither warning nor additional resources. Planning was appalling. Isolation increased. The compelling patriarchy at the heart of suburban life became more intense and less manageable: 'the all-man's land of quiet civilization serviced by women situated in a miniature version of the English country house' (p. 88). This was, however, always a socially mixed version of suburbia: loans were available to the working class. It was also a suburban development powerfully suffused by an ideology of progress; progress however only reluctanctly acknowledged, in a kind of resigned disbelief. Suburban history, in Chambers's account, is women's history. And they are, as it were, both its heroes and its victims. But it is they who were offered, and in one way or another gained, through their occupation of their suburban plots and in their capacity to manage the social space, a stake in the country.

However, the suburb is more than a matter of location, more than merely space. It is also a matter of time. Gary Cross traces the rise of the weekend, an essentially suburban phenomenon and claimed not so much by the high bourgeoisie as by those wage-earners who, as the twentieth century progressed, increasingly laid claim to structured days of rest. The weekend is the result both of emulation and escape: emulation of the leisure and freedom of the upper classes; escape from the incessant demands of waged work. It marks an escape from production to consumption, but it also reinforces the sharp distinction between them. At the same time the weekend as a temporal site for consumption is double-edged and ultimately possibly self-destructive, as Cross himself points out.

The release from the workplace and from work time brought men home at defined times. It provided time to spend, legitimately, with the family and enabled familial and social identities to be created and sustained. From public obligation to private autonomy. Private creativity intertwined with public display. Do-it-yourself

work enabled traditional gender roles to be sustained – the men with their drills and the women with their stoves and washing machines. Indeed the suburban weekend depends, as does suburban life as a whole, on a traditional division of labour: the site for both work and leisure for women whose weekend as a result could never have quite the same significance as it had for their menfolk.

The suburbs expanded in the aftermath of depression and world wars, as government policies, especially in the United States, recognized the importance of reinforcing family life. Suburban homes were built for those increasingly desirous of leaving cities or recovering from economic and political disruption. They depended on growing disposable incomes. And the spaces that marked a new kind of space for living required in their turn a new kind of time, though it was not until the 1960s that the two-day weekend was recognized in the UK. The golden age of the suburban weekend, the middle years of the present century, was marked by a romance of feminine domesticity and the glory of (more or less) creative and conspicuous consumption. Yet arguably the drive to consume has been a factor in the weekend's decline, consumed itself as much by the extension of the market, both the liberty and the pressure to buy, as by the increasing participation of suburban women in the workforce and the creeping financial and social insecurities of everyday life. As Theodor Adorno and Max Horkheimer once noted, presciently perhaps, even the weekend is regimented into the structures of the working week, fundamentally being undermined by the same forces that created and sustained it.

Suburbia as a site for consumption, and above all for gendered consumption, is Alison J. Clarke's theme as she explores the wonderful mysteries of Tupperware and the Tupperware party. On the face of things this form of marketing dragged the commodity into the heart of the household and symbolized much that was oppressive in mass consumption. Tupperware embodied, and embodies perhaps still, much that was both despised but also lauded in modernity. Tupperware plastic was a dramatic expression of modern technology, aesthetically appealing, hygienic and labour-saving. It signified and made possible the housewife's full participation in suburban culture, which could just as easily be (and might often have been) described in similar terms. Clarke, while acknowledging the full force of the various aesthetic and social critiques, points both to the paradoxes at the heart of Tupperware's symbolic – embodied in the conflicting moralities and agendas of Tupperware's founder, Earl Tupper, who never departed from a functionalist puritanism and its chief marketer, Brownie Wise, who pursued glamour and mystique as if there was no tomorrow – and to the potential for its appropriation by the otherwise downtrodden and denigrated suburban housewife.

Clarke's argument draws on Daniel Miller's recognition that the commodities of contemporary capitalism become meaningful only in their appropriation. Commodities become objects only when those who buy and use them, and in this case participate in the rituals associated with their commodification, make them their own. They are incorporated into the spaces, times and discourses of everyday life, into a domesticicty that has to be created and must be maintained precisely and only through the resources that mass culture makes available. The women who participated, and still participate, in the cascade selling which Tupperware pioneered, are, for Clarke, expressing their identities in ways that feminists have either overlooked or undervalued. Tupperware parties sanctioned a kind of sociability that enabled women to leave, albeit momentarily, the confines of the family. Indeed, as she shows quite convincingly, the Tupperware women, predominantly but by no means exclusively white and middle class, used their participation in this nakedly commercial operation to 'enhance their self-respect and utilize their skills in service to their neighbourhoods as valued members of the community' (p. 143). The study of Tupperware powerfully and eloquently reveals many of the contradictions at the heart of suburbia, particularly as they affect suburban women.

This chapter is followed by two which both focus on the politics of suburbia, though each takes quite a different view. Together they make possible a focus on the complexities of class and gender as they work their way through the modern and indeed the postmodern suburb, offering visions of a political landscape that is in turn either reductively and locally conservative or expansively and universally transformative.

Nancy and James Duncan offer a rather bleak view of the politics of suburbia as it manifests itself among the shady and carefully zoned acres of Bedford County, Westchester, New York. Here they find a combination of possessive individualism and conservative aesthetics which together serve to maintain a community's hold over its neighbourhood. The untrammelled and unquestioned American belief in the individual and in the private ownership of property leads to an aesthetic ideology which requires, and is sustained by, the visible evidence of individual success. High, single-class suburbia provides the most consistent such evidence. Supporting it, and supporting a correlative refusal to alter the social geography of the county, is an intense localism and consequent parochialism, which in turn serves to preserve the inevitable structural inequalities that lie not far below the surface of urban and suburban spaces.

These suburban spaces, and the rights to ownership of, and access to, them are defended not so much on political as on aesthetic grounds, as Bedford County

residents appeal both to history and to nature as witnesses to the legitimacy of their case for preservation and continuity. Their ideologies are suffused by more or less romantic versions of the colonial past and of nineteenth-century Englishness. Nature is either untamed, and therefore requiring stewardship, or pastoral, and therefore needing careful ownership. Either way, argue the Duncans, what is involved is both a naturalization of aesthetics and an aestheticization of nature. And together, following Walter Benjamin, they converge as an aestheticization of politics. Their analysis of suburban mentality provides, even in its reflexivity, an image of a kind of congealed suburbanization locked into a culture of defensive possessiveness, in which differences and distinctions between classes are the operative factors. This is indeed a singular suburbia, whose politics and culture seem far removed from the more urgent, contradictory and fragmentary ideologies of late twentieth-century suburban life, but it is nevertheless immediately recognizable not just in its relatively passive form in Westchester but in the much more aggressive defensiveness of the equivalent communities in Los Angeles (Davis 1990).

At this point, and appropriately on the axis of the political, the contributions to *Visions of Suburbia* shift. The shift is both methodological and substantive. It involves a lesser concern with space, and with place as literally and materially, location. On the contrary, from now on suburbia becomes passably de-reified and dislocated. It is to be found not only in the mores and histories of suburbanites but also in the imaginary: in the representations and meanderings of a universal, global, mediatized culture. To be sure, suburbs remain. Suburban lives go on, though increasingly less secure perhaps and increasingly varied and conflictful in character. But these lived experiences are overshadowed by their reflection, refraction and transformation in the narratives, images and fantasies of contemporary electronic culture: in film, on television, in magazines, in music.

John Hartley's suburbia is above all a media space; a suburban diffusion, a suffusion even, of privatized, feminized, sexualized images. Behind the closed doors of suburban villas a new politics is being worked on and out, a politics no longer of rational critique, of the classically but atavistically defined public sphere, but a politics of consumption and display, of gender and of class; of the glance rather than the look; an ephemeral politics of sensuality rather than sense and of the virtual rather than of virtue. In this suburban 'semiosphere' what matters is what is seen, the 'frocks' pop not the vox pop, in which a kind of almost post-suburban rationality is constructed out of the rhetorics of the smiling faces of pop idols and where the body politic is replaced by the politics of the body – an

empress (if Kylie Minogue, Sophie Lee or Elle Macpherson could be called empresses) without any clothes.

Suburbia provides the fertile ground for this novel emergence because the suburb has always been marginalized and denigrated by, as well as excluded from, the formal processes of national politics and modernist culture. To engage now with such politics requires a recognition that what is emerging is a suburban public sphere, in which judgements of taste are what pass for political judgements, and where power dressing has more significance than the traditional dressings of power. Hartley points to the methodological significance of this new power game. It requires a focus on cultural politics and a commitment from those in the academy who are interested in such things to make cultural studies above all the study of the (suburban) popular, to address the production of meaning in and through the conduct of everyday life.

This is indeed, at least in part, Lynn Spigel's project. Continuing an emphasis on suburban and cultural politics, though this time stressing the politics of exclusion, the politics of difference, the politics of the other, Spigel traces the interweaving of images of suburban domesticity with ideas of the theatre in, above all, 1950s television situation comedies. Perhaps most classically in the *Burns and Allen* show, ideas of suburbia as theatre, and of television theatre as suburban, were played out within a double proscenium that reproduced and pastiched Victorian mores of domestic theatricality. Spigel points to the ways in which the suburban is defined in and through the competing metaphors chosen to represent it. Suburbia is an imaginary. It is seen through the picture windows framing both the outside and the inside of tract housing; it is reconstructed in interplanetary households; and it is parodied and transgressed as aliens land on earth and struggle with the need to conform to white middle-class suburban culture. The space race provided images for a rhetoric of the suburban, just as suburban images provided the rhetoric for the space race, most typically in defining the character of those who were (or in the case of the black astronaut Edward J. Dwight, who were not) going to leave the atmosphere.

Reflections and distortions – the suburbanized images of space and the fantasies that were encouraged in their representation both offered a novelty and familiarity. Suburbia there was just like suburbia here – only perhaps more so. Suburbia here was reframed through a discourse that both secured it and offered, through dramatic images of travel, an opportunity to leave it all behind – a kind of domesticity of course which looks, when you get there, remarkably like the one you left behind. The space race provided therefore an opportunity for a distinct aestheticization of everyday life, as popular music, furniture design and the tail fins

on motor cars grafted one set of images on to another, making the familiar strange as well as the strange familiar.

Meanwhile suburban sitcoms provided a reinforcing ideology of segregation, gender oppression and whiteness, as time and again otherness was seen as a threat. In images as in life, in the space race as well as in the suburbs of California (and elsewhere), what was being asserted was – and palpably still is – an ethic of exclusion – insistently homophobic, consistently racist. This remained despite the momentary repositioning of the suburb as between the city and space, rather than the city and the country. In a critique which insists on recognizing the force of the metaphoric as it penetrates the fabric of everyday life, Spigel draws attention to the re-emergence (was it ever lost?) of suburban ideology in the new rhetoric of the internet and of virtual communities.

Returning once more to the 1950s and 1960s – the suburb's golden age – and then beyond, Andy Medhurst explores how suburbia appeared on the originally monochrome screens of the nation's television sets and Odeons. The suburbs were distinguished as much by their absence as by their distinction in the British cinema of war and immediate postwar time, and only in the brief flowering of 1960s kitchen sink films as that postwar period of mild (but mildewed) social confidence began to erode did the suburb appear as anything other than conveniently benign. On the other hand, and perhaps from the beginning, a gently ironic playfulness marked television's indigenous genre, the sitcom, where suburban narratives, much like suburban hedges, were and are sharply defined both to 'out' and to defend the hidden agendas of suburban neatness. Stability, hierarchy and emotionlessness are given visibility as much through the interaction of suburban doyennes and eccentrics as in the mock tudor, pebble-dashed, begnomed closes and cloisters they inhabit.

The suburban sitcom is a place where the trivial is raised to the status of an art form, where gentility rules and the troubled agendas of class, patriarchy and homophobia buffet precariously on the washing lines. Tony Hancock and Reginald Perrin, Margo in *The Good Life*, Martin in *Ever Decreasing Circles* and Hyacinth Bucket in *Keeping Up Appearances* (all British sitcoms) offer models of suburban eccentricity now male, now female, now excluded now excluding, which define the particularly British version of suburban dreams and nightmares. 'Know your place': that is the message, and, despite the satire, the suburban vision remains, tarnished perhaps but not yet quite torn.

However, once the purview expands to include other genres, the complexity of British television's version of suburbia becomes more visible. Medhurst sees in the gritty proletarian British soap opera resolute antagonism towards the suburban

and the middle class, ridiculed when they appear, more often than not simply absent. He points to the failure of the genre when its attachment to regionality is abandoned, and, curiously neglecting the much trumpeted but oversold *Eldorado*, as well as excluding the Australian soaps which have been so successful in the UK, nevertheless insists that the soap has no place for gnomes.

Suburban culture is middle-brow, and suburban music, even in its aggressive and reactive mode, is, if nothing else, pop. While this excludes the kind of music-making that goes on behind closed parlour doors (for which see Finnegan 1989), it is essential to point to the distinctiveness of the suburban sounds in the postwar history of British rock music. This is a theme which is picked up by Simon Frith and also by Vicky Lebeau in the two following chapters. Here Andy Medhurst finds both in 'Penny Lane' and in the various manifestations of punk and the New Romantics versions of a kind of suburban survival myth, satirizing or savaging the not so gentle conformities of an everyday life lived, for the most part, behind the flapping lace and iron curtains of suburban window panes.

Simon Frith argues that the working-class rhetoric of class and street is itself the product of the suburban dream: a paradox, and not the first, which sees in the suburban reaction to the suburban the seeds of an albeit ephemeral culture: the culture of youth, of the street, the culture above all of pop and rock. Pop is perhaps quintessentially suburban, blurring and uniting cultural categories, longing for otherness, and seeking to unmask suburban pretension, claustrophobia and discontent. In pop and rock are to be found the germs of suburban fantasy.

In this account too the suburb has a precise location: south-east London; and a precise ethnicity, class and gender: white, middle class, male. David Bowie and Boy George have, among many others, marked out a territory, a territory which extends from Bromley's bedroom Bohemia to the not too distant city. Yet the city is a place to visit, not one to occupy, and a place to play escape and to domesticate decadence. The city is the lamp around which suburban moths flutter: camp, elegant, marginal and modestly dangerous, and in all of these things resolutely other than dully suburban.

Frith's account focuses on one of the more recent suburban pop phenomona, Suede, whose musical and stylistic claims, modelled within the genre, depended on an assertion of decadence, sexual ambiguity and the slightly dour, pretentious, intense – and thus, in suburbia, entirely familiar – figure of the boy next door. Suede builds on the acknowledgement of the marginality within, celebrating suburban alienation and creating a kind of utopia of boredom in which the city is less than a real place: something made up in suburbia itself. London, then, is not a place to live but a backcloth against which to imagine living, and Frith

suggests that perhaps in this version of suburban (and anti-suburban) culture there is a lack of any real desire to escape.

British suburbia is as much a product of pop as the reverse, and pop has created its own version of the suburban. Indeed the suburban itself is quite a different experience for children and their parents (adults leave them to go to work at least). The young are trapped and bored. They dream complex media dreams that shudder between the mundane and the apocalyptic. The result, often, and certainly recently, is a suburban Gothic: music written and style expressed against growing up. British pop has involved, and still involves, the turning of suburban alienation into aesthetic objects and cultural commodities. It offers, perhaps, the only continous reflection of what suburbia is and what it does to the young.

Finally, Vicky Lebeau's complex and sensitive analysis of suburban conflict and contradiction brings the particularities of punk music and culture to a head, arguing that it not only signals an age and class reaction to the oppression of suburban conformity and neatness, but that it manifests, in its strangulated, peremptory, frustrated anger the deep-seated pathologies of the suburban life-in-death of the current young generation's parents.

Lebeau takes as her starting point Phil Cohen's focusing on the significance of postwar urban renewal and inner city destruction for the generation of subcultural forms, and locates their emergence in the reactive formations of the displaced working class to the disturbance caused both by the loss of the community and the iron cage of the punitive, autistic culture and endless boredom of suburban days and nights. She points both to a kind of repetition compulsion (punk reproduces suburbia's own brand of alienation) and to the complex antagonisms of class as together crucial for an understanding of this unique cultural expression.

The suburb is neither uniform nor secure. First generations of middle-class suburbanites resented the arrival of the rehoused East-enders, and the newly arriving East-enders found a society of sullen privatization to which they would have to adapt, since the supports of the traditional family and neighbourhood networks (both identified and beloved by Wilmott and Young in their seminal 1950s study of Bethnal Green) were no longer in place. On the one hand, few shops, fewer pubs and ubiquitous television. On the other a suburban uncanny, a barely articulated fear of the familiar.

Punk – the sound of the city but with its fans in the suburb – is the response, though whether it expresses a sort of solidarity with what was once working-class culture, or whether it emerges as a parody of suburban anomie, in touch with the barely repressed aggression so often marked as characteristic of suburban life, is

very much the issue. Lebeau argues for a geneaology of punk that recognizes these contradictions, and at the same time casts suburbia itself as a cultural battleground.

REFERENCES

Berman, Marshall (1982) *All that is Solid Melts into Air*, London: Verso.
Bourdieu, Pierre (1984) *Distinction: A Social Critique of the Judgement of Taste*, London: Routledge.
Carey, John (1992) *Intellectuals and the Masses*, London: Faber.
Davis, Mike (1990) *City of Quartz: Excavating the Future in Los Angeles*, London: Verso.
Finnegan, Ruth (1989) *The Hidden Musicians*, Cambridge: Cambridge University Press.
Fishman, Robert (1987) *Bourgeois Utopias: The Rise and Fall of Suburbia*, New York: Basic Books.
Flink, James (1988) *The Automobile Age*, Cambridge, MA: MIT Press.
Garreau, Joel (1991) *Edge City: Life on the New Frontier*, New York: Doubleday.
Goldthorpe, John H., David Lockwood, Frank Bechofer and Jennifer Platt (1968) *The Affluent Worker in the Class Structure* (3 vols), Cambridge: Cambridge University Press.
Grossmith, George and Weedon (1892/1945) *The Diary of a Nobody*, Harmondsworth: Penguin.
Habermas, Jürgen (1989) *The Structural Transformation of the Public Sphere*, Cambridge: Polity Press.
King, Anthony D. (1984, second edition 1995) *The Bungalow: The Production of a Global Culture*, London and Boston: Routledge & Kegan Paul.
Langman, Lauren (1992) 'Neon cages: shopping for subjectivity', in Rob Shields (ed.) *Lifestyle Shopping: The Subject of Consumption*, London: Routledge, pp. 40–82.
Light, Alison (1991) *Forever England: Femininity, Literature and Conservatism between the Wars*, London: Routledge.
Modleski, Tania (1983) 'The rhythms of reception: daytime television and women's work', in E. Ann Kaplan (ed.) *Regarding Television*, Los Angeles: AFI.
Richards, Lynn (1990) *Nobody's Home: Dreams and Realities in a New Suburb*, Melbourne: Oxford University Press.
Sack, Robert (1992) *Place, Modernity, and the Consumer's World*, Baltimore: Johns Hopkins Press.
Silverstone, Roger (1994) *Television and Everyday Life*, London: Routledge.
Soja, Edward (1995) 'Postmodern urbanization: the six restructurings of Los Angeles', in Sophie Watson and Katherine Gibson (eds) *Postmodern Cities and Spaces*, Oxford: Blackwell.
Spigel, Lynn (1992) *Make Room for TV: Television and the Family Ideal in Post-war America*, Chicago: Chicago University Press.
Thompson, F. M. L. (1982) *The Rise of Suburbia*, Leicester: Leicester University Press.
Venturi, Robert Scott, Denise Brown and Steven Izenour (1977) *Learning from Las Vegas*, Cambridge, MA: MIT Press.
Whyte, William H. (1956) *The Organization Man*, Harmondsworth: Penguin.
Williams, Raymond (1974) *Television, Technology and Cultural Form*, London: Fontana.

1

COLONIAL SUBURBS IN SOUTH ASIA, 1700–1850, AND THE SPACES OF MODERNITY

John Archer[1]

INTRODUCTION

SPACES AND PRACTICES

Suburbs and colonies, like other forms of human production, are instruments conceived to advance certain interests. Ordinarily the beneficiaries are the builders and people who may live or work there, though in many cases spaces are articulated just as intentionally to limit the interests of others. In any event, spaces of any sort that people occupy are more than mere containers or settings for human activity. The specific configuration of any space actually plays a crucial role in the formation and sustenance of the consciousness of all those who exist there. Likewise space is integral to the delineation and facilitation of the whole spectrum of relations among individuals, institutions, and social fractions (classes, castes, genders, races, etc.). Indeed the very terms and dimensions of human praxis – economic, political, moral, religious, artistic, etc. – are embedded in, and sustained by, the configuration of surrounding spaces.[2]

In light of such considerations, the study of colonial spaces is particularly complex – and particularly rewarding – since colonial space simultaneously sustains not only two or more distinct cultures, but also the complex array of boundaries, relations, and negotiations among them. Embedded in this array are such processes as differentiation, amalgamation, segregation, domination, exploitation, and resistance. And of particular interest in the case of colonial suburbs, the articulation of new kinds of space can sustain residents in their construction

of new positionalities outside the canons of either culture – for example, the legitimation of practices outside the limits ordinarily imposed by caste or by class. The particular ways in which spaces are configured, then, are instrumental not only in the constitution, but also in the ongoing transformation of social structures and human practices.

COLONIES AND SUBURBS

Colonies and suburbs (in the sense of a locale outside the settlement proper) have existed almost since the beginning of organized settlement. For much of this time colonies and suburbs were sites of exile and alienation. Both were politically and economically dependent on the metropole. And both served the same dual functions: they were places from which to import goods that could not be produced or finished within the settlement proper, and they were places to which the unwanted could be exported (criminals, heathens, pollution). Toward the end of the seventeenth century, however, the expansion of European mercantile economies and the corresponding expansion of European bourgeoisies occasioned the refinement both of colonial settlements and of suburbs into more sophisticated and purposeful instruments for the realization of specific societal practices and relations.

Suburbs in particular, instead of being unregulated sites for practices the cities found impermissible, slowly were transformed into highly desirable, detached, clearly circumscribed, exclusively residential (and generally bourgeois) enclaves. Central to this transformation was a fundamental change in the character of the relation between suburbs and cities from *hierarchical* to *contrapositional*. The positionalities of city and suburb no longer were tied to each other by simple relations of hierarchy (e.g. one locale being intrinsically superior to the other). Rather, those positionalities came to be predicated on an array of binary oppositions (e.g. commerce/domesticity, res publica/family) which gave to each locale an integrity in part defined by negation of – not subordination to – the other. Thus I use 'contrapositional' to refer to the distinct, and in many respects opposed, positionalities adopted by the modern suburb and city.

Throughout the eighteenth century and into the nineteenth, the further transformation of suburbs and colonial cities – and suburbs *of* colonial cities – served to articulate key dimensions in which European cultures were evolving: social differentiation, economic extraction and consumption, the political redefinition of property and of possessive individualism, and the aesthetic

articulation of the self. All of these dimensions are evident in the suburban growth of three colonial cities to be discussed below, Batavia, Madras, and Calcutta. But first it will be helpful to explore in more detail the role of built space in effecting social differentiation.

SOCIAL DIFFERENTIATION

It is commonly advanced as axiomatic that colonial cities as well as suburbs in general are apparatuses, even engines, of racial segregation.[3] In many cases, this presumption is wrong, for it mistakes a sometime effect for a fundamental principle: race was by no means the sole or primary axis along which space was divided. In many cases, such as suburbs of Batavia or Singapore, Chinese bourgeois households were intermingled with those of Europeans. Likewise for at least the first sixty years of English settlement in Calcutta, European businesses and residences could be found spread throughout all sectors of the city; only after the battle of Plassey (1757) and subsequent intensification of economic and political pressure on the East India Company could explicit patterns of racial segregation be demarcated.

A more effective way of approaching the problem of segregation – and one that by no means discounts its widespread presence – is to approach all inhabited spaces, urban and suburban, metropolitan and colonial, as necessarily being instruments of social differentiation. They are necessarily so because human society never has functioned, and probably never could, without multiple dimensions of differentiation. The particular manner in which any culture, group, or individual configures space not only serves as a cognitive anchor of those dimensions, but also is instrumental in their facilitation and maintenance.

The flip side of difference is homogeneity. As Foucault recognized in his essay on heterotopia,[4] space not only institutionalizes difference; it simultaneously provides for locales where sameness and likeness are reinforced. Differentiation, moreover, occurs in part by condensing and concentrating certain common characteristics of various social groups and fractions. As part of this process, differentiation according to such characteristics as gender, caste, race, ethnicity, occupation, religion, and citizenship comes to be institutionalized in the culture through spatial and architectural means.[5]

Early in the nineteenth century, belief in the efficacy of exploiting certain degrees of differentiation for economic and political purposes was fundamental to the design of colonial cities as well as suburbs. Sir Thomas Stamford Raffles's 1822

plan for Singapore is an archetypal example of a city where particular sectors were designated for specific functions and population groups (Figure 1.1). Not long afterward John Claudius Loudon, in his epitome of suburban design, *The Suburban Gardener, and Villa Companion* (1838), took for granted the need for homogeneity within such sectors. Speaking of residential enclaves adjacent to metropolitan cities, he lauded those in which 'the houses and inhabitants are all, or chiefly, of the same description and class as the house we intend to inhabit, and as ourselves'.[6]

In Singapore as well as in the English suburbs that mushroomed in the decades following Loudon's treatise, as in virtually every built space, the axes of differentiation were complex and multiple. Among the axes that are relevant to the discussion of colonial cities, and metropolitan and colonial suburbs, four stand out most prominently. First are the parallel distinctions between metropolitan and peripheral, and between urban and sub-urban. Both rely on the constructed notion that certain highly privileged activities (e.g. finance, legislation, 'culture') are located in the hub or core, while other sorts of activities that are beneath or beyond the scope of the core are relegated to the margins. Thus the original sense of 'suburb' in English connoted an area in which noxious, dangerous, and illicit activities occurred. Yet the eighteenth-century inversion of the term into something with very positive connotations still retained the sense of opposition-ality to the core, pitting suburban aesthetic pleasure, leisure, and virtue against metropolitan politics, business, and corruption.

Second is the axis of collective identity. The different quarters that were reserved for different ethnicities in Singapore, although not wholly residential enclaves, announced a function in many respects like the suburban locales that Loudon described, where elements 'of the same description and class' would be concentrated. In both cases, the reservation of a specific locale for specific elements would provide for the spatial definition and support of an identity that would be seen as distinct in relation to other, differently configured portions of the city or its dependencies. The point is not only the construction of a common, homogeneous identity; it also is the differentiation of that identity from all other groups.

The third axis is the distinction of elite from non-elite. A site detached from the urban centre can be highly effective for the construction of status and prestige, since it distinguishes the site-holder as above or beyond standard constraints and rules. Examples range from ancient Roman and Italian Renaissance villas to modern-day gated enclaves. In the case of colonial cities the same axis of distinction existed, but the poles were reversed. The European metropole was

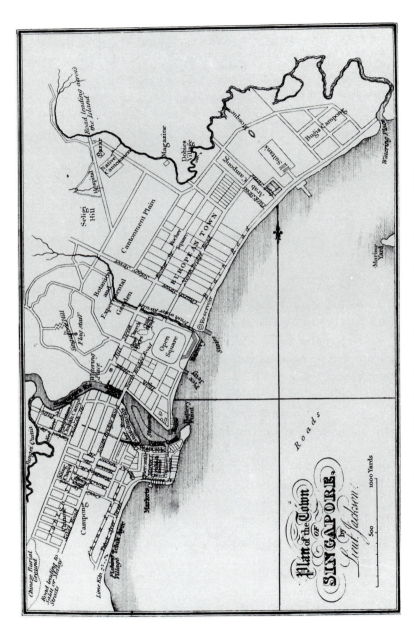

Figure 1.1 'Plan of the Town of Singapore, by Lieut. Jackson', 1823

Source: John Crawfurd, *Journal of an Embassy*, London, 1828 (University of Minnesota)

the centre of fashion, learning, art, privilege, and power, characteristics embedded everywhere in its architecture, its public spaces, its interior and exterior furnishings, its theatres, the dress of its people, and so forth. The colony, then, was articulated spatially not in terms of the local idiom, but rather in terms (such as neoclassical architecture) that betokened its fealty to the centre, terms that concomitantly confirmed its provincial character. This was necessarily so: any divergence from this relation would have been inconsistent with – indeed a threat to – the enforced political and economic dependency of the colony.

Finally, and by no means least, the fourth axis differentiates leisure from productive labour, a distinction that became increasingly pertinent in the eighteenth century as capital began to supplant both labour and land as an instrument for the production of wealth, status, authority, and power. Country estates from the time of ancient Rome to seventeenth-century England were, as a rule, productive working estates: they raised crops and animals, and even manufactured certain goods, for the use of the household and for export. The first decades of the eighteenth century, by contrast, saw the rise of exclusively residential villa enclaves on the outskirts of London. What distinguished these enclaves, and especially the individual estates within them, was their explicit *lack* of productivity. Landscapes were tailored for aesthetic contemplation, for showy luxuriance, or for sport, but above all were constructed as sites of leisure. Indeed such sites, with their manifest evocations of Arcadian plenty-without-labour, became in effect the figure in which the identity of the owner was constructed: man of leisure, unaffected by pressure of time, money, or politics, and clearly dissociated from the material constraints and pressures of the city. In the case of colonial settlements, a comparable axis obtained between colony and metropole, but once again with poles reversed: colonial cities were expected to be centres of production and extraction, revenues from which would be sent to Europe for purposes of leisure and consumption.

BATAVIA

The Dutch forcibly established Batavia (Jakarta) in 1619 as the headquarters for the Indies of the Dutch East India Company. The first century of Batavia's existence under Dutch control also was the century during which Amsterdam enjoyed pre-eminence as a burgeoning centre of global trade. Thus it is perhaps to be expected that Batavia, lying like Amsterdam on a low, flat, ill-drained plain,

would be developed by the Dutch according to a system of canals and polders similar to that which had proved so successful at home (Figure 1.2).[7] Unlike the British at Madras (established 1639), the Dutch provided adequate room in their original city plan not only for administration, defence, worship, and some trading enterprises, but also for many decades' expansion of manufacturing, retailing, and residential sectors for Europeans and some non-European groups. Still, from an early date some non-European populations were excluded from the city proper and required to settle on the outskirts in their own enclaves, or *kampongs*. By the end of the seventeenth century such areas were commonly known as the 'suburbs' of Batavia, a usage that still retained Renaissance European connotations of subordination and inferiority.[8]

Expansion of Batavia from the mid seventeenth to mid eighteenth century generally occurred according to three distinct spatial patterns. All of these were

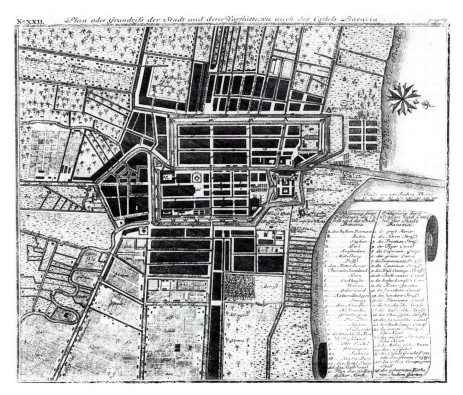

Figure 1.2 'Plan oder Grundriss der Stadt und derer Vorstätte, wie auch des Castels Batavia'

Source: Johann Heydt, *Allerneuester . . . Schau-Platz*, Willhermsdorff, 1744 (University of Minnesota)

in some respect 'suburban' in that they involved discrete locales close to the city proper, the locales and their inhabitants were economically and socially tied to the city, and each locale exhibited a certain uniformity, being dedicated to a single category of people and/or a single use. On the other hand, these locales were not entirely suburban, at least in the modern sense of the term, for one cardinal reason: in most respects their relation to the centre remained *hierarchical* rather than *contrapositional*.

NON-EUROPEAN 'KAMPONGS' OR 'KWARTIERS'

Even before the forcible occupation of the site of Batavia by the Dutch, the Javanese settlement of Jacatra (which the Dutch destroyed) was surrounded by several Javanese *kampongs* and at least one Chinese *kampong*. To the extent that these did not interfere with Dutch plans for laying out Batavia, they were allowed to remain, since they continued to provide a source of much-needed food and other provisions. But the Dutch remained mistrustful of the Javanese. Concerned primarily to manage a secure administrative centre and trading station, not an entire city, the Dutch prohibited Javanese from living in Batavia proper. This consequently effected a crucial difference from the state of affairs before the Dutch arrival: economically and politically the Javanese *kampongs* had become subsidiary elements of a private trading enterprise, their existence being suffered only to the extent that it was conducive to the economic goals of the VOC (Vereenigde Oost-Indische Compagnie or Dutch East India Company).

In the case of the Chinese population, the situation was different for some time. As Leonard Blussé has shown, a considerable portion of the success of Batavia was due to the entrepreneurial efforts of the Chinese, whom the Dutch necessarily allowed to reside in the city proper.[9] All this changed in 1740, however, when an insurrection of Chinese peasants from outlying areas precipitated carnage within the city walls. Thereafter, the Chinese were banished, and concentrated in an area immediately south-west of the city known as Glodok, which remains today the Chinese quarter of Jakarta. As with Javanese, Ambonese, and other non-European 'Kwartiers', all clearly differentiated from the Dutch city proper, this dispersion of the population into ethnically defined settlements articulated in material terms the primacy of the Dutch colonial economic enterprise, which remained fundamentally oriented toward *extraction*, not *development*.

DRAINAGE AND RECLAMATION

One of Batavia's principal functions, as a major entrepot, was the resupply of all military and commercial vessels that called. Although the economy of the region was probably well above subsistence levels prior to the arrival of the Dutch, the ongoing need to provision large fleets clearly exceeded local production, efforts to increase which soon became necessary. The process began with draining and reclaiming tracts of land around the city's perimeter in a manner quite similar to the way in which Dutch polders had been reclaimed since the twelfth century.[10] The physical circumstances were quite similar: the land all across the surrounding plain was described as flat, marshy, and subject to flooding, as with areas in the Netherlands that had been reclaimed. The Dutch therefore did what they did at home: beginning with areas immediately adjacent to the eastern and western flanks of the city, they marked out narrow strips of land perpendicular to existing canals, and then cut drains along the sides of those strips. Earth dug from the drains could then be used to raise the level of the land in between. Maps as early as 1650 indicate that substantial swaths of land facing the city's eastern and western perimeters were thus laid out, and then subdivided into smaller fields for different varieties of crops.[11] Although some maps show dwellings here, of a scale suggesting bourgeois splendour, they were in all likelihood only farmhouses and barns. Indeed these reclaimed areas were suburban in only the same, subordinate sense as the *kampongs* or *kwartiers*: they were subsidiary spaces satisfying a specific economic need of the city proper.

EUROPEAN RADIAL DISPERSION

The third manner in which Batavia grew, unlike the first two, was not so neatly confined to specific quarters or tracts. Rather, it was a process of radial dispersion along canals and rivers leading west, south, south-east, and east toward forts the Dutch had erected to protect the lands surrounding the city. These forts – Angke, Rijswijk, Noordwijk, Jacatra, and Ancol, already prominently indicated on Johannes Nieuhof's map of 1682 – were located two to four miles outside the city, and stood watch over extensive rice fields and lands for grazing cattle. In the direction of the two southern forts, Rijswijk and Noordwijk, the principal thoroughfare was, at least for the seventeenth century, a canal. Begun in 1648 by a Chinese entrepreneur, Phoa Bingam, and originally intended for floating timber

down to the harbour and shipyards, the Molenvliet was the principal corridor south of the city for about two and a half miles, where it made water connections with the two forts. But the Molenvliet and the corresponding corridor leading eastward to Ancol soon became more than routes for goods and defence. In part because these were the principal means of travel through this low and marshy landscape, and in part because of the security provided by the forts and the city at either end, these routes also became the prime location for VOC officials and wealthy traders to establish their country residences, or *buitenplaatsen* (literally, 'sites outside' the city proper). These were not country 'seats' in the English sense of the term – landed estates that served as a base of economic and political security *apart from* the metropolis. Rather, their existence and utility were wholly dependent on their owners' engagement in the administration and trade of the city.

Maps from the first part of the eighteenth century, such as Homann's map of 1733 or Heydt's as published in 1744 (Figure 1.3), show the landscape beyond the city proper to be sparsely inhabited, given over primarily to paper and powder mills, rice fields, plantations, and meadows. Still, isolated country retreats had begun to appear in the vicinity of Batavia as early as the 1620s.[12] By the middle of the seventeenth century a few estates and gardens appeared along the way to Ancol and upriver toward Jacatra, retreats that would have been used for occasional daily outings. Yet it was still unsafe to stay overnight. By the early eighteenth century the pattern of usage had begun to change toward continuous occupation of outlying residences. In 1706, for example, the Dutch painter Cornelis de Bruijn was presented to the former governor-general, Willem van Outhoorn, who was living in retirement in a 'villa situated a little distance from the town'.[13] And beginning in the 1720s the pattern of settlement became more consistent: the landscape was slowly transformed into several continuous strips of bourgeois habitations, particularly along the corridors from the city to the several forts.

In the 1760s the artist Johannes Rach began a series of drawings of the city and its environs, and his work shows the banks of the Molenvliet and the Ciliwung (which led toward the Jacatra fort) lined with bourgeois dwellings set in elegantly landscaped garden plots.[14] Few such dwelling sites were productive estates, and in many cases the entire site was given over to formal landscaping. As in the case of modern suburbs, productive agricultural land had been subdivided and re-landscaped for purposes of leisure and aesthetic enjoyment. One of the more imposing sites, the house and garden of Jan Schreuder, Councillor Extraordinary and Governor and Director of Ceylon (Figure 1.4), occupied the land between

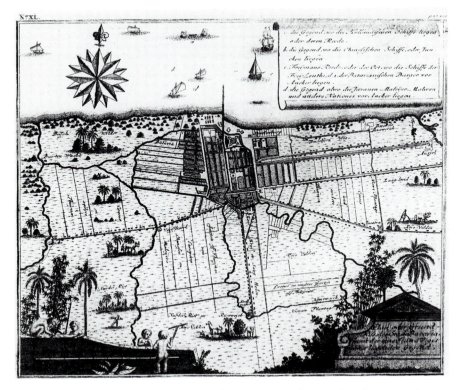

Figure 1.3 'Plan oder Grundriss der Stadt Batavia, samt der eine Stund weges umher liegendes Gegend'

Source: Johann Heydt, *Allerneuester . . . Schau-Platz*, Willhermsdorff, 1744 (University of Minnesota)

a bend in the Ciliwung river and the road to the Jacatra fort. The plan clearly shows elegant formal parterres fronting the villa, and a matrix of lawns, formal walks, and drives leading toward stables, several garden pavilions, and the river. Rach's views of other houses in this vicinity and along the Molenvliet portray a series of comparable villa estates, each fronted by elaborate plantings, topiary, sculpture, and ornate fences, in effect constituting the flanks of elegant boulevards radiating out from the city (Figure 1.5). The agricultural, commercial, and defensive character of these corridors had been altered, at least over substantial segments, to become locales dedicated to recreation, entertainment, leisure, and retreat.

The number and opulence of these estates also bespoke much broader changes in the economic and political landscape. Well into the eighteenth century the territory surrounding Batavia had been regarded as unsafe for continuous

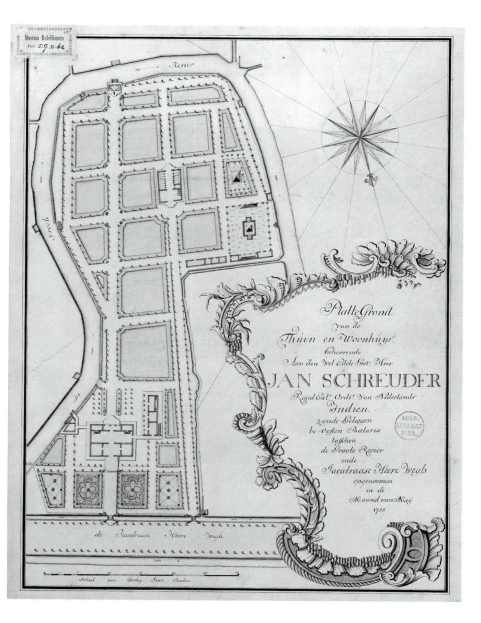

Figure 1.4 'Platte Grond van de Thuyn en Woonhys behoorende Aan den Wel Edele Gestr. Heer Jan Schreuder', 1755

Source: Leiden University Library, Collectie Bodel Nijenhuis

Figure 1.5 Johannes Rach, House of Willem Hendrik van Ossenberch, *c.* 1764–70

Source: J. de Loos-Haxman, *Johannes Rach en Zijn Werk*, Batavia, 1928 (photo: University of Minnesota)

habitation because of the threat of incursions by Javanese or Chinese from outside the vicinity, and even the threat of raids by escaped slaves who lived in the nearby jungle.[15] A clear relation obtained between Batavia and the surrounding territory. The fortified town served as the European redoubt, an instrument for the implementation of colonial jurisdiction and trade. The *ommelanden* – the surrounding lands with their various *kampongs*, fields, and plantations, largely controlled by non-Europeans – were alien and threatening. By the mid to late eighteenth century, however, these relations increasingly were overwritten by a new, more complex matrix. The proliferation of domestic retreats along certain corridors leading away from the town was, in many respects, the leading edge of this change. As more jungle was cleared, and as the prosperity and influence of the trading settlement extended further across the region, it became safer not only to build houses outside the town fortifications, but also to live in them on a regular basis. By the late eighteenth century, those who could afford to do so increasingly lived outside the town and commuted in daily. By the early nineteenth century, rush hour was a daily ordeal: as G. F. Davidson observed in the early 1820s,

From four to five o'clock every evening, the road leading from the town to the suburbs is thronged with vehicles of all descriptions, conveying the merchants from their counting-houses to their country or suburban residences, where they remain till nine o'clock the next morning.[16]

The consequences of this spatial shift were considerable: the town was progressively reduced to an economic and administrative centre, inhabited only by the least privileged strata, while outside the city new tracts of elite and bourgeois dwellings flourished. The relation between redoubt and alien territory had been inverted: the town itself was alien territory, for the elite to occupy as briefly as possible while doing business, and then to be abandoned every night. And the relation between the suburban tracts of European dwellings and the *ommelanden* became even more acutely problematic: arrayed along a few major routes, adjacent to or facing each other, European residences ignored the surrounding landscape, its economy, and its peoples. Even though the town still presented a wary, defensive façade to the surrounding territory, the European residential enclaves, in order to perfect their illusion of an Arcadian setting, concertedly had to ignore it.

The corridor-enclaves of European houses along the Jacatra road and the Molenvliet were, as yet, not altogether suburbs. The actual roads and canals, however elegantly bordered by topiary and ornamental fencing, remained important and no doubt busy thoroughfares for people and goods. The houses

were not, as yet, isolated from commerce in a detached, wholly residential setting. Such a wholesale suburbanization of Batavia was only achieved early in the nineteenth century, when the city's administrative apparatus was entirely relocated to Weltevreden, a site close to the end of the Jacatra road. Governor Daendels concentrated administrative and military facilities around an open square subsequently named the Waterlooplein. Just to the west, there developed a detached European residential quarter surrounding the vast, pastoral expanse of the Koningsplein. Daendels was unable to complete his building campaign owing to the arrival of the British in 1811, but the die was cast for a tripartite segmentation of the Batavian landscape: Europeans had now altogether abandoned the town proper except as a centre of finance and trade; civil and military government was concentrated at Weltevreden; and a residential quarter, focused inward on the broad expanse of the Koningsplein – not unlike the manner in which terraces surrounded Regent's Park in contemporary London – now was isolated by itself in suburban natural splendour.

MADRAS

A full history of modern Anglo-American suburbia has yet to be written, particularly with respect to its articulation of specific new modes of architectural and spatial organization that helped to define and advance emerging forms of bourgeois consciousness.[17] The suburbanization of Madras constitutes a chapter in that history; but the story begins early in the eighteenth century with a concentration of houses in the Thames Valley, west of London in the general vicinity of Richmond. A good number were of diminutive size compared to other 'retreats' in the vicinity, a quality emphasized by introduction of the term 'villa' to describe them. But the most distinctive characteristic of these dwellings was that they were architecturally suited for little other than leisure pursuits. They were sited on parcels of land too small for the production of significant revenue through any form of husbandry, and in most cases the grounds were landscaped in a manifestly uneconomic manner according to the aesthetic conventions of the period. Located at a sufficient distance from London that the proprietors could feel wholly disconnected from the city – though necessarily they remained politically and economically quite connected – they were close enough to London that one could commute back and forth on a weekly, weekend, or even daily basis.[18] The genesis of this and subsequent clusters of comparable dwellings

cannot be explained simply as a matter of changing 'taste', or of geographic dispersion based on factors such as economics and transportation. Rather, it also is a matter of critical changes in English modes of consciousness at the beginning of the eighteenth century: consciousness that began to anchor identity primarily in the autonomous *self* rather than in a social hierarchy or collective.[19] The suburban villa was instrumental in the construction of this consciousness: it did so, in part, by spatially differentiating private from public, by establishing the suburban plot as a site for cultivation of the self (e.g. through leisure pursuits) instead of commerce and politics.

Much the same predilection for enclaves of detached villas actually occurred simultaneously, or perhaps even earlier, in Madras. Occupied by the British since 1639, Madras quickly became the principal centre of East India Company activity in India. Though by no means the equal of Batavia, let alone London, it boasted a highly concentrated European trading centre at Fort St George, as well as adjacent quarters and villages in which indigenous populations lived and worked. And no less than in Batavia, the economic and political basis of Madras was narrowly mercantile: institutions, regulations, buildings, and personnel all were deployed for the purposes of trade and extraction. And yet the British mode of mercantile extraction differed from its Continental competitors: the British sought to be engaged as little as possible in designing or regulating the physical, financial, or political structure of their colonial settlements. Especially in the seventeenth and early eighteenth centuries they preferred, to the extent feasible, to adapt existing financial, mercantile, juridical, and physical structures to supply their needs.

These conditions help us understand the early appearance of suburban enclaves in the vicinity of Madras. A concentrated mercantile settlement such as the East India Company established within the limited confines of Fort St George did not provide very well for the differentiation of civic or social activities – let alone individual identities – from the narrow purposes of the Company. Certain locales for leisure activity did flourish adjacent to the Fort, within the city proper, and several are visible on the map prepared by Thomas Pitt about 1710. Most notable were the 'Company's Gardens' and an array of private 'gardens', many of which were laid out in formal avenues and parterres, and surrounded substantial residences. The largest and most elaborate of these, encompassing as much as six or seven acres, were dispersed around the periphery of Peddunaickenpetta, an otherwise largely built-up Indian quarter to the north-west of the Fort. Still, as the basic character of the area was Indian, the few European gardens on the perimeter were hardly able to constitute a distinct, discrete suburban locale.

But another site, with precisely those qualities, was described by Captain Alexander Hamilton, who visited Madras as early as 1707. The place he visited, some eight miles south-west of the city at the foot of St Thomas's Mount, had become a popular site for erecting 'Summer-houses where Ladies and Gentlemen retire to in the Summer, to recreate themselves, when the Business of the Town is over, and to be out of the Noise of Spungers and impertinent Visitants, whom this City is often molested with'. This site, contemporary with comparable enclaves in the Thames Valley, was configured for much the same purposes: to afford people whose business was in the city proper the opportunity to 'retire' or escape from the city's 'Business' and 'Noise' for a week, a weekend, or possibly even an afternoon or an evening. Here they could go about the business of 'recreating' – restoring, enlivening, gratifying – themselves in an explicitly anti-urban, leisured setting.[20]

By the 1740s European 'garden houses' had proliferated around Madras, but according to an increasingly dispersed pattern. Unlike the garden houses in Peddunaickenpetta and other parts of the city proper that were cheek by jowl with Indian properties, and unlike the isolated aggregation of garden houses at St Thomas's Mount, newer garden houses were scattered comparatively loosely within an arc of unsettled territory one to two miles south-west of the city, pointedly avoiding established Indian residential, commercial, and religious centres in the vicinity. Near Triplicane, about two miles south of the fort, a survey located some 67 garden houses as early as 1727.[21] The Choultry Plain, about two miles west-south-west of the fort, soon became the most popular locale for country residences. Some of these are shown on a sketchy map of Madras made in 1746 by a French military officer, Captain Paradis (Figure 1.6). Although the map is inaccurate in many respects, it renders very effectively the mapmaker's impression of a city ringed by partly inhabited terrain, substantial portions of which have been taken over by the enclosed garden-house tracts of private individuals – private domains closed off not only from the city beyond, but also from their neighbours, indigenous settlements, major roads, and their immediate surroundings (rendered here inaccurately, but tellingly, as empty land). Following the 1748 cessation of hostilities with France, which meant that Europeans could live outside the fort in comparative safety, maps show an explosion of garden houses across the Choultry Plain, along the road to St Thomas's Mount, and then even further inland in areas due west of the Fort.[22]

Yet by 1759 it had become official policy to discourage residential building on the Choultry Plain: the stated rationale was couched in terms of personal morality: private garden estates served 'merely to gratify the Vanity and Folly of

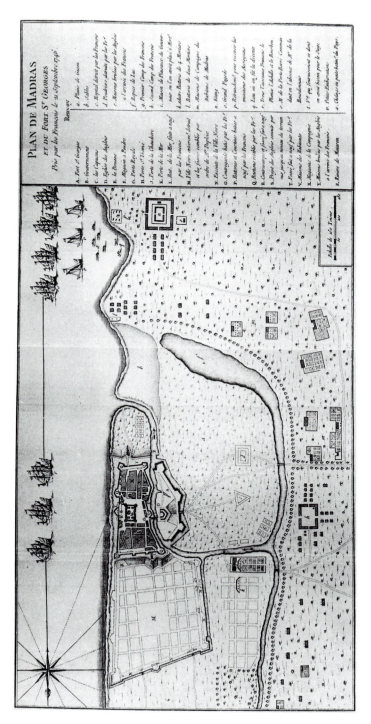

Figure 1.6 'Plan de Madras', 1746, after Paradis

Source: Henry Davidson Love, *Vestiges of Old Madras*, London, 1913 (University of Minnesota)

Merchants in having the Parade of Country Houses and Gardens'. But a more trenchant concern was the manner in which such a 'Parade' diminished the 'Distinctions which belong only to our Governour and the principal persons of Madras'.[23] By 1769, official rhetoric had escalated: in summarily rejecting the application of a low-level 'Writer' on the Company's staff for a grant of land on which to build, the government based its decision on the grounds that privatization of space not only abetted moral corruption, but also diminished productivity and threatened the public order:

> the general Argument, which has been used very plausibly, Viz. That Cultivation and improvement tend to the publick Benefit, appears in the present Case to be liable to great exception. . . . In the Grants made to Europeans, the Improvements are chiefly ornamental, such as Buildings and Gardens of Pleasure, which tend to the Encouragement of Idleness, Expence and Dissipation, the Consequences of which, in a Colony constituted as this is, are but too obvious.[24]

In other words the uppermost rank of Company officials, for whom isolated country estates had long served as instruments of rank and distinction, sought to bracket and condemn as morally corrupt the class of bourgeois traders who now were locating here as well, because the proliferation of new houses cheapened and eroded that distinction.

And indeed some Company personnel may have construed this colonization of the city's peripheral space as an even more radical act. For the Choultry Plain and Mount Road areas, where large numbers of garden houses were concentrated, afforded the nouveaux riches more than the simple opportunity to emulate elite privilege. Rather, these were locales where their bourgeois, mercantile identity – both individually and as a class – could be realized. Distanced from the fort, adjacent to no commercial or administrative centre, and occupied by a homogeneous class of professional and mercantile residents who pursued much the same interests and activities as each other, these areas became prime locales for the articulation of personal identity as independent of the Company and its interests – precisely the sort of 'Vanity and Folly' the Company sought to condemn. This was more than a threat to the status of a few high-ranking Company officials. It amounted to the creation of an instrument by which Europeans (and, increasingly, Indians) could anchor and legitimate their economic and political interests as private entrepreneurs *apart* and *distinct* from the interests of the Company, which remained confined to the Fort.

Less than two decades later the transformation of Madras into a suburban society was undeniable. Louis de Grandpré, visiting in 1789, indicated that the White Town had been reduced to a business and administrative quarter, deserted

at night by a commuting population that resided in the suburbs.[25] Estimates of the number of garden houses in the Choultry Plain ranged upwards of two hundred as early as 1780. By the early nineteenth century, over four hundred could be counted in a broad swath south and west of the fort.[26]

Early nineteenth-century accounts confirm the twin processes of condensation and dispersion by which production and trade remained concentrated in the Black Town and adjacent areas, and administration and finance took over Fort St George, while traders, financiers, officials, and other professionals and entrepreneurs, Indian and European alike, continued to lay out enclaves of private residential compounds around the south-western, western, and north-western perimeter of the city. And in all of these enclaves, residents continued to emphasize the spatial construction of personal privacy. Visiting in 1804, Lord Valentia remarked on the consistency with which individuals screened out awareness of each other. Unlike Calcutta, he said, Madras has

no European town, except a few houses, which are chiefly used as warehouses in the fort. The gentlemen of the settlement live entirely in their garden-houses, as they very properly call them; for these are all surrounded by gardens, so closely planted, that the neighbouring house is rarely visible. Choultry-plain . . . is now covered by these peaceful habitations, which have changed a barren sand into a beautiful scene of vegetation.[27]

Another visitor's account of 1811 made it explicit that isolated, detached residences in a 'garden' setting had become paradigmatic of European life in Madras (Figure 1.7). Not only was it unfashionable to live in the town itself, but the garden house was a necessary instrument for the *contrapositional* constitution of self and family as domestic counterparts to the toil and commerce of the city. Some Europeans had shops, counting-houses, or even residences in the vicinity of the Black Town:

but for a family-residence, it is quite unfashionable, these being all two or three miles distant, and called Garden Houses. . . . The *appropriate mansions of familiar intercourse* are the garden-houses, so called from being situated more in the country amid trees, flowers, gardens, and all the other attendants on rural life. . . . The merchant, fatigued with the labours of the day in the [counting]-house, retires hither at four or five o'clock, to rest for the evening, in the bosom of his family.[28]

As Susan Neild Basu has well demonstrated, the suburbanization of Madras generally did not occur at the expense of indigenous villages or temple sites. Rather, garden compounds screened themselves from nearby settlements, and even were served by a largely separate road network. Thus suburbs and indigenous settlements existed in separate social and spatial systems.[29] In part this can be

understood on the basis of economics: purchasing uninhabited land is cheaper than taking over existing settlements. In part it can be understood as ethnic or even class prejudice. But also it needs to be understood in terms of the desire to configure space to sustain retreat, 'retirement', recreation, leisure, and other conditions necessary to the constitution of the private self. Thus the importance of screening out both indigenous settlements and European neighbours: creating a road system on which indigenous commerce would have little occasion to travel correspondingly sustains the apparent setting of private, Arcadian leisure.

Figure 1.7 'The environs of Madras. Surveyed in 1814. London: W. Faden, 1816'

Source: By permission of The British Library, Oriental and India Office Collections, X/9771

CALCUTTA

The suburbanization of Calcutta was delayed, necessarily, until after the Battle of Plassey (1757) and the consequent assumption by the British of administrative control over Bengal. Before Plassey, British commercial interests were concentrated in and around the original Fort William, built on the bank of the River Hooghly at approximately the site where Job Charnock had established his East India Company trading settlement in 1690. The British generally resided in Fort William and its immediate vicinity, though individual European gardens and garden houses could be found at various locations within a three-mile radius, including in the portion of the city subsequently known as the 'Black Town'.

After Plassey, however, as administrative control of Bengal and eventually all of India was concentrated in Calcutta, and as Calcutta rose to economic primacy as the East India Company's chief station in India, British residential patterns changed significantly. With the completion in 1773 of the new Fort William and its vast surrounding esplanade south of the established city centre, large new tracts of land to the east, south, and south-west not only became far more accessible to the city, but also came under direct military protection (Figure 1.8). A 1780–4 survey of this area by Captain Mark Wood shows well over a dozen large residential estates landscaped in European style with formal parterres, allées of trees, and the like. Wood's depiction of a large number of 'tanks' (reservoirs) and indigenous place names indicates that most European estates were interspersed quite closely among indigenous settlements. Thus it would be hard to characterize the European estates as yet forming an enclave. Indeed the landscaping of the grounds and the orientation of the approach roads represented efforts to assert the independence, even the obliviousness, of each with respect to the other.

A decade later, however, the scale and orientation of dwellings in the area immediately east of the Esplanade had been radically transformed (Figure 1.9). Aaron Upjohn's map of 1792–3 shows that traces of a few large estates remained, but that they now were crowded by dozens of much smaller houses, on very compact sites, each of which was (or soon would be) enclosed in its own walled compound. This area, divided into 'Chouringhy' and 'Dhee Birjee' on Upjohn's map according to local nomenclature, but soon to be called just Chowringhee, quickly became the principal European residential quarter of Calcutta.

Although it was adjacent to the city's administrative and commercial centre, which lay along the northern boundary of the Esplanade, Chowringhee remained distinctly residential. Its inhabitants commuted to work daily, a distance of half a

Figure 1.8 'A survey of the country on the eastern bank of the Hughly from Calcutta to the fortifications at Budgebudge including Fort William . . . from the Year 1780, till 1784. Mark Wood'

Source: By permission of The British Library, K.Top.115.38

mile to two and a half miles, and at other times made use of the drives around and across the Esplanade for leisure activities such as promenading and, eventually, horse racing.

Over the next three decades nearly all of Chowringhee became covered with

Figure 1.9 'Map of Calcutta and its environs, from an accurate survey taken in the years 1792 and 1793, by A. Upjohn'

Source: By permission of The British Library, K.Top.115.43

residential compounds, each of which typically encompassed three-fourths of an acre to three acres (Figure 1.10). Ordinarily the house stood isolated in the centre of the compound. The perimeter of the compound was walled, both for privacy and for security. Ranges of sheds for servants, cooking, and equipment storage lined the insides of the walls. Otherwise the grounds were kept completely cleared as a way of improving ventilation – not only for reasons of comfort, but also to minimize the accumulation of 'miasmatic' vapours that supposedly were conducive to disease.

Unlike Batavia's radial dispersion along narrow transportation corridors, or Madras's loose enclaves of garden estates, house compounds in Chowringhee did coalesce into a distinct and discrete, predominantly residential, quarter. At the same time, Chowringhee inverted the standard European spatial paradigm: instead

Figure 1.10 Henry Salt, View of Calcutta from a House in Chowringhee, 1803

Source: By permission of The British Library, Oriental and India Office Collections, WD 1297

of architectural ensembles linked to each other and to streets, squares, and plazas, each compound articulated its own autonomy; streets were fronted by blank walls, and dwellings faced only the interiors of their own compounds. Indeed Chowringhee may well have antedated the appearance of comparable suburban tracts in Britain. Instances there of bourgeois residences arrayed in detached, well-defined enclaves actually postdate the situation in Chowringhee as shown on Upjohn's map.[30]

By the 1790s most Europeans who would make vast fortunes in India, the 'nabobs', already had returned home. They had established a precedent and a pattern, however, of using their time, position, and influence as Company officials to amass great fortunes and enhance their personal status. Although a variety of political and economic factors limited the ability of following generations to match this level of wealth and splendour, they managed to succeed on a somewhat lesser scale. In Calcutta, the spatial articulation of Chowringhee was both a product and an instrument of this success, in at least four respects – all of which have been integral to the development of the modern suburb. First and foremost, Chowringhee was a locale distinct and apart from – indeed *contrapositional* to – the business and administrative centre. It provided those who lived there a spatial anchor for the construction of an identity or persona that differentiated itself from the political-economic nexus and instead celebrated the autonomy of the self. Second, the houses' isolation within the open spaces of their compounds served to articulate a concept of personal prestige based not only on an implied opposition to politics and commerce, but even on dissociation and detachment from other such individuals. Third, the huge scale and ponderous neoclassical ornament of these houses, together with the manner in which they dominated the scores of servants whose huts were pressed against the compounds' perimeters, bespoke an ongoing, progressive effort to redefine the seat of authority, detaching it from the purview of the Company and situating it instead in the domain of private individuals. And finally, all of these factors contributed to an ever more refined spatial articulation of the rise of economic individualism. The private compounds of Chowringhee not only represented, but actively facilitated, a new positionality for bourgeois personnel. Presenting themselves no longer as Company 'Servants', but instead as private agents concerned with the personal appropriation of wealth, their suburban Chowringhee residences served as instruments not only for protection and legitimation of that wealth, but also for its enjoyment and consumption.[31]

CONCLUSION: THE SPACES OF MODERNITY

The three case studies introduced above exemplify the double dimension in which the suburb, starting in the early eighteenth century, began to articulate the spaces of modernity. First, it provided a site for establishing a new, contrapositional – anti-urban – mode of relation to the city proper. And second, it afforded sites whose principal raison d'être was the establishment and augmentation of a person's individual identity. No longer was the suburb simply terrain for whatever the city cared to reject; no longer was the city the singular spatial criterion for civilized identity. Rather, the suburb became a site for realizing and legitimating criteria of equal but opposite force. Eighteenth-century European thought had begun to articulate some of the fundamental polarities of modern Western culture – subject/object (or mind/body), public/private, masculine/feminine, etc. – but such distinctions had no more than putative existence until they could be realized in the material domain of everyday life. Such changes of course occurred in many dimensions, ranging from economic relations and legal codes to dress and demeanour, to artistic and leisure pursuits. Yet in many respects the most durable medium for institutionalizing such binary distinctions – and therefore a powerful instrument for sustaining and perpetuating those relations – is the material, physical space that defines the parameters of everyone's personal and social activity.

Since the eighteenth century, suburbs have afforded a premier locale for the material articulation of such binary distinctions. In colonial Batavia, Madras, or Calcutta, just as ever since throughout Europe, America, and Australia, suburbs became instruments crucial to the subversion of economic and social hierarchies. On the one hand, the newfound commercial and spatial autonomy of private traders progressively subverted the state-sanctioned centralized mercantile authority of companies such as the VOC or the East India Company. And on the other hand, so were the dominion and domain of polis and commune subverted by provision of a site that was socially, legally, and literally beyond the pale – i.e. in some measure outside the mercantile, military, or municipal authority. Bourgeois individuals could sustain their enterprise and their identity from sites that now were construed as economically and socially distinct from the city – i.e. opposed, not subordinate, to it.

This was especially feasible in a *colonial* setting, since in many respects those who settled oustide a 'Fort' and its immediate precincts were occupying not so

much a *subordinate* locale, in the manner of lands surrounding European feudal cities, but rather a locale already demarcated as *alien* to the city, in the sense that it was part of the indigenous, non-European landscape. Such a locale provided a perfect basis for construction of a modern bourgeois identity. Alienated in terms of wealth and privilege from the surrounding indigenous population, and in economic and social terms from the urban centre of authority and production, the individual built an estate or compound that architecturally celebrated that alienation – even though in other, now hidden, respects the individual remained inextricably dependent on both the city and its hinterlands. That celebration of individual alienation – no small component of modern liberal 'individualism'[32] – still remains a critical element of the modern suburban landscape.

NOTES

1 Research for this chapter was generously supported by the John Simon Guggenheim Memorial Foundation, American Institute of Indian Studies, National Endowment for the Humanities, and Graduate School of the University of Minnesota.

I am grateful to the following for their insight and generous assistance: Dr Jane Hancock, Prof. S. Ambiranjan, Profs Frederick M. and Catherine Asher, Pascale Bos, Dr Bea Brommer, Dr Dirk de Vries, Dr Max Gitz, Prof. Dr Adolf Heuken SJ, Prof. Jeanne Halgren Kilde, and Andrew Kincaid.

2 Here I am drawing in particular, but not exclusively, on: Pierre Bourdieu, *The Logic of Practice*, Stanford, Stanford University Press, 1990; Michel Foucault, *Discipline and Punish*, New York, Vintage, 1979; Erving Goffman, *The Presentation of Self in Everyday Life*, Garden City, Doubleday, 1959; David Harvey, *The Condition of Postmodernity*, Oxford, Blackwell, 1989; Henri Lefebvre, *The Production of Space*, Oxford, Blackwell, 1991.

3 Pradip Sinha, 'Social Forces and Urban Growth – Calcutta from the Mid-Eighteenth to the Mid-Nineteenth Century', *Bengal Past and Present* 92:2, July–December 1973, pp. 288–302.

4 Michel Foucault, 'Of Other Spaces', *Diacritics* 16:1, Spring 1986, pp. 22–7.

5 For caste, see the numerous spatial restrictions in Indian pre-colonial architectural manuals. For occupation, note the concentration of particular trades (e.g. goldsmiths) each in its own locale, whether in London or in pre-colonial and colonial India. For religion, note how in the early years of the New Haven colony only the 'elect' were permitted to live in the town proper, while the non-elect were required to live in the 'Suburbs'. John Archer, 'Puritan Town Planning in New Haven', *Journal of the Society of Architectural Historians* 34:2, May 1975, pp. 140–9. And for citizenship, note Alberti's recommendation to 'lay out the platform of our City in such a manner, that . . . *Strangers may have their habitations separate*'. *The Architecture of Leon Battista Alberti*, trans. James Leoni, London, Thomas Edlin, 1739, II:23ʳ, emphasis added.

6 John Claudius Loudon, *The Suburban Gardener, and Villa Companion*, London, Longman, 1838, p. 32.

7 The standard source on Batavia is Frederik de Haan, *Oud Batavia*, Bandoeng, Nix, 1935. More recently see the excellent topographical account by Bea Brommer, *Historische plattegronden van Nederlandse steden, deel 4: Batavia*, Alphen aan den Rijn, Canaletto, 1992.

8 The Javanese word *kampong*, meaning an enclosed settlement or quarter, had no such connotations. It was commonly translated into Dutch as 'Kwartier,' as in the 'Javasche Kwartier' and 'Chinese Kwartier' that appear on the Conradi 1780 map of Batavia.

9 Leonard Blussé, 'Batavia, 1619–1740: The Rise and Fall of a Chinese Colonial Town', *Journal of Southeast Asian Studies* 12:1, March 1981, pp. 159–78.

10 Audrey M. Lambert, *The Making of the Dutch Landscape*, London, Academic Press, 1985.

11 In Brommer, *Batavia*, see for example maps BAT K11, BAT K12, and BAT K14.

12 Brommer, *Batavia*, BAT M02.

13 Jean Gelman Taylor, *The Social World of Batavia*, Madison, University of Wisconsin Press, 1983, p. 53.

14 J. de Loos-Haaxman, *Johannes Rach en zijn werk*, Batavia, G. Kolff, 1928.

15 Susan Abeyasekere, *Jakarta: A History*, Singapore, Oxford University Press, 1987, p. 23.

16 G. F. Davidson, *Trade and Travel in the Far East*, London, Madden & Malcolm, 1846, pp. 3–4, 6–7.

17 Notwithstanding the pioneering work of Robert Fishman, *Bourgeois Utopias*, New York, Basic, 1987.

18 'Retiring houses' for the 'Gentry and Citizens' of London were dispersed throughout Middlesex and other counties surrounding London at least since the mid seventeenth century, and perhaps the Middle Ages. See Thomas Fuller, *The History of the Worthies of England*, London, Thomas Williams, 1662, p. 176, and Sylvia L. Thrupp, *The Merchant Class of Medieval London*, Chicago, University of Chicago Press, 1948, pp. 279–87. What was new in the eighteenth century was the *concentration* of such houses in certain discrete, fashionable locales. John Archer, '"Retirement" and the Constitution of the Self: The Eighteenth-Century Compact Villa', Society of Architectural Historians Annual Meeting, Charleston, SC, April 1993.

19 The history of these changes spans a complex intersection of ideological, economic, and political currents to which I can only allude here. Perhaps the most crucial ideological statement of the autonomy of the self appeared in John Locke's *Essay Concerning Human Understanding*, London, 1690.

20 Alexander Hamilton, *A New Account of the East Indies*, ed. Sir William Foster, London, Argonaut Press, 1930, I, p. 198.

21 James Talboys Wheeler, *Annals of the Madras Presidency*, Delhi, B. R. Publishing, 1985, III, p. 4.

22 See for example: 'A Plan of Fort St. George and the Bounds of Madraspatnam Surveyd & Drawn by F. L. Conradi 1755'; 'The Environs of Madras. Surveyed in 1814. . . . London: Published by W. Faden, . . . 1816'.

23 Henry Davidson Love, *Vestiges of Old Madras 1640–1800*, London, John Murray, 1913, II, p. 505.

24 Love, *Vestiges*, II:615–16.

25 Louis de Grandpré, *Voyage in the Indian Ocean and to Bengal*, Boston, W. Pelham, 1803, p. 112.

26 Susan M. Neild, 'Colonial Urbanism: The Development of Madras City in the Eighteenth and Nineteenth Centuries', *Modern Asian Studies* 13:2, April 1979, p. 243; and Susan M. Neild, 'Madras: The Growth of a Colonial City in India 1780–1840', Ph.D. dissertation, University of Chicago, 1977.

27 George Annesley Mountnorris, Lord Valentia, *Voyages and Travels*, London, Miller, 1809, I, p. 389.

28 *A Visit to Madras*, London, Richard Phillips, 1821, pp. 9–10. My emphasis added.

29 Neild, 'Madras', pp. 329–30.

30 The generally accepted first instance is St John's Wood (1794).

31 Room in this volume does not permit discussion of the parallel creation of Indian bourgeois residential space during this period, in a manner sometimes comparable to European space.

32 Robert N. Bellah, Richard Madsen, William M. Sullivan, Ann Swidler and Steven M. Tipton, *Habits of the Heart: Individualism and Commitment in American Life*, Berkeley, University of California Press, 1985. John Archer, 'Ideology and Aspiration: Individualism, the Middle Class, and the Genesis of the Anglo-American Suburb', *Journal of Urban History* 14:2, February 1988, pp. 214–53.

EXCAVATING THE MULTICULTURAL SUBURB

Hidden histories of the bungalow

Anthony D. King

5. Cafés. Tea Rooms. Confectioners. Billiard Rooms. Chess.

In the City.
TEA ROOMS.
Lyons & Co., 168 Regent Street, 213 Piccadilly, 154 Strand, 23 Cheapside, 20 Great Chapel Street, S.W., etc.; *Hungarian Bread Co.*, 124 and 215 Regent Street and 41 Old Bond Street; *Kettledrum*, 43 New Bond Street; *Studio*, 85 New Bond Street; *Bungalow*, 21 Conduit Street, W.; *Fuller*, 358 Strand, W.C., and 31 Kensington High Street, W.; *Mrs. Robertson*, 161 New Bond Street; also the shops of the *Golden Grain Bread Co.*, the *British Tea-Table Co.*, and the *Aërated Bread Co.*

Karl Baedeker, *London and Its Environs* (1896), p. 19

This is the symbolization of English identity . . . what does anybody in the world know about an English person except that they can't get through the day without a cup of tea? Where does it come from? Ceylon – Sri Lanka, India. There is no English history without that other history.

Stuart Hall, 'Old and New Identities: Old and New Ethnicities' (1991)[1]

What is a bungalow? . . . our imagination transports us to India.

Robert A. Briggs, *Bungalows and Country Residences* (1891), Preface

It is not an overstatement to claim that the Western suburb is quintessentially an imperialist form of human settlement.

Michael Leaf 'The Suburbanization of Jakarta' (1994), p. 341

INTRODUCTION

Just over a hundred years ago, what was to become a simple though quite revolutionary change was introduced into the living habits and domestic architecture of many suburban dwellers in England. A centuries-old tradition by which builders of urban houses stacked rooms, full of people, possessions and activities, on top of one another was selectively abandoned, to be replaced by a different spatial practice by which rooms were placed adjacent to each other in a single storey, and in a separate building, on the ground floor.

This was, of course, the principal significance of the bungalow – the name that was to be given to the building form with such an arrangement[2] – and it was precisely the more spacious, less expensive land of the suburban environment that was to encourage this development. The year was 1891.[3]

The suburb was instrumental in producing the architectural form of the bungalow, just as the bungalow was instrumental in producing the spatial form of the suburb. It was a process that, in the early twentieth century, was to be repeated in the suburbs of Anglophone colonial and post-colonial countries worldwide: the United States, Canada, Australia, New Zealand and eventually elsewhere (Ashford 1994; Butler 1992; Clark 1986; Gowans 1986; Holdsworth 1982; King 1984a; Lancaster 1985; Winter 1980; Wright 1981).

The social and architectural significance of the bungalow can be simply stated. As the archetypical form of the modern freestanding or detached single-storey dwelling, the bungalow represents two important and interrelated social, spatial and cultural changes which, for an increasing proportion of the population, have taken place since the term and idea were introduced from India into the West.

The first (spatial) change might be described as both vertical and horizontal, a move from living in houses of three or four storeys in large, densely populated cities and towns, dependent on the railway, to ones of two or, increasingly one storey, in more spacious outer suburbs dependent primarily on the car. The second was a social and architectural change, from living in an architectural form containing many households – such as (in Britain) the ubiquitous Georgian or Victorian terrace, or perhaps semi-detached villa, or (in North America) the apartment, row house or 'brownstone' – to living in the modern detached or semi-detached house or bungalow containing only one. From an urban political economy perspective, the bungalow is about the symbolic display of private property and ownership.

In North America and Australia, where these developments have gone much

further than in Britain (and other countries in Europe), and where suburban, single family, single-storey homes are the typical pattern, the history of the bungalow (in its various styles and forms) in contributing to the process is both widely acknowledged and extensively written. Architecturally, it is seen as a forerunner of Frank Lloyd Wright's 'Prairie House' style; it has an especially favoured place in the history of the Arts and Crafts movement (Brooks 1972; Cumming and Kaplan 1991: 123–5; Robertson 1993) and architectural historians see it as the source and immediate predecessor of the contemporary single-storey ranch house. Its particular distinction in the United States is that it is generally regarded as the first truly *national* type of domestic (and suburban) architecture, an architectural form as characteristic of the inner edge of the modern city as the high-rise office tower is of the centre (though now, also of the suburbs).

In England, however, the *Complete Social and Architectural History of the Bungalow* has still many unwritten pages. As I have suggested elsewhere (King 1984a: xiv), this is partly owing to the gap between its particular class connotations in the past and the predominantly bourgeois interests of much architectural history today. Ever since 1927 when a prominent member of the Anglican establishment, the Dean of St Paul's, coined the phrase 'bungaloid growth' in the context of what was to become a class war over the future of the countryside and who was to be allowed to live there (King 1984a; Punter 1986), 'bungalow' was to become, for a middle- and upper-class public, a term overly charged with social meaning. Whatever the reason, a conspiracy of silence reigns in British architectural studies concerning anything to do with the B-word.

It is, however, the *political* and *cultural* significance of the Anglophonic diaspora of the bungalow that forms the main theme running through this chapter. In telling three stories from a larger political economy of culture, what I want to highlight is the extent to which global architectural and urban developments at the turn of both the nineteenth and the twentieth century were, and indeed still are, dependent on the existence of colonial and post-colonial cultural regimes. Each of these three stories – hidden narratives excavated from the silent, subterranean suburbs of architectural history – is concerned with the reception, and social and spatial translation, of unfamiliar phenomena generated by the interaction of cultures under the conditions of colonialism. Each of the three stories says something about the social meanings associated with the bungalow at particular times and places in history – but, also, about the times and places in which the bungalow exists.

The first story, prompted by Gayatri Spivak (1985) and, especially, Edward Said's *Culture and Imperialism* (1993), concerns an elaboration of the argument by

which the introduction of the bungalow depended on the facts of empire; but it also sheds some light on matters of sexuality, race, gender and domestic space in late Victorian London. The second story pursues some more formalist issues in the high culture of architectural history, including the relation of the bungalow to the Arts and Crafts movement in Britain and the dependence of both on a developing imperial culture. When first introduced, the bungalow was an innovative, even radical, social and architectural idea, produced by, and for, a unique configuration of economic, political and cultural circumstances. That it was such an innovative idea is suggested by the fact that some of the earliest bungalow designs were produced by architects now seen as prominent figures in the Arts and Crafts movement: C. F. A. Voysey, M. H. Baillie Scott, R. Norman Shaw, G. H. Brewerton and especially Robert A. Briggs.

The third story is much more up to date. It concerns the suburban bungalow in Australia and the contemporary economic and social conditions that are both changing the nature of its domestic space and transforming its meaning into a paradigmatic symbol of our multicultural times.

I want, therefore, to prise open the closed cupboards of architectural history and put into their empty drawers some of the multicultural polysemicity associated with the bungalow. To take the reader back, as it were, to a time before the term 'suburbia' had been invented (1895, according to the *Oxford English Dictionary*) or the concept even thought of.

THE BUNGALOW IN THE WEST

As I have discussed elsewhere (King 1984a: chapter 2; 1990a: chapter 6), the bungalow – as a culturally distinctive, historically specific, functionally differentiated, and terminologically distinguished building form – was first introduced from India into the Western hemisphere at the end of the 1860s.

Yet the small cluster of less than ten bungalows built on the north Kent coast some two hours from London between 1870 and the early 1880s seems to have gone relatively unnoticed in the imperial metropolis. More important than these few examples are the two different discourses that were to develop around both the term 'bungalow' and the object that it signified, and these did not really begin, either in London or elsewhere, in any substantial sense until the end of the 1880s. They were discourses not only on what kind of architectural form a 'bungalow' should take but also on what kind of social meaning 'bungalow' carried; a subtle

social semiotics which was a question not just of denotation but also of connotation (Barthes 1994: 89).

The space of the first discourse was relatively restricted, of a somewhat technical nature, and concerned the features this new building type ought or ought not to have, and it was confined to a limited professional readership of some of London's more specialized architectural and building journals (*The British Architect*, *Building News*, *The Builder*, *Academy Architecture* and the more arty *Studio*).

The second discourse, however, was broader and much more public, was essentially social, and aired in a London theatre, a monthly magazine, and in the novels of various writers such as George Gissing, H. G. Wells, and others (King 1984a: 100–15).

It is this second, connotative, social discourse on the bungalow that was introduced into the imperial metropole of London at the end of the 1880s. But not, however, into the space of the capital's far-flung or even nearer suburbs but, more surprisingly, into the heart of the heart of empire itself – London's West End. It was in Toole's Theatre, in a street just off the Strand (now William IV Street), where Fred Horner's three-act comedy called simply *The Bungalow* opened on 7 October 1889. It was to run, uninterrupted, for three hundred performances.[4]

THE EMPIRE IN THE CITY

I have spelled out in detail elsewhere the distinctive political, economic, and essentially material and social conditions which were to account for the transplantation of the idea of the Anglo-Indian bungalow from India to Britain, especially in the two decades spanning the end of the nineteenth century (King 1984b, 1990a). More recently, Edward Said (1993) has discussed at length the construction of what he refers to as an imperial culture in the metropole, especially in relation to the development of the novel.[5] It is, Said suggests, at the end of the nineteenth century when 'scarcely a corner of life was untouched by the facts of empire' and when 'British rule in the Indian subcontinent [was] at its height [that] empire was a universal concern' (pp. 7, 76). These were the years of the paradigmatic colonial stories of Joseph Conrad, Rudyard Kipling, André Gide, and many others, a time when 'all cultures are involved in one another; none is single and pure, all are hybrid, heterogeneous, extraordinarily differentiated, and unmonolithic' (p. xxix).

Said has suggested that 'the novel, as a cultural artefact of bourgeois society, and imperialism, are unthinkable without each other' (p. 84). The same might be said about both the play *The Bungalow* and the built form it represented. Yet just as the novel often hides, or marginalizes, its imperial connections, so also does Fred Horner's comedy. The 'structure of attitude and reference' of the play, to use Said's phrase, means that the world beyond England is never seen 'except as subordinate and dominated' (p. 89). The discourse of empire is displaced, turned into a comedy, a 'code' that can be laughed at. Thus, apart from the derivation of the play's title, the only signs of India are deliberately trivial and ironic: for the stage set, there are ornamental Oriental rugs, a monkey on a rail, a parakeet on a perch; in the script, a few, equally ironic references to India. The only Indian figure represented in the cast is the bit part of a female 'Hindoo' housekeeper, whose name, 'Puty Beebee', already signals a subordinated social sexuality.

The narratives which both structure and also script the comedy are those which, through the 1890s, were increasingly to invest meaning into the as yet unfamiliar, though attractive, and mellifluously sounding term of 'bungalow',[6] narratives of masculinity, sexual transgression, marital infidelity, flirtation, Bohemianism, artistic flouting of social convention, Orientalism, and also racism. For all of these, 'bungalow' was to be the sign.

To appreciate how these meanings were derived we need, of course, to read the play. But before this, we might begin by considering the interactive social and spatial qualities of the bungalow, as something of an uncertain and enigmatic idea, introduced from India to a middle-class theatregoing population in London which, in 1889, was the largest city in the world.

As I've suggested earlier, it was a population accustomed to living in what, by today's standards, would be seen as large households, of perhaps five, six, or seven people, plus one or two servants, in homes whose vertically arranged rooms were separated by steepish staircases, in two-, three-, or increasingly even four-storeyed houses which, for the most part, were linked together in clustered rows.

For such an urbanized, middle-class, and crowded population, the idea as well as the spatiality of the bungalow was both strange and unfamiliar (I'm deriving these insights from the play). The image was of a dwelling characterized by social and spatial apartness; separate not only from other people and other dwellings, but also separate from the city itself, a house surrounded on all sides by space.

As the rooms were all on one floor, there were no stairs to signal (for a bourgeois population) the conventional and proper distinction between night and day and the behaviour and activities appropriate to each: undressing and dressing, sleeping and being awake. The existence of bedrooms adjacent to the sitting room

inflected the social and moral space between them and – not least in terms of the social codes which regulated Victorian middle-class life – introduced a potentially dangerous overlap between formal and informal, proper and improper activities. Thus, the bed – with all its connotations – instead of being located in the private space of 'upstairs' and reached only after a conscious decision to expend the necessary energy ascending them, was only footsteps, and seconds, away from the drawing room couch. The bungalow, in short, had a different moral geography, the mapping of which required new social codes which had to be invented before they were learnt.

Equally important was another outcome of the bungalow's single-storeyedness, the problem of controlling ingress and egress. Unlike the conventional terrace or row house, or semi-detached villa, with clearly marked front and back doors, and established social rules governing their use, the late Victorian bungalow might have doors on all its four sides, not to mention the French windows (the adjective itself already suspiciously suggestive) from – and to – the bedrooms. With these understandings, we can move towards the play.

The dramatis personae of the comedy are the hero, Frederick Leighton Buzzard (twenty-eight), an artist; his two friends, Henry Vaughan and Percy Gwynn and their wives; Zeffie Williams, the artist's model; Gregory Bell (forty-five) and his wife, Jane, parents of Millicent Bell (twenty) whom Buzzard, the artist, wishes to marry; and Puty Beebee (thirty), a Hindoo, housekeeper to Buzzard. The play opens on the lawn of Buzzard's Putney bungalow, leading to the river. Stage directions indicate that 'Everything is elegantly ornamental with Indian articles'. There are various (nude) statues around, including one of Cupid. A monkey is on the rail of the house (presumably, the veranda), down stage. As the curtain goes up, Buzzard is discovered, dressed in a velvet smoking jacket and – naturally – smoking.

The principal character, of course, is a hardly veiled reference to Sir Frederic Leighton, according to Newall (1990: 138) 'the most distinguished nineteenth century President of the Royal Academy and the most eminent painter of the Victorian age'. Leighton (1830–96), leader of the Victorian neoclassical painters, was particularly renowned for making nude studies which he subsequently draped for his large, neoclassical compositions. Pillar of the Victorian art establishment, Leighton was President of the Royal Academy from 1878 to 1896 (Newall 1990; Wood 1974) and the first artist to be raised to a peerage.

Leighton's sensuous nudes, however, and the gossip around his relations with his London models (Barrington 1906: II, 273) also made him a controversial figure. The last painting he made of the female nude for its own sake, according

to Newall, was *The Bath of Psyche*, the moment represented being that where Psyche undresses and prepares to bathe in readiness for her bridegroom, Cupid. I cite Newall's account: 'The girl is standing at the extreme edge of the pool of water, in which the reflection of her legs and feet appears. Beyond is a flight of four marble stairs, from which rise two fluted columns.' Presumably in relation to the male gaze, Newall suggests that 'The naked figure is exposed for the delectation of her unseen admirers, just as in the legend the person of Psyche was offered to an unknown husband.' In Newall's opinion, *The Bath of Psyche* was

perhaps close to the boundary of what was permissible in terms of the display of the female nude. Leighton largely escaped the charge of lewdness . . . partly because his nude subjects illustrated mythological events . . . and partly because they were sufficiently generalized to fulfil that general criterion of classicism which rejected the specific or the recognizable.

(1990: 122)

Sexuality, in short, was legitimately displayed, 'though displaced through the device of representing the exotic' to quote Janet Wolff (1990: 27).

As the painting was exhibited at the Royal Academy in 1890, it seems more than likely that Leighton was working on it (and not unknown to others) in the previous year – but this was, in any case, only the last of a number of socially controversial paintings and criticism had been increasing through the 1880s. In any event, according to a contemporary, 'In 1889, the fashion of running Leighton down had become all but universal, only the very elite of the art world remained true' (Newall 1990: 116).

The play – of which the spatial ploys are not dissimilar to those in the domestic comedies of Alan Ayckbourn – revolves around a series of liaisons and spatial encounters between husbands, wives, Zeffie the model, and Buzzard's prospective parents-in-law. Buzzard is keen to marry Milly, whose mother, Jane Bell, has, however, made this conditional on his giving up painting, refusing to allow her daughter's future husband to have anything to do with models. For Mrs Bell, association with artists and models makes the bungalow forbidden territory: 'I have told you, I have no wish to enter the precincts of your bungalow while you are a bachelor.' None the less, Mrs Bell, with a prurient curiosity about what the bungalow is like, and what is in it, had asked her husband about it: 'I told her as best I could that a Salvation Army barracks was not in it for purity of thought.' However, precisely because of Mrs Bell's moral reservations, her husband is enabled to visit Buzzard – and also Zeffie, the model – unhindered: 'Here in the house of an artist, in your bungalow, I am safe . . . [my wife] wouldn't enter it

for the world . . . [she] would think her soul entirely lost if she came in a place frequented by models.'

As Buzzard plans to move the next day (into a new house in Maida Vale), leaving the bungalow uninhabited, Bell asks to borrow the key; he also likes 'to dabble in painting' (he had previously engaged a model and attempted a painting entitled *The Crowning of Elizabeth*, though the outcome, Buzzard suggested, was that 'Eliza' had probably been 'crowned'). But which key? Buzzard asks, as all 'visitors' are apparently coming at various times; the front door? the lawn approach from the river? the side door? even, the door on to the lawn from the bedroom?

Other of Buzzard's married friends call, one wife because she concludes that 'there must be something dreadful to see in a bachelor's bungalow'. The women enter, but only after various paintings are turned to face the wall, and handkerchiefs placed over the statues. As the play proceeds, it appears that each of Buzzard's (married) male friends wants to borrow the key of the bungalow for his own liaisons. At one point, one married 'lady friend' is on the point of swooning at the prospect of being discovered 'alone here, in a bachelor's bungalow. How foolish of me to come!'

The novelty of the bungalow, elegantly furnished in Indian style, is made apparent in the ironic comments of Buzzard's lady visitors: 'I had no idea a bungalow could look so nice! And how convenient too, all on one storey. . . . Moreover, one hasn't got to go all the way to India to see it. Much cosier than the Indian article.' There were also 'no snakes or mosquitoes to be afraid of . . . it makes one fancy oneself in tropical parts'.

'Puty Beebee', Buzzard's thirty-year-old 'Hindoo' housekeeper, enters the play principally as a gendered, sexual, and also racial sign, though not an altogether unambiguous one. Early in the play, the (older) Bell comments, 'I say, you've got a rather nice place here; and then to have a darkey for your housekeeper – sly dog, you!' to which Buzzard retorts that, as he was 'obliged to have some housekeeper to look after the bungalow', it would 'stop people's tongues and be in harmony with the surroundings' if he engaged a 'real Hindoo'. A later reference by Bell to her as a 'nigger girl', sharply rebutted by the young artist Buzzard, suggests that the (literal) staging of racism, as well as its contestation, was as present in the marginally multicultural London of the 1890s as it is in the much more culturally diverse metropolis today. Thus, though the play is largely farce, there is also a strong thread of satire, always with a political edge.

If empire provides the first frame of reference for the play, and the events of

Leighton's career the second, a third seems likely to have come from Horner's knowledge of events that were to become increasingly familiar in metropolitan circles about this time, namely, the development two years earlier (1887) of a prominent estate of (very upmarket) bungalows set in the depths of the Surrey countryside. Named Bellagio after the lakeside resort on Italy's Lake Como, the development was reached by train from London's Victoria Station and a ten-minute carriage drive from the local railway station of Dormans (with connections to London and Brighton) opened in 1884. By 1891 there were some forty impressive 'bungalow residences' 'dotted about the copse-clad slopes'. 'If you want peace and quiet' reported the *British Architect*, 'Bellagio is decidedly the place to get it, for here in your bungalow, hidden away among wooded slopes, you can be lost to the outer world as completely as you wish' (1888: 74). As I've discussed elsewhere, other things could be lost, as well as reputations. Bellagio was to confirm the Bohemianism of the bungalow (King 1984a: 100–1).

A handful of bungalows had been designed and built by a young London architect, Robert Alexander Briggs, whose *Bungalows and Country Residences* (1891 and later editions) has the distinction of being the first book of architectural designs on the bungalow to be published in Britain. Much more than the earlier Kent example, Indian imagery and the consciousness of empire and colonies were to be the principal source for Briggs's ideas:

What is a bungalow? . . . our imagination transports us to India . . . to low, squat rambling one-storied houses with wide verandahs, latticed windows, flat roofs and with every conceivable arrangement to keep out the scorching rays of the sun. . . . Or else we think of some rude settlement in our colonies, where the houses or huts built of logs of wood, hewn from the tree and with shingle roofs gives us an impression, as it were, of roughing it.

(Briggs 1891: Preface)

THE ARCHITECTURAL DISCOURSE OF THE BUNGALOW

I turn now to my second story. I referred at the start to the conspiracy of silence surrounding the bungalow in the more orthodox architectural histories in Britain, not least in the otherwise well-documented history of the Arts and Crafts movement. This is especially the case in comparison to historical scholarship in the United States where the popular Craftsman bungalow is seen as embodying

the movement's fundamental ideas (Brooks 1972; Cumming and Kaplan 1991; Robertson 1993).[7]

Thus, in two of the principal monographs on the doyen of Arts and Crafts architects in Britain, C. F. A. Voysey, there is no hint of the term (Durant 1992; Simpson 1979).[8] Despite Voysey, Shaw, and M. H. Baillie Scott having designed specifically named bungalows at the beginning of their careers, these have either been expunged or marginalized in the canonical British texts. And by excising the bungalow, they have also eliminated the connection between the change of architectural paradigms and the imperial context which triggered it off. For information on the early bungalow designs of British architects, we have to rely on an American scholar (Kornwolf 1972).

I mentioned earlier that the earliest identifiable reference to the bungalow as a form of architecture suitable for the suburbs (whether in Britain, North America, Australia, or elsewhere) was in 1891 (King 1984a: 105); yet the idea was to go through many transformations before it caught on.

Developments at Bellagio and the publication of Briggs's book, with its many illustrations and wide variety of designs, apparently opened up the gates of architectural experimentation. Briggs made a distinction between a bungalow, which generally had one storey though also sometimes with bedrooms in the roof space, and a bungalow house, the latter with verandas, balconies, and an informal architectural style. In a frequently quoted phrase Briggs wrote:

A Cottage is a little house in the country but a Bungalow is a little country house, a homely little place, with verandahs and balconies, and the plan so arranged as to ensure complete comfort with a feeling of rusticity and ease.

(Briggs 1891: Preface)

The larger economic and social conditions behind these architectural developments have already been hinted at. By the end of the nineteenth century, London was unquestionably the political, social and economic heart of empire. Its pre-eminent position as banking, finance, and services centre in the international economy (King 1990b) had created a substantial professional and service class, some of whom (along with 'returnees' from the colonies), in adopting a scaled-down version of the country house, were already making their social and architectural presence felt in the Home Counties. In Briggs's terms the bungalow was 'a *little* country house', not for the aristocracy but for a new bourgeoisie. As Clive Aslet has pointed out, it was this middle-class interest in the country house which led to the success of the magazine *Country Life*, which began in 1897 (Aslet 1982).

A second factor was the growing acceptance by members of this class of the increasingly institutionalized practice of the 'weekend', a social reorganization of time set aside for recreation and leisure, to be eventually embodied in building and spatial form – the weekend bungalow or cottage (King 1980). These social conditions, combined with Briggs's translation of the bungalow idea, were behind the high architecture bungalow concept in the 1880s. The essence was its principal single storey and the new emphasis on the horizontal disposition of the rooms. Kaplan (Cumming and Kaplan 1991: 121) suggests that 'the source of an Arts and Crafts building's horizontality is often unclear', seeking to ascribe this to the influence of individual architects, styles, or vernacular buildings. As with these bungalows, however, it was rather that they were appropriate to the larger, often less expensive, sites in the (reachable) country districts and the spacious suburbs of Edwardian towns.

About 1885, a youthful C. F. A. Voysey produced a decidedly undeveloped, though multicultural, bungalow design for the weekend retreat at Bellagio. Taking the name and the image of the vast roof from Anglo-India, its huge bay window from an Elizabethan or Jacobean English Renaissance past, and the two-and-half storey gable from the neo-vernacular ideas of Norman Shaw in the present (Kornwolf 1972: 56) Voysey's design for the 'Italian' Bellagio amply confirms Said's comments about late Victorian cultural hybridity. The spacious ground floor studio provides a clue to the bungalow's use, as well as the gendered connection between the (male) artist's 'little place in the country' and similar masculine spaces in the imperial city (Rhodes 1979; Walkley 1994) (Figure 2.1).[9]

Equally hybrid in its origins is the late 1880s design for a bungalow at Douglas, Isle of Man, by Baillie Scott which, according to Kornwolf (1972: 85) is the architect's earliest surviving design (Figure 2.2), apparently inspired by an American source published the previous year (Figure 2.3).[10] Already, therefore, the bungalow, as a social, architectural, and spatial idea – first introduced into North America in 1880 (Lancaster 1985) – was well on the way to becoming transnationalized.

Between 1893 and 1898, the *Building News* held three design competitions: for a countryside, hillside, and riverside bungalow. The winning designs all suggest not only the essentially recreational and leisure function, with plenty of time-consuming spaces in the billiard room, encircling verandas, belvedere towers and accommodation for golf irons and bicycles, but also, in their size and accommodation for servants and guests, Briggs's notion of the bungalow as 'a little country house' (Figure 2.4), as is also the case for the two previous examples. Both Briggs's use of the term, and that of his contemporaries, suggest

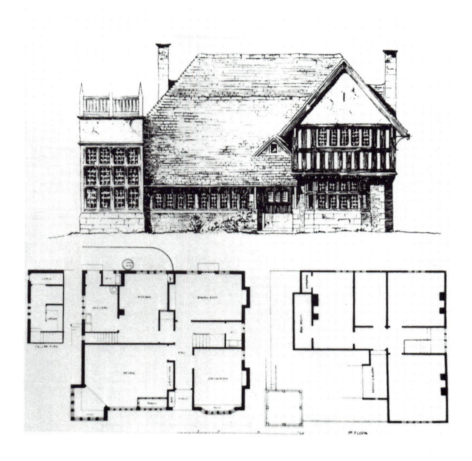

Figure 2.1 C. F. A. Voysey, Design for a bungalow at 'Bellagio', c. 1885
Source: *The British Architect*, 10 June 1898

that the main defining characteristics at this time were the use of solid walls for one storey only, a large, frequently sweeping roof under which additional accommodation could be included and, often, a veranda encircling all or part of the ground floor.

Like the design for a 'hill-side bungalow, a few miles from London, for a gentleman' (Figure 2.5), most of these examples were for occasional weekend or summer use. Yet it is clear from Briggs's Preface (1897) that his designs were also for more permanent living in the spacious suburbs and outlying districts of early

Figure 2.2 M. H. Baillie Scott, Design for a bungalow at Douglas, Isle of Man, 1889–90

Source: *Building News*, 18 July 1890

Figure 2.3 Charles Edwards, Bungalow at Paterson, New Jersey, 1886

Source: Building News, 12 March 1887

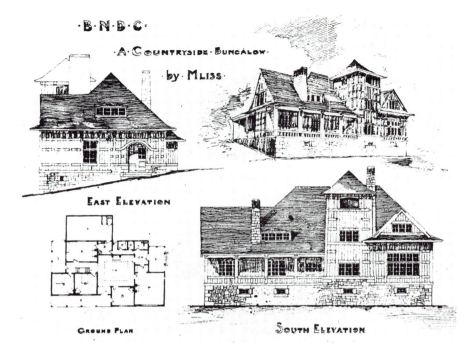

Figure 2.4 Winning design for 'A Countryside Bungalow' by Mliss, 1893
Source: Building News, 7 July 1893

Edwardian towns. He refers, for example, to the desire not only for artistic but also for 'appropriate dwellings . . . among the large number of persons of moderate income . . . hitherto content to reside in the *ordinary suburban villa* of a stereotype pattern' (emphasis added). Though 'moderate income' can be interpreted in different ways, in the drawings for a class of house costing £1,000 to £2,000, his interpretation of the bungalow idea includes dining and drawing rooms and three bedrooms and bathroom all on the ground floor (Figure 2.6).

Further out of town is A. Jessop Hardwick's proposed megabungalow, with strong neo-vernacular trimmings, for an obviously well-heeled client in Tunbridge Wells, published in the *Builder's Journal* in 1903 (Figure 2.7). Somewhat more modest and, from the presence of other houses nearby, apparently in a more genuine (though also 'professional') suburban setting, is 'Dr Emerson's bungalow' at Southbourne, the product of another Arts and Crafts designer, G. H. Brewerton (Figure 2.8).

By the turn of the century, Briggs's influence had spread well beyond the Home Counties. In the new, prosperous, merchant and professional suburb of Roundhay in Leeds (at the time, the fifth largest city in England), 'The Bungalow' was built

Figure 2.5 Winning design for 'A Hill-side Bungalow, a few miles from London, for a gentleman' by Centaur

Source: *Building News*, 20 May 1898

Figure 2.6 Robert A. Briggs, Bungalow design as an alternative to 'the ordinary suburban villa of a stereotype pattern'. In 1897 this model had been 'lately built in Sussex' (p. xii)

Source: R.A. Briggs, *Bungalows and Country Residences*, 1897 (fourth edition)

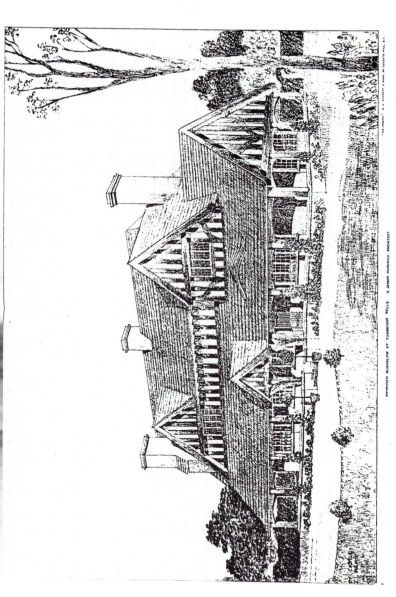

Figure 2.7 A. Jessop Hardwick, 'Proposed bungalow at Tunbridge Wells, Kent'

Source: *Builder's Journal*, 17 May 1903

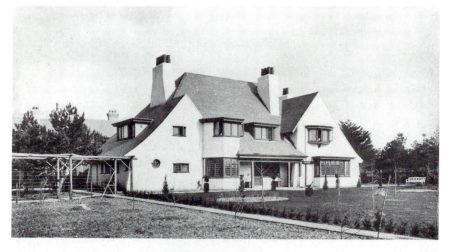

DR. EMERSON'S BUNGALOW AT SOUTHBOURNE
Designed by G. H. Brewerton. From the south-west (Page 149)

Figure 2.8 G. H. Brewerton, 'Dr Emerson's bungalow at Southbourne'
Source: 'Home Counties', *Country Cottages*, 1905

in 1900 (Figure 2.9), its features closely following Briggs's prescription of the bungalow as 'an artistic little dwelling with verandahs, oriels and bay windows'. On the ground floor are three bedrooms, bathroom, and dining and sitting room, with four further bedrooms, and bathroom, in the roof space, and billiard or smoking room in the gable.

Like other Arts and Crafts designs of this period, such as Baillie Scott's house at Letchworth (Kornwolf 1972: 303), the asymmetrical façade is balanced between the long slope of the roof line on one side and the M-shaped gable on the other. As is evident from all the discourse spelling out the variety of alternative lifestyles and social meanings invested in the bungalow, the symbolic dimensions of its architecture were meant to signify everything that city architecture was not: to be informal rather than formal; vernacular rather than classical; artistic, free and easy, rather than rigid, businesslike and uptight. As the space under the vast roof melted away to flow down and settle around the ground floor, the lines of the bungalow spread out horizontally at the base like a huge A, closing in at the top. It was all very different from the right-angled, H-like verticality which had governed urban classicism from the Renaissance.

These combined features of a new suburban organicism opened up a new space, with new social codes, where an increasingly commercial shopocracy, and

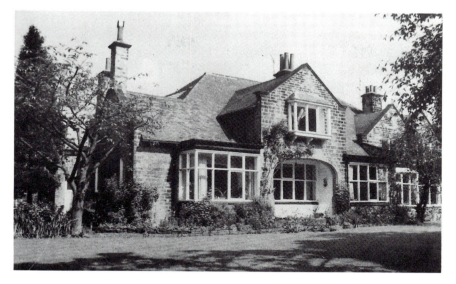

Figure 2.9 The Bungalow, Oakwood, Roundhay, Leeds, 1900–1. Architect unknown, but designed after R. A. Briggs, *Bungalows and Country Residences*, 1891
Source: Author's photo, 1987

professional class, came into its own, dependent, not least, on the new goods, opportunities, and prosperity which the Empire now supplied. And though the flattened 'pyramidal' nature of the lines may well have helped the form of these buildings cling closer to the landscape, the horizontality of the bungalow was a response not only to the new economic and spatial conditions of the expanding suburbs but also to the practical issue of the 'servant problem' and the need to cut down on unnecessary labour. At a slightly greater, rail-commuting, distance was a bungalow in the suburb of Bramley, three miles from the centre, designed by Leeds architect Percy Robinson and erected in the same year (Figure 2.10).

I have gone at some length into this somewhat conventional, formalistic analysis in order to reinsert the bungalow into the canon of architectural history, so as to expose the connection between what is often represented as a purely 'autono-mous' national, 'neo-vernacular' design tradition of the Arts and Crafts movement and the imperatives of imperialism, a 'national' discourse which is, in fact, made possible by Empire. As I have discussed elsewhere, when these up-market bungalows were introduced, they were both a symbol of, and container for, consumption – of time, of space, and of money. The surplus was channelled principally through the imperial metropolis and other large cities and it came at

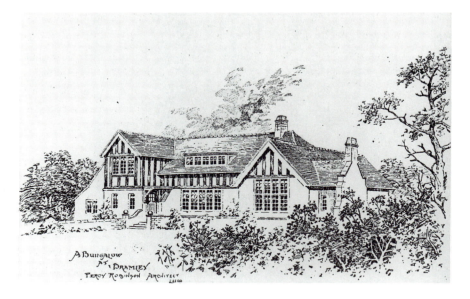

Figure 2.10 Percy Robinson, Design for a bungalow built at Bramley, Leeds, 1900

Source: *Building News*, 31 August 1900

a particular historical conjuncture. Near the peak of this high architecture bungalow boom, J. A. Hobson wrote in *Imperialism* (1902):

As our empire has grown larger, a larger and larger number of [officials] have returned to the country . . . many of them wealthy . . . devoted to luxury and material display. . . . Could the incomes expended in the Home Counties and other large districts of Southern Britain be traced to their sources, it would be found that they were in large measure wrung from the enforced toil of vast multitudes of black, brown or yellow natives.

(King 1984a: 262)[11]

THE MULTICULTURAL SUBURB IN AUSTRALIA

My third and last story is a short one. It comes from contemporary Australia, a colonial settler society first established by white migrants from Britain in 1788. Two hundred years later, in the 1990s, Australia is not only one of the most urbanized countries in the world, but also the most suburbanized: it has one of the lowest urban densities worldwide principally because of the predominance of

low-density, detached housing. Over 77 per cent of all homes in Australia are separate (and generally single-storey) dwellings (Judd 1993: 15). With the highest degree of home ownership worldwide (over 70 per cent), Australian cities such as Melbourne or Sydney contain all the classic elements which make up suburbia – not the least of which are the unimaginably vast numbers of California bungalows (as well as those of a more British and Australian variety) introduced from the first decade of the twentieth century (Butler 1992; King 1984a) and with the fashion alive and well into the 1950s.

Yet the California bungalows of Sydney's suburbs are changing, not least as part of larger political, demographic and cultural transitions. Till the 1950s, Australia's population largely, though not entirely, had come from the British Isles – the English, Irish, Welsh, and Scots. Until it was repealed comparatively recently, a policy of 'White Australia' steered the process of immigration.

Today, the more general effects of globalization combine with the very specific results of the last gasps of British colonialism to change the shape of Sydney's suburbs, not least transforming the space (and face) of the ubiquitous bungalow.

As 1997 brings British rule in Hong Kong to a close, the exodus of Chinese migrants (and their money) joins the larger diaspora of some thirty million Chinese now established in the countries of the Pacific Rim (Ley 1995). Like earlier Greek, Italian, Turkish, Vietnamese and other immigrants before them, Chinese families move into the suburbs, cranking up the levels of difference and diversity in the already multicultural landscape. Under the sign of a multinational American realty company, Century 21, Eddy and Simon Tan sell bungalows to their one-time compatriots in Blacktown (the toponomy resulting from an earlier term of racist abuse given by white colonists to Australia's indigenous people) (Figure 2.11). If Chinese money keeps up bungalow appearances in the displaced Scottish space of Glenfarne Street or the royal, loyalist plots on Kings (*sic*) Georges Road (Figure 2.12) in Granville, California bungalow forms as well as façades are being Sinicized. As Ley (1995) observes in relation to the Chinese diaspora in British Columbia's Vancouver, for the new transpacific migrants access to light through large windows, unimpeded by vegetation, is inspired in part by the traditional metaphysics of *feng shui*. Vestiges of Anglo-Tudor are erased and the Anglo–Indian–Californian–Australian multicultural bungalow is step by step transformed into an ordinary Chinese 'house' (Figure 2.13). Though developers have commissioned a new, neo-vernacular Australian Federation architecture to add a nostalgic Australian identity to some of Sydney's wealthier suburbs, such as Castle Hill and Cherry Brook, it is at least partly on owners of Chinese origin that the authenticity of the cultural landscape depends (Figure 2.14).

1995 年 4 月 7 日星期五　　THE CHINESE HERALD

Century 21

CARROLL COMBINED R/E
621 8000
40 FLUSHCOMBE ROAD, BLACKTOWN
(EXIT OFF GREAT WESTERN HIGHWAY)

STH BLACKTOWN　$128,000
寬敞三睡房住宅,高室内天花板,現代化
廚房,大家庭室,獨立客廳,二個洗手間,
游泳池,雙泊車位,近學校,商店和交通,
請電 SIMON 018 609 093。

EASTERN CREEK　$108,950
寬敞三睡房瓦頂板房,地大 800 平方米,
近商店、學校和交通。擁有超大客廳,廚
房,飯廳,停車位和車庫。

BLACKTOWN　$105,950
二睡房單位,客飯廳,廚房,車庫,步
行至車站、學校和商店。

BLACKTOWN 減至 $97,950(可議)
僅售土地價格
二大睡房,獨立廚房和冷餐室,步行至車
站、學校和一切設施。

STH BLACKTOWN　$119,950
全面新油漆之二睡房 VILLA,有車庫,近
學校、商店和交通。

BLACKTOWN　$199,950
五分鐘至車站
現代化住宅,寬敞客廳,家庭室,五大睡
房,雙車庫,警報系統,靜街。

EDDY TAN 先生(018)469 863 精通國、粤語、福建話、潮州話
SIMON TAN 先生(018)609 093 馬來語、印尼語、英語

4215

Figure 2.11　Colonial space: Blacktown bungalows
Source:　The Chinese Herald (Sydney), 7 April 1995

Figure 2.12 Floating signifiers: Chinese, American, Indian, English, Scots, Australian . . .

Source: *The Chinese Herald* (Sydney), 7 April 1995

Figure 2.13 Cultural translation: Bungalow to 'house'

Source: *The Chinese Herald* (Sydney), 7 April 1995

Figure 2.14 Ambiguous identities in Sydney's multicultural suburbs

Source: *The Chinese Herald* (Sydney), 7 April 1995

CONCLUSION

It is evident from these three stories that the Empire is not only in the city (King 1990b) but also in the suburbs – though in these post-imperial times, it is just as likely to be joined by the rest of the world as well. Capitalism is global, and liberalized Beijing is now part of the multinational scene. With the China World Trade Center now located in downtown Beijing, a new breed of global managers looks for somewhere to live. This might be in the Legend, or River Garden Villas ('the ultimate lifestyle in Beijing') advertised in the mid-1990s in the English-language *China Daily* or in 'Pure American-Canadian style Beijing Dragon Villas' – 'just like Beverly Hills of California . . . Richmond of Vancouver . . . Bayview Hill of Toronto . . . Long Island of New York' (Figure 2.15). Can the Beijing Dragon bungalow be very far behind?

Figure 2.15 Globalization and hybridity

Source: *China Daily* (Beijing), September 1994

ACKNOWLEDGEMENTS

My many thanks to Alan Crawford, Janet Wolff and Deryck Holdsworth for their valuable comments on an earlier draft; also to Greig Crysler, whose spirited ideas provided material for another chapter. Rob Freestone and Bruce Judd were my

expert guides to the multicultural suburbs of Sydney, and Abidin Kusno supplemented my documentation of Beijing. Chris Focht made an excellent job of the photography. The final responsibility for the result must, of course, remain with me. Earlier versions of the paper were presented in spring 1995 to the Department of Architecture, University of Melbourne, the Urban Studies Research Group, University of Western Sydney, the Departments of Town Planning and of Architecture, University of New South Wales and the Graham Foundation Seminar in Architectural History, Chicago. My thanks to numerous colleagues for their comments on these occasions.

NOTES

1 Stuart Hall, 'Old and New Identities: Old and New Ethnicities', in King, ed. (1991).

2 There had, of course, long been a tradition of single-storey cottages, though these were predominantly in rural areas.

3 See King (1984a: 105). The first specifically named bungalows in Britain were located at the seaside (1869–77); in 1886–91, a somewhat different version was introduced for the rail-commuting countryside; though the earliest identifiable texts recommending their suitability for the suburb were published in 1891, this is not to say that there are not extant suburban examples built before this, though they are likely to be few.

Though not addressing the international, or imperial context of suburban development (or defining the 'suburbia' of his title), Thompson (1982) none the less provides a valuable account of the process in Britain, addressing changes in spatial and architectural form, including the introduction of the semi-detached house in the 1790s (in St John's Wood) (pp. 8–9).

4 Fred Horner, *The Bungalow: A New and Original Comedy in 3 Acts.* Printed as manuscript in 1892 but not published. The author's address is given as The Lindens, Aberdeen Place, St John's Wood, London, NW and agent, Samuel French. Reproduced by Micropaque New York, Readex Microprint 1981 (English and American Drama, Nineteenth Century).

5 Said's notion of an imperial culture, produced in the metropole (and predominantly in the metropolis) in the context of the structures of attitude and reference of empire, should be distinguished from that of a colonial culture produced in the colony (King 1976; 1990a; 1990b). Though related in important and interesting ways, the concepts are not the same.

6 Innumerable songs and poems using the subject and rhyming possibilities of the bungalow testify to this fact. As an American commentator pointed out as early as 1905, the name was exotic, new, and had 'the same sort of charm as the word "Mesopotamia" to a lady in Maine' (King 1984a: 154). Gowans (1986: 75) writes: 'Because the word includes sounds as irresistible to real estate copywriters as the "o" of "cozy" and "homey" and the "u" of "cuddly" and "comfortable", the temptation to apply it to any and every sort of small dwelling was overwhelming.' In the 1889 play, one of the characters, suddenly put off his guard by unforeseen developments, nervously refers to the artist's 'gumbalow'. Over a century later, the saga continues: in a recent book of children's holiday poems, *Bungalow Fungalow,* I read 'Bun ga low. Bun galow (What a crazy word). Bungalow Donegalow. Fungalow Gungalow. Gunga Din' (and more to follow) (Shea 1991).

7 The American co-author of a recent monograph on *The Arts and Crafts Movement* (1991), Wendy Kaplan, takes two or three pages to write on the bungalow in the United States, though there is no reference to it by the British co-author, Elizabeth Cumming, writing on Arts and Crafts architecture in Britain. Apart from a two-line reference to 'Bungalow Briggs', the standard book on *Edwardian Architecture* by Alistair Service (1977) makes no reference to the bungalow, which is also the case with Richardson's *Architects of the Arts and Crafts Movement*

(1983). The links between imperial culture, India, the bungalow, and Arts and Crafts architecture in Britain sketched out here are probably only the tip of an iceberg (though see Metcalf 1989). Further research would be needed to verify some of these ideas. My thanks to Alan Crawford for his comments here.

Robertson (1993) notes that the *Los Angeles Examiner* in May 1904 reported that 'every street in Pasadena had a bungalow' as also was the case in Los Angeles and Hollywood.

8 Both Simpson's and Durant's books, presumably on the assumption that the design is not what the authors, at the end of the twentieth century, think what a bungalow ought to look like, reproduce a Voysey design which he specifically labels as a 'bungalow'. Both authors refer to the design as 'Lodge Style', taking as a proper name what the architect, in a related drawing, was clearly using as a type or category.

9 Between the ages of 16 and 22, Voysey had been articled to John P. Seddon, one of the two architects responsible for the second phase of the first bungalow development in England, at Birchington in Kent. Voysey's acquaintance with both the term and the idea was therefore quite early in his career.

10 Though Kornwolf (1972, p. 85) suggests one American source, it seems more likely that Baillie Scott's design was based on a drawing of 1886 by another American architect, Charles Edwards, and published in the American journal *Building* (12 March 1887) (Lancaster 1985, p. 81) (see Figure 2.3).

11 I have sketched out elsewhere some of the connections between fluctuations in the imperial economy and suburban expansion round London at the turn of the century of which the bungalow is an obvious cultural sign (King 1990b, pp. 24, 79–80). Nurse (1994, p. 62) adds another dimension, citing the vicar of a West Dulwich (south London) church in 1900 to demonstrate how the shift of imperial plutocrats to wealthier suburbs seriously impacted the class of housing subsequently built on Dulwich College estate: 'The richer people are moving out to Beckenham and Bromley. There has been a complete change of character in the last fourteen years' (i.e. 1886–1900); 'then everyone had something to do with India . . . drawn by the nearness of Dulwich College (and the Girls Public Day School in Sydenham). These have almost gone now.' The Horniman Museum (built 1896–1901) in adjoining Forest Hill, a paradigmatic example of Arts and Crafts design, and known for its ethnographic collections, was the spatial extension in the metropolis of H. J. Horniman's tea plantations in Ceylon and India.

REFERENCES

Ashford, J. (1994) *The Bungalow in New Zealand*, Auckland: Viking/Penguin.

Aslet, C. (1982) *The Last Country Houses*, New Haven, CT: Yale University Press.

Baedeker, K. (1896) *London and Its Environs*, London: Dulau.

Barrington, Mrs R. (1906) *The Life, Letters and World of Frederick Leighton*, 2 vols, London: George Allen.

Barthes, R. (1994) *Elements of Semiology*, New York: Hill & Wang.

Briggs, R. A. (1891) *Bungalows and Country Residences*, London: Batsford (also 1894, 1895, 1897 and 1901).

Brooks, H. A. (1972) *The Prairie School: Frank Lloyd Wright and His Mid-West Contemporaries*, Toronto: University of Toronto Press ('The Bungalow and Arts and Crafts', pp. 21–2).

Butler, G. (1992) *The Californian Bungalow in Australia*, Port Melbourne: Lothian Books.

Clark, C. E. (1986) *The American Family Home, 1800–1960*, Chapel Hill and London: University of North Carolina Press.

Cumming, E. and W. Kaplan (1991) *The Arts and Crafts Movement*, London: Thames & Hudson.

Durant, S. (1992) *C. F. A. Voysey*, Architectural Monographs no. 8, London: Academy Editions and New York: St Martin's Press.

Gowans, A. (1986) *The Comfortable Home: North American Suburban Architecture 1890–1930*, Cambridge, MA and London: MIT Press.

Hall, S. (1991) 'Old and New Identities: Old and New Ethnicities', in A. D. King, ed., *Culture, Globalization and the World-System: Contemporary Conditions for the Representation of Identity*, Binghamton: State University of New York and London: Macmillan Education , pp. 41–68.

Holdsworth, D. (1982) 'Regional Distinctiveness in an Industrial Age: Some Californian Influences on British

Columbia Housing', *The American Review of Canadian Studies*, 12, 2, pp. 64–81.

Horner, F. (1892) *The Bungalow: A Comedy*, unpublished New York: Micropaque, Readex Microprint, 1981.

Judd, B. (1993) *Designed for Urban Living: Recent Medium-density Group Housing in Australia*, Red Hill, ACT: Royal Australian Institute of Architects.

King, A. D. (1976) *Colonial Urban Development: Culture, Social Power and Environment*, London and Boston: Routledge & Kegan Paul.

King, A. D. (1980) 'A Time for Space and a Space for Time: The Social Production of the Vacation House' in King, ed., *Buildings and Society: Essays on the Social Development of the Built Environment*, London and Boston, Routledge & Kegan Paul, pp. 193–227.

King, A. D. (1984a) *The Bungalow: The Production of a Global Culture*, London and Boston: Routledge & Kegan Paul (second edition, with new preface and bibliography, New York and London: Oxford University Press, 1995).

King, A. D. (1984b) 'The Social Production of Building Form: Theory and Research', *Environment and Planning D: Society and Space*, 2, pp. 429–46.

King, A. D. (1990a) *Urbanism, Colonialism and the World-Economy: Cultural and Spatial Foundations of the World Urban System*, London and New York: Routledge.

King, A. D. (1990b) *Global Cities: Post-Imperialism and the Internationalisation of London*, London and New York: Routledge.

King, A. D. (1991) ed., *Culture, Globalization and the World System: Contemporary Conditions for the Representation of Identity*, Binghamton: State University of New York and London: Macmillan Education.

Kornwolf, J. D. (1972) *M. H. Baillie Scott and the Arts and Crafts Movement*, Baltimore and London: The Johns Hopkins Press.

Lancaster, C. (1985) *The American Bungalow*, New York: Abbeville Press.

Leaf, M. (1994) 'The Suburbanization of Jakarta: A Concurrence of Economics and Ideology', *Third World Planning Review*, 16, 4, pp. 341–56.

Ley, D. (1995) 'Between Europe and Asia: The Case of the Missing Sequoias', *Ecumene: A Journal of Environment / Culture / Meaning*, 2, 2, pp. 185–210.

Metcalf, T. (1989) *Imperial Vision: Indian Architecture and Britain's Raj*, Berkeley and London: University of California Press.

Newall, C. (1990) *The Art of Lord Leighton*, Oxford: Phaidon.

Nurse, B. (1994) 'Planning a London Suburban Estate: Dulwich 1882–1920', *London Journal*, 19, 1, pp. 54–70.

Punter, J. (1986) 'A History of Aesthetic Control', vol. I, 1909–47, *Town Planning Review*, 57, 4, pp. 351–81.

Rhodes, C. 'Through the Looking-glass Darkly: Gendering the Primitive and Constructing a World in the Practice of the Brucke', in R. Wrigley and L. Durning, eds, *Architecture and Gender*, in preparation.

Richardson, M. (1983) *Architects of the Arts and Crafts Movement*, London: Trefoil.

Robertson, C. (1993) 'The Resort to the Rustic: Simple Living and the California Bungalow', in K. R. Trapp, ed., *The Arts and Crafts Movement in California: Living the Good Life*, New York, London and Paris: Abbeville Press, pp. 89–108.

Said, E. (1978) *Orientalism*, London and Boston: Routledge & Kegan Paul.

Said, E. (1993) *Culture and Imperialism*, London: Chatto & Windus.

Saint, A. (1976) *Richard Norman Shaw*, New Haven, CT and London: Yale University Press.

Service, A. (1977) *Edwardian Architecture: A Handbook to Building Design in Britain 1890–1910*, London: Thames & Hudson.

Shea, P. D. (1991) *Bungalow Fungalow*, New York: Clarion Books.

Simpson, D. (1979) *C. F. A. Voysey: An Architect of Individuality*, London: Lund Humphries.

Spivak, G. C. (1985) 'Three Women's Texts and a Critique of Imperialism', *Critical Inquiry*, 12, 1, pp. 243–61.

Thompson, F. M. L. (1982) 'Introduction: The Rise of Suburbia', in Thompson, ed., *The Rise of Suburbia*, Leicester: Leicester University Press, pp. 1–26.

Walkley, G. (1994) *Artists' Houses in London 1764–1914*, Aldershot: Scolar Press.

Winter, R. (1980) *The California Bungalow*, Los Angeles: Hennessey & Ingalls.

Wolff, J. (1990) *Feminine Sentences: Essays on Women and Culture*, Berkeley: University of California Press.

Wood, C. (1974), *Dictionary of Victorian Painters*, London: Antique Collectors Club.

Wright, G. W. (1981) *Building the Dream: A Social History of Housing in America*, New York: Pantheon.

Wrigley, R. and L. Durning, eds (1997) *Architecture and Gender*, in preparation.

A STAKE IN THE COUNTRY

Women's experiences of suburban development

Deborah Chambers

The ways in which women negotiate, articulate and define changes in their physical environment, housing, public services, employment, neighbourhoods and communities, family and domesticity, are factors that have not been extensively investigated in the context of suburban development.

This chapter reports on an exploratory cultural study of women's experiences of the early stages of suburban development in 1950s western Sydney.[1] Using oral history as a method of enquiry, the project recorded women's perceptions of their changing circumstances during a crucial period of spatial and cultural change in the transition from a rural to a suburban culture. The significance of this study is twofold. First, it attempts to contribute to an understanding of the experiences of a social group about whom we have little knowledge concerning the cultural impact and negotiation of neo-suburban planning within a formerly rural area. Second, the study is located in a region where public debates about urban and regional planning and suburban development are indicative of current patterns of planning in other cities, regarding the desire for medium-density housing and/or semi-rural zones. Australia is one of the most highly suburbanized societies in the world, and western Sydney represents the fastest-growing region in the country with 45 per cent of Sydney's total population now living there. It is estimated that over 90 per cent of Sydney's development will take place in western Sydney over the next twenty years.[2]

The findings of this study provide indicators about the diverse range of experiences of women who witnessed the suburbanization of their local communities. The contributions of women to the establishment of community networks and a sense of community are significant for an understanding of the

ways in which government planning, and related policies, organize the everyday life experiences of specific social groups, and the processes of intervention by such groups in shaping the initial, emerging meanings of suburban living.[3]

PROMOTING SUBURBIA

We know that the obsessive concern with suburbs of houses on separate blocks arose from the early twentieth-century Western abhorrence of crowded city slums and the associated fear of disease and moral degeneracy. In Australia, it was proposed that 'correct' town planning would 'culminate in the development of greater civic pride and love of the country in our city and town dwellers'.[4] The physical shaping of the suburbs has inscribed the ideology of a stable and hierarchical social order. It is now acknowledged that the built environment tends to institutionalize not only class relations, but also patriarchal relations.[5] New suburbs in Britain and Australia were thought to nurture desirable values and lifestyles through the design of straight, regular streets and houses with space around each side, separated by fences so that their occupants could retreat into the private world of the family.[6]

The suburban lifestyle was not simply a response to the rising patterns of consumption of an expanding economy. It was also a material and cultural expression of the ideology of feminine domesticity: woman as homemaker. Suburbanization was an experience of egalitarianism in Australia, yet only for men, as Game and Pringle argue:

What is most distinctive about Australia is that urbanisation long preceded industrialisation, and by 1890, had progressed to a degree rare anywhere else in the world. It was largely for women and the production of children that the great Australian suburbs were built. The semblance of equality was achieved by the virtual conscription of women to the service of the home and family.[7]

Marriage, home ownership and the notion of wholesome family life were traditional values consolidated as universal and constant ideals, throughout the period of rapid social change in 1950s and 1960s Australian suburbia.[8]

Within the Australian advertisements, catalogues, journals, conferences and promotions of the 1920s and 1930s, the idea of home ownership signified a life of thrift and hard work. It was thought to engender self-esteem and a 'stake in the country'.[9] Home gardens would be expected to have a 'quieting and civilising effect', with their flower beds and vegetable patches, signifying industriousness

and civic pride.[10] Such themes were brought together in the advertisements and publicity about the expanding suburbs of western Sydney. Publicity by the Merrylands Chamber of Commerce to attract residents to a country township that was transforming into a suburb of western Sydney, for example, stressed affordability, health, progress, and available amenities:

Merrylands represents a type of life for which the average man has a yearning, to be in the turmoil of the city and yet away from it all when the occasion arises. In the town of Merrylands life goes on in its even tenor; there is a constant stream of business . . . the shops are many – gay, inviting, but not rapacious. To the city businessman life here takes on a different hue, the spirit of friendliness, of helpfulness is still foremost.[11]

The publicity is aimed, not at women, but at businessmen. The image draws upon a sense of nostalgia for simple, tranquil country life as a complete style of living which is contrasted with the 'turmoil' and 'rapaciousness' of the city from which the businessman is beckoned to escape. Yet the suburb, signified as country, is not a ghost town. It contains a spirit: of gayness, friendliness and helpfulness. Such advertisements draw upon connotations that refer back to the notions of countryside and village life within the mother country. The search for the mother can end in Merrylands. She is located there, in the margins between nature and culture, between perilous city and perilous bush, where a former periphery is colonized and tamed as centre: the all-man's land of quiet civilization serviced by women situated in a miniature version of the English country house. Within a simultaneous expression of 'utopia and convenience',[12] suburbia is represented as — the object of men's desire as father, husband, owner of property and the family. It is the feminine 'other' named and domesticated by the father. But this is only the utopian fantasy, the suburban dream. How did women actually cope with the realization of planners' and businessmen's dreams within the social space of the emerging suburbs?

THE COLONIZATION OF WESTERN SYDNEY

The regional development plans of the 1950s for western Sydney created the foundations of suburbanization during the 1950s and 1960s. This led to dramatic changes in the lives of existing farming communities in the West. Apart from the munitions factories developed during the Second World War, the region from

Parramatta, west of Sydney, to the foothills of the Blue Mountains was sparsely populated and characterized by poultry and vegetable farms until the 1950s. Thereafter, the planned migration of the population to the west of Sydney was effected by the division of the land into quarter-acre blocks for the building of residential accommodation and gardens.

The region began transforming into a suburban space as a direct result of the County of Cumberland Planning Scheme, 1948.[13] Together with the Sydney Region Outline Plan of 1963, this scheme echoes the 1900s desire to create larger local government areas through the merging of small towns such as St Marys with larger towns such as Penrith, and the identification of greenbelt areas and satellite cities. The aim of the Department of Local Government in the 1950s was specifically to establish a satellite city in the area of Penrith–St Marys.

The first significant increase in the population of the country town of Penrith, situated on the plains below the Blue Mountains, took place between 1947 and 1954 when it reached 17,900. Thus, an increase of 13,000 people resulted from the opening up of land around Penrith to city and overseas migrants. The population reached 46,300 by 1966, and today the population of Penrith is over 135,000.

The period 1947–54 was selected for study as a key stage when women who were in their early twenties between those dates experienced the rapid transition from a rural community to a suburban region. Women who moved to the rural communities of Penrith and Blacktown as part of the suburbanization of the western Sydney region in the 1940s and 1950s were composed of three distinct groups. Aspiring working-class families migrated to the west from Sydney. These families regarded the new developments out in the Cumberland Plains of western Sydney as an opportunity to participate in the realization of the middle-class suburban dream of a detached house with a garden or to establish an independent business. A second group emigrated from Britain and eastern and southern Europe after the Second World War. A third group came with their parents from more remote parts of rural New South Wales.

The Regional Planning Authority opened up the land in western Sydney for urban development by sharply raising the rates on large and small farming properties, forcing owners to sell out their orchards and poultry farms to the council. The women interviewed were very well informed about the regional planning developments in western Sydney prompting the population explosion through to the 1960s and 1970s. Several women portrayed the process of suburbanization as a series of battles between the council and planning authorities and members of the local community. Many recalled the population growth

around the early 1950s with concern about the speed with which the changes took place:

It was only like five years after War was over, but once the electrics came in and electrification [of the railway line] went through, well that's where the influx came and it just spread, and there was land that had been poultry farms, they were all being subdivided and of course it spread out and ever since then it's been going and going and spreading more. At times when you go around you think 'Oh that was vacant land, look at all the houses that's going up.' And see, even on the way out, on the Richmond Road, there are so many. A lot of them are housing settlements with the Housing Commissions buildings and others are private homes, and up near Rooty Hill turnoff, all that was big poultry farms and now it's all homes across there.

(Clare)

Marjorie recalled her and her husband's move in 1954 to Blacktown where they bought a poultry farm on the advice of her brother who had moved into the poultry farming business. Marjorie's husband gave up his employment in insurance in Sydney and bought ten acres of land in western Sydney which was 'ridiculously cheap by today's standards'. The labour-intensive farm struggled to modernize through increased competition within the poultry industry and was then lost to urbanization in the late 1960s through the State Planning Authority's re-zoning of the land:

So in the end we were really forced to modernize our farm, or go – and we were all ready by that time. In 1969 or 1970 the government brought out the Regional Plan of Sydney to the Year 2000, and we, in our area where we lived, it was zoned as proposed open space, and on top of that the new Western Freeway was to cut into the corner of our property. So we then had to battle with the State Planning Authority, it was the – it's the Department of Planning today. . . . So we tried to sell our farm, but because it was proposed open space nobody wanted to buy it. So we said to them well you're the only buyers and you want it. You've got to make up your mind now. And they bought it. Oh, it was a battle.

EARLY SUBURBAN HOUSING IN WESTERN SYDNEY

The developing suburbs were composed of detached houses on separate quarter-acre blocks. There was concern in the 1930s that smaller blocks would 'create a slum area in the bush'[14] as a negative response to the smaller plots of Housing Commission residences for the relocation of the urban poor. The 1933 and 1947 censuses demonstrate that all dwellings were made of wood, brick or stone.

Families who moved to western Sydney thereafter typically bought single or double blocks of land in the centre of town or in nearby orchards that had once been fruit farms where the land had been vacated and subdivided. Many who were born in the region bought a neighbouring block from their parents who had invested in double or larger blocks during their move to the region in the 1940s to maintain close proximity with the extended family.

Those who could afford it built in the preferred materials of solid brick with tiled roofs, but the majority of families were forced to select bungalows made of the cheapest postwar material of fibro, or weatherboard, with corrugated iron roofs from the timber merchants' catalogues of prefabricated cottages. Young couples who built their own houses lived in garages and sheds or with their parents while they were building their homes. They often moved in before the interior was partitioned, or built 'half-houses' whereby the back of the house was nailed up with sheets of fibro until the couple could afford to buy the materials to complete the house. Most couples extended by adding extra bedrooms, verandas, inside toilets and patios to the basic design over the years:

[The bank] financed the house for a two-bedroom place, and then my husband and I built the rest of it on to a four-bedroom house two years later. We just kept building. . . . It was fibro and we'd modified it so it was very open-plan and then it was the two bedrooms, a lounge, dining room, kitchen, toilet and laundry out in the backyard and the bathroom in the house. And then we extended it and put a back veranda on it and another bedroom, and then we extended it and put another bedroom and brought the laundry in and then finally, only in the last couple of years, we've put the toilet in as well.

(Patricia)

These foundations to the emerging suburbs contrast with today's suburbs in terms of the social mix of residents. Although the Housing Commission residences were composed of a homogeneous class of unskilled factory labourers, the class and ethnic differences of all other residents in the developing suburbs of western Sydney were mixed owing to the purchase of land rather than houses. The suburbs in the inner city were class-segregated through the purchase of a residence selected from a street of uniform houses. In the rural areas where the land was being subdivided for purchase as residential blocks, a mixture of labourers, professional couples and skilled tradespeople were situated in close proximity. The land was comparatively cheap and, in contrast to the UK where bank loans were restricted to the professional classes, bank loans were accessible to the Australian working class as part of the drive to populate the bush and farmed land on the city margins.

The original suburbanization process in such rural regions did not immediately establish cultural distances between people of different social classes even though the local councils and chambers of commerce tried to shape 'ideal suburbs' through class segregation by attracting 'a better class of person' to the region. The choice of building one's home in various stages also entailed the possible failure ever to afford to extend the half-house. Together with the merging of the home and workplace by growing vegetables and keeping livestock in the backyard for home produce and barter in preference to the creation of neat gardens of shrubs and lawns, this meant that the newly emerging suburbs of western Sydney initially looked messy, chaotic and disordered rather than neat, uniform and manicured.

The Australian egalitarian ethos served as a positive national myth, inviting people to 'muck in' together in the establishment of a community with their new neighbours. The first suburban houses built in Penrith were necessarily sucked into the daily work routines of a country town, exemplified by escaped cattle wandering along high streets and into backyards. By the 1960s, the Housing Commission was effectively enforcing social segregation through the regional plans and housing commission building policies by placing specific social groups, according to family size, ethnic identity and age in commission-built houses with no amenities.

WOMEN'S EXPERIENCES AND NEGOTIATIONS OF SUBURBAN PLANNING

Although the railway service from western Sydney to the city was regular, there were very few bus services interconnecting the western suburbs. The public transport system was not designed to give women access to local facilities. Like the telephone service, it was designed for men and their businesses. Yet it was women in particular who urgently required public transport, since most either did not drive or did not have access to the family car – which was typically used by the husband. Most women walked, with small children in tow, to the shops and other local amenities. Support networks were necessarily limited to small areas, intensifying the sense of community within them. As the towns grew in size, and cars became more cheaply available in the 1960s, women began to drive regularly to the shops, which led to a fragmentation of the community of women. Walking everywhere guaranteed that people met one another regularly within the small

community. Shopping later became a more impersonal activity, with less likelihood of meeting neighbours on the way to town.

As the suburbs expanded in the 1960s and 1970s, and housing settlements were built farther and farther away from the town centres, so the women of the newer suburbs experienced an increased sense of social isolation. Public transport and amenities were not expanded to meet the increasing demands of the new residents, particularly in the poorer housing commission areas. Women and children living on Housing Commission estates were so cut off from the central activities of the town that the inhabitants were inevitably treated as marginal, as a species foreign to the community that they were supposedly part of:

I think the biggest upheaval was when they built the housing estate at Mount Druitt. It caused a lot of resentment around this area because, you know, the old established people didn't like the idea of 'no-hopers', as they called them, coming into this area because they felt they were worse than the migrants you know. That's the way they felt. You know, because they were down and out.

(Margaret)

Pat recalls the same event through her memories of direct involvement as a foster parent and a prominent member of community services, and was actively involved in local politics, which indicates the level of active intervention of women in the improvement of amenities in the urbanization of the region:

Also, of course, they brought in huge floods of people, like 30,000 people. At one stage the population of Mount Druitt was 90,000, 60,000 of whom were under the age of 15. So it was like having a giant kindergarten suddenly plonked in the middle of the area, with no facilities, no postal, no telephone, and people were just suiciding like crazy out there. . . . And also they put people together, like Serbs and Croatians, who traditionally hadn't spoken to each other for thousands of years and in fact were very violent to one another. They put all the old people in certain streets. All the people with nine children got the five-bedroomed houses in other streets. So you could never get away from your problem. If you were old and couldn't open your window because it was stuck, neither could the person next door, because they were old as well. If you had nine children and were going round the bend, you couldn't get away because the people next door had nine as well. So it was really terrible planning, without facilities. Blacktown Council then undertook a pilot project called 'Section 94' where we took the developers to court to have them contribute so much from every block of land towards community facilities and we won that. And that was a really big, like two and a half year/three year court battle, and all the Community Services people surveyed every aspect of the area from where you want your bus stop to how many children and why do they play on the road, and it was observed at the time that children in Housing Commission areas liked to play on the road. Well that's rubbish – there was only the road. So a lot of myths were shot down during that Section 94 case. So it was an important landmark for us out there for community development, because also after that came estate workers, new estate workers, facilities went in before the people went in, the bus service was lined up to go in with the first resident in the area.

Once the postwar wave of settlers to the west had established themselves in remote areas that were marked for urban expansion, the alarm experienced in witnessing the radically changing physical environment followed:

You know, when I went to school this was the fruit bowl of the West, the fruit bowl of Sydney, I mean, Penrith and Emu Plains and Castlereagh. They were all under orchards! All under orchards. Beautiful soil and market gardens and heaven knows what, but mostly citrus orchards. Now when we first came up here to live you could see down here and you could see all the citrus orchards. Now all you can do is see houses and you can see through the trees, but the trees have blotted that out. The thing that bugs me is the fact that they've allowed so many factories and so many commercial enterprises to go up, grouped with housing, and you've got housing on one side of the road and commercial enterprises on the other side of the road, or light industry. All the people who live in the south work in the north, and all the people who live in the west work in the east, and they all meet on Castlereagh Road corner there at about four o'clock in the afternoon. So you can be sitting there for five sets of lights before you manage to get through. I think that the planning of Penrith has just gone to rack and ruin, and where all those – even that nice rose garden they have down there in Judges Park has been put under a car park.

(Pat)

Both the women who were brought up in the region, and those who migrated to the region in the 1940s and 1950s were highly critical of the manner in which the suburbs were planned, but some reluctantly interpreted the changes as part of 'progress', a catchphrase of the period:

Well it's a shame really because it was pretty, you know, down there – the river flats and looking towards the mountains. I thought it was very pretty you know. But it's gradually been sold. Particularly out at Cranebrook . . . there's a terrible lot of houses out there now. Oh, I did see part of it one day. Some friends drove me around from the Kingswood end. But oh, in one way I think it's a shame because Penrith was quiet and it was more of a rural atmosphere when we came here. Now it's commercialized – it's really spoilt. But that's progress I guess! There's nothing you can do about it.

(Eugiene)

Patricia claimed that the local residents won many significant planning battles in the early days of the 1950s, but also that these forms of intervention were increasingly difficult to sustain as the suburban development increased its pace in the 1970s:

It was a good place to live, and it was open and airy. It was challenging – nothing was easy, but it was easy also to win victories and to gain benefits once people got together and knew to do that. So it developed enormously. I don't see a lot of change in it now. I mean there is to the 1950s, but there isn't to the 1970s. It hasn't gone far . . . I think it took a character in the 1970s that will stay

with it, I think, for quite some decades to come. But those early years were only marked by the isolation and the lack of facility, the lack of planning – I mean Blacktown just grew up all over the place. It didn't actually get planned that hard.

Many women regrettably described how older houses built in the 1900s were demolished by the Housing Commission in the 1960s to give way to uniformly built modern houses and flats for the poor:

Just bulldozed over, sort of thing. There is an old house just on top of the hill there, on the left, back behind some of the new ones, where Douglas Mawson lived. You know the Arctic explorer? I don't know that it's the original house he lived in, but I understand it is, and it's still standing there behind some others. . . . It was the Housing Commission in those days and they said they weren't sentimental about old houses and things, but then the Heritage Council stepped in and picked out a few that they said had to be saved.

(Iris)

WOMEN'S WORK IN NEO-SUBURBIA: THE HOME AS A PRODUCTIVE AND CONSUMING UNIT

During Australia's postwar period, the Factory Acts, unions and government promoted middle-class values to encourage and force women to move out of the jobs they had held during the war, re-enter the home and take up motherhood – and housekeeping as full-time careers. Radio programmes and popular women's magazines such as *The Australian Women's Weekly* emphasized this middle-class – ideology of domesticity. Not only were home and employment divided along gender lines, but the ideology of motherhood was also linked to ideas about the correct manner in which to raise children and care for husbands in the interests of the 'nation'. Not only did most husbands actively deter wives from working but married women were barred from public service careers such as nursing and teaching until the late 1960s:

No. That really wasn't the done thing in those days, you know. I used to say I'd go and get a job but Doug said 'Oh my wife's not going to work.' It's amazing how quickly it's changed hasn't it? It's just the thing to work now isn't it?

(Audrey)

The ideology of homemaker and increased consumption were intertwined in the sense that, on the one hand husbands and employers collaborated to deter married women from entering the workforce, and on the other hand husbands bought

domestic appliances 'for their wives' from manufacturers who advertised their goods as household necessities.

The women interviewed were, not surprisingly, much more concerned about the hot water and toilet facilities than domestic appliances. Some homes in Blacktown area did not have sewerage connected until the 1980s, but others received the facility in the 1960s, depending on the zoning. Most of the women interviewed had experienced outside toilets until at least the 1960s.

Not the toilet. Oh, no. In those days it was a walk down the garden path down the back. The sanitary, it didn't come on until the middle 1960s or something when the sewerage started into Blacktown . . . I know the first refrigerator we got was the Golden Jubilee one that – Silver Jubilee – for King George V and Queen Mary. . . . Well, it was quite a large size but we thought it was big enough in those days, after having an ice chest, and of course you had either to go and get the ice or the iceman would come around if you ran out.

(Clare)

Few households had washing machines in the 1950s owing to the lack of supporting facilities, and few owned vacuum cleaners because houses contained wooden floors some of which were covered in lino. Carpets, bricks, tiles and even baths were in short supply after the war. Some households waited over a year for the delivery of items such as bathroom tiles.

Husbands' low 'family' wages forced wives to be highly resourceful. The home continued as a productive unit but also gradually extended into a consuming unit during this neo-suburban transitional phase between the rural and urban community. Women sewed clothes for themselves and their children from the material of old clothes or from cheap cloth bought locally. Many commented that they never bought jumpers but knitted everything, even socks for the children. They grew their own vegetables and kept hens and cows for the domestic supply of eggs and milk as butter was rationed up to 1954. They made their own cakes, jams, pickles and preserves and some women proudly claimed that they did not need to shop for vegetables and fruit at all. Those who could not afford, for example, the doctors' fees engaged in bartering by offering their home-grown produce as remuneration. Bartering between neighbours was a common activity:

The Yugoslav people that were our neighbours, she'd send me down tomatoes 'cause that's . . . and I'd send her up eggs, and down would come more tomatoes and up would go more eggs.

(Audrey)

Yes, and we had fruit trees so that you always did your own food and bottling, and we bought from the markets in the city and Jim would bring it by car by the box. . . . Well we used to barter quite

a lot with people . . . in fact I used to barter my knitting and my sewing as well as the jams and pickles and things that you would swap with people who did something or other else. And in fact, when I was telling you about learning to drive, that's one of the ways I paid for the driving lessons, was in bartering.

(Patricia)

Women's support networks, which were so vital in country towns before the Second World War, continued to be conveyed through kinship, friendship and bartering structures thereafter. Although bartering extended through to the 1960s it became increasingly difficult for these older families to sustain hens and fruit and vegetable gardens as they aged. Their offspring and the newer residents relied increasingly on retail produce as so many women began to engage in paid employment by the late 1960s.

It is clear that, in some respects, shopping was actually perceived to be easier before the superstores arrived in the towns. The now commonplace traumas associated with the search for parking spaces and waiting in shop queues in the crowded town centres of Blacktown and Penrith were frequently portrayed as experiences inferior to that of the convenient weekly deliveries made by horse and cart by the local grocer, baker, milkman, butcher, wood fuel merchant and even dry cleaning service in the 1950s. Despite the regular deliveries, some women took leisurely walks to the shops every day with their children, and some with their mothers. The experience is generally recalled as an enjoyable one, except when the weather was scorching hot. Shopping was perceived as a social activity which took hours, not only because the women generally walked to the shops, pushing prams, but because they stopped to talk to virtually everybody they met in the streets: they simply 'knew everybody' in the township.

Well there was a local shop there and while I'm in the supermarkets now I often wish it was still there because I could send the order in on Monday or Tuesday and they delivered it on the Wednesday, and I didn't have to walk up and down all those aisles looking for things [laughs] and stand in queues at the check-out.

(Iris)

Visits by rail to the city of Sydney took place perhaps once or twice a year – roughly an hour's journey – and were seen as a 'big excursion' for 'serious shopping' such as hats, shoes and outfits for special occasions. White gloves and hats were generally worn to all formal functions such as Sunday church services and evening entertainment.

FAMILY MEDICAL CARE

The nostalgia associated with daily living in the past in comparison with an inferior present hides many of the struggles faced by women during the years just before the suburbs became established. Most women either did not drive or did not have regular access to the family car. During an emergency, when Iris's baby daughter had something lodged in her throat, her husband had to run a mile to the nearest telephone to ring for an ambulance, 'and I turned her upside down and slapped her back and she started breathing after that'.

The average size of families has shrunk considerably since the 1950s, with the now widespread availability of contraceptives for women. Most of the women admitted that the conception of their third or fourth child was 'an accident' rather than planned. The largest family consisted of nine children: 'No [I didn't plan them], they just arrived!' Most women were reluctant to go into detail about family planning, but it was clear that they received poor medical advice, being informed that they were less likely to conceive while breastfeeding (which was proved wrong time and time again) or after a certain age but long before the menopausal phase:

The stupid doctor is saying, you know . . . how can you say that to anybody? At thirty-seven you're past having . . . very unlikely to fall pregnant! So, the pill had come out before that – no wait there, no after I had . . . I did go on the pill after Lance and it didn't agree with me. I got lethargic and put on weight and I thought, 'oh, damn this', you know. So I never bothered with the damn thing again. We were just very, very careful [laughs].

(Doreen)

Unlike their mothers' generation who gave birth at home administered by midwives, the majority of women gave birth to their children in hospital. The maternity wing of Penrith hospital was not opened until the mid-1970s, so the conditions were perceived as 'very primitive'. Yet the hospital environment was 'very friendly, everybody knew everybody there'. Mothers with babies and toddlers frequently planned visits to the health clinic to coincide with the weekly shopping in town.

SUBURBAN COMMUNITY NETWORKS

The women of the emerging suburban communities were a significant group that initiated and established community and neighbourhood networks of a social and voluntary nature at the crucial stages of suburban development. The community networks in Blacktown and Penrith were considerable in number and highly active in supporting charities that aimed to serve the needs of the elderly, the sick and the poor. Almost all the women interviewed were active in several associations or voluntary organizations both as young women and continuing as older members of the community.

Voluntary work was centred on the church groups and the Country Women's Association. The latter was initiated during the 1930s to cater for the needs of women and families on the land within farming communities and adapted over the years to cater for the suburban women. The Red Cross was established in Blacktown in the 1920s. The Women's Guild, the Inner Wheel, the Quota Club (service club), the Torch Bearers for Legacy, the Hospital Auxiliaries, the bush fire brigade ladies auxiliaries, parents and citizens associations all held regular meetings and fetes. These organizations served the purpose of creating neighbour-hood networks and raising money for regular dances, card nights, social afternoons, and carnivals as well as supporting older widowed women and those who lost their homes in bush fires. Events were regularly advertised in the local press. Meetings were often held in women's homes as there were few meeting halls to call upon.

Although voluntary work was increasingly secularized during the Second World War in serving the war effort, the church played a central role in women's lives in the foundational stages of suburban development by co-ordinating the voluntary work and self-help community networks developed by women, as Clare commented:

And we had a Friendship group which were all young marrieds and we'd get together I think once a week on Monday night, and meet at different homes of our members, and the Ladies Church Aid, they'd have cake competitions and all that sort of thing.

The involvement of women in voluntary and charity organizations is regarded as an extension of their domestic role as wife and mother, fulfilling 'an essential economic and ideological function for the capitalist state in contributing to the processes of accumulation and legitimation'. Baldock (1983) claims that unpaid voluntary work by women is justified as an extension of their domestic role:

The structure and ideology of patriarchy ensures the continuation of the myth of motherhood and home-making within western capitalist society. It also ensures the myth of altruism as a female preserve . . . much of the literature sees the motive of altruism as an essential factor in the availability of volunteer labour.[15]

Although in the narrow socio-economic sense women were indeed treated as a reserve army of labour, released after the war to engage in voluntary work to support the community in ways that the state failed to do, there is no doubt that women became empowered through various forms of intervention in shaping the suburbs to the needs of the community rather than the needs of consumerism and capital. More overtly politicized women's organizations, for example, also played central roles in culturally combating the material inequalities erected from the original planners' narrow visions in the physical articulation of suburbia, as Patricia explained:

There was a group called the Union of Australian Women that were out there then, and those women were in everything, and they had all of the things to do that had any sort of political or social change, those women belonged to the UAW. And they used to sell . . . we used to go and pick strawberries out of the fields and sell those on the roadside to get money to send somebody away to a conference. . . . But it was a very tight, united supportive community and the women, who were all a lot older than I was, were really fantastic to me because they could see me getting lost in all of these [foster] children and did everything they possibly could to make life easier for me. . . . But their political influence was very great too. . . . The Union of Australian Women was a mixed bunch. It comprised a lot of the left-wing women and also a lot of the church women at the time. . . . But my mother and father, and my husband's mother and father were both card-carrying Communist Party members here in the city, and executives of the Communist Party here in the city, so we'd both come from a very left-wing background and political background so it fitted in very well out there [Blacktown]. . . . And when Lalor Park developed as the Housing Commission area, they were the people who were doing all the politicizing and advocating for conditions for the young ones that had been put out there in such isolation, and in ghettos. They were very influential. They were represented on Council and on most of the committees to do with the Workers' Club and sporting bodies, cultural bodies.

Patricia went on to make a highly successful career founded on her initial involvement in the provision of community arts developments of the suburbs of Sydney:

But I went to work for Blacktown Council for ten years as their first Community Development Officer and their first Community Arts Officer and one of the first Community Arts Officers in Australia. . . . There was enormous groundswell from people out there wanting things to happen, and the facilities were like negligible. But they still are – it hasn't changed a lot. The Arts and Craft Group, the Literature Group, the Society of Women Writers were there and the Fellowship of

Australian Writers, the Historical Society, all those people met in buildings that the Council built at the Showground, and still function there. It's a really dynamic little hive of activity and development. But mainly people were spread out and that made it difficult.

WOMEN'S VIEWS OF SUBURBAN NEIGHBOURS AND IMMIGRANTS

Those women who were not born in the region and who had no extended family to rely on for help and advice relied on neighbours and friends. Neighbouring women offered to babysit when women were, for example, taking driving lessons. The establishment of strong support networks between women was essential in order to overcome the lack of extended family support. Many women commented that it was actually easier to make friends with neighbours and members of the rural community before the population expanded: 'that's one thing in a rural area, you make friends much more quickly than you do, say, in suburbia.'

Those who lived miles out of town in the 1950s were physically isolated. Weekly deliveries of provisions from the local shops, the need to walk into town regularly which guaranteed meeting familiar faces, and the large number of community organizations that the women belonged to meant that women rarely felt socially isolated. Even with the rapid rise in the population, these early suburban settlers had established such strong neighbourhood and community networks that immigrants from overseas and more recent arrivals were able to link in with the community of women. There is evidence to indicate that social isolation is experienced by women in families who migrated to the west after the population expansion of the 1950s and 1960s, especially those living on out-of-town housing estates with few amenities and poor public transport facilities. As Marjorie commented:

Yes, [we had] more contact then than I think we have now, because . . . I don't know what it is! Most of the neighbours now go to work you see and we don't see much of them at all. We know they're there if we need them, but we don't have much contact.

The women interviewed reported that the new inhabitants to the region who migrated from eastern and southern Europe after the Second World War were accepted well by the rural community. A woman who emigrated from England said:

We were all very close. All very close, and we all got on very well. There was quite a mixture of nationalities because at that period there was a lot of migrants. So we had quite a lot of different nationalities all around us. . . . I think because we had this common bond, this experience of being migrants too. And although we were British migrants, I suppose we felt just the same as they did. We could speak the language which was one great thing, except that we all had terrible Yorkshire accents in those days [laughs]. In fact I can remember the first few weeks I went to work at the telephone exchange [before I was married], an irate man rang up one day and said, 'Who's that bloody Pommie?' Really! He was quite angry. He didn't like the idea of this accent. It was terrible.

(Pat)

Many non-English-speaking migrants were 'businesspeople' who opened shops in the town or ran poultry farms and market gardening. They were perceived as 'hard workers'. Some worked on the night shift in the local factories in St Marys. Although the local women claimed to have made good friends with the immigrants, they seemed to know little about their lives and rarely asked them about their backgrounds or struggles in adapting to a new country: 'We made good friends from immigrants and they didn't affect us.'

The migrant women who were interviewed reported that they set up their own migrant community networks before they were gradually integrated into the community. Some of the early hardships faced by migrants to the region are, however, hinted at:

All the immigrants who arrived – they arrived to nothing! There was one day, one Friday afternoon – John was in sixth class – it would be 1949. The train pulled in at the station we lived just near and we could see it and there were twelve hundred people got out of that train – filled the platform. And they were taken by bus out to the area and they made some of the factory buildings into a living area for them. . . . And on the Monday morning 124 new children arrived at school! With no preparation, no extra teachers, no extra classrooms, nothing!

(Eugiene)

FORMS OF ENTERTAINMENT IN NEO-SUBURBIA

In addition to church organizations, hospital auxiliaries and service clubs, other leisure groups established by the women included local historical societies and choral groups. The forms of outdoor social entertainment typically engaged in by young couples in the 1950s and 1960s included tennis parties at the local social club, dancing until the dance hall was demolished in the 1960s in Penrith, picnics

with their children in the mountain bush, horse riding, swimming in the local river and visits to the beach resorts. Community activities included boat parties on the local river on Anzac Day, the Regatta, the Penrith Show, the Camden Show. Only a small minority went to concerts and other leisure activities in Sydney. Indoor leisure revolved around musical instruments and the radio until the introduction of television in the late 1950s, inviting friends for tea, and relatives to lunch on Sundays.

The wide open spaces of the developing suburbs of western Sydney were seen as 'a good place to bring up children' even though it was recognized that there was little childcare available after the war in the drive to force women back in the home as full-time mothers. There was limited organized activity available for children during the 1950s and 1960s. Most children participated in organizations such as Brownies, Boy Scouts and Girl Guides, and enjoyed a range of extracurricular school team sports such as cricket, hockey, soccer. With the increase in the population of the region came the commodification of leisure.

Much of what the mothers described as their own leisure actually involved accompanying children to, and spectating at, children's recreational activities. In fact, the gender divisions and structures of patriarchy imposed many constraints on women's leisure, which became home-based and child-centred. By engaging in regular duties such as shopping and community care as intrinsically social and sociable activities, women in the emerging suburban communities placed a high value on the pleasures of regularly meeting other women in mutual support groups: 'it's more pleasurable to work for the poor and the good of the community'. Women necessarily saw themselves not only as the physical and emotional caretakers of the family, but as the unofficial caretakers of the community as a whole since they were both culturally and systematically excluded from public office and employment.

A STAKE IN THE COUNTRY

The Australian suburbs were clearly founded on the powerful theme of progress, symbolizing the overwhelming desire to reshape and improve the 'half-world' between city and farmland. 'Progress' may have been a 'vague, utterly ubiquitous catchword', as Karskens says, but it 'captured the urgency, the optimism, the exciting potency of the new age'.[16] The term was often used by the women in

expressing both positive and negative feeling about the spatial changes: 'it's really spoilt. But that's progress, I guess.' Joy typically reported that urbanization was progressive but negatively qualified this as something inevitable and which leads, among other problems, to pollution:

Yes it is progress and it's inevitable. It has to be I suppose. But I think they'll have to stop soon. You know, there's trouble with the river and the pollution and it can't take any more really.

(Joy)

On the whole suburbanization was perceived by the women as a deterioration in the quality of life. The principal evidence given was a decrease in personal security and the rise in the crime rate; the rise in the number of factories and other large businesses built too close to residential areas; the council demolition of old houses, churches and other significant monuments and landmarks which signified the heritage of the community; unruly children and increases in drug use by the growing teenage population in the area; the loss of the pleasures of shopping as a social occasion; and crowded, impersonal city centres. Many respondents commented that they never locked their doors in the 1950s and felt quite safe at night because 'there wasn't a soul around'. Some slept on their verandas. But as the suburbs became increasingly populated, so the sense of security was eroded: 'it came that we had to get keys and change locks and all that sort of thing.'

Many women felt swamped by the rising population and the increase in housing and factories in the region, experiencing the social and physical changes in ways reminiscent of a moral panic. Terms such as 'you could hear it' and 'you could feel it' were used, as if the housing and factory developments were uncontrollable floods or plagues:

And they came in their hordes you see. It went from, in that time to 165,000. It's an awful lot of people. It was developing quickly from '46 onwards. Oh yes, it was happening all around you. It was happening, another subdivision would be opened up in Penrith and what you used to call country was now covered in houses. Yes, you could hear it happening. . . . There were greenbelts everywhere. Mistakenly they've built on a lot of those. They've been released, you know, which is a shame, which makes it houses from Sydney right to here – that ribbon development instead of having space.

(Audrey)

Astonishingly detailed descriptions of the landscape and townscape before the existing factories and houses were repeatedly given. Several women remembered exactly which old shops, cottages, paddocks and open spaces existed in place of

the existing suburban landscape. Statements reporting exactly who lived down what street usually ended with comments about the encroaching buildings such as 'and you could feel it closing in on you'. The word 'space' itself became a symbol of a lost golden age.

The early physical isolation of the rural settlers became a discursive device in the creation of community identities among women. Voluntary work organizations, bartering and other strong feminine social networks led to the creation of an imaginary unity of 'country' folk. The narrative of colonizing and forming allegiance to a symbolic country community provided a set of local traditions, landscapes and images to be shared by the women in connecting their everyday lives to the physical location of the region. Women, in particular, were most likely to feel dislocated and estranged by the rupture of postwar suburbanization as they were barred from employment and thus relied heavily on social networks as full-time mothers and housewives. Yet this symbolic system of egalitarian community not only served to create united identities and overcome feelings of dislocation but also served as a mobilizing category in effecting collective interventions against the rupture of suburban planning. The early country settlers felt exiled and estranged much later, as the population continued to grow in the 1970s.

The suburban dream of a 'stake in the country' – realized as a struggle over meanings associated with space, community, identity – appears to have been mythically recreated in the present as the unspoilt past within a defensive retreat from identification with the vast, sprawling suburbs of today. The old semi-rural community functioned as a source of meanings, memories and a sense of heritage in a way that the fragmented urban complex cannot provide for this ageing group of women. They no longer have a stake in the meanings being negotiated by the newer and younger residents of the region.[17]

By directly reporting women's experiences, this study demonstrates some of the ways in which women's circumstances change during the process of suburbanization. Their own accounts indicate that women are a significant group who initiate and establish community and neighbourhood networks, and a sense of community, at the crucial early stages of suburban development. Women negotiate and actively contribute to social and spatial change by intervening in the planning of suburbs. As the population of western Sydney grew, the feelings of unity within the communities diminished. Combined with the loss of a sense of space and security, women who witnessed the suburban expansion of the Cumberland Plains experienced a sense of physical dislocation and fragmentation of identity. The study provides clues about the involvement of women in shaping and implementing government planning principles in favour of local needs. To

paraphrase Marx: women make history, but only on the basis of conditions which are not of their own making.

NOTES

1 The *Western Sydney Women's Oral History Project: From Farms to Freeways* was conducted with associate investigators Carol Liston and Chris Wieneke, and assisted by Summer Research Scholar Larissa Banberry, at the Women's Research Centre, University of Western Sydney, Nepean. The project was funded by an Australian Research Council Small Grant, 1991. The taped interviews were administered and transcribed by research assistant Robyn Arrowsmith.

2 See Hovarth, Mills and Mee (1989) and Chesterman and Schwager (1990).

3 This study reports on the key changes in women's lives through the voices of the women who were interviewed. In this way, women's experiences of suburban expansion and living out of their ideals, values and opinions are intentionally privileged over public reports of suburban development. Two-hour taped discussions were held with thirty women aged sixty and over, who were in their early twenties during the region's population growth. The majority of women interviewed were Australian-born, and of Anglo-Celtic origin since the introduction of migrants to the region was a feature of the suburbanization process. For analyses of oral history as a research method, see for example Passerini (1990).

4 *Building*, 12, 1920, quoted in Karskens (1991).

5 See Wajcman (1991).

6 Karskens (1991).

7 Game and Pringle (1979), p. 4.

8 Karskens (1991).

9 Karskens (1991).

10 Karskens (1991).

11 Merrylands Chamber of Commerce promotional pamphlet, 1940, quoted in Karskens (1991).

12 Barthes (1977), cited in Morris (1988); Harvey (1989).

13 See Spearitt and Demarco (1988).

14 Karskens (1991).

15 Baldock (1983), p. 289.

16 Karskens (1991), p. 110.

17 See Richards (1990) for a comprehensive sociological study of contemporary gendered experiences of the Australian suburbs including neighbours, friendships and groups, and women's voluntary work.

REFERENCES

Baldock, C. (1983) 'Volunteer Work as Work: Some Theoretical Considerations', in C. V. Baldock and B. Cass (eds) *Women, Social Welfare and the State in Australia*, Sydney: Allen & Unwin, p. 289.

Barthes, R. (1977) *Image-Music-Text*, London: Fontana.

Chesterman, C. and J. Schwager (1990) *Arts Development in Western Sydney*, Redfern: Australia Council and WESTIR.

Game, A. and Pringle, R. (1979) 'Sexuality and the Suburban Dream', *Australian and New Zealand Journal of Sociology*, 15, 2, July, pp. 4–15, pp. 4.

Hovarth, R. J., C. Mills and K. J. Mee (1989) *A Skills Atlas of Western Sydney*, Department of Geography, University of Sydney.

Karskens, G. (1991) *Holroyd: A Social History of Western Sydney*, Sydney: University of New South Wales Press.

Morris, M. (1988) 'Things to do with Shopping Centres', in S. Sheridan (ed.) *Grafts, Feminist Cultural Criticism*, London: Verso.

Passerini, L. (1990) 'Attitudes of Oral Narrators to their Memories: Generations, Genders, Cultures', in D. Wiles (ed.) *Oral History and Social Welfare*, Oral History Association of Australia Journal, 12, pp. 14–19.

Richards, L. (1990) *Nobody's Home: Dreams and Realities in a New Suburb*, Melbourne: Oxford University Press.

Spearitt, P. and C. Demarco (1988) *Planning Sydney's Future*, Sydney: Allen & Unwin.

Wajcman, J. (1991) *Feminism Confronts Technology*, Sydney: Allen & Unwin.

4

THE SUBURBAN WEEKEND

Perspectives on a vanishing twentieth-century dream

Gary Cross

Like the suburb, the weekend is a central construct of industrial society. The suburb is a logical culmination of the spatial division of market work and residence. That split was an outgrowth of both the drive for productive efficiency and an attempt to escape from the environment of that productivity. The same dynamic prompted a temporal segmentation into the work week and weekend. Of course, pre-industrial societies produced many examples where the privileged escaped to the fresh air and space of the urban periphery. And all societies that have been organized around routinized work have created an artificial cycle of work and compensatory rest. But the linkage of the suburb and weekend in the last two centuries is in many ways unique. Mechanized transport has increased distances of suburbs from the centre, today often overshadowing the metropolis. Ultimately as a byproduct of productivity, the weekend has lengthened from the Sabbath to a regular two-sevenths of a week spell from work. The private home, purged of productive or market functions and removed as far from that environment as possible, has become a democratic right, a main object of labour struggles for equity in the distribution of the fruits of productivity. The demand for continuous blocks of time free from market obligation has paralleled the desire for private space.[1]

Oddly, this linkage has largely been ignored by the scholarly and prescriptive literature concerning the suburb. This failure is connected to the habit of identifying the suburban idea to the values of the property-owning classes. The modern suburb and weekend may well have been the 'invention' of the familialist bourgeoisie; but these ideas were more than emulated by the less affluent wage-

earner. The quest for spatial and temporal 'freedom' also grew out of working-class experience. The objective of liberation from industrial space and time was obviously hard to win; it was based upon an historically unusual confluence of extraordinary productivity, a high degree of labour organization, and a particular gender order that emerged for a short time in the twentieth century. While it is not clear what is replacing the 'suburban weekend', the ideal of spatial and temporal segmentation is disappearing in so far as the market colonizes suburban space and weekend time. What follows is a brief, historical, and necessarily partial and speculative reflection on the suburban weekend – its role in the literature and its rise and decline in the twentieth century. While this ideal is seldom directly addressed in the historical record, the suburban weekend was nevertheless a logical culmination of common aspirations of industrial peoples for autonomous space and time. My sources will largely be Anglo-American.

SUBURBAN WEEKENDS IN THE SUBURBAN LITERATURE

The modern suburb has usually been interpreted within the context of the rising middle class and critiques of its anti-urban, familialist aesthetic and ethic. Historians generally stress early nineteenth-century origins of the modern suburb. They note how it emerged with new forms of transportation that allowed a commercial or industrial class with sufficient time and money to abandon the confines of the 'walking' city for the extensive 'riding' city. As transportation became cheaper and faster (progressively shifting from private carriages to omnibuses, commuter trains, and trams), the suburban ideal trickled down the social hierarchy.[2] Social emulation, the argument goes, was built into this spatial extension. Historians stress as motives for suburbanization the desire for domestic seclusion, retaining rural life, and distance from plebeian disorder and aristocratic decadence. Suburban homes were to recreate families free from the distractions and threats of the city. Finally, scholars characterize suburbs as 'borderlands' reflecting the contradictory aesthetic and moral values of their residents torn between rural and urban life.[3]

These historical perspectives are generally useful. But they reinforce the long-standing modernist understanding of the suburb as merely the affluent family's escape from responsibility to the industrial city and the poor. American urban intellectuals in the 1920s transferred their earlier hostility toward the 'cultureless

frontier' into a caricature of the new outlying suburbs. The American urbanist Lewis Mumford attacked the suburban 'wilderness' as a false escape from the city's ills. From the 1890s, satirists mocked the pretensions of the upper middle-class suburb with its house-proud inhabitants, obsessions with gardening, and the inconveniences of commuting. The suburban weekend has often been attacked as escapist and trivial.[4]

The popular origins of the aspiration for suburban life have been obscured by the Veblenite emphasis on social emulation. The Victorian bourgeois home, as 'both a showcase for the world and a shelter against it', became a norm and thus an ideal for lower strata.[5] Of course, the formality of the Victorian parlour and garden surely gave way to the more open space of the bungalow living room and more natural garden in the first decades of this century. Especially from the 1890s, American weekend gardening blossomed (in imitation of English models). The founding of the Garden Club of America in 1913 symbolized this shift as did the massive growth in plant nurseries and garden tool businesses.[6] But overshadowing the evolution of the domestic aesthetic was the trend of consumerist emulation. This was a central theme of the Americans F. Stuart Chapin, Robert and Helen Lynd, and Fernand Lundberg in the interwar years and of the Briton Dennis Chapman in the 1950s. Aspiring classes bought into higher status by imitating the consumption styles of their betters.[7]

Thus historians and sociologists have usually understood the democratization of the suburban vision as merely another form of emulation. The respectability that was expressed in a 'proper burial' for the Victorian skilled worker was realized in the twentieth century in the suburban home.[8] Skilled manual and white-collar workers distanced themselves from their social inferiors when they moved to the suburbs; in turn, they imitated those who had literally already 'arrived' in the new neighbourhood.[9] 'Window to window' relations in the suburbs replaced the old 'face to face' knowledge of neighbours in the old working-class urban districts. Thus, the social acts of status seeking and 'belonging' inevitably became entwined with home display and the aspiration for consumer goods. So concluded Michael Young and Peter Willmott in their classic study of the movement of wage-earners to a London suburb in the early 1950s.[10]

Implicit in these analyses was a privileging of the 'intimacy' of old urban or small town neighbourhoods. This perspective was a product of selective memory of Anglo-American autobiographical writers which certainly seeped into socio-logical analysis.[11] Modernist intellectuals and architects combined an aesthetic snobbism, self-interest, and a lack of understanding of popular aspirations in a many-sided attack on the popular suburb in the interwar years.[12] The English

critic Osbert Lancaster condemned endless rows of nearly identical houses as an eyesore: 'the largest possible area of countryside is ruined with the minimum of expense'. And George Orwell mocked the suburb as a 'line of semi-detached torture-chambers where the poor little five-to-ten pounders quake and shiver, every one of them with the boss twisting his tail and the wife riding him like a nightmare and the kids sucking his blood like leeches'.[13]

But respectability was more than emulation; and the work of the house-proud was more than a materialist substitute for 'real' social relationships. Both were part of a strategy of self-definition and autonomy vis-à-vis a wider world of work. However, orthodox treatments of the suburb have been predominantly hostile to these aspirations. Scholars have labelled as escapist and imitative the suburban vision of autonomy in spatial and temporal 'blocks' separate from market space and time.

Instead of understanding the popular suburb in terms of self-determined segmentations of space and time, critics set the suburb against cosmopolitan social and cultural ideals. They express a general 'disappointment' in the fruits of mass affluence as expressed in the leisure and family life of new bedroom communities and the failure of the garden city movement of the 1900s. This was particularly true of the 1950s. A well-known, mostly American literature portrayed suburbs as producing rootless, transitory upwardly mobile 'status seekers' and hypersocial communities of conformists. There, children were smothered by Momism and fathers were absent. Suburban women were characterized as lonely while men felt used as mere providers. Critics claimed that social interaction was based on the accidents of house placement and the ages of children. Accordingly, the suburb absorbed the energy of all to the disadvantage of urban culture while offering few amenities beyond the endless obligations of worklike leisure in garden, club, and family.[14] While David Riesman acknowledged that the 'modern suburb is the product of the car, the five-day week, and the banker's hours of the masses', he complained that free time was increasingly being absorbed by the solipsistic car commute and gardening. Unlike city-dwellers, suburbanites were 'tied to his house as the doctor is to his practice'. The pretensions of the Victorian parlour may have disappeared but so had promenades in grand city parks, and the promise of adult education was never realized.[15]

Of course, sociologists have questioned many of these stereotypes.[16] In the 1960s, Bennett Berger found in his study of a northern California working-class suburb none of these baleful effects of suburbanization: as compared to the old urban neighbourhoods, social life hardly changed; most interaction remained familial and informal neighbourhood contacts survived.[17] Harold Wattel

discovered that the suburban Levittowners spent their weekends in individualizing their mass-produced homes.[18] Young and Willmott found family-oriented fathers, not absentees. Suburbs did not make working-class families into joiners; instead, they remained far more familial than did the middle classes.[19]

Still, these writers were often defensive and emphasized the cultural conservatism of the popular suburb rather than what motivated migration from the city. Most of all, neither they nor other scholars of the suburb showed much sensibility to the centrality of the weekend. *Leisure, a Suburban Study* (1934) set the course. The authors assumed that the free time of affluent Westchester County, New York was a harbinger of a status-driven leisure of the rest of the country.[20] Instead of analysing the rhythms of the suburban week, they compared the ideal of 'good' leisure against the reality of emulative and commercial leisure.

TIME AND THE STRUGGLE FOR THE SUBURBAN WEEKEND

We need to bring time and the work experience into the spatial meaning of the suburb. In recent years, time increasingly has been understood as a social construct, a means of co-ordinating roles in a 'social time grid'.[21] The week is especially an artificial construct (unlike the day or even the year). As Eviatar Zerubavel notes, its importance has grown with the declining significance of nature in everyday life. The 'week', at least 1,500 years old, is essentially an artificial means of regulating rhythms of labour and rest – connected neither to astrological nor food-gathering cycles. Moreover, while the day measures cycles of work and bodily rest, the week sets patterns of public obligation and private autonomy. It regulates the assembling and disassembling of groups – defines social roles in rituals of inward and outward movement from the market.[22] The week is not merely a social temporality but it is inextricably bound with space. As Don Parkes and Nigel Thrift note, '*timed space* is the essence of place . . . it is the timing component which gives structure to space and thus evokes the notion of place'. Social roles are realized in those timed spaces. Most important, different types of time are associated with market and domestic places. The week gives coherence to confusion of time and space roles by separating them.[23]

Two essential points need to be added to these insights. First, the week is more than a social convention. It expresses lines of power. The week has been segmented unequally by social class, and changes in its allocation have been

products of social conflict. Second, segmentation of time and space, as in the suburban weekend, represent a *generally valued* compromise of obligation and autonomy for most participants in industrial society. The intensification of the work week has led to the separation of public and private time and space. Concentrating business in cities increases the velocity of communications and goods flow (saves time); decentralizing residences reduces that intensity of communications (and thus diminishes the stress of time). Transitions, especially in the commute, serve to scale up or down the intensity of time.[24] Weekend time is necessarily linked with weekend space – a temporal or spatial 'emigration' from workplace and marketplace time. The suburban weekend represents 'escape' but also a valued, self-defining time-place – relief from both high-intensity space and time use.[25]

An essential part of the struggle over the consequences and fruits of industrialization was the demand for space and time free from the market. Indeed the two were often linked, especially from the 1890s. Perhaps inevitably the popular classes embraced the status that personal space gave to the rich.[26] Olivier Zunz found that home ownership was more common among working-class immigrants in Detroit in 1900 than among the native middle class.[27] This was unusual to the American situation; but what impeded working-class suburbaniza-tion was less cultural than economic constraints. Simultaneously, workers demanded time. For wage-earners, contrasting meanings of time were partic-ularly sharp early in the twentieth century. Time at work inevitably dragged; anticipation of the 'red light' or bell signalling release at the end of the day or week dominated consciousness.[28]

Obviously time and space free from work was an essential corollary to economic modernization. Industrialization not only increased productivity, but it physically separated productive from 'reproductive' or family activities. An expulsion of leisure from the workplace and the spatial division of home and work required an equally sharp temporal demarcation. The quest for reduced working hours in part can be seen as the only practical means of recovering in 'blocks' of family or leisure time the 'bits' of that time lost in industrialization.

One manifestation of this trend was the demand of British workers in the 1890s for an eight-hour day in order to compensate for the increased time lost to commuting. For example, central residential neighbourhoods in London were converted to businesses and, at the same time, new living standards and new tram routes encouraged suburban migration. Historian G. Stedman Jones notes that, with suburbanization, working-class men began to abandon the pub of their workmates. They shifted to the neighbourhood bar which they increasingly visited

with their wives. Long evenings began to count more than long work breaks.[29] In the 1920s, the Western European left defended the eight-hour day as a vehicle for wholesome suburbanization. A reduced work day would provide wage-earners with the time necessary to abandon the overcrowded tenements located near the factory for the more spacious suburbs. French socialists praised the uplifting value of gardens as well as chicken and rabbit husbandry as positive alternatives to the lure of the bar. Most important, the shorter work day would allow wage-earners to 'enjoy fully the life of the family'. Reduced hours meant that women workers would have more time to make the home an attractive alternative to the bar for husbands.[30] The struggle for free time was clearly related to a popular quest for domesticity and distance from the workplace culture.

More specifically, the attraction of longer continuous blocks of free time at home contributed to the demand for the weekend. Early industrialism and the commercial market eliminated Saturday half-holidays and even Sundays free from work. In response, from the 1830s, religious conservatives, leisure reformers and trade unionists insisted on weekly 'rest'. They viewed the Sunday and Saturday half-holidays as antidotes to the social divisiveness of economic competition and as means of preserving family solidarities and religious practices. The image of Sunday as a day for the restoration of moral as well as physical faculties became a commonplace in Victorian England.[31] Into the twentieth century, English sabbatarianism survived in late rising and afternoon naps (for men, at least); the reading of several Sunday papers (if not the Bible); and dressing in Sunday best for afternoon strolls to the pub (if not to church). Weekday patterns were reversed: homes and gardens were full of activity and streets were relatively empty.[32]

From the 1830s and 1840s, skilled building trades and shop and office workers in Britain began to negotiate for shorter work on Saturdays. The Saturday half-holiday became an important symbol of family life and of the therapeutic value of leisure in Britain. In the 1850 Factory Act, women and children in textiles were freed from work at 2 p.m.[33] Authorities assumed that women would use the time productively in shopping and house cleaning. Working-class women could be, at least, weekend housewives even if wage-earning men could not afford full-time homemakers. However, reformers went further when they began to argue that Saturday afternoons would give fathers time to develop 'a power over their [children's] minds, and to exercise a more genial and trustworthy authority than that which would be merely granted to his position as a parent'.[34]

The idea of the weekend implied a suburban family centred on the home and built around a homemaking wife and 'caring' wage-earning husband. But this goal anticipated the reality of the weekend and popular suburb by decades. It should

not be surprising that, following the general adaptation of the eight-hour day after the First World War (in a six-day working week), labour movements demanded longer blocks of weekly free time: in the 1930s, they called for the two-day weekend and paid vacations. Workers wanted continuous periods of time free from work, rather than further reductions in the work day. The popularity of long blocks of time free from work corresponded with the rise of the popular suburb as an ideal of distance from the workplace. The suburban weekend had distinctive origins among wage-earners that extended far beyond middle-class emulation. The common association of familial privacy with the bourgeoisie and the culture of the street with the working classes is at best a distortion.[35]

SOCIAL MEANINGS OF THE SUBURBAN WEEKEND

The weekend was not only a means of affirming economic and social status; it was a time for creating a family and personal identity. To some extent, working-class familialism and localism reflected the 'hidden injuries of class' in wage-earners' refusal as youth and parents to join the crowd that denied them social recognition. Instead, youth and workers often sought localist and familial intimacies.[36] Here, however, I will stress the personal appeal of self-controlled rhythms of the weekend time of adults.

A central expression of this appeal is the often nostalgic quest for rural or craft competencies. Most discussion of this theme has focused on the middle-class male. Steven Gelber notes how a new craftsmanship emerged on weekends in the 1890s among affluent suburban American men who formerly would have hired a handyman, gardener, or carpenter. The 'do-it-yourself' (DIY) movement was a complex response to complex change: it was a creative compensation for unrewarding work as middle-class men increasingly abandoned entrepreneurship and became white-collar employees. DIY was leisure but consistent with a still powerful work ethic. It could be justified as an investment and perhaps as cost saving. It gave men a role and even a place in the new suburban home. As the age-old tasks of cutting and hauling wood, for example, disappeared with modern stoves and heating, men shifted to gardening and minor carpentry. This probably was a change that affected most men, at least the vast majority without servants. But DIY entered the ranks of the wealthy too. About 1900, as the old bourgeois ideal of the masculine library separate from the feminine parlour gave way to the

ungendered 'living room', even men who had no need to do their own repairs or home improvements found a new refuge in the basement or backyard 'work room'. Finally, DIY had the virtue of being a leisure built around traditional male tools. The advent of the power drill and saw, marketed in the 1950s to home craftsmen, confirmed a comfortable association of modern tools with traditional male competency.[37]

Ian Bentley and Paul Oliver similarly stress the role of the do-it-yourself movement in England as an arena of private creativity (back garden) and public display (front garden). Simple carpentry and gardening skills allowed home-owners to create a personal statement.[38] Handicraft magazines in both countries abounded in the interwar years. *Popular Mechanics* mixed reports on the latest advances in science and gadgetry with practical instructions on everything from window repair, toy making, and personalizing radios with handmade dials to the construction of basement workshops and even houses. This magazine offered men domestic leisure while affirming their desire to be part of a wider world of technological competency.[39] Suburban weekends constructed a 'masculine domesticity' in the early twentieth century according to Margaret Marsh. 'Domestic feminists' and others encouraged fathers to be 'companions' not mere breadwinners.[40] Masculine domesticity represented a moderate compromise with an ascendent feminism by integrating men into a domestic sphere largely controlled by women.[41]

While historians have recently investigated the origins of a broad middle-class suburban cult of masculine domestic competence, there is little doubt that this culture extended, with obvious variations, into the working class. Young and Willmott suggest that the 'house-centred' spirit of wage-earning men went along with ownership as an expression of pride of ownership and as an investment.[42] Magazines and tool-makers also promoted home improvement projects as vehicles of domestic togetherness for working-class families.[43]

In many ways the twentieth-century suburban weekend has been a male construct. It was built around the commonly masculine alteration of work time and leisure and buttressed by the trend toward the 'family wage' — a father's income sufficient for support of the family without need of the wages of wives or children. Feminists have defined suburban space as an extension of the artificial division of the public and private wherein women were confined to the limiting roles of home and motherhood.[44] Suburbanization radically sharpened the sexual division of labour because it separated production from consumption, paid work from the home. Thus, according to American historian Dolores Hayden, the suburb 'made gender appear as more important self-definition than class, race or

ethnicity'.[45] Similarly Karen Davies argues that women's conception of 'spatial time' built around meeting social needs contrasts with the alternative or 'point-in-time' concepts of men. Accordingly, because women's time is not naturally 'chopped up', the 'male' notion of linear time segmented by work and leisure is alien to women.[46] One might question the assumption that the division of labour time and place is best understood as a male imposition. But it is clear that alternative time and place was a predominantly male experience. In the 1920s, only 26 per cent of residents of New York City's Long Island suburbs commuted, almost all breadwinning men.[47] By contrast, the home was the principal place of both work and leisure for most married women. In the interwar years, for example, never more than 12 per cent of married women in Britain had market jobs while that figure hovered around 90 per cent for men.[48] American figures were similar.[49]

These gender differences shaped the significance of the suburban weekend. 'Real' time in the market workplace made the suburban weekend meaningful to providers. The pains of weekday labour gave breadwinners permission to enjoy weekend leisure; and work schedules structured those 'sacred' moments of freedom.[50] This dichotomy, of course, did not exist for most married women. Indeed, it was their routine labour that made the suburban home a haven from market work. Weekday domestic labour of women was organized around the goal of making weekend time enjoyable. The wife's hours of housework justified her access to her husband's money and her enjoyment of the private time that she largely created.[51] Of course, men 'worked' at the weekend – but in tasks that were often the mirror opposite of wage-earning jobs. Studies from the 1960s suggest that women probably spent more time doing household chores at the weekend than did men.[52] DIY and other enhancements of domestic weekends seem to have meant different things to male and female adults. In a recent American survey, men stressed the personal achievement and value added to their homes in their domestic projects. Women associated their work in creating a homy environment with family relationships and memories.[53]

The weekend, however, never was merely an abstract self-determining activity, the mirror opposite of public obligation of the working week – even for men. Freedom from wage work also encompassed the liberty of time to consume. As American sociologist Paul Douglass wrote in 1925, 'Man creates wealth in the central city and spends it in the suburbs.'[54] The suburb was always as much a consumer market as a refuge from production. In the long run, family togetherness had to compete at weekends with service jobs and individualized shopping (a point to which I will return).

As production was removed from the home in the nineteenth century, weekends increasingly became absorbed in shopping. Saturday evening or Sunday morning shopping competed for time with recreation. Shopping shaped the division of Saturday and Sunday, at least until recently. Victorian wage-earners (especially women) devoted Saturday evenings (or afternoon where the half working day was practised) to frenetic shopping even as men socialized around club and sports. Of course, Saturday rush time was supposed to turn into solemn time on Sunday. But the Sabbath was hardly divorced from the market, even though markets were to be closed. Time 'at home' became occasions for the consumption of goods.

However, domestic consumption was far more than passive and manipulated. Through home goods, families displayed and expressed themselves as both members of chosen communities and as unique. Indeed, consumer items probably provided a valued balance between belonging and autonomy. Unlike other forms of self-expression, spending created 'community' without the risks of intimacy (such as in social clubs or informal neighbourhood interaction). In fact, much of the sociability of groups and neighbours was built around shared and compared displays of goods. This, of course, is a purpose of stamp or antique auto clubs and discussions of landscaping across backyard hedges. But weekend consumption time provided more than social markers: it offered both continuity and memory through accumulated goods. The home became a 'private museum of treasures' as noted one English memoir of the 1920s. These artefacts guarded against the intrusion of society and change. Consumer goods made possible a private world.[55]

Male DIY was and is essentially a consumerist activity. It involved the acquisition of tools and work materials and the shaping of these possessions into self-expressions and value. But it was primarily the woman who orchestrated domestic consumption. She worked with purchased goods and transformed them into displays of status and into individual expressions of familial privacy and comfort throughout the house. Women used goods to organize those 'special' times that all family members longed for at the weekends and on holidays.

The suburban weekend combined both social identity and privacy. It provided rich alternatives to routinized work time through cyclic and confined moments of freedom. These temporal experiences were realized in and through goods. Suburban weekends reinforced the commitment to steady work. Without the routine of the waged working week, the freedom of weekend consumption was economically impossible and psychologically meaningless. The weekend thus both relieved and reinforced commitments to the working week.[56] With the

emergence of mortgaged, especially suburban, housing, families bought member-ship into an intimate community of private spaces and temporalities enjoyed on the weekend. The suburban weekend was essentially linked to the urban working week. But it was chain forged in acts of spending.

THE GOLDEN AGE OF THE SUBURBAN WEEKEND, 1920–70

The suburban home was part of a trade-off after the First World War, promised, if not realized, in exchange for accepting bureaucratic or mass-production work. It became a democratic possibility in that extraordinary combination of economic growth, labour strength, and the provider or homemaker gender order that prevailed in the generation after the Second World War. Lloyd George claimed in 1918 that an England 'fit for heroes' meant improved housing.[57] Between the wars, an average of 33,000 units per year were built in Britain, mostly by private speculators for middle-income families. But, after 1932, lower interest rates and down payments and long-term mortgages made home ownership accessible to even lower income strata (providing they were in employment). Only 10 per cent of British families owned homes in 1914. But by 1949 that figure rose to 21.5 per cent of manual workers and 51.9 of white-collar employees. Of course, not all of this housing was suburban; but increasingly it was.[58] In the United States in the 1920s, the bourgeois Victorian suburb was overshadowed by the new rows of bungalows and other more modest homes that sheltered over seven million mostly lower middle-class families on the periphery.[59] Los Angeles alone opened 3,200 subdivisions to Midwestern migrants seeking a promised land of sunshine and lawns. Roosevelt's New Deal after 1932 encouraged the thirty-year mortgage that made home ownership feasible to many working-class families even though few could avail themselves of it until after the Second World War. Roosevelt supported highway construction that laid the foundation of modern suburban sprawl. In 1939, Roosevelt signed legislation that offered tax deductions on mortgage interest, thus providing a major subsidy to suburbanization. From 1934 to 1953, the American suburban population rose by 75 per cent (compared to only 25 per cent for the country as a whole).[60]

Of course, suburban housing starts were depressed during the slump of the 1930s. But ironically this period of mass unemployment set the stage for a full embrace of the ideal of the suburban weekend after the Second World War. The

Depression deepened the privatization of the family despite the apparent growth of unions and social solidarities. In the 1930s, the British social scientists Ruth Durant and Kate Liepmann noted how suburban 'dormitories' broke up work groups. Informal neighbourhood societies failed to replace the sense of community that formerly may have been built around work. Community centres, for example, became homes of transient, often relatively privileged, and cliquish members.[61] Probably we should not be surprised by this, given the familial objectives of suburbanization. But the Depression's denial of the community of work surely reinforced trends toward the privatization of families wherever they lived. E. Wight Bakke's studies of British and American working-class neighbourhoods found a similar retreat to the home and family especially among the unemployed.[62] The inability of churches, fraternal orders, or even neighbourhood credit and retail businesses, to provide for the people's needs explain much. This breakdown forced people to turn both inward on the family as well as outward to the state. This privatization of life was carried with working-class families when some of them migrated to the suburbs after the war.[63]

The Depression reinforced the ideal of the alternative times of the working week and weekend, especially for men. While social scientists theorized that unemployment would lead workers to despondency and destroy work habits, joblessness tended rather to reconfirm loyalties to *routines* of public work time and private play time. The unemployed 'has seen the clock go around but he has nothing to show for the hours that have passed', observed the American Eli Ginzberg.[64] Hobbies grew in popularity in the Depression as a 'job you can't lose' filling time with work-like activity.[65] Jobless Britons made a tenacious effort to maintain a leisure schedule structured around the now absent working week. They continued to attend the cinema on the Saturday night exactly as when they were in jobs – even though the Wednesday matinée was cheaper. They also 'worked' at finding employment during 'normal' working hours (or stayed home to avoid being discovered with 'nothing to do'). Contrary to middle-class prejudice, few of the jobless actually 'loafed' or drank in pubs during the weekdays.[66] The absence of a distinction between the working week and the weekend only reinforced the desire for such a segmentation.

The Depression experience also reconfirmed the notion of personal fulfilment through domestic consumption – best expressed in the suburban setting. The trauma of austerity centred on frustrating efforts to maintain consumption routines that fitted customary temporal rhythms. An example was the attempt to carry on the annual habit of summer holidays. Some American families tried to maintain consumption routines through deficit spending.[67] Instalment buying,

which had become habitual in the 1920s, continued in the Depression decade. And, of course, families dreamed of new homes.[68]

Disruptions to the sexual division of labour included well-publicized, but exaggerated, observations of jobless husbands at home while wives worked.[69] These traumas theoretically made possible a domestic power shift. But the Depression tended to reinforce the identity of men as providers and women as keepers of a private domestic order. And this gender order was built around the polarities of the working week and weekend. Reduced income undermined the male's 'provider' role but did not lead to more symmetrical gender identities.[70] Even when married women held jobs while their husbands did not, female domestic power was not often enhanced nor were roles changed. Men seldom assumed domestic work roles or did so reluctantly. As the American historian Winifred Wandersee observes, wage-earning wives 'faced the double task of maintaining [the home] both economically and emotionally. . . . It is thus no wonder that few women exulted in this enforced leadership; it was undertaken at great cost to themselves and their families.' This strain was even more apparent for many women during the Second World War when the conflict between job and domestic obligations was often unbearable.[71] In the light of these experiences, married women and their daughters in the 1950s commonly chose the 'feminine mystique' of consumer domesticity and men embraced the ideology of providing.[72] This gendered system created the ideal 'balance' of wage work and consumption time that emerged after the Second World War around the forty-hour working week and the suburban weekend.

After 1945, returning veterans expected new affordable homes. 'By the time World War II ended,' notes Margaret Marsh, 'it seemed as if the suburb and the single-earner, nuclear family had always been two parts of a single idea.'[73] Memorable postwar American films, *Miracle on 34th Street*, *Mr Blandings Builds his Dream Home*, and even *It's a Wonderful Life* provided a visual image of the popular dream of a suburban home. American government mortgage insurance programs (Federal Housing Administration and Veterans Administration) went far beyond the guarantees of the 1930s. Highway construction, especially the interstates from 1956, encouraged peripheral construction of detached houses. Because of lines of credit, large builders like Levitt and Sons accounted for two-thirds of housing construction by 1949. Suburban housing increased by almost 20 per cent between 1950 and 1956 alone. Public housing promised in the 1949 Housing Act was largely reneged under Eisenhower; cost-saving measures on land and materials produced the anti-suburb, the inner city 'projects'. Nearly sixteen million American veterans resettled after the war, most sharing a common vision of a

good life away from the cramped quarters of parents' apartments or urban houses, and as far from the barracks as possible. Despite the fact that many, especially minorities, were left out, wage-earners were incorporated into the suburban culture of the prewar middle classes.[74] Suburbanized privacy reinforced the American consensus around the 'family wage' of male providers and the priority of personally disposable income.[75]

American policy favouring suburbanization ran far in advance of Britain. Still, when postwar planners hoped for a more open community built around new non-exclusive public housing, Britons largely rejected the tower blocks; instead, they longed for the suburban comforts of the semi-detached houses. Half of a 1943 survey wanted suburban housing (and 40 per cent preferred country homes) as compared to only 6 per cent who favoured the town in this most urban of countries. Interviews with young British women just after the war found the same commitment to suburban domesticity that had attracted young American wives. They sought practical marriages with good provider husbands, hoping to avoid the humiliation of the Depression years when the often jobless status of their fathers had sometimes forced their mothers to engage in unwanted jobs.[76] Despite the hard times of postwar Britain, the Trades Union Congress won the 44-hour week extending the weekend at least to Saturday afternoon for most workers in 1946. The full two-day weekend was finally gained in the 1960s. (It came officially in 1938 in the United States although Saturday overtime was common, especially during the war.)

The British suburban weekend, however, extended substantially beyond the middle classes only in the 1960s. While real wages rose 40 per cent between 1950 and 1965, only after about 1960 did this growth translate into new forms of working-class suburbanism. The share of family income devoted to housing costs rose from 13.9 per cent in 1953 to 18.9 per cent in 1968. Home ownership increased from 42 per cent in 1960 to 55 per cent by 1980. In the 1960s, sociologists noted the shift from older peer-group expenditures on drink, gambling, tobacco and sport to spending on homes (in mortgages, cars, and DIY expenses).[77] The numbers engaged in do-it-yourself activities, a clear sign of weekend domesticity, increased sharply between 1959 and 1981 in Britain (rising from 55 to 81 per cent of men and from 48 to 60 per cent of women).[78]

Numerous studies confirm this trend toward family-and-home-based weekends (even though few identify a specific 'suburban' weekend). Couples and children minimized their social obligations outside the family. In a mid-1960s American study, jobbed men had only 1.2 hours of leisure on weekdays compared to almost three hours at weekends. The figures for housewives were not much different at

2.3 and 3.5.[79] In Young and Willmott's English study of working men with families, 82 per cent of time on Saturdays and 87 per cent on Sundays was spent at home.[80] In an early 1970s study, British workers showed a trend toward preference for continuous time: in an electronics factory only 4 per cent wanted 45 minutes more leisure per day as compared to 28 per cent desiring an extra half-day at the weekend and 68 per cent five extra weeks of holiday.[81] Those social pressures that encouraged suburban consumerism in the interwar years reappeared after 1945. Pent-up demand for consumer goods was released after the Second World War. Suburban homes were filled with what American Thomas Hine has termed 'populuxe' possessions – flying-saucer lamps and purple cars with chromed tail fins.[82]

Despite cookie-cutter construction for the homogenous mass market, wage-earning suburbanites often redesigned their houses to reflect their personality and lifestyles. They created 'a combination of picturesque variety and community harmony that was the hallmark of the nineteenth-century model suburb'. Thus, as Barbara Kelly notes, Levittown, New York did not become a suburban slum, as many had predicted. It became 'an acceptable address for middle-class residents', even though the social composition remained working class. Owners converted unfinished attics in 'Cape Cod' Levittown houses into bedrooms. They remodelled to eliminate what they saw as wasted floor space and finished basements into 'rec rooms' as children demanded play areas. They made weekend space.[83]

A 1981 Australian study confirms the desire for segmentation of space and time. Proximity of the suburban home to friends, relatives, and jobs was relatively unimportant (significant to only 47, 27, and 21 per cent of home-owners respectively) as compared to the pride of ownership (94 per cent) and the setting (neighbourhood and privacy) and layout (both in the 80 per cent range). These contemporary suburbanites defined themselves as being 'in the same boat' as others in the neighbourhood – even if life chances were often very different. This sameness was in sharing a common commitment to active weekends of homemaking. Men may have seen their suburban weekends as havens from work and women, alternatively, as 'homes' of family togetherness, but both have shared a common culture of domestic consumption.[84]

DECLINE OF THE SUBURBAN WEEKEND

The postwar ideal of the 'affluent working class' has suffered since the 1970s. And no more so than in the dream of the suburban weekend. The material base for this democratic ideal has eroded; but so has the gendered order upon which it was built. As important, the consumer culture, through which suburban families formed their identities, has increasingly colonized the space and time of the suburban weekend. Here I can offer only an outline of these changes.

Obviously a major factor is the shrinking of expectations as 'Fordist' economies, based on relatively secure, high-wage industrial jobs, have declined.[85] Home ownership is more costly and new suburban construction has shifted to the upscale market. Despite repeated demands in the 1980s for reduced working hours, often as longer weekends, the decline of the political and economic power of wage-earners doomed these efforts. American evidence suggests an actual increase in working hours caused by a complex blend of stagnant real wages and declining labour organization and union political influence.[86] From the 1960s, 'productivity agreements' in British industry have obliged increasing numbers to work non-social hours and days: shift work doubled to 25 per cent between 1950 and 1968 and many were forced to be 'on call' at all hours, undermining family life. This was only the beginning of a trend that has continued to the present.[87] Thus the suburban home and the free time upon which it was based are increasingly an elusive ideal for young working people.

Another and related sign of this change is the entry of married women into the labour market. The figures are well known: the participation of married American women in the workforce increased from 25 per cent in 1950 to 41 per cent in 1970 to 57 per cent by 1988 (even though 66 per cent of part-time jobs were held by women by the end of the 1980s). The rise was even more dramatic in Britain (from 25 per cent of married women in work in 1950 to 61 per cent in 1981, 44 per cent of which where part-time).[88] The dual income household inevitably changed the meaning of the weekend. For example, domestic work, upon which weekend leisure depends, has been increasingly shifted to Saturday and even Sunday. Despite much change in the content of housework, women still do about 70 per cent of it. In one recent American study, the longest combined wage/domestic working weeks occurred among women whose husbands' working weeks were the shortest. The greater the husband's presence at home, apparently, the more house (and wage) work for women.[89] The pressures of wage and caring work places special stress on women

whose 'free' time husbands and children assume to be 'available' for family needs.[90]

The dual income household has probably also meant less weekend time for families to be together. Moonlighting increased 20 per cent in the 1980s in the United States. By the mid-1980s, a quarter of American employees worked Saturday, and an eighth on Sunday. By 1985, one-third of American households had couples working different shifts.[91] The gendered wall separating public and private time and space has been partially breached; but the price is the decline of shared free moments in carefree settings – the suburban weekend.

These interrelated erosions of affluence and gender roles are only part of the change. Another trend is the suburbanization of consumption. The automobile-dependent strip shopping centres and enclosed malls have brought consumerism to the periphery. These commercial sites increasingly line thoroughfares and freeways that once served as mere conduits to the city and have replaced the central business district.[92] Increased hours of shopping are as important. This trend is a major historical reversal of the prohibitions of Sunday shopping that characterized late Victorian social reform. Competitive pressures made petty Victorian storekeepers reluctant to close their doors on Sundays and in the evening – even though most gave in by the First World War. But these pressures have returned with a vengeance. Chain discount stores and fast-food outlets, who rely on part-time employees, find few impediments among their underorganised workforces to weekend work. In the 1980s, Saturday morning banking hours became common in Britain. And, despite parliamentary rejection of Sunday retail shopping in the 1980s, this bastion of British Sabbatarianism has finally begun to fall.[93] The self-employed storekeeper with a personal interest in his or her own family life is increasingly rare and thus less a force for limiting shop hours. The impact of this trend, of course, is the shift toward weekend work of one or several members of the suburban family. Inevitably it particularly affects women who often have found a compromise between the demands of family and income in part-time, often weekend jobs.[94]

Profit-maximizing mega-corporations, of course, drive the colonization of time and space by the market. But the massive shift of retailing to the suburbs and the advent of a full-week economy reflect also consumer demand. As I have stressed, this is by no means new. With modern affluence, consumption has inevitably 'colonized' time, especially at the weekend. As the Swedish economist Staffan Linder notes, with rising real wages the 'cost' of free time rose, obliging 'rational' workers to opt for overtime and moonlighting to optimize their gains; economic maximizing means also intensification of the 'consumption' of leisure

time. People choose time-saving consumer goods like television sets and cars to aid in their leisure. This means that people work more than otherwise necessary to maximize the 'return' on their leisure. Goods and their maintenance saturate free time. These trends have produced a 'harried' working and leisure class of consumers.[95] The problem is nicely captured in a study of an American suburb, 'Crestwood Heights'. There, 'time seems almost the paramount dimensions of existence'. The most basic rule is 'that there shall be no lost weekends!'[96]

The space and goods of the home that have given expression to relationships and personality so characteristic of the suburban weekend have easily degenerated into a 'terminal materialism' – no longer a means of satisfaction but an end itself.[97] This trend was surely more advanced in the United States. By the 1970s, not only did Americans spend as much as four times as many hours shopping as did Europeans, but Americans devoted far more space to shopping malls and other retail commercial activity. The distinction between leisure and consumption for many Americans had disappeared as time and money had become one.[98] But Europeans are quickly following the same path. The Australian sociologist Lyn Richards points out the irony of the suburban domestic dream. Nobody is home to enjoy the home because it takes two incomes to make it possible. The result, as one suburbanite noted: 'Everybody is working. Weekends go out.'[99]

NOTES

1 Anthony King links industrial affluence with the segmentation of time and space in connection with the vacation home. See his 'A Time for Space and a Space for Time: The Social Production of the Vacation House', in Anthony King, ed., *Buildings and Society: Essays on the Social Development of the Built Environment* (London, 1980), pp. 193–227.

2 Examples are numerous, including F. M. L. Thompson, *The Rise of Suburbia* (Leicester, 1982), chap. 1; Henry Binford, *The First Suburbs: Residential Communities on the Boston Periphery 1815–1860* (Chicago, 1985), chap. 3, pp. 142, 169–86. More popular studies share this view: David Fishman, *Bourgeois Utopias* (New York, 1987) and Kenneth Jackson, *Crabgrass Frontier* (New York, 1985) .

3 John Stilgoe, *Borderland: Origins of the American Suburb, 1820–1939* (New Haven, CT, 1988) and Peter Rowe, *Making a Middle Landscape* (Cambridge, MA, 1991), for example.

4 H. C. Bunner, *The Suburban Saga* (New York, 1896); Eric Hodgins, *Mr Blandings Builds His Dream House* (New York, 1946); H. G. Wells, *Ann Veronica* (London, 1909); and Penelope Mortimer, *Daddy's Gone A-Hunting* (London, 1958). Note, of course, Lewis Mumford, *Sticks and Stones: A Study in American Architecture and Culture* (New York, 1924), especially pp. 186–7.

5 Jonas Frykman and Orvar Loefgren, *Culture Builders: An Historical Anthropology of Middle Class Culture* (Brunswick, NJ, 1990), pp. 127 and 140. See also Colleen McDannell, *The Christian Home in Victorian America* (Bloomington, IN, 1986); Gwendolyn Wright, *Moralism and the Model Home: Domestic Architecture and Cultural Conflict in Chicago, 1873–1913* (Chicago, 1980); Simon Bronner, *Grasping Things: Folk Material Culture and Mass Society in America* (Lexington, KT, 1986), chap. 2; and Jessica Foy and Thomas Schlereth, eds, *American Home*

Life, 1880–1930 (Knoxville, KT, 1992). See also Margaret Marsh, *Suburban Lives* (New Brunswick, NJ, 1990), chap. 1 and pp. 41 and 83 and Stuart Blumin, *The Emergence of the Middle Class: Social Experience in the American City, 1760–1900* (Cambridge, 1989), chap. 5.

 6 Patricia Tice, 'Gardens of Change', in Foy and Schlereth, *American Home Life*, pp. 190–208.

 7 Stuart Chapin, *Contemporary American Institutions* (New York, 1935), pp. 373–97; George Lundberg, Mirra Komarovsky, and Mary McInerny, *Leisure: A Suburban Study* (New York, 1934), p. 155; Robert and Helen Lynd, *Middletown* (New York, 1929) and *Middletown in Transition* (New York, 1937); and Dennis Chapman, *The Family, the Home and Social Status* (London, 1955), pp. 24–42, 50–1, 102, and 170–3.

 8 See, for example, L. Duncan, 'Home Ownership and Social Theory', in L. Duncan, ed., *Housing and Identity* (London, 1981), pp. 98–134; Dolores Hayden, *Redesigning the American Dream: The Future of Housing, Work, and Family Life* (New York, 1984), pp. 32–4; and Fishman, *Bourgeois Utopias*, chap. 6. American homeowners increased from 45.9 per cent to 47.8 per cent in the 1920s. US Bureau of the Census, *Historical Statistics of the United States* (Washington, 1960), p. 395.

 9 Mass-Observation Archive, File Report 2084, 'Report on Hire-Purchase in Chester, 16 May 1944' and, Alan Jackson, *Semi-Detached London* (London, 1973), pp. 168–9.

 10 Michael Young and Peter Willmott, *Family and Kinship in East London* (London, 1957), pp. 107–8, 142–6, and 154–64.

 11 Note, for example, the British R. Gamble, *Chelsea Child* (London, 1979), p. 20; Phyllis Willmott, *Growing Up in a London Village: Family Life between the Wars* (London, 1974), pp. 1–28 and 133; and Grace Foakes, *Between High Walls: A London Childhood* (London, 1972) as well as the American R. and H. Lynd, *Middletown*, pp. 250–7. That tradition survives in much of the history of the suburb. Note especially, Jackson, *Crabgrass Frontier*, p. 281.

 12 Paul Oliver, Ian Davis and Ian Bentley, eds, *Dunroamin: The Suburban Semi and its Enemies* (London, 1981), pp. 46–7 and 21–2.

 13 Osbert Lancaster, *Here, Of All Places* (London, 1959), p. 152 and George Orwell, *Coming Up for Air* (New York, 1950), p. 12.

 14 Among this industry of suburban smashing, the most important were Richard Gordon, Katherine Gordon, and Max Gunther, *The Split-Level Trap* (New York, 1964), chaps 2 and 3 especially; Peter Wyden, *Suburbia's Coddled Kids* (New York, 1962); John Keats, *The Crack in the Picture Window* (Boston, 1956); and William Whyte, *The Organization Man* (New York, 1956), chap. 25. More popular versions include C. B. Palmer, *Slightly Cooler in the Suburbs* (Garden City, NY, 1950), chap. 11 especially. Later feminist commentary follows along somewhat similar lines as in Betty Friedan, *The Feminine Mystique* (New York, 1963) and Barbara Ehrenreich, *The Hearts of Men* (New York, 1983).

 15 David Riesman, *Abundance for What? and Other Essays* (Garden City, NY, 1964), pp. 244, 246, and 247.

 16 Among the critical discussions of this anti-suburban literature are Bennett Berger, *Working-Class Suburb* (Berkeley, 1968), chap. 1; Scott Donaldson, *The Suburban Myth* (New York, 1969); William Dobriner, *Class in Suburbia* (Englewood Cliffs, NJ, 1963); and Herbert Gans, *The Levittowners* (New York, 1967).

 17 Berger, *Working-Class Suburb*, chap. 2 and p. 73.

 18 Harold Wattel, 'Levittown: A Suburban Community', in William Dobriner, ed., *The Suburban Community* (New York, 1958), pp. 287–313.

 19 Peter Willmott and Michael Young, *Family and Class in a London Suburb* (London, 1960), pp. 21, 91, and 109.

 20 Lundberg et al., *Leisure*, pp. 20–3. Similar, if more abstract and critical is C. E. M. Joad, *Diogenes: or, The Future of Leisure* (London, 1935).

 21 Norbert Elias, *Time, An Essay* (Oxford, 1992), pp. 95 and 146–7.

 22 Note the discussion of the social functions of the calendar in Emile Durkheim, *The Elementary Forms of the Religious Life* (New York, 1965), pp. 245–51. See also Eviatar Zerubavel, *The Seven Day Circle: The History and Meaning of the Week* (New York, 1985), chaps 5 and 6 especially.

 23 Don Parkes and Nigel Thrift, 'Putting Time in its Place', in Tommy Carlstein, Don Parkes, and Nigel Thrift, eds, *Making Sense of Time* (New York, 1978), pp. 119–29.

 24 'The morning train is generally a psychological stimulus of some sort, the evening train a sedative.' Harlan Paul Douglass, *The Suburban Trend* (New York, 1925), p. 190.

 25 Murray Melbin, 'The Colonization of Time', in Tommy Carlstein, Don Parkes, and Nigel Thrift, eds,

Human Activity and Time Geography (New York, 1978), pp. 100–13.

26 See, for example, Robert Sommer, *Personal Space: The Behavioral Basis of Design* (Englewood Cliffs, NJ, 1969), chaps 3 and 4; and I. Altman and M. M. Chomers, *Culture and Environment* (Monterey, CA, 1980), chaps 4–6.

27 Olivier Zunz, *The Changing Face of Inequality: Urbanization, Industrial Development and Immigrants in Detroit, 1880–1920* (Chicago, 1982), pp. 152–3.

28 A French poster agitating for eight-hour day legislation in April 1919 shows a struggle between the bourgeoisie and workers with ropes lashed to the minute hand being pulled away and toward eight o'clock. See the cover to *Voix du peuple* (1 May 1919). See also Gary Cross, ed., *Worktowners at Blackpool: Mass-Observation and Popular Leisure in the 1930s* (London, 1990), p. 21.

29 G. Stedman Jones, *Languages of Class: Studies in English Working Class History* (Cambridge, 1983), pp. 205–8 and 218–19. See also Standish Meacham, *A Life Apart* (Cambridge, Mass., 1977), chaps 4 and 5 and Gary Cross, *A Quest for Time: The Reduction of Work in Britain and France, 1840–1940* (Berkeley, CA, 1989), pp. 64–9.

30 Cross, *Quest for Time*, chap. 8.

31 Sources are in Cross, *Quest for Time*, chap. 4.

32 Mass-Observation, *Meet Yourself on Sunday* (London, 1949), pp. 10–11, 13, 30–1, and 14–15 and Mass-Observation Archive, File Report 2467, April 1947.

33 Full discussion is in Cross, *Quest*, chap. 4. Note also Albert Larking, *History of the Early Closing Association to 1864* (London, 1914), pp. 1–16; John Litwall, *The Half-Holiday Question* (London, 1856), pp. 1–24; and John R. Taylor, *Government, Legal and General Saturday Half Holiday* (London, 1857).

34 John Dennis, *The Pioneer of Progress or the Early Closing Movement in Relation to the Saturday Half-Holiday and the Early Payment of Wages* (London, 1860), p. 47.

35 This theme is discussed in Gary Cross, *Time and Money: The Making of Consumer Culture* (London, 1993), chap. 7.

36 Richard Sennett and Jonathan Cobb, *The Hidden Injuries of Class* (New York, 1972).

37 Steven Gelber, 'Homo Faber: Tools, Gender and Do-It-Yourself', unpublished paper provided by the author.

38 Oliver et al., *Dunroamin*, chaps 6 and 8.

39 *Popular Mechanics* was founded in 1902 as a digest of science and engineering. Soon it became also a manual of the do-it-yourselfer. Note, for example, *Popular Mechanics* (1912), pp. 93, 122, and 281 and (1923), pp. 139, 229, 278, 651, and 789.

40 Note, for example, Carl Werner, *Bringing up Boys* (New York, 1913) and Margaret Sangster, *The Art of Being Agreeable* (New York, 1897).

41 Marsh, *Suburban Lives*, chaps 2 and 3.

42 Willmott and Young, *London Suburb*, pp. 22–7.

43 Examples of this literature are Virginia Robie, *The Quest for the Quaint* (Boston, 1917); Alice Van Leer Carrick, *The Next-to-Nothing House* (Boston, 1922); and the Stanley Rule and Level Plant publication, *How to Work with Tools and Wood: For the Home Workshop* (New Britain, CT, 1927). See also Stilgoe, *Borderlands*, pp. 260–8.

44 Note for example, E. Gamarnikov, David Morgan, June Purvis and Daphne Taylorson, eds, *The Public and the Private* (London, 1983) and M. Rosaldo, 'Woman, Culture and Society', in M. Rosaldo and L. Lamphere, eds, *Women, Culture and Society* (Stanford, 1974), chap. 1.

45 Hayden, *American Dream*, p. 34. See also Glenna Matthews, *'Just a Housewife': The Rise and Fall of Domesticity in America* (Oxford, 1987), chap. 7.

46 Karen Davies, *Women, Time and the Weaving of the Strands of Everyday Life* (Aldershot, 1990), pp. 33–8 and 46.

47 Douglass, *Suburban Trend*, p. 174.

48 Department of Employment, *Historical Abstract of Statistics (1921–61)* (London, 1962), p. xxx.

49 Only 10.7 per cent of married American women reported outside employment in the 1930 census (rising to 15.6 per cent in 1940). US Bureau of the Census, *The Statistical History of the United States* (New York, 1976), p. 133.

50 Eviatar Zerubavel, 'Private-Time and Public-Time', in John Hassard, ed., *The Sociology of Time* (London, 1990), pp. 168–87.

51 Jo Anne Vanek, 'Time Spent in Housework', *Scientific American* (November 1974), pp. 116–20 and Hayden, *American Dream*, p. 81.

52 In a 1965/6 American study, John Robinson finds women spend 272 minutes with housework on Saturdays (25 minutes more than an average day); but only 241 minutes on Sunday (31 minutes less). Men did 85 minutes of housework on Saturdays and 77 minutes on Sundays (only 53 minutes on an average day). Suburban 'free time' differed little from non-suburban. John Robinson, *How Americans Use Time* (New York, 1977), pp. 66–7. See also Kathryn E. Walker and Margaret Woods, *Time Use: A Measure of Household Production of Family Goods and Services* (Washington, 1976), p. 46.

53 Mihaly Csikszentmihalyi and Eugene Rochberg-Halton, *The Meaning of Things: Domestic Symbols of the Self* (New York, 1981), pp. 130–1, 143–4.

54 Douglass, *The Suburban Trend*, p. 84.

55 Willmott, *London Village*, pp. 26–7. See also Eugene Rochberg-Halton, *Meaning and Modernity: Social Theory in Pragmatic Attitude* (Chicago, 1986), pp. 155–88.

56 The relationship between time, especially on the linkage between the working week and the weekend, and television watching as a shaper of leisure, is explored in H. Sahin and J. P. Robinson, 'Beyond the Realm of Necessity: Television and the Colonisation of Time', *Media, Culture, and Society*, 3, 1 (1981), pp. 85–95.

57 John Barnett, *A Social History of Housing* (London, 1978), pp. 215–21, 233–7, and 249; Karl Silex, *John Bull at Home*, (London, 1931), pp. 39–45; and C. Hall, *Married Women at Home* (London, 1977), pp. 62–81.

58 See Jackson, *Semi-Detached London*, chaps 9 and 11; Arthur Edwards, *The Design of Suburbia* (London, 1981), chap. 3; Gordon Cherry, *Leisure and the Home* (London, 1982), pp. 22–7; Ivor Brown, *The Heart of England* (London, 1935), p. 100; Hall, *Women at Home*, pp. 78–81; and Helen Barrett and John Phillips, *Suburban Style: The British Home, 1840–1960* (London, 1987), chaps 4 and 5.

59 Sources include: Fishman, *Bourgeois Utopias*, chap. 6; Anthony King, *The Bungalow* (London, 1984), chaps 2–4; Clifford Clark, *The American Family Home, 1800–1960* (Chapel Hill, 1986), chaps 6–7; and Cliff May, *Western Ranch Houses* (Menlo Park, CA, 1958). Mark Foster, *From Streetcar to Superhighway* (Philadelphia, 1981), pp. 45–8. Marsh, *Suburban Lives*, pp. 30, 85, and 141 contain very revealing tables detailing changes in space use in American houses build between the 1860s and 1920s. See also her chap. 5.

60 Gertrude Fish, ed., *The Story of Housing* (New York, 1979), pp. 136 and 183–241; *The President's Conference on Home Building and Home Ownership* (Washington, 1932); Hayden, *American Dream*, pp. 32–4; Kenneth Jackson, *Crabgrass Frontier* (New York, 1985), pp. 172–87 and 204–18; Foster, *Streetcar to Superhighway*, pp. 65–70; and Marsh, *Suburban Lives*, pp. 146–55.

61 Kate Liepmann, *The Journey to Work* (London, 1944), pp. 74–5, 169. Ruth Durant, *Watling: A Social Survey* (London, 1939), pp. 88–90 and chap. 4. See also Dianna Gittins, *Fair Sex. Family Size and Structure, 1900–1939* (London, 1982), pp. 138–40.

62 Note the following by E. Wight Bakke: *Unemployed Man* (London, 1933), pp. 153–4; *Citizens without Work: A Study of the Effects of Unemployment upon the Workers' Social Relations and Practices* (New Haven, CT, 1940), pp. 5–7; and *The Unemployed Worker* (New Haven, CT, 1940).

63 Lizabeth Cohen, *Making a New Deal: Industrial Workers in Chicago, 1919–1939* (New York, 1990), pp. 218–38.

64 Eli Ginzberg, *The Unemployed* (New York, 1943), p. 75. See also Marie Jahoda, 'Time: A Social Psychological Perspective', in Michael Young and Tom Schuller, eds, *Rhythms of Society* (New York, 1988), p. 157; and John Hayes and Peter Nutman, *Understanding the Unemployed: The Psychological Effects of Unemployment* (London, 1981).

65 Steven Gelber, 'A Job You Can't Lose: Work and Hobbies in the Great Depression', *Journal of Social History* 24, 4 (1990), pp. 741–66.

66 Bakke, *Unemployed Man*, pp. 183–8.

67 Cross, *Blackpool*, chaps 3 and 4.

68 Roland Vaile, *Research Memorandum on the Social Aspects of Consumption during the Depression* (New York, 1937), pp. 19, 28; Robert Lynd, 'People as Consumers', in The President's Research Committee on Recent Social Trends, *Recent Social Trends in the United States*, vol. 2 (New York, 1933), pp. 862–3, 892, and 896.

69 This theme can be easily overstated: the percentage of married women in the American workforce rose only from 11.7 per cent in 1930 to 15.6 per cent in 1940 and never more than 12 per cent of British married women held paid jobs in the 1930s. Of course, these figures doubtless ignore much work done in the 'informal'

economy. US Bureau of the Census, *Historical Statistics of the United States*, Part 1, p. 133 and UK Department of Employment, *Historical Abstract of Statistics (1921–61)* (London, 1962), p. xxx. See also, for Britain, Jane Lewis, ed., *Labour and Love: Women's Experience in Home and Family* (London, 1986) and Deidre Beddoe, *Back to Home and Duty: Women between the Wars, 1918–1939* (London, 1989). For the United States the standard work is Ruth S. Cowan, *More Work for Mother: The Ironies of Household Technology* (New York, 1983).

70 Bakke, *Unemployed Man*, pp. 69–70 and Mirra Komarovsky, *The Unemployed Man and His Family* (New York, 1940), p. 77.

71 Komarovsky, *Unemployed Man*, p. 42 and Wandersee, *Women's Work*, chaps 3–6, quotation on pp. 112–13. On British women's wartime experience, see Gail Braybon and Penny Summerfield, *Out of the Cage: Women's Experience in Two World Wars* (London, 1988), chaps 4, 5, and 14.

72 Winifred Wandersee, *Women's Work and Family Values, 1920–1940* (Cambridge, MA, 1981), pp. 115–16 and Glen Elder, *Children of Depression: Social Change in Life Experience* (Chicago, 1974), pp. 279–82 and 290–1.

73 Marsh, *Suburban Lives*, p. xv. Note also John Richards, *Castles on the Ground* (London, 1946), p. 35 and Brown, *Heart of England*, pp. 69–70.

74 Donald Rothbatt and Daniel Carr, 'Suburbia: An International Perspective', in Barbara Kelly, ed., *Suburbia Re-examined* (Westport, CT, 1989), pp. 23–4.

75 Elaine May, *Homeward Bound* (New York, 1989). See also Clifford Clark, 'Ranch-House Suburbia: Ideals and Realities', in Lary May, ed., *Recasting America: Culture and Politics in the Age of Cold War* (Chicago, 1989), pp. 171–91.

76 UK Department of Employment and Productivity, *British Labour Statistics, Historical Abstract* (London, 1971), pp. 407, 382–3, and 394 and Pearl Jephcott, *Rising Twenty: Notes on Some Ordinary Girls* (London, 1948), pp. 42–6 and 65–7.

77 Gordon Cherry, *Leisure and the Home* (London, 1982), pp. 48–50. See also UK, Office of Population Census and Surveys, *General Household Survey* (London, 1977). A fine summary is in James Cronin, *Labour and Society in Britain, 1918–1979* (London, 1979), chaps 8 and 9.

78 Henley Centre for Forecasting, *Leisure Futures* (London, 1982), pp. 30–1.

79 Robinson, *How Americans Use Time*, p. 107.

80 Michael Young and Peter Willmott, *The Symmetrical Family: A Study of Work and Leisure in the London Region* (Harmondsworth, 1973), pp. 95, 99.

81 Young and Willmott, *Symmetrical Family*, p. 142. Similar findings were found in the Chicago region by Philip Ennis, 'Leisure in the Suburbs', in Dobriner, *Suburban Community*, pp. 248–70. Later studies were similar: Fred Best, *Flexible Life Scheduling* (New York, 1980), pp. 133–5 and Roland Cuvillier, *The Reduction of Working Time: Scope and Implications in Industrial Market Economies* (Geneva, 1984), pp. 52–3.

82 Thomas Hine, *Populuxe* (New York, 1986), pp. 4 and 15–58.

83 Barbara Kelly, *Expanding the American Dream: Building and Rebuilding Levittown* (Albany, NY, 1993), p. 17 and chap. 5.

84 Lyn Richards, *Nobody's Home: Dreams and Realities in a New Suburb* (Melbourne, 1990), pp. 13–14, 66, 126, and 145.

85 David Harvey, *The Condition of Postmodernity* (Oxford, 1989), for example.

86 Juliet Schor, *The Overworked American: The Unexpected Decline of Leisure in America* (New York, 1991), chap. 2 calculates that Americans worked an extra 163 hours or one month in 1989 as compared to 1969. Schor estimates that women have borne the major brunt of this increase in paid work (305 extra hours) as compared to the ninety-eight hours of men even though when housework is included the increased burden is almost equal.

87 William Roche, 'The Chimera of Changing Employee Time Preferences: Working Hours in British Industrial Relations since World War II', in K. Hinrichs, W. Roche, and C. Sirianni, *Working Time in Transition* (Philadelphia, 1991), pp. 108–12.

88 Susan Chistopherson, 'Trading Time for Consumption: The Failure of Working-Hours Reduction in the United States', in Hinrichs, Roche, and Sirianni, *Working Time*, pp. 171–87; Paul Flaim, 'Work Schedules of Americans', *Monthly Labor Review* 109 (November 1986), p. 3; Jane Lewis, *Women in Britain since 1945* (Oxford, 1992), pp. 74–5; and Theodore Caplow et al., *Recent Social Trends in the United States, 1960–1990* (Montreal, 1991), pp. 127, 133.

89 This literature is discussed in Cynthia Negrey, *Gender, Time and Reduced Work* (Albany, NY, 1993), chap. 2. Note also Arlie Hochschild, *The Second Shift: Working Parents and the Revolution at Home* (New York, 1989).

90 Richards, *Nobody Home*, chap. 7 and Davies, *Time, Women*, chap. 8.

91 Helen Presser, 'Employment Schedules among Dual-Earning Spouses', *American Sociological Review* 59 (June 1994), pp. 348–64.

92 An insightful, if impressionistic analysis, is William Kowinski, *The Malling of America* (New York, 1985).

93 Roche, 'Time Preferences', pp. 113–15.

94 For example, N. Paulson, 'Change in Family Income Position: The Effect of Wife's Labor Force Participation', *Sociological Focus* 15, 2 (1982), pp. 77–91.

95 Staffan Linder, *The Harried Leisure Class* (New York, 1970).

96 R. Seeley, R. A. Sim, and E. W. Loosley, *Crestwood Heights* (New York, 1963), p. 77.

97 Csikszentmihalyi and Rochberg-Halton, *Meaning of Things*, p. 230.

98 Schor, *Overworked American*, p. 107 and chap. 5. See also John Robinson, Philip Converse, and Alexander Szalai, 'Everyday Life in Twelve Countries', in A. Szalai, ed., *The Use of Time: Daily Activities of Urban and Suburban Populations in Twelve Countries* (The Hague, 1972), p. 114.

99 Richards, *Nobody Home*, p. 164.

TUPPERWARE

Suburbia, sociality and mass consumption

Alison J. Clarke

INTRODUCTION

Suburbanisation broke up old urban, ethnic neighbourhoods . . . middle-class images on television became ubiquitous, the social reality of all women was increasingly dictated by the consumer culture . . . it created an illusion of change and freedom while encouraging passivity and 'private' solutions.[1]

The depoliticization and growing domestication of women in postwar American culture is a familiar historical tenet. Accounts of this period frequently conflate suburbia, mass consumption and feminine identity as symptoms of increasing embourgeoisment and alienation.

In this context, the historical representations of women's roles during the 1950s, as availing 'sex object, wife, mother and housekeeper', are as stereotyped and two-dimensional as the contemporary advertising imagery. Popular historical narrative constructs women as hapless victims lost in a confusing wilderness of products 'available in a lurid rainbow of colors and a steadily changing array of styles'.[2] The upward economic mobility of suburbia, we are told, with its abundant supply of desirable household appliances, supplanted the authentic social relations of the extended family. With the rise of corporate power and manipulative advertising, the sanctity of the 'private sphere' diminished as commerce followed 'women into their own kitchens and laundries'.[3] This insidious state of alienation (delineated in Friedan's *The Feminine Mystique*) was the direct result, historians have argued, 'of post-war suburban migration . . . and the demise of any feminist or socialist sentiment'.[4]

Academic consensus frames this era as a 'low point', a shameful regression in

women's history.[5] Whilst domestic subordination is commonly aligned with the ideology of the moral home defined by Cold War politics, Friedan's account of 'The Problem With No Name' popularized the notion of women in the postwar period as 'domestic and quiescent'.[6] Although recent work convincingly challenges Friedan's interpretations of postwar feminine culture, most revisionist accounts look to the radicalism of politicized and working women to counterpoise the pervasive suburban stereotype.[7] These histories self-avowedly avoid 'women on the right . . . consumerism and glamour' and so the image of the suburban housewife as a de-skilled and trivialized victim of modernity and, more significantly, consumerism prevails.[8] The typical historical narrative of this period suggests that individual desire and self-determination of women diminished as the culture of consumption offered the passive role of spending freely.

Tupperware, a product which developed contemporaneously with postwar suburbia, wholeheartedly embraced domesticity and conspicuous consumption. Its fashionable pastel designs and amiable hostesses embodied the burgeoning aspirations of white, American suburbia. Whilst Tupperware products like the Party Susan (a segmented hors d'oeuvres dish) and the 'TV Tumbler' filled what has been described as the 'perfect consumption space of suburbia', the Tupperware Party became an emblem of suburban life. Maligned by critics as a metaphor for the inauthentic sociality and 'unnatural' matriarchy of suburban living, Tupperware embodied all the academically vilified constructs of postwar feminine identity.

Analysing Tupperware as an icon of suburbia, this chapter considers the role of mass consumption and material culture as a potentially active rather than passive aspect of the formation of postwar feminine identity. During the period 1950–8 Tupperware achieved its greatest expansion of sales. Suburbia provided a newly regulated female sales force, a fecund network of social relations and 'modern' homes. Contemporary corporate sources described suburbia 'as a picnic ground for direct selling'.[9] The Tupperware Party developed as the exclusive distribution method of Tupperware merchandise from 1951 onwards; the sales, distribution and manufacturing concerns were geographically and managerially separate.

The Tupper Corporation, headed by the company's president and product inventor Earl Silas Tupper, was situated at the manufacturing plant in Blackstone, Massachusetts. Tupperware Home Parties Incorporated, headed by vice-president Brownie Humphrey Wise, conducted its sales distribution from the purpose-built headquarters in Kissimmee, Florida. This dynamic, gendered, and later controversial relationship was a crucial force behind the creation of Tupperware as a product of modernity and suburbia.

This chapter begins by establishing Tupperware beyond its status as a modernist archetype, relating its material culture instead to the broader concerns of modernity in postwar America. Analysis of the Tupperware Party distribution method challenges the elision of suburbia and inauthentic social relations. The final sections explore gender, consumption and non-radical feminism as vital components of suburban history.

'POLY-T MATERIAL OF THE FUTURE?': RE-ASSESSING A MODERNIST ICON

In 1955 Tupperware kitchen containers and implements were added to the twentieth-century design collection of the Museum of Modern Art, New York, as 'carefully considered shapes ... marvellously free of that vulgarity which characterizes so much household equipment'.[10] Praise focused on their 'rational', technologically determined modernist forms, attributed to their designer, Earl Silas Tupper. Whilst the Design Museum, London, exhibits Tupperware as an exemplar of 'distinctive design', design historians reduce its cultural significance to it being a 'functional' product 'with a clever airtight lid'.[11]

The first Tupperware object, produced under the patent 'Poly-T Material of the Future', was a seven-ounce, injection-moulded, milky white polyethylene container manufactured by the Tupper Corporation in 1939. Historical accounts construe Earl Tupper as a figure at the forefront of American modernism. His self-proclaimed mission was to act as a twentieth-century 'super-co-ordinator' who would 'observe general trends i.e. form, streamlining, jazz, health, food, exercise, sunlight, then invent, not too radically to be accepted by a conservative audience, the next logical step in each trend'.[12] His earliest experiments in plastics could not have been further removed from the radical formalism of utilitarian modernist design.[13] Inspired by popularist visions of technology and science, his designs ranged from adjustable-lens spectacles and waterproof mirrors to pseudo-Egyptian slave jewellery and paint-on nail ornaments.[14] In October 1937, for example, Tupper proudly recorded the invention of 'a kit having suitable nail ornaments for all occasions (shamrocks, hearts, valentines, etc.)'. His wife acted as adviser and product tester. Typically he commented, 'this evening [I] mentioned it to Marie', he continued, 'Blanche, Mary and Jenney [fellow workers] said they would like to try [the nail kits] so I made their initials.' He envisaged the paint-on nail accessories, made up with the customer's and her

boyfriend's initials, selling millions over 1930s department store counters.[15]

Sketch book, diaries and invention notes reveal Tupper's reliance upon observations of everyday domestic life and social relations as the key to his design process. Women from shop counter girls, factory workers to close family members provided consistent imput to his designs. Whilst his wife encouraged him to improve and innovate household appliances, his active parental role included the creation of numerous items, including a patented streamlined sled, which formed the staple of his design practice. Many of his ideas were direct extensions of his own household provisioning and semi-skilled labouring jobs.

As a detailed diary entry reveals, Tupper's visions were bound by notions of morality and tradition rather than the radicalism of modernism:

the Colonial Village [at Springfield Eastern Sales Fair] was good, and one of the most beautiful sights was a motherly old fashioned lady who took batches of several colors of wool that had been clipped, washed and dyed. . . . Talking sweetly all of the time, explaining the whole procedure, she proceeded to spin . . . right before our eyes . . . it is hard for me to find any words in common all today that are fitting to describe such a mighty thing as we had witnessed.[16]

By 1949 an illustrated catalogue, featuring an expanded range of thirty-four object types, read as a product manifesto. The orthodoxy of the domestic sphere mediated the overt radicalism of 'Poly-T, Material of the Future'. Using a series of didactic table settings and highly detailed product use descriptions, 'Poly-T' complemented the role of china, glass, pottery, silver, crystal (Figure 5.1). The maintenance of manners, social relations and domestic rituals associated with such conventional tableware prevailed: 'this material is so clean and wholesome of itself that it lends that feeling to the whole table when it is placed there', read one promotional plea.[17]

Direct editorial reference to aesthetic distinction, such as 'simple good taste', related less to the technocratic ideals of modernism and more to the restraint of Protestantism. References made to 'chaste lines', 'restrained dignity', 'clean, graceful paring' and 'values of decor' implied that the products' design embodied the comfort of moral fortitude. Tupperware, it proposed, could contribute to the maintenance of domestic stability and refined sensibility. It readily assimilated the rituals of etiquette and socialization associated with food and entertainment within the home:

Early indoctrination in the fundamentals of gracious living sets a pattern that will endure for years and form a natural feeling for the niceties of life. So, the mother who does not permit even the partaking of the midday luncheon by the children in other than an orderly and pleasing manner, uses her Tupperware.[18]

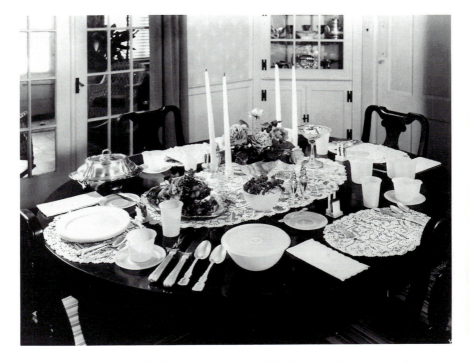

Figure 5.1 Formal table setting featuring 'Poly-T: material of the future'
Source: Mail order product catalogue-C, Tupper Corporation, Farnumsville, Massachusetts, 1949

Tupperware was constructed not as an occasional household implement, but as a 'method' of substantiating and expanding the values of everyday civility. This synthesis of materiality and spirituality is at the crux of what historians have described as 'the Puritan aesthetic'; a notion, some have argued, crucial to the formation of American history and mass consumption.[19] This 'strange communality of people and icons', to quote one historian, which made 'human beings and material objects ... interchangeable' created an overwhelming belief in the potency of icons and the power of material forms.[20] Embedded in this tradition, Tupperware operated beyond the stricture of an alienable commodity. Just as the motivations for its production were informed by a broader historical, cultural and social agenda, so was its consumption.

Plastic during this period acquired an ambiguous reputation owing to its prolific, and frequently inappropriate, use as a novelty and substitute for established materials. Yet it embodied the optimism of postwar America, to quote Meikle: 'the material benefited from heightened public interest in technological

progress as a counter force capable of vanquishing economic and social stagnation'.[21] Earl Tupper saw his invention – non-toxic, odourless and lightweight – as a gift to humanity. He envisaged the total 'Tupperization' of North American homes.[22]

The October 1947 edition of *House Beautiful*, an established home interiors magazine, dealt specifically with the contentious issue of plastics in the middle-class American home. Tupperware was imbued with a status which exceeded the banality of most utilitarian household goods. Under the title 'Fine Art for 39 cents', the polyethylene wares were praised for their 'fingering qualities of jade', and likened to 'alabaster and mother of pearl'. Whilst Tupperware received acclaim for its 'fitness for purpose' and 'truth to materials', the female author of the article, Elizabeth Gordon, focused her product appraisal on tactility, sensuality and desire; 'Does it satisfy our aesthetic craving to handle, feel and study beautiful things?' she asked rhetorically. Tupperware, she concluded, exceeded any measurable, rational criterion for assessment; for 'above all else, the bowls have a profile as good as a piece of sculpture'. As an icon of modern artistry it provided 'shining points of interest as soup or berry bowls, or condiment dishes'.

When colouring was introduced to the Tupperware product range in 1949, descriptions referring directly to the technology or chemistry of the products were avoided. Instead descriptions alluded to precedents of 'natural' beauty; the organic, mouth-watering assortment of Pastel Tones – Orange, Lemon, Lime, Raspberry and Plum; the precious mineralogy of 'Frosted Crystal, Ruby, Amber and Sapphire Blue'.[23] Later colour variations were, according to oral histories, inspired by Earl Tupper's observations of the delicate shades of Florida's native orchids.

From the onset, then, the promotion and interpretation of Tupperware, as an innovative product and new material, operated outside the simplistic notion of the self-satisfying rational consumer of economic theory. As Miller argues, material culture is created as much by social life as rational economic utilitarianism: 'it is the object's relationship to the social group which is crucial, rather than its ability to perform a transformation of nature under the sign of utility.'[24]

Social theories of modernity commonly divide production and consumption, 'public' and 'private' spheres respectively.[25] It is this dichotomy of social life which has defined women as the passive recipients of commodity culture. Demystification of the design process, however, undermines the rigidity of this supposition. It was the interrelation of private and public spheres which shaped Tupper's inventions rather than his vanguardism as a leader of twentieth-century industrial design.

Ultimately Tupperware's modernity was proffered not in ideal utilitarian

forms, but in terms of artefacts designed to enhance and expand the intricate manners of modern social relations. The 'Tupperware Place Card Holder', with its receptacle for two cigarettes and a book of matches, and the 'Tupper Styrene Sandwich and Food Guides' designed to 'add the dash of piquancy; the "soupcon" eagerly sought after' by the hostess would, the catalogue assured, 'be gratifyingly commented upon by her guests'. 'The King Cigarette and Match Case' and accompanying 'Silent Partner Poker Chips' ('flexible, tough and unbreakable') flattered the 'man of the house' 'who loves to play host'. These faddish and apparently trivial objects are conveniently precluded from modernist accounts of Tupperware as a 'design classic'.[26] This chapter argues that such object types are integral to the understanding of modernity, consumption and suburbia.

'PARTIES ARE THE ANSWER': SUBURBIA, SOCIALITY AND THE TUPPERWARE PARTY

Tupperware initially failed to sell in sufficient amounts from hardware or department store displays and its mail order business was minimal. Inspired by established direct sales concerns such as Stanley Home Products, and Fuller Brush Co., the Tupper Corporation adopted the 'Party Plan' system in 1951 with the employment of saleswoman Brownie Wise. Wise attracted Tupper's attention with enormous sales orders placed by her small direct sales company, Patio Parties. Whilst Tupperware formed only a proportion of her door-to-door sales, Wise found it a particularly suitable product for demonstration to groups of enthusiastic homemakers. Earl Tupper was persuaded of the virtues of the 'Party Plan' system in furthering the 'Tupperization' of American homes (Figure 5.2). By 1954 over twenty thousand women belonged to the Tupperware party network as dealers, distributors and managers.[27]

The Tupperware Party elaborated established door-to-door sales techniques by incorporating party games, refreshments and sophisticated product demonstrations (Figure 5.3). As well as serving as a highly rarefied sales forum it acted as a ritual interface between maker, buyer and user. The structure of the 'Party Plan' system utilized the fluidity of theoretical boundaries: domesticity/commerce; work/leisure; friend/colleague; consumer/employee; commodity/gift. The 'hostess' offered the intimacy of her home and the range of her social relations with other women (relatives, friends, neighbours) to the Tupperware dealer in

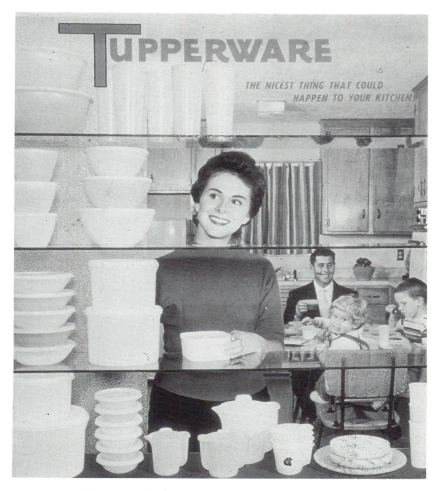

Figure 5.2 'Tupperware, the nicest thing that could happen to your kitchen'
Source: Product catalogue, Tupperware Home Parties Inc., Orlando, Florida, 1958

exchange for a non-monetary gift. The dealer, supplied by an area distributor, used the space to set up a display of products and recruit further parties from amongst the hostess's guests. The dealer benefited from commission accrued on sales and the potential for further party reservations.

Suburban homemaking provided Tupperware with its most comfortable niche: the corporate slogan read, 'the modern way to shop for your houseware needs; conveniently, leisurely, economically'.[28] Concepts of thrift and excess co-existed happily in the Tupperware ethos. Whilst items such as the 'Econo-canister' and

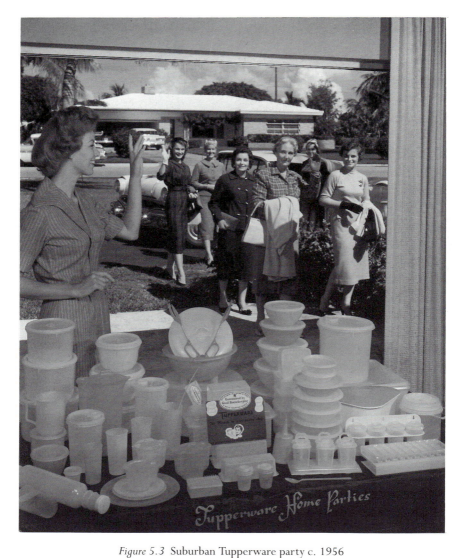

Figure 5.3 Suburban Tupperware party c. 1956

Source: Promotional shot, Archive Centre, Smithsonian Institution, National Museum of American History, Washington DC

'Wonderlier Bowl' made possible bulk storage, and the ability to turn 'Left-Overs into Plan Overs', spindly legged condiment holders provided the perfect centrepiece at any impromptu buffet party. Suburban rituals, such as the barbecue, flourished with the Tupperware range (Figure 5.4).

As 'The answer to the Housewife's demand for efficiency – economy . . . the

Figure 5.4 Tupperware promoted as the ideal barbecue accessory
Source: Product catalogue 'Guards Food Flavor . . . Freshness', Rexall Drug and Chemical Company, c. 1969

woman's demand for beauty', Tupperware products underwent rigorous testing. Elsie Mortland, the company's official executive 'homemaker', sanctioned and mediated the Tupper Corporation's products to meet the requirements of suburban American women. As an 'ordinary' housewife Mortland served as an interface between the corporation and consumers with her adept understanding of household provisioning and associated skills: 'I knew how far a housewife expected her budget to stretch, what her storage priorities were and what kind of cookies she might like to make for her children.'[29] This overtly tacit design process highlights the interrelation of social relations, domestic economy and market economics; and the arbitrariness of the division between private and public spheres.

The 'Tupperware Burp' (a technique developed to expel air from the containers) formed the focal point in a demonstration devised to show the product's 'varied and distinctive features'. Tupperware Parties animated the product range; during game sessions such as 'Clothes Pin', 'Waist Measurement' and 'Game of Gossip', miniature brand-named Tupperware 'trinkets' were awarded for performance. Initiates showed their familiarity with the product range by deciphering the specifics of Tupperware's product language (Scrub-E-Z, Serve-n-Save, Hang-It-All, Fly-Bye-Swot, Square Round, etc.). In addition to embracing conservative and domestic

feminine concerns, more subversive activities manifested themselves in the form of husband-focal games. Guests were required to write hypothetical newspaper advertisements to sell their partners; read out for the amusement of the other women they proved particularly popular: 'One husband for sale. Balding, often cranky, stomach requiring considerable attention!'

Dorothy Dealer's Dating Diary,[30] a full-colour cartoon booklet issued to potential dealers, outlined strategies of informal salesmanship (sic), networking and 'friend finding'. Women were dissuaded from adopting a corporate image and encouraged to use their own social skills to 'create incentive or change excuses into a positive party date'. A typical scenario read:

Potential hostess: 'Oh, but Janice I just can't have a party . . . I'm right in the middle of redecorating.'
Dealer: 'But wouldn't that be a wonderful chance for your friends to see your newly decorated home?'

Whilst the booklet described the benefits of 'prospecting' amongst a wide range of people and situations (for example, the single working woman, the widow, the urban apartment dweller), suburbia formed the locus of its attentions. A 'Check List for Party Dating' asking dealers 'Whom do you know?' proceeded to map out the social relations of suburbia with suggestions ranging from 'Your Real Estate Agent' to 'Your Neighbors, Church Members and Club Members'.[31]

Suburban communities were offered the 'Club Plan' and 'Round Robin' schemes whereby Tupperware parties could be used to supplement the treasury funds of charitable organizations.[32] Dealers were advised to 'Watch the society page in *your* paper and contact an officer in every club in *your* community!'[33] Tupperware women enhanced their self-respect and utilized their skills in service to their neighbourhoods as valued members of the community. To quote one oral history, 'When I had been with Tupperware [for] just two weeks folks said I was no longer the shrinking violet they had once known!'[34]

It is the ambiguity of the Tupperware Party, the intrusion of the 'market' into the sanctity of 'domesticity', which has led some critics to berate it as the ultimate anti-feminist, capitalist sales device: 'This form of organizational parasitism, while it has its unique features, is analogous to that form of colonialism which extracted taxation by utilizing the existing tribal structure rather than developing its own grass roots system of administration and collection.'[35] It is true that employment with Tupperware was organized on a casual basis, therefore it offered little security and no formal insurance benefits. But in a pragmatic sense this flexibility 'allowed' women to be 'informally' employed *and* manage traditionally circumscribed roles as

mothers. Tacit homemaking and management skills were paramount in the 'Party Plan' sales system, as were sociability and sharing in the process of establishing successful sales networks. Whilst exploiting sociability and economic disadvantage, Tupperware offered non-radical solutions to domestic isolation.

The Tupperware Party, though, is commonly critiqued (like suburbia itself) as an empty, parochial and divisive institution.[36] To quote Donaldson, 'most social commentators regard . . . suburbs [as] homogeneous, conformist . . . conservative, dull, child centered, [and] female dominated'.[37] Suburban living is viewed as a form of moral and social bankruptcy, the ultimate relinquishment of political responsibility: 'people in the suburbs, it is charged, regard each other as tools, or commodities'.[38] Most significantly, postwar suburbia represented a shift from a production to a consumption economy.

A famous in-depth study of a North American suburb titled 'Crestwood Heights', published in 1956, described the suburban home as:

Little more than a repository of an exceedingly wide range of artifacts. It contains the traditional bed, stove, table and chairs, of course; but it also contains (among other things) freezers and furnaces, Mixmasters, medicines, bed-side lights, rugs, lamps, thermostats, letter boxes, radios, door bells, television sets, telephones, automobiles, foods of all kinds, lead pencils, address and engagement books, pots and pans, mousetraps, family treasures, pictures, contraceptives, bank books, fountain pens, and the most recent journalistic proliferations.[39]

The accumulation of material culture is automatically associated with pecuniary emulation.[40] The picture window, the study concludes, 'seems less to give the occupants a view of the outside . . . and more to extend an invitation to the outsider to look in . . . [at] a grand piano, valuable crystal chandelier, or a striking red brocade chair'.[41]

Mass consumption and material culture in suburbia are judged, implicitly, as embodiments of alienation. Lewis Mumford's description, for example, equates suburbia with vacuity of the commodity form:

a multitude of uniform, unidentifiable houses, lined up inflexibly at uniform distances, on uniform roads . . . inhabited by people of the same class, the same income, the same age group, witnessing the same television performances, eating the same tasteless pre-fabricated foods, from the same freezers, conforming in every outward and inward respect to a common mold.[42]

False consciousness and the increasing consumption of goods stand as commonly ascribed conditions of suburban living. Ethnic groups moving to the suburbs were described as 'selling their souls' to the American dream rather than reaping benefits and opportunities that were rightfully theirs. Such critiques, to quote

Donaldson, nullified any apparently constructive endeavours the suburbanite might make: 'the suburbanite clearly can't win, if he leaves his home as he found it, he is accused of standardisation and conformity; if he attempts to alter his home, he is accused of a shallow competition for status.'[43]

On the contrary, Miller, in his analysis of modernity and suburbia, argues that '"peoples", "classes", "values", and "interests" derive their form and meaning from the problematic nature of modern culture'.[44] More specifically he posits the material culture of suburbia as a pro-active opposition to 'imposed' ideologies.[45] Mass consumption, he asserts, 'may serve equally well as an instrument for confronting as the medium for creating the sense of alienation'.[46]

In his contemporary analysis, *Suburbia: Its People and Their Problems*, Wood highlights historical notions of American community and the tendency to condemn modern forms as less 'meaningful': 'Modern interdependence among neighbors is not expressed in fighting Indians or gathering crops, but in sharing children's clothes and alternating trips to the supermarket.'[47] Similarly the Tupperware Party was discounted by critiques as an inauthentic charade, which sought to disguise the 'meaninglessness' of contemporary commodity culture with the 'mock' authenticity of applied sociality:

rather than adding decoration to products, Tupperware added a ritual, the party, which helped new suburbanites deal with the insecurity and loneliness that was part of their pioneering lives. The company added the ritual for the same reason that most manufacturers added the decoration.[48]

The Tupperware Party stands as a metaphor of suburbia as a white, parochial and homogenized culture. Corporate images featured well-groomed, affluent and Caucasian suburban housewives. Yet the very nature of the 'Party Plan' system meant that Tupperware 'infiltrated' sections of American society and was appropriated by those otherwise precluded from the trappings of the 'American Dream'. Dealers tapped into their specific and localized networks of women. Black and Hispanic women, single mothers and divorcees formed the less visible force behind Tupperware's expansion.[49] Transcripts of Tupperware sales seminars make consistent reference to 'the Negro market' as a significant arena of consumption. Vice-president Brownie Wise made several guest appearances at black colleges, promoting the role of business and positive self-growth philosophy.

For all women, employment with Tupperware and Tupperware Parties themselves raised the status of feminine and homemaking skills. Tupperware boosted support networks and confidence:

before I attended a Tupperware Party I thought the last thing I'd like to do was sit with a whole

load of other homemakers and talk recipes. But I had a sociable time and it helped me with my first boy, 'cos you know I wasn't so confident about child care in them days.[50]

Tupperware did not merely act as an empty vessel, a neutral commodity upon which social relations were brought to bear. Tupperware was appropriated in systems of informal economy to expand existing fissures and make social and material alternatives possible. Dealers with children might barter Tupperware to enable themselves to accrue income selling Tupperware:

I remember as a Tupperware dealer with my babies I exchanged time for Tupperware with my neighbours. In other words let's say you would watch my children for three hours, well, rather than paying you 50 cents an hour . . . I would give you a dollar and a half worth of retail Tupperware. Now please remember, that was a set of cereal bowls back in those days.[51]

Tupperware Parties provided sanctioned all-female gatherings outside the family. Loyalty to fellow neighbours and friends was the linchpin for attendance to many parties (some informants even recalled budgeting within the monthly housekeeping for attendance at Tupperware Parties) but for numerous women it was an opportunity to socialize outside the home at little expense. Whilst the pretext of the gatherings was domestic this did not preclude women from directing the conversation and interaction towards other concerns. A sociological study by Elayne Rapping, for example, suggests that Tupperware Parties have offered a viable forum for the politicization of working-class women.[52]

Tupperware, then, embodied the contradictions of a growing postwar consumer culture. Whilst substantiating predominantly conservative and traditional feminine roles, it provided a pragmatic, pro-active alternative to domestic subordination.

'FAITH MADE THEM CHAMPIONS': POSITIVE THINKING AND NON-RADICAL FEMINISM

In her re-assessment of Friedan's *The Feminine Mystique* Meyerowitz acknowledges the significance of non-radical feminism in her plea that 'historians need to explore further the influence of human potential psychology on contemporary feminism'.[53] Whilst Tupperware celebrated domesticity and 'feminine' skills, Brownie Wise, vice-president of the Home Parties distribution network, preached a potent doctrine of positive thinking and sorority.[54] As the first saleswoman to

be featured on the front cover of *Business Week*, her maxim read: 'If we build the people, they'll build the business.'[55] The inside pages described her ethos of caring and nurturing as intrinsic elements of a successful business operation. She promoted communality of experience rather than individual profit. Feminine reciprocity and loyalty were seen to bolster individual productivity, which in turn was seen to benefit others: 'In the unity of our ideas and our ambitions lies our greatest strength. . . . A drop of water contains but an infinitesimal molecule of strength . . . powerless in itself. But the merging of billions of drops of water produces the tremendous power of Niagara Falls.'[56]

Wise designed the headquarters of Tupperware Home Parties Incorporated as the Mecca for Tupperware women nationwide. A classically inspired gleaming white colonnaded building stood amidst a thousand acres of lush, lagoon-filled gardens filled with Italianate statuettes, and dedication plaques. 'The Walk of Fame', a pathway imprinted with footprints of successful dealers past and present, led to a lagoon named 'Poly Pond': blessed by Brownie casting a handful of raw polyethylene pellets to its depths, women could be baptised at the water's edge with 'Tupper Magic'. The golf course, swimming pool and expansive auditorium offered the ideal Tupperware showcase.[57] The 'Tupperware Museum of Dishes', featuring kitchen vessels from the 'pre-historic era to present day', placed Tupperware at the forefront of American material culture. The collection, including Shaker boxes, American Indian ceremonial vessels and decorative Tiffany glassware, culminated in an illuminated stack of Tupperware containers. Beatnik artists painted, in the 'contemporary style', a forty-foot-long mural exhibited in the foyer entitled 'The Evolution of Dishes' (Figure 5.5); and adjacent to the 'Consumer Lounge' there featured a display of Tupperware archetypes floating against a black velvet background and a 'Lollipop Tree' for the pleasure of visiting children.

The headquarters formed the backdrop for the extraordinary annual events referred to as 'Tupperware Homecoming Jubilees'. These celebratory gatherings brought together women from the furthest corners of America and, acting as a form of 'potlatch', embraced the significance of the 'gift' in numerous extravagant displays. Solely responsible for these events (Earl Tupper, according to oral histories, was made physically sick by large gatherings of women), Wise showered women with gifts and commemorative awards as glamorous and public demonstrations of loyalty.[58]

For the 1954 Homecoming Jubilee celebrations, for example, top dealers and managers were invited, in keeping with a pioneer theme, to 'Dig for Gold'. Forty-five thousand dollars' worth of consumer durables had been buried beneath the

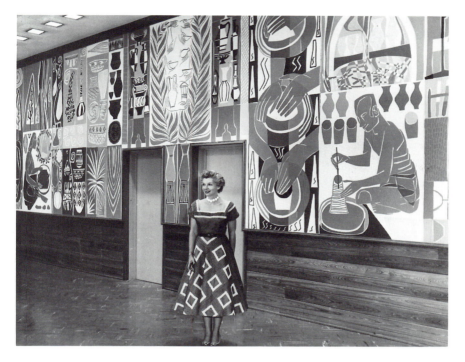

Figure 5.5 Brownie Wise, vice-president of Tupperware Home Parties Inc., standing before a mural entitled 'The Evolution of Dishes' in the foyer of the corporate headquarters, c. 1953

Source: Archive Center, Smithsonian Institution, National Museum of American History, Washington, DC

headquarters grounds. Several hundred spades were poised for women, dressed up as 'Cowboys and Indians', to dig uninhibitedly for de-luxe toasters, fur coats and diamond rings in a hybridized charade of American cultural mythology. Describing the 'All Girl Gathering', *Life* magazine ran a major photo-story of the bizarre proceedings.[59] The 'Dig For Gold' theme stood as an analogy where the spoils of a postwar industrial nation replaced raw gold: while a Methodist preacher spoke at length of the value of Tupperware as a national icon and a 'defensive bulwark against communism', a Wish Fairy, clad in theatrical gold tutu and sparkling tiara, made a celebrity wish-fulfilment appearance. Waving her diamante wand, she granted saleswomen anything from entire Parisian haute couture wardrobes (from satin pyjamas to strapless ball gown), luxury bedroom suites, washing machine ensembles and brand new Ford convertibles. In courting women with such gifts Wise was scrupulous in her pragmatism – organizing, for example,

the babysitting arrangements for the eleven children belonging to the recipient of a luxury weekend vacation.

The seemingly disparate concepts of glamour and pragmatism were consistently unified under the auspices of Brownie Wise. As 'an ordinary middle-aged housewife' and single mother she had 'turned rags to riches' through positive thinking and perseverance with the 'Cinderella Company'.[60] Featured on the front covers of *Tupperware Sparks*, the monthly in-house magazine, she appeared in charismatic and glamorous poses: flanked by the kneeling male executive proffering gifts; standing resplendent in strapless satin gown; embracing high-achieving Tupperware women. The pages were filled with her anecdotes, household tips and descriptions of her lace couture dresses, pastel pink Cadillac, luxury lakeside home and dyed pink canary. Foibles such as her compulsive eating habits were discussed at length for a popular female audience in magazines such as *Woman's Home Companion*:

Brownie fixes herself a snack of pickles, cheese and walnuts before going to bed. She packs away enormous breakfasts frequently topped off by ice-cream, eats dessert before her hamburger at lunch and munches ice-cream sticks whenever she feels hungry during the day.[61]

Wise became the darling of the women's press. As a heroine who glorified 'frenetic activity' she reduced domesticity to a 'sideshow' which, as Meyerowitz points out, was a common theme of postwar feminine culture.[62] As an exceptionally charismatic and talented saleswoman, Wise, in turn, relied on the support and reciprocity of the Tupperware sales force. She regularly received gifts and letters of appreciation and responded personally to the enquiries, comments and achievements of Tupperware women, converting, for example, her own shopping sprees into provisioning for their gifts.[63]

The dynamic of this relationship is exemplified by the prose of a Tupperware dealer who, taking notes at a sales class promoting confidence in feminine skills (entitled 'Know-How'), is compelled to leave her leader a token of her affection. It read:

Brownie – just sitting here looking at you and listening to you talk I wonder if you can ever realize the tenderness in our affection for you, and the really deep and abiding gratitude that most of us (me in particular) feel for this wonderful opportunity in business we now enjoy. Thank you Brownie for being a constant shining example of never tiring energy and a moving force that keeps us all in constant motion – love Helda Degraves.[64]

Initiated in response to women's persistent requests, the pinnacle of the gifting rituals was the donation of the leader's own publicly worn garments. Restricted

to the sales elite, the 'Vanguard', this exceptional accolade was highly coveted and consequently described in the most tantalizing and indulgent detail:

the dress I wore at the last jubilee graduation is to be one of the awards . . . (it's an 'original' of imported pink batiste . . . fine pin tucks and lovely Irish lace, with flaring gores breaking at the knee with a deep permanently pleated flounce, and a matching pink taffeta slip).[65]

Women were unified in their desire not just for material luxuries, but for a sense of belonging. Becoming a dealer or manager meant having a large network of social relations, extra money and a standing in the community. Far from construing postwar women as 'domestic and quiescent', Tupperware, and its potent articulation of material culture and social relations, operated as a blatant promotion of ambition and control: 'If you believe in a thing you work for it. You work with it. You are active in it. You participate.'[66]

The Tupper College of Knowledge offered a form of certificated qualification to a social class otherwise precluded. At graduation soft, stirring choral music and candlelight accompanied women of all ages in a formal celebration of their achievements. They met Wise, their inspirational leader who, pinning a fresh orchid corsage to their breast, handed them a certificate, commemorative medal and a copy of her autobiography, *Best Wishes, Brownie Wise*, as 'The Star Spangled Banner' signalled the close of the ceremony. Several weeks later the company magazine featured a roll of honour 'to all those who had triumphed'.

Women active within the Tupperware Corporation utilized the moral economy of informal domestic relations in creating business 'Know-How'. In numerous oral histories women spoke of belonging to the 'Tupperware Family' as a major enhancement to their self-esteem. The anthems which pervaded sales gatherings celebrated these sentiments:

> There's only one place for me
> One place I want to be
> A part of the Tupperware Family
> With my head held high
> Singing praises to the sky
> As a part of the Tupperware Family
> Gone are the lonesome days
> These are the golden days
> Glad to be up with the sun
> There are Oh! so many sensations
> To enjoy with all your relations
> In the Tupperware family.[67]

Tupperware Home Parties Incorporated courted women with dedications of loyalty, positive self-help doctrines and glamorous gifts – features which patriarchal culture promised, through heterosexual romance, but rarely delivered.

'A GALAXY OF GIFTS': GENDER, GLAMOUR AND CONSUMPTION

Mass culture, style and consumption are considered, particularly by historians of the interwar period, as vital components of a gendered experience of modernity.[68] Yet the consideration of material culture and consumption in the lives of postwar women is comparatively lame. Side-stepping issues of glamour and display, historians of design and housework confine themselves to technological determinism and 'labour saving' debates.[69] Yet consumerism and glamour are trivialized aspects of popular feminine identity.

In 1953 Brownie Wise sent a memo to Earl S. Tupper, regarding a New York press party, which read as a statement in defence of glamour.[70] It began: 'The setting for the party was the most beautiful, undoubtedly, that I have ever seen . . . tables were set on blue-grey linen and . . . centred with huge vases of the new Tupperware Beauty Rose.'[71] Whilst the cocktails and luncheon served could 'only be described in superlatives', Wise defended the occasion by reiterating that 'at least 40%' of the editors present were male. She continued: 'I had to shed a little personal glamour for the benefit of the editors . . . who were primarily engrossed in determining just how any appreciable amount of honest-to-goodness business was conducted by "a mere woman".'

That same year Wise issued Tupper with a comprehensive business plan, including sales projections, and implored him to maintain the exclusivity of the Tupperware Party distribution method. The immense success of the 'Party Plan' system, whilst boosting Tupperware's public profile, had somehow (Tupper insinuated) undermined the objects' propriety. Expenditure on Jubilee celebrations, gifts and glamorous press parties, as well as undercutting profit, contradicted the very essence of the Tupperware object's existence: thrift, frugality and everyday function. Wise defended these 'extravagances' as essential assets of the Tupperware business and advised Tupper that releasing Tupperware to formal retail outlets undermined the effort of her dealers and the entire 'Party Plan' network.

Whilst Tupperware appealed to increased refrigeration facilities, domestic

rationalization and hygiene standards, 'glamour' constructed the product as a suburban icon. 'Cadillacs and new homes are the hallmarks of Tupperware distributors' boasted the corporation.[72] These material signs were, though, the result of women's affirmative action. This corporate culture provided a unique space for female fantasy and wish fulfilment. Women's wishes were viewed as a recognizable force: 'Without *your* wishes where would we be? Everything begins with a wish.'[73] Whilst Tupperware served as a functional object, its success relied upon the Home Party Plan's potent articulation of consumption, modernity and gender.

Whereas Earl Tupper's vision of social progress involved finding 'the true purpose and intent of everything' without 'jarring harmony', Brownie Wise viewed modernity as a liberating celebration of human potential through 'use' – or consumption. It is perhaps significant that Tupper's house in Rhode Island was a bastion of New England Protestant aesthetic values. Ironically it negated any reference to technological advancement or 'contemporary style'. It contained antiques, a traditional open fireside, wooden panelled walls and a spinning wheel. In stark contrast, Brownie's lakeside home in Florida was filled with contemporary rattan furniture, flamingo pink upholstery and contemporary art. The living room, wrote one journalist, was reminiscent of 'the lobby of a swank beach hotel'.[74]

Wise combined notions of individual responsibility and public service in a typical treatise entitled 'Things We Should Use'. It condemned 'stinginess' and implored women to 'Use it all. Use yourself freely. For you'll never, never, never use yourself up.' The doctrine extended to material culture: 'we put slip covers over furniture to save the upholstery and never see the beautiful color . . . or the pattern or the material . . . we put away our precious lingerie, save junior's suit for Sunday School wear, until it's too small for him.'[75]

Women's liberation could be sought through self-esteem and appreciation of the value of their own thoughts, opinions and experiences; for 'they', wrote Wise, 'are as much a part of the inventory of our mental and spiritual possessions as anything else'. In this sense the fantasies and wishes of women constituted acts of positive self-determination: 'everything', declared Wise, 'begins with a wish.' Material goods, by extension, embodied choices, values and moral integrity: 'Thoughts ARE things; table glass, permanent in your hair, roof on your house, engine in your car.'

The Tupperware Family Album, an illustrated publication offering dealers a range of gifts (acquired through accrued sales points) 'to thrill' their 'entire family', placed commodities firmly in the context of a moral economy. Simulating

a photograph in a conventional photograph album, each portrait-size picture of the white, suburban, extended family was mounted in juxtaposition within chosen commodities. The gift objects, with consistent and prominent reference to their brand names, were themselves represented as potential 'members of the family'. All photographed, in open and availing presentation boxes, as posturing subjects within themselves, they were identified according to gendered and social relations: 'Mother' with the 'Crown Jewel Ladies Schick Razor', 'Manicure Set by Griffon' and electric knife ('delicate slicing action'); 'Father' with a 'Garcia Mitchell Fishing Rod Outfit' and a traditional carving knife set ('Dad will be master of the holiday meals!'); youngest daughter 'Judy' with a 'Giant Doll Playhouse' ('the dream of every little girl') pictured opposite her brother Tommy and his 'Deluxe Microscope Set' ('Not a Toy') and 'Electric Racing Car Set'.

Similarly, traditional feminine rituals such as the bridal shower party (where friends of the bride-to-be pool gifts for a 'trousseau' in celebration of the woman's marriage) were appropriated and expanded through the Tupperware Party network (Figure 5.6). The 'Little Miss Tupperware Party Set', a range of miniature pieces packaged in 'an attractive pink box', initiated even the youngest woman with an impression of the significance of the product and its associated role. Mother/daughter kinship was recognized, in establishing the 'use' of the objects, as a valued identity operating outside the realms of status prescribed social roles: 'with each box comes a descriptive leaflet so Mama can show daughter what each piece is.'

Promotional pleas such as 'Christian Dior isn't the only one coming up with a new look these days!', used in a 1957 television tumbler product launch, linked Tupperware with other popular, gender specific metaphors of modernity, revealing the sociality and participatory nature of the Tupperware consumer experience.

In 1960 the winner of a Miss Teen contest, 'Blonde hair . . . Blue eyes . . . Fair skin . . . Meet the prettiest teenager in U.S.A.', was awarded, along with a Hollywood screen test, a complete wardrobe from Bobby Brooks and a beautiful Lane Sweetheart Chest, 'a set of terrific Tupperware that will last a lifetime'.[76] In the same year, Co-Ed – 'the Magazine for Career Girls and Homemakers of Tomorrow' – featured recipes, illustrated with Tupperware, for the 'smart hostess' to serve at her swim party where a 'revolving "Party Susan" could offer sophisticated snacks by the poolside'.[77]

Such examples reveal the concomitance of gender and consumption. The identities of Miss Teen and the 'smart hostess' blur the boundaries of 'public sphere' and 'private sphere', relying upon consumption as the locus for individual and social self-construction. In this sense material culture and mass consumption

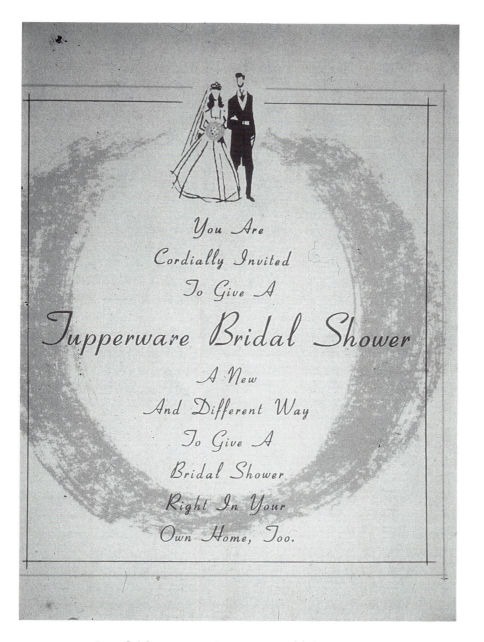

Figure 5.6 Invitation to a Tupperware Bridal Shower Party

Source: Archive Center, Smithsonian Institution, National Museum of American History, Washington, DC

provided a means through which women mediated, negotiated and challenged prescribed 'race', class and gender roles.

These examples acknowledge the potential of mass consumption and commodity forms in countering alienation and constructing meaning in contemporary social life. The sociality of 'the gift', the nuances of household provisioning and complexity of social identities are pursued through, as much as jeopardized by, mass consumption. Economic and materially determinist accounts have systematically undermined the significance of material culture and mass consumption in developing sociality, kinship and identity.[78] In this context the early writings of Brownie Wise offer an insight into meanings of homemaking and consumption as a crucial component of popular feminine identity. In the late 1930s, desperate to earn a living, Wise practised writing under the pseudonym 'Hibiscus' for the 'Experience Column' of the *Detroit News*. The column acted as a literary space for a community of women to 'discuss' domestic news and passing observations of everyday life. Her assumed identity as a Southern belle turned newly wed homemaker provided numerous opportunities for wishful reminiscing. In a particular excerpt she imagines her fictional family, doting husband 'Yankee' and baby son 'Tiny Hands', in their soon to be occupied 'Lovehaven':

I let the door swing back, and I stood in the kitchen . . . so efficient looking, so sleek, so shining. 'That', I thought, 'would look like an ordinary kitchen sink to anyone else, but to me it's a magic carpet.' I shall stand before it and watching Tiny Hands busy in the sandpile outside the window, dream wonderful dreams . . . I went into the nursery . . . my mind's eye ran ahead again, and I saw the pink and blue nursery paper which tells the story of Peter Rabbit coming down from its wall, to be replaced with a saga of trains and airplanes and boats, and still later . . . a striped wall plastered with . . . football schedules and athletes pictures.

Whilst the prose belongs to a broader cultural context of popular literary romance, its sentiment patently weakens the view of aspiration, domesticity and consumption as a simplistic expression of materialistic emulation and alienation.

Similar treatments of suburbia reduce the collective experience of modernity to little more than a 'parade [of] objects up and down in front of some anonymous mass in an assertion of status . . . the route to the American Dream'.[79] Reductionist approaches to consumption fail to acknowledge the moral economies, and the historical and cultural specificity, within which material culture operates: that commodities in a basic sense are taken 'home', adapted and re-interpreted in establishing relationships and social positions.

Tupperware and its integral relation to suburbia illustrates the role of mass consumption in negotiating the complex and gendered social relations of

'everyday life'. Beyond the realms of status-seeking and individualized desire, Tupperware, like suburbia, belonged to a complex and authentic system of sociality and moral economy.[80]

Tupperware products and parties became such an integral part of postwar United States suburbia that in 1958 Earl Tupper, uncertain of the products' relevance to the oncoming decade, made the decision to sell the corporation. Brownie Wise, heavily criticized for her 'prima donna'-like behaviour, was ousted from the company.[81] Unsuccessful in her attempt to sue Tupper for $1 million for wrongful dismissal, Wise began her own cosmetics party plan company, named 'Cinderella'. She received a $30,000 settlement fee. Earl Tupper sold the company to Justin Dart of Rexall Drug Company and received cash, Rexall shares and a seat on the executive board.[82]

In 1961 Tupperware was appropriated and re-invented by a British public. *Which?* consumer magazine criticized Tupperware (despite rating its functional performance) for its elaborate and immoral American sales technique, which

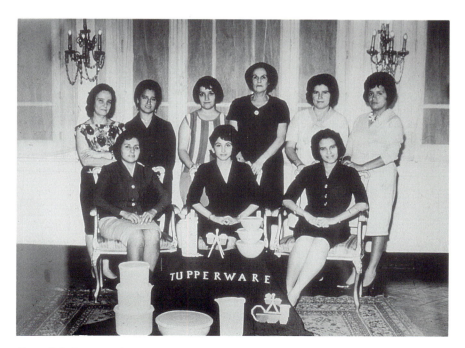

Figure 5.7 A group of Hispanic Tupperware dealers honouring a fellow 'Tupperite' with an embroidered textile for product display, c. 1959

Source: Elsie Martland, ex-Tupperware Home Parties executive, personal collection

brought commerce directly into the sanctity of the home.[83] Numerous newspaper reports condemned the divisive Tupperware Party; a typical headline read 'As Soft Sell Steals into Suburbia'. But British women defied all marketing surveys (which were predicated on Tupperware's reliance on US suburban culture) and embraced the network enthusiastically.[84] The National Housewives Register integrated Tupperware Parties as part of their 'getting to know you schemes' on new suburban estates and by the mid-1960s the product and its party, featured on the front cover of the fashionable and aspirational *Queen* magazine, were both symbols of a newly perceived social mobility.

CONCLUSION

The phenomenon of the Tupperware Party and products is left unexplained by production-led accounts of self-satisfying, rational consumers. A design history narrative, for example, explains the Tupperware object's 'success' as a logical outcome of its functional, technologically determined form. Yet from its invention and mediation to its localized consumption the product operated within the realms of an ethically and socially informed context.

Tupperware products, 'lightweight, unbreakable . . . attractive in pastel jewel-like colors and modern designs',[85] like visions of suburbia itself, offered liveable, pragmatic manifestations of modernity. The Party Plan system embraced, rather than jettisoned, the intricacies and nuances of everyday domestic economy. Undermining the postwar image of the housebound, passive and privatized suburban consumer, Tupperware embodied consumption as a liberating and celebratory form.

The exploration of Tupperware as a symbol of suburban lifestyle offers an insight into the neglected, parodied and vilified activities of 'women on the right . . . glamour and consumerism'.[86] It challenges these activities as apolitical and wholly inauthentic aspects of modernity. For many working- and lower middle-class women, divorcees and ethnic groups Tupperware offered an active form of non-radical feminism. Glamour, sorority and popular psychology made the Party Plan system a suburban success. But the gifts and rituals of the network were less a corporate invention than a 'grassroots' response. Tupperware was appropriated as a vehicle for popular feminine identity and, as such, reveals the historical significance of moral and informal economies: 'economies' systematically neglected and trivialized by liberal economic models of consumption (Figure 5.7).

NOTES

1 Rochelle Gaitlin, *American Women Since 1945* (London, 1987), p. 54.

2 Thomas Hine, *Populuxe* (London, 1988), p. 3.

3 Gaitlin, *American Women Since 1945*, p. 54.

4 Ibid, p. 54.

5 Glenna Matthews, *'Just a Housewife': The Rise and Fall of Domesticity in America* (Oxford, 1987) for example describes the enhanced prewar 'possibility for self-respect on the part of the housewife' as having 'dissolved by the mid-twentieth century', p. 222.

6 Elaine Tyler May, *Homeward Bound: American Families in the Cold War Era* (New York, 1988) links postwar domestic subordination with reactionary politics of the Cold War and McCarthyism. In Betty Friedan's *The Feminine Mystique* (New York, 1963; reprint 1982) the alienation and malaise of feminine domesticity are described under the chapter heading 'The Problem With No Name', p. 13.

7 Joanne Meyerowitz, 'Beyond the Feminine Mystique: A Reassessment of Post-war Mass Culture, 1946–1958', *The Journal of American History*, March 1993, pp. 1455–82 challenges Friedan's passive domestic construct of the postwar American woman and re-assesses popular feminine literature as a potentially active force which drew on 'the tension between domestic ideals and individual achievement', p.1458. In her edited volume Joanne Meyerowitz (ed.), *Not June Cleaver: Women and Gender in Postwar America, 1945–1960* (Philadelphia, 1994) brings together a selection of essays to challenge the typical textbook subheadings of the period such as 'The Suburban Family', 'Life in the Suburbs', 'Domesticity' and 'Back to the Kitchen', p. 1. This volume offers 'other' histories of women as political activists, single mothers, new immigrants, lesbians, etc. Similarly Gaitlin in *American Women Since 1945* considers women's involvement in counter-cultures and labour, race and class activism.

8 Meyerowitz, *Not June Cleaver*, admits that the volume does not offer a comprehensive history and that it aims instead 'to subvert the persistent stereotype of domestic, quiescent, suburban womanhood, and to generate new histories of a complicated era', Introduction, p. 11.

9 'Direct Sales; Techniques and Approaches', pamphlet distributed by Patio Parties, c. 1949, Wise Papers (#509), Archive Center, Smithsonian Institution, National Museum of American History.

10 A. Drexler and G. Daniel, eds, *Introduction to Twentieth Century Design* (New York, 1959), p. 75.

11 J. Heskett, *Industrial Design* (London, 1987), p. 156.

12 Opening title page, 'My Purpose in Life' of Earl S. Tupper's Invention Diary and Sketch Book 1937 (#470), Series 2/Box 5, Archive Center, Smithsonian Institution, National Museum of American History.

13 For explanation regarding the contention between European modernism and populist American streamlining see Dick Hebdige, chapter 3, 'Towards a Cartography of Taste 1935–1962', in *Hiding in the Light* (London, 1988), p. 45.

14 Diary entries provide accounts of Tupper's keenness to read the latest copies of *Popular Mechanics* and *Reader's Digest*, as part of his endeavour to become 'a super-co-ordinator'.

15 Diary entry 4 October 1937 (#470), Series 2/Box 5, Archive Center, Smithsonian Institution, National Museum of American History.

16 Diary entry 25 September 1937, Tupper Papers (#470), Box 5/Series 2, Archive Center, Smithsonian Institution, National Museum of American History.

17 *Tupperware Product Catalogue – C* (Farnumsville: Tupper Corporation, 1949), p. 4, Tupper Papers (#470).

18 *Tupperware Product Catalogue – C* (Farnumsville: Tupper Corporation, 1949), front cover, ibid.

19 See Sacvan Bercovitch, *The Puritan Origins of the American Self* (New Haven, 1975) and Colin Campbell, *The Romantic Ethic and the Spirit of Modern Consumption* (Oxford, 1987) respectively.

20 Ann Kibbey, *The Interpretation of Material Shapes of Puritanism* (Cambridge, 1986), p. 44.

21 J. Meikle, 'Into the Fourth Kingdom: Representations of Plastic Material 1920–1950', *Journal of Design History*, vol. 5, 3, 1992, p. 175.

22 Numerous oral histories described Earl Tupper as an inspired but reclusive character. One informant commented: 'he never had much interest in people but he loved things', Elsie Mortland, Tupperware Home Parties executive, Kissimmee, Florida, 2 December 1989.

23 *Tupperware Product Catalogue – C* (Farnumsville: Tupper Corporation, 1949), p. 6.

24 Daniel Miller, *Material Culture and Mass Consumption* (London, 1987), p. 118.

25 For a comprehensive analysis of this argument see Barbara L. Marshall, *Engendering Modernity* (London, 1994).

26 See for example K. Hiesinger, ed. *Design Since 1945* (London, 1983).

27 This was announced on the front cover of the in-house magazine *Tupperware Sparks*, October/November 1954, vol. 3, 21, 22, author's personal collection.

28 'The Tupperware Home Party Way' promotional pamphlet, Tupper Papers (#470), Series 3/Box 6, Archive Center, Smithsonian Institution.

29 Recorded interview with Elsie Mortland, ex-Tupperware Home Parties executive, Kissimmee, Florida, 2 December 1989.

30 Dorothy Dealer's Dating Diary (Florida: THP Inc., 1959), author's personal collection.

31 'Check List: Whom Do You Know?', c. 1951, Wise Papers (#509).

32 The 'Tupperware Club Plan' (all members present) and 'Round Robin' (parties conducted individually with group members) used demonstrations as the focal point of charitable meetings and gave the dealer access to a high percentage of future party recruits.

33 'A Timely Reminder', pamphlet dated 6 November 1952, Wise Papers, (#509), Archive Center, Smithsonian Institution.

34 Oral history interview recorded 24 October 1989 with Janet Foster, Winter Park, Florida, former Tupperware dealer 1952–3.

35 Rex Taylor, 'Marilyn's Friends and Rita's Customers: A Study of Party Selling as Play and as Work', *Sociological Review*, vol. 3, 26 (1978), p. 574.

36 Scott Donaldson, *The Suburban Myth* (New York, 1969) identifies the 'Kaffeeklatsch' as a commonly pilloried symbol of 'mock' friendliness in suburbia: 'left to themselves during the day, the neighborhood ladies get in the habit of sitting around drinking coffee and exchanging lies', p. 111. Classic contemporary critiques of suburbia include William Whyte in the chapter 'The New Suburbia' in *The Organization Man* (New York, 1956); David Riesman's chapter 'The Suburban Sadness', in William Dobriner, (ed.), *The Suburban Community* (New York, 1958); John Keats, *The Crack in the Picture Window* (Boston, 1956); Richard E. Gordon, Katherine K. Gordon and Max Gunther, *The Split Level Trap* (New York, 1964) describes 'Disturbia', a neurosis brought about through suburban living.

37 Donaldson, *The Suburban Myth*, p. 23.

38 Ibid., p. 12.

39 John R. Seeley, R. Alexander Sim and Elizabeth W. Loosley, *Crestwood Heights* (New York, 1956), pp. 42–3.

40 Thorstein Veblen, *The Theory of the Leisure Class* (1899; reprint London, 1925). Chapter II, entitled 'Pecuniary Emulation', continues indirectly to inspire the assumptions of many critiques of consumption.

41 Seeley et al., *Crestwood Heights*, p. 50.

42 Lewis Mumford, *The City in History* (New York, 1961), p. 486.

43 Donaldson, *The Suburban Myth*, chapter I, 'Onslaught against the Suburbs', p. 9.

44 Daniel Miller, 'Modernism and Suburbia as Material Ideology', in Christopher Tilley and Daniel Miller, eds, *Ideology, Power and Prehistory* (Cambridge, 1984), p. 47.

45 Miller, ed., 'Modernism and Suburbia as Material Ideology', refers to British interwar suburbia and the mock-Tudor semi-detached house as a response to modernism.

46 Daniel Miller, *Modernity: An Ethnographic Approach* (London 1994), p. 74.

47 Robert C. Wood, *Suburbia: Its People and Their Problems* (Boston, 1958), p. 131. Wood draws parallels between suburban conformity and pioneering communities of old.

48 Hine, *Populuxe*, p. 36.

49 Oral histories provide the most substantive evidence to support this claim which needs further investigation. An African American woman described organizing her first black Tupperware Party in 1952 after discovering Tupperware containers while working as a maid. A group of retired New Yorkers from an Osceola, 'Mall Walkers' group in Florida spoke of predominantly Jewish Tupperware parties. Hispanic women in the same group spoke of using their large social networks to generate essential income. Single women and divorcees frequently featured in the in-house magazine *Tupperware Sparks* as top achievers; obviously for many of these women it was the only viable means of employment.

50 Recorded interview with former Tupperware hostess Jolene Richards, Miami, Florida, 13 November 1989.

51 From a taped interview with Pat Jordon (18 November 1989) substantiated by Elsie Mortland (2 December 1989) and transcriptions of 'Prospecting and Previewing', a lecture given at the 1953 second managerial convention.

52 Elayne Rapping, 'Tupperware and Women', *Radical America*, vol. 6, 14 (1980).

53 Joanne Meyerowitz, 'Beyond the Feminine Mystique 1946–1958', p. 1455.

54 Brownie Wise avidly followed and documented the preachings of America's key proponents of positive thinking. For an historical analysis of the popularization of this movement see Carol V. R. George, *Norman Vincent Peale and the Power of Positive Thinking* (Oxford, 1993).

55 *Business Week*, 17 April 1954, cover.

56 'The Tupperware Creed', *Tupperware Sparks*, vol. 3, 6 & 7 (July–August 1953), Wise Papers (#509), Archive Center, Smithsonian Institution.

57 The spectacular Tupperware National Headquarters featured on the Greyhound Florida sightseeing tour itineraries throughout the 1950s.

58 In the classic anthropological work *The Gift* by Marcel Mauss (New York, 1976) 'potlatch' and gifting are presented as all-consuming displays of pre-capitalist sociality in contrast to the commodity exchange of modern industrial economies.

59 *Life* magazine, 3 May 1954.

60 Whilst the biography of Brownie Wise might initially be interpreted as corporate myth-making, in fact, according to personal documents, accounts of her hardship and endurance were not exaggerated. See Personal Documents, Wise Papers (#509), Archive Center, Smithsonian Institution.

61 'Help Yourself to Happiness', *Woman's Home Companion*, August 1953, p. 34.

62 Meyerowitz ('Beyond the Feminine Mystique') challenges Friedan's interpretation of postwar popular feminine literature, and argues that active and heroic female figures, in fact, predominated.

63 Receipts, corporate memos and personal letters reveal how Brownie Wise personally responded to correspondence and gave gifts from her personal shopping sprees. Wise Papers (#509), Archive Center, Smithsonian Institution.

64 Wise securely filed this note amongst her business and personal papers. Wise Papers (AC #509).

65 *This'n' That*, no. 1, in-house publication THP (1957), Wise Papers (AC #509).

66 'Personal Growth Comes from Know-How', *Tupperware Sparks*, vol. 2, 5 (May 1952), Wise Papers (AC #509).

67 Jubilee Celebration Song c. THP 1959, ex-Tupperware dealer's personal collection.

68 See Andreas Huyssen, 'Mass Culture as Woman: Modernism's Other', in Tania Modleski, ed., *Studies in Entertainment: Critical Approaches to Mass Culture* (Bloomington, 1989); Martin Pumphrey, 'The Flapper, and the Housewife and the Making of Modernity', *Cultural Studies*, vol. 1, no. 1 (1987); Sally Alexander, 'Becoming a Woman in London in the 1920s and 30s', in *Becoming a Woman and Other Essays in 19th and 20th Century History* (London, 1994); Deborah S. Ryan, 'The Daily Mail Ideal Home Exhibition and Suburban Modernity 1908–1951' (Ph.D. manuscript for submission 1995, University of East London).

69 See, for example Ruth Schwarz Cowan, *More Work For Mother* (New York, 1983) and Adrian Forty, *Objects of Desire: Design and Society 1750–1880* (London, 1986).

70 Memo 27 October 1953 from Brownie Wise to Earl S. Tupper 'RE: Press Party in New York'. Tupper Papers (#470), Series 3, Box 6. Editors present at the press party included those from *Business Week*, *American Journal of Commerce*, *Mademoiselle*, *Glamour*, *Opportunity*, *Newsweek*.

71 Brownie Wise sponsored the hybridization of a Tupperware rose by the horticulturialist responsible for what she described as 'the only truly thornless rose'.

72 Quoted in 'An Open Letter to All Distributors and Dealers', 21 August 1955, Tupper Papers (#470), Series 3, Box 6, Archive Center, Smithsonian Institution.

73 'Wishes Can Come True With Tupperware', pamphlet, c. 1954. This sentiment was prevalent in Wise's numerous public addresses. Wise Papers (#509).

74 'Inside the Home of the Week', *Orlando Sentinel*, *Florida Magazine*, Sunday 25 April 1954, p. 5-D.

75 'Things We Should Use', pamphlet, p. 1, Wise Papers (#509), Archive Centre, Smithsonian Institution.

76 *Teen*, June 1960, vol. 4, p. 39.

77 *Co-Ed: The Magazine for Career Girls and Homemakers of Tomorrow*, vol. 5, no. 8 (May 1960).

78 M. Csikszentmihalyi and E. Rochberg-Halton, *The Meaning of Things* (Cambridge, 1981) provides a thorough ethnographic study of material culture and consumption but prioritizes generation meaning and the significance of 'cherished objects'. A. Vickery, 'Women and the World of Goods: A Lancashire Consumer and her Possessions, 1751–81', in J. Brewer and R. Porter, eds, *Consumption and the World of Goods* (London, 1993) provides a useful historical model which challenges the division between 'public' and 'private' domains and accentuates the historical significance of domestic economy and consumption.

79 J. Carrier, 'Reconciling Personal Commodities and Personal Relations', *Theory and Society*, vol. 19 (1990), pp. 579–98.

80 In this context the term 'moral economy' is principally derived from anthropological literature. An excellent summary of its relevance to consumption studies is provided by Silverstone, Hirsch and Morley in Chapter 1, 'Information and Communication Technologies and the Moral Economy of the Household', in R. Silverstone and E. Hirsch, eds, *Consuming Technologies: Media and Information in Domestic Spaces* (London, 1992). They emphasize the moral economy of the household as 'both an economy of meanings and a meaningful economy' which most significantly 'stands in a potentially or actually transformative relationship to the public, objective economy of the exchange of goods and meanings', p. 18.

81 Wise's departure from the company was shrouded in mystery and caused great embarrassment to the corporation. During my research there was a notable reticence to speak of the circumstances surrounding the events. One oral history of a long-serving female member of staff suggested that Wise constituted a hindrance to the public sale of the Tupper Corporation: 'no one minded a man having such power over women but the following Brownie generated, woman to woman, spooked the male executive'.

82 Details contained in unpublished manuscript, 'Outline for a Biography of Earl S. Tupper' by Neil Osterweil, Tupper Papers (AC #470).

83 *Which?* Consumer Association report, December 1965.

84 The *Daily Mail*, 23 June 1961, described Tupperware activities under the headline 'As the Soft Sell Steals into Suburbia'.

85 Product description cited in catalogue 'Tupperware – a household word in homes everywhere!' under the title 'How did I ever keep house without it?', THP, 1957, p. 29.

86 Meyerowitz, *Not June Cleaver*, p. 11 emphasizes that such issues have been avoided by feminist historians of postwar America.

DEEP SUBURBAN IRONY

The perils of democracy in Westchester County, New York

Nancy G. Duncan and James S. Duncan

INTRODUCTION

In this chapter we analyse the role played by the landscape in the aestheticization of the suburban politics of exclusion. The empirical material we have based this chapter on is drawn from a long-term research project conducted in Westchester County, a suburban area outside New York City. We have been studying Westchester on and off for twenty years (J. Duncan 1973; Duncan and Duncan 1984; N. Duncan 1986; Duncan and Duncan forthcoming). We have family living there and Nancy was born and raised there. We will focus primary attention on Bedford Village, which is among the most affluent towns in the county[1] and whose landscape is maintained by some of the most exclusionary zoning practices anywhere in the United States. Approximately 80 per cent of the town is zoned for single-family houses on a minimum of four acres, approximately 95 per cent for houses on one or more acres, and less than 1 per cent for two-family dwellings or apartments. Furthermore, unusually stringent subdivision regulations make the subdivision of very large properties into legal lots of four or more acres, in most cases, prohibitively expensive. The town's zoning thus effectively shifts the burden of providing housing for the county on to other less affluent and politically less well organized communities.[2]

Bedford's residents are extraordinarily vigilant and at times aggressive in retaining and maintaining the dirt roads lined with dry stone walls.

Conservationists protect its brooks, ponds and wetlands with great zeal and at great cost to the town; and historical preservation committees buy, maintain, restore, and/or closely regulate the most minute architectural details of the white wooden shops in the village centre.

We also look at an adjoining town, Mount Kisco, because it provides contrast to Bedford in socio-economic terms[3] and has a less restrictive zoning code, especially in its much smaller minimum lot size requirements. Mount Kisco is more urban in character than Bedford and has only very recently experienced anti-growth movements. Unlike Bedford, Mount Kisco is known for its boosterism, and its merchants, developers and politicians have traditionally wielded more power than ordinary citizens. Mount Kisco has been home to a series of low-income immigrant groups, most recently from Central America.

Challenges to exclusionary zoning in Bedford have remained largely ineffective. Denial of the right to housing is excluded as a charge because housing is not considered a fundamental constitutional right in the United States and fur-thermore only those who already own land in the town have standing in court in order to bring a suit against a town; thus potential residents are barred from challenging the town's zoning. Furthermore, the almost universally cherished 'home rule' concept has effectively kept at bay most challenges to its zoning by developers, regional planners and others wishing to open it up as a potential site for affordable housing. Bedford's zoning (greatly compounded by the fact that much of the surrounding county is nearly as exclusive)[4] causes hardship in the form of overcrowded, over-priced housing, much of which is located far from suburban and New York City jobs.[5] It produces a segregation of rich and poor and as a result an inequality of public services, especially education. As one commentator put it:

The exclusionary laws are not completely explicit: there are no zoning maps divided into racially or economically restricted areas, so labelled. But there are thousands of zoning maps which say in effect: 'Upper-Income Here', 'Middle to Upper Income Here'; 'No Lower-Income Permitted Except as Household Employees', 'No Blacks Permitted'.

(Reeves 1974: 304)

Although the causes of the inequities wrought by exclusionary zoning are largely structural, we found that they were reinforced by hegemonic ideologies subscribed to *not* only by those whose material interests are served by the structural arrangements, but also by those whose interests are not.

At the deepest level, and least open to question, are such structural arrangements as the institution of private property. Other related structural

factors include a high degree of fragmentation of local governments into many relatively autonomous units. Each town has control over its own school system supported largely by local property tax money and therefore very unequal budgets. Each town also controls its own zoning ordinance. This allows relatively homogeneous communities to protect their property values, preserve their amenities, restrict the numbers of households, types of houses and consequently types of people who may live in a community. Thus there is a clear 'mobilization of bias' in the structure of local government which favours the interests of certain classes. Ironically, this bias is reinforced by the fact that those whose interests are not served are largely unaware of it.

The results of a survey of 130 residents of Bedford, Mount Kisco and two other contiguous towns confirm an ignorance of zoning as a structural factor affecting their access to residential, educational, and environmental resources, despite wide publicity given to court cases against 'snob zoning' in the popular press. Less than 14 per cent of those asked cited exclusion as a purpose of zoning, while the majority thought it was to retain the rural atmosphere. When the answers are correlated with occupations, of those in the semi-skilled manual and unskilled manual category only 20 per cent thought it was exclusion. In the lowest education category (high school or less) only 17 per cent thought so. Typical of the answers we were given to the questions about the purpose of zoning was 'To give people elbow room. I think that it's all right – to each his own. People must want it that way.' Expressed over and over again was a belief in the inherent value of the 'right to choose' with little thought given to the interdependence of these alleged 'choices' (N. Duncan 1986: 282–322).

The structures that maintain the spatial arrangements of populations and resources were found also to include hegemonic belief structures, such as the American values of home rule or local self-determination and possessive individualism. In order to understand the extent to which the attitudes of a whole cross-section of residents of the two towns may reinforce the institutional biases, seventy interviews were conducted in Bedford and forty in Mount Kisco.[6] Respondents were chosen to represent a socio-economic cross-section of the populations of the two towns.[7]

We have identified two multi-stranded ideologies which underlie the consciousness and practices of these suburbanites. The first is what C. B. MacPherson (1962) has called possessive individualism and the second is the ideology of the aesthetic. Possessive individualism can be seen as comprising private ownership, democracy, and, by extention, local control. The aesthetic, as we use it in this context, is composed of distinction,[8] heritage,[9] and environmental preservation.[10]

THE IDEOLOGY OF POSSESSIVE INDIVIDUALISM

The ideology of possessive individualism forms the ideological basis of the modern liberal/humanist political theory of capitalist society. It is a set of propositions derived from the political theories of Hobbes and Locke.

Three important components of the ideology of possessive individualism are private ownership, democracy among equal individuals, and local control. Private ownership is the idea that the individual is the proprietor of his or her own person, capacities and possessions and by extension that one is largely responsible for his or her own position in life. As such, private ownership is a basic tenet of bourgeois market society. Privately owned goods are markers of identity, even constitutive of identity. In the American context, democracy combined with localism (which can be considered the counterpart to individualism at the community level) posits the rights of theoretically free and equal individuals to come together at the local level to decide rules for protection of property and maintenance of a community of like-minded individuals who value their relative independence from state and federal governments.

Several different types of questions were asked in order to elicit views on the causal processes of landscape change and the role of individuals versus institutions or structures in these processes of change. Answers revealed that a belief in possessive individualism is strongly adhered to throughout all educational and occupational levels of the local population. By asking people why they chose to live in their town, we were able to get a sense of the aspects of the living environment which were most important to people and the degree of freedom people believed they had in choosing between various locations. There was a clear contrast, for example, between those who emphasized the aesthetic values of particular landscapes which they have chosen for themselves and those whose reasons were of the negative 'the only place I could get' variety as in 'my landlord threw me out and my social worker got me a place here'. It appeared from the interviews that the perception of choice or self-determination in one's living environment is apt to be related to an active approach to maintaining or improving one's living environment. A more passive approach, on the other hand, is usually correlated with a lack of economic resources.

Questions were also asked about the following: how they thought towns had developed, any changes in the physical appearance and nature of the population of the town that they had noticed, as well as what changes they expected, wished

for, and feared. Each of these questions was a lead-in to more revealing questions about why the respondents think these changes have taken place. Examples include: 'Why would you say these towns developed differently?' 'How would this come about? 'Could you or someone like you influence these changes in any way?' 'Why would this happen?' 'What would prevent this?' 'Do you belong to a homeowners' association?' 'Have you ever participated in a zoning controversy of any kind?'

Answers revealed people's understandings of the causal processes by which landscapes develop and the power they think individuals have to influence changes in the landscape. Thus we were able to reconstruct perspectives on power and gauge the degree of alienation from the structural contexts of individual action. We could thus understand more about the basis for an individual's activity or inactivity which is an important part of the structuration, and especially, the reproduction, reshaping, and maintaining of the larger structural context.

By combining answers to the above questions we categorized their positions on the basis of pluralism, elitism, and structuralism. The correlation of answers with education and occupation is dramatic. Most of those respondents with more education and higher levels of occupation appeared to subscribe to a pluralist view of power, the idea that all individuals or interest groups have a fairly equal opportunity to influence local government decision-makers who are seen as responsive to the desires of citizens.[11] Those with the least education and lowest levels of occupation and income tended to subscribe to elitist theories which see only politically powerful or elite members of society as able to determine change. Very few people of any level of education or occupation subscribed to ideas that could be considered structural. In other words the majority did not recognize the degree to which institutional structures constrain their freedom to act. We would argue that these answers reveal the power of individualism as an American ideology.[12]

It seems logical that there is a dialectical or self-fulfilling relationship between political consciousness, that is, popular theories of power which people hold, and the amount of power they actually obtain. This certainly is not to say that people can exercise as much power as they want. We are suggesting that there are clear variations in the amount of power to which people can have access and that one, but only one, of the factors creating this differential is political culture. Individual political efficacy also varies depending upon access to various political resources and structures. Some people may be a part of an elite social network with informal ties to members of planning or zoning boards, others may simply have more education, or have free time to circulate petitions, or increasingly individuals use

their money to hire experts to bolster whatever case they wish to make. For example, on numerous occasions experts have been brought in by individuals and groups, often at great personal expense. Environmental lawyers and law professors, environmental consulting firms, and national conservation organizations including the Sierra Club (founded in the nineteenth century to protect wilderness areas in the US, it now has 750,000 members in North America) have been asked to lend their expertise and support by those with the time and money to devote to fighting the further development of open spaces in Bedford.

The case of Mount Kisco illustrates the dialectical aspects of the attitudes and structures in that more of its citizens hold to an elitist theory of power than do Bedford's. Over the long term these attitudes have been an ideological force helping to create a political culture that has moulded and been moulded by an elitist structure of politics in the town.

Some people, especially the better educated of Bedford, may actually have less power and freedom than they believe they have. Although they are constrained to work within a highly structured context, they take this constraint for granted to such an extent that they are largely oblivious to it. They thereby reify it, reproducing it intact, unaware of the limits to their freedom.

The wide range of responses was striking. When asked how much influence to bring about change she believed she had, a respondent with some graduate education replied 'I have [made changes in zoning] by my sole initiative.' Another with a college degree said, 'Definitely, petition circulation is thriving around here.' A third remarked, 'I am a member of the Bedford Garden Club. The Club has been most influential. We need eternal vigilance. There are six thousand acres of land. That gives us a tremendous responsibility.' Another said, 'You have to let your voice be heard. Zoning was not foisted on this town. You can make it or keep it as you want it. The taxpayer's voice is heard.' An attorney said, 'In this town people of all persuasions can have a say.' And yet another said, 'I helped my neighbours push for upzoning.' An African American man with one year of graduate school education said, 'Sure. Politicians are like anybody else. If you make enough noise they have to change it.' One respondent who hopes the landscape will remain 'unspoilt by indecent commercial downzoning' claimed, 'If it is possible anywhere it is possible in Bedford. People are very careful about zoning. We have a very fastidious beautification committee.'

In contrast to these confident views, a stonemason from Bedford with eight years of education said, 'It's up to the ones who run the village. If they have a good idea they will do it.' Another respondent with a high school education replied, 'I doubt it, it's the higher ups that do everything. So why take an interest?'

And yet another said, 'I am only a rent payer, *they* have more of a right to decide.' A housewife with ten years of education said, 'Are you kidding? No matter how much you voice your opinion.' In Mount Kisco a seventy-five-year-old African American handyman with three years of formal education said, 'How can I make a change?' He named two merchants: '[they] will tell you how to run this town. They run this town.' A retired railway clerk with eight years of education commented, 'No, because wealth is not spread out. The wealthy control the growth of this town.'

As we have stated above, a third strand of possessive individualism is localism. Of all the questions we asked, it was the one about localism which showed the least differentiation on the basis of education or occupation. In fact there was almost complete consensus on the idea that a community should be self-governing. More than 98 per cent of the respondents preferred planning and zoning to be done at the town level. For virtually every respondent 'home rule' was taken for granted as beneficial; in fact many people expressed horror at the very idea of anything else. The term 'home rule' was used over and over again although it was never used in the questions asked.

This is interesting, because we would argue that local control is *not* in the interests of many of those interviewed, namely those who are excluded by the locally controlled zoning laws. Nevertheless there was strong support for the present structure of planning and zoning expressed by respondents, with only one person suggesting that it should be done at the regional level rather than each town retaining responsibility. Typical answers were: 'That would be striking at the heart of the American way of life', 'I would *hate* that', 'You have to have home rule', 'It's unfair for people from elsewhere to dictate changes. Each town is different', 'Each town knows its own problems', and 'A disaster! A gross infringement!'

Localism is traced back to colonial New England and is associated with the idea of harmony and consensus among a small, homogeneous community of like-minded individuals.[13] As with individualism, localism is also founded on the notion of racially independent autonomous units. It would appear that the majority of those interviewed assumed that the uneven distribution of housing opportunities is an outcome of so-called natural forces of supply and demand in which individuals exercise relatively free choice in housing decisions. Thus individualism adds reinforcement to the often unrecognized structural bias in favour of the more wealthy and the already established residents of Westchester.

Questions were asked about people's awareness of the interdependence between towns, and the responsibility they believe their own and other towns have towards meeting a share of the region's need for rental and subsidized housing.

Sixty per cent of the more educated, professional respondents and 92 per cent of the least educated, semi- and unskilled respondents believed that a town's zoning policy would not affect surrounding towns. Few people recognized the negative impact one town can have on others. The thought that each town does and should represent a self-contained autonomous community of like-minded individuals was taken by many as a self-evident truth.

Most respondents did not think that the town had a responsibility to provide any more affordable housing for the metropolitan area. While this may be unsurprising, we would argue that it points to a need for effective planning and rezoning at a regional scale, an idea which, as we have noted above, was rejected by more than 98 per cent of our respondents, including many who would benefit from the opening up of the more exclusive Westchester towns to affordable housing.

The most tragic effects of the individualistic ideology we found are what Sennett and Cobb (1973) have called 'the hidden injuries of class'. These hidden injuries result from the fact that the hegemonic ideology, which assumes that the individual is largely responsible for his or her own social and economic position, is often subscribed to by those whose interests are not served by this ideology. It is the self-doubt of people who see only individual factors in their relative success and failure. The results of the survey confirm an ignorance of zoning as a structural factor affecting life chances.

People who live in the poorer parts of Mount Kisco tend to see the overcrowded rundown condition of their home environment as tangible proof of their failures. Again we would argue that this blindness to structural causation is a result of the tendency of Americans to blame or credit themselves for their failures and successes. It is a good example of the ideology of individualism at work in society, suppressing potential political action against inherent (but largely unrecognized) biases in the structure of local government.

Of course we should mention that to some the landscapes of Mount Kisco are seen as a tangible sign of success, particularly to those new immigrants who were not raised to expect as much as the American dream promises. Also we should point out that the ideological structures in Westchester are by no means monolithic and include oppositional as well as hegemonic ideologies; nevertheless a very high degree of consensus on individualism is strikingly evident. It appears that whether or not they are rich or live in Bedford, almost all seem to think that those who live there deserve to. They fail to see the structure of zoning as a subsidy to the residents by guaranteeing far more privacy and low density of housing than they could otherwise afford. Thus through legislation which requires

that all one's neighbours own at least four acres of land, the 'beauty' of a pastoral landscape is maintained for a resident that even owning one hundred acres could not otherwise achieve.

Most of our respondents see the landscape of Bedford as material proof that the American dream is achievable. Even if they themselves never expect to live there, many of them hope that their children will. As one person said of four-acre zoning in Bedford: 'People who can afford it should have it; if you like seclusion – if you have the money. It doesn't hurt anyone.' Another said, 'They want suburban country life. If individuals want and can afford four acres – a secluded country atmosphere – they should have it.' 'If you have the money you can go there.' And another, 'to each his own. People must want it.' Over and over again the right to choose is invoked; virtually no thought is given to the interdependence of these choices.

When respondents from both Bedford and Mount Kisco were asked, 'would you say that Bedford's land use policies affect surrounding towns such as Mount Kisco?' a clear majority (61 per cent) said no. Only 25 per cent said yes and 14 per cent said the effect would be minimal or insignificant. Comments such as 'They've done their own thing'; 'I don't think so, except we keep big homes here so surrounding values go up'; 'I don't see how unless people resent it'; 'No because there's enough land to spread out'; and 'No, because if you have the money you can go there' were typical. On the other hand some others said, 'It will push more people this way. They are protecting themselves' and 'Yes, everything gets thrown into Mount Kisco.' It might be noted that the bitterness comes primarily from those living in middle-class housing who do not want any more apartments in Mount Kisco. The 'live and let live' attitude comes primarily from the poorer residents.

One Bedford resident who lived on four acres himself did observe that the American dream of upward mobility is an important factor in supporting legislation that helps to reproduce social distinctions. He said, '"Keep Bedford Green" is a euphemism used by those who inherited or bought property. You often hear people say I worked hard for what I have, I don't want anyone to take it away.' He then added that 'often it is more true of those who don't live on four acres, but hope to'.

THE IDEOLOGY OF THE AESTHETIC

In market society where identity is linked to possessions, the aesthetic occupies a key place. Landscape taste functions as a marker of identity and in particular of class identity (Duncan 1973). The residents of Bedford much more than Mount Kisco appear to attach symbolic and sentimental value to their town's landscape. For some people landscapes have their primary symbolic value as an indictor of social status and a particular lifestyle based on the model of the English country house, an idea commonly associated with high status among North Americans (Duncan and Duncan 1984). Residential location and landscapes are collectively and conspicuously consumed. Especially where zoning is tightly controlled, a residential landscape is a positional good which can help in the reproduction of a class or status group, because a limited number of people can share in it. Furthermore, aesthetic appreciation of particular landscape styles and patterns of consumption can be subtly defined and redefined to exclude others. Achieving a place in the landscape goes a long way towards achieving a place in the status group whose landscape taste is represented by that landscape. The struggle to preserve landscapes can thus become quite acrimonious not only because property values are involved but, perhaps more importantly, because identity is involved as well. Thus, there is no such thing as 'mere aesthetics'. There is always a politics of aesthetics, and in the case of Bedford, we argue, an aestheticization of politics.[14]

DISTINCTION

We use the term 'distinction' to refer to the aestheticization of class. The aesthetic serves as the basis of a taxonomy which effectively depoliticizes the notion of economic classes about which Americans tend to be – at the very least – uncomfortable.

Such an aesthetic classification serves to legitimate social differentiation and obscure its economic basis by quite literally concretizing it in the material landscape.[15] The aesthetic ideology of distinction operates only partially on discursive knowledge; much of this ideology functions on the practical level (that which people know but do not articulate).[16] It is, as Bourdieu (1984: 3) puts it, 'an enchanted experience of culture which implies forgetting the acquisition'.

Following Barthes (1986: 129), one useful definition of ideology is the conversion of the cultural and historical into that which is thought to be natural. In the case of the Bedford elite, aesthetic judgements about landscape constitute this type of 'enchanted' or ideological form of cultural knowledge. As Bourdieu (1984: 11) points out: 'upper class propriety treats taste as one of the surest signs of true nobility and can not conceive of referring taste to anything other than itself.'

In Bedford it is common to believe that the purpose of zoning is either principally or solely aesthetic, 'to preserve and beautify'. As one person said:

I think it's aesthetic more than environmental and it isn't about who lives in these houses either – it's about how well they preserve the Bedford style. Money certainly isn't the question. In fact having money can be considered a liability around here; if you have bad taste it shows all the more because you have more discretionary income to put into making over your property.

Another person said, 'I am afraid that they will overthrow zoning and ravage beautiful land as in Long Island.' Another said, 'Why should the land be ruined for the rest of us?' 'Keep city developers out. They're not the right type to develop Bedford.' Such aesthetic judgements extended from the scale of the landscape of the whole town down to decorative details on buildings. For instance, the colonial-style lamp posts and eagle ornaments commonly found on developer-built houses in the area were considered, as one respondent put it, 'in dubious taste'. Another said that the many new electrified iron gates at the entrances to properties in Bedford are 'just *nouveaux riches* showing off. You can't see their houses down the long driveways so they have to announce the fact that there is a grand house back there. Gates are bad but stone lions are worse.'

Restating this issue of the aesthetics of class in terms of MacPherson's categories, one could say that taste, having undergone a process of cultural enchantment, is transformed into a natural, objective possession of the sovereign individual. Distinction as an aesthetic ideology is interpenetrated by two other aesthetic ideologies, that of history and that of nature.

THE AESTHETIC IDEOLOGY OF HISTORY

History as an aesthetic ideology within the context of Bedford is encoded in a few large tomes composed by amateur historians, preserved in official records and family genealogies, and re-enacted in public pageants. However, for most of the

respondents Bedford's history is artefactual. It is encoded in the landscape itself. It is represented by such fine old buildings as the library, the museum, the courthouse, small, privately owned, pre-revolutionary farm houses and large, nineteenth-century houses set amid fields on large estates, by houses built by famous early twentieth-century architects like Stanford White, and by 'natural' objects such as the highly revered three-hundred-year-old Bedford Oak.

It is not uncommon for the three centuries of Bedford's official history to be conflated into a generalized and aestheticized notion of the past. One of the most common adjectives used to describe Bedford was simply 'historic', which is seen as inherently good. One resident claimed that he moved to Bedford 'because of its pre-revolutionary flavour' while a local author said: 'Here in Bedford we have a late 18th and early 19th century village "on ice" so to speak, visualized for us in total, and almost perfectly preserved' (Parker 1979: 53).

This aesthetic encoding of history is crosscut by a number of different ideologies. The few remaining small, pre-revolutionary houses could be said to encode an egalitarian individualism in the idealized rural democracy of small self-sufficient farmers, whereas the nineteenth-century mansions and estates symbolize urban capital emanating out of New York as well as the coveted imagery of the aristocratic estate life of rural England at that time. One can see elements of the former belief in statements such as 'Bedford is the only New England Village in New York State and its tradition of citizen participation in government derives from this.'[17] And one can see elements of the latter in real estate advertisements entitled 'English Manor House', 'a parklike English Country setting', and 'An eighteenth century beauty. Time has not changed the views from this spectacular 12 acre pastoral hilltop.'

The town's historical society invites people to celebrate the history of their town, to identify with it, and to see it as part of their own heritage. Respondents made such remarks as, 'We are proud of the history of our town', or 'We must preserve our heritage'. The linking of identity to the past (our town, our heritage) operates by invoking the discourse of ancestry and hence naturalizes it. Again, as we saw with the ideology of distinction, the cultural is mystified through conversion into the natural and taken for granted. But this search for the authentic, for the 'way we were' is a fictive history of identity often based upon a fictive kinship. While the vast majority of residents do not have ancestors from Bedford, there is a large group of residents whose ancestors were the Italian labourers who built roads, aqueducts and buildings throughout Bedford and the surrounding area. It is these Italian workers whose lives have largely been erased from the myth history of Bedford. Their middle- and upper middle-class

descendants today would appear to accept the Anglo history and anglicized historical aesthetic of Bedford as their own.

One group that has recently begun to migrate to Bedford comprises actors, actresses, and others in the entertainment industry from Hollywood. We interviewed several, and they all expressed a desire to live in a 'real' understated community where they can raise their families away from what they see as the 'inauthenticity' of Hollywood. They wish to partake of the historical 'authenticity' of Bedford. As one respondent put it:

People know who you are but they want privacy themselves, so they respect yours. We feel that we can lead a quiet life in a healthy atmosphere to raise our children where they can learn to respect nature and animals.

Later in the interview she stated that through 'living in Bedford he [her son] is developing a sense of American history'.

Because the historical is aestheticized and treated as an object by those of 'good taste' it can be consumed as a good. 'Tradition' and 'ancestry' are sold to an upwardly mobile generation moving out of Manhattan, as can be seen in such blatant real estate advertisements as those entitled 'Born Aristocrat', 'Lord of the Manor' or '18th Century Gentleman's Farmstead'. People are told that they can partake of the heritage of the place if they own property there.

THE AESTHETIC IDEOLOGY OF NATURE

The aesthetic ideology of nature in Bedford is inextricably intertwined with the ideologies of possessive individualism, distinction, and history. It is important to note that nature within Bedford is also privatized and thus is based in possessive individualism. Despite the rhetoric of public good and public responsibility (gifts of land to the town are encouraged and received), in fact nature is bought, possessed, and sold.[18] Having said this, it is useful to discern two interconnected strands of the aesthetic ideology of nature: the mythology of 'natural', 'untamed', picturesque nature on the one hand, and the mythology of the pastoral, rural, or tamed nature on the other. The mythology of the natural partakes of eighteenth- and nineteenth-century romanticism, of a belief in the righteousness of stewardship, in this case the charity of preserving 'nature' through low population densities. As one resident said:

I think our zoning should be 40 or 35 acres. There could be a tax benefit for keeping the land open. I resent real estate people. I call this holy land. I love this land. Politicians and developers are hard hearted people who don't understand ecology.

In Bedford, the Town Board and influential citizen groups have been able to enlist the support of national groups such as the Sierra Club to help fight land subdivision in the name of preserving the natural environment. On one dead-end road in Bedford, several properties adjoined a large, undeveloped, rather hilly and rocky piece of land. Many residents on the road signed petitions and organized meetings at which they had arranged speakers who were experts on environmental law to oppose its possible development. A number of years ago an environmental lawyer was hired by the town to replace the local attorney because the other side (developers) hired lawyers specializing in opposing exclusionary zoning.

Although one could say that environmental preservation is to nature what historical preservation is to history, this might lose sight of the fact that nature as an aesthetic ideology is also historicized. The picturesque, wild nature, even of the often simulated variety found in Bedford, is seen as an attribute of the past. Americans tend to associate wilderness with a retreat from the stresses of modern civilization. This is the romantic, regenerative ideology of wild nature that elites see as their duty to preserve. The upper-class notion of stewardship is exemplified in the following pronouncement by one of our interviewees: 'it is our *duty* to preserve the many lovely trees and also to conserve the wetlands.'

The second ideology of nature is that of the pastoral or tamed nature which is known locally as simply 'rural'. The pastoral as aesthetic ideology, sometimes linked to Anglophilia, is seen in the preservation of well-tended country estates, of manor houses and outbuildings, of fields studded with great oaks and surrounded by stone walls, of ponds stocked with ducks and geese, and of hundreds of miles of bridle paths interconnecting the wooded areas and the open fields. One respondent informed us:

We want to keep Bedford rural. We personally like being surrounded by property. Some people say we have our zoning to keep other people out, but they don't understand. You have to keep the population down to keep it rural. We are not talking about discrimination, we are talking about aesthetics.

We can see the linkages drawn by the speaker between the rural, property ownership, exclusion, and a cultural aesthetics.

The pastoral partakes of the ideology of possessive individualism, as well as the

aesthetic of history, in that it encodes early American liberal democracy or rural populist democracy, the small freeholder on the land. For some however, it can simultaneously signify an elitist ideology of distinction in its evocation of the landscape model of the eighteenth- and nineteenth-century English landed elite.[19] Thus we have the overarching concept of the rural.

Nature, whether we are speaking of the picturesque or the pastoral, is an ideology linked to possessive individualism, distinction and history. It is used to aestheticize the politics of land use and exclusion. It serves to naturalize the process of landscape development in such a way that issues of economic class and social justice are mystified. Thus we would argue that in Bedford, as is often found elsewhere, there are few things more cultural than nature.

CONCLUSION

To conclude we ask what role we as academics have in the situation we describe. We have taken a strong line on the effectiveness of hegemony and the weakness of resistance in this particular time and place. Indeed our hidden injuries of class argument employ a concept of contradictory or ambivalent, if not false, consciousness. While we critically investigate the possessive individual as a subject position constructed through liberal humanist discourses, as products of this discourse ourselves we may also find it difficult to escape from. It is hard thoroughly to grasp the idea that the power of ideologies is not imposed on and against an already free subject, but rather is constitutive of the subject. In our analysis of the ideology of individualism and discourses of distinction and the hidden injuries these inflict, we must confront the fact that a simple unmasking of the ideology is not possible, because it mistakenly presumes that behind the false appearances there exists a free subject that is merely misinformed. In other words we might succeed in convincing more people in Westchester of the structural biases in favour of the rich, and structural solutions might accordingly be sought. However, the much more fundamental hidden injuries of individualism are so thoroughly productive of individuals' fragmented and complex identities that no simple demystification would be possible. Therefore, by claiming to unmask it, we in fact reinforce the humanist individualism we wish to criticize. We must therefore admit a more circumscribed role for ideology critique and demystification.

Geographers have noted with pride that since the advent of postmodernism the

ideas of space- and place-based identities have increased greatly in popularity outside geography. However, it is possible that when metaphors of localism such as spaces of resistance are seen in material, on the ground, geographical terms, the consequences we discussed earlier such as the social inequities that result from localism and segregation simply cannot be avoided. While localism can in other cases be empowering for oppressed groups, it is frequently conservative of the status quo. Even more than subordinate groups, elite groups with the most political resources use localism as a basis for reinforcing their power. Localism, like individualism, may be an optimistically naive discourse that suggests that people are equal and sovereign consumers free to vote with their feet by moving from one space to another maximizing the congruence between their individual preferences and particular bundles of goods and services available in particular locations. As one woman in our study put it, 'Each town has its own personality and its own approach. If I wanted a different approach I would move there.' Her freedom to move may not be shared by the majority of the population. Furthermore, as we found in our study of exclusionary zoning, some of the most effective spaces of resistance are elite spaces of resistance to socially progressive change.

To summarize the argument presented in this chapter briefly, we suggest that there is an aestheticization of the suburban politics of exclusion focused on the landscape. This aestheticization operates through appeals to both historical preservation and environmental conservation as well as the ideals of the pastoral and the picturesque. This aestheticization is effective, we argue, because the American ideology of individualism influences people to seek concrete, visual evidence of individual successes and failures; such evidence is often sought in the residential landscape. Residents of the most sought-after residential areas attempt to maintain and enhance the beauty (and hence prestige) of those areas by excluding new development, especially higher-density, less expensive housing. Appeals to the virtually universal values of history and environment allow the exclusion to proceed with support not only from the excluders, but from a significant proportion of the excluded as well. This we refer to as the aestheticization of politics. Again the ideology of individualism and localism reinforces this process by obscuring the mobilization of structural biases such as locally controlled zoning and planning in favour of the wealthy.

Although we claim to have uncovered ideological blindness, we feel somewhat uncomfortable with the modernist moral certitude of ideology critique which so valorizes the idea of critical distance and expert judgement. Nevertheless, we do not want to be forced by such postmodern angst into an uncritical stance. Finally,

we believe that the study of hegemony in places where it is extremely strong is as important as the study of hegemony where it is fragile and highly contested and that Bedford is clearly an example of the former.

NOTES

1 The mean 1990 annual family income in Bedford was $124,109; the median was $80,690.

2 For further references in the geographic literature on the class politics of zoning see Cox (1989). Cox offers an alternative to analyses (such as our own) which define zoning conflicts in terms of contests between classes defined by socio-economic status. He suggests that a territorial politics of collective residential consumption can be linked through the concept of flexible accumulation to the opposition between labour and capital. While acknowledging that this is a valuable project, we focus our attention in this chapter on questions of alienation, ideological blindness, and the aestheticization of politics.

3 Mount Kisco's mean and median annual family incomes, although not low by national standards, are considerably lower than Bedford's. The mean for 1990 was $61,822; the median was $51,486.

4 One nearby town, North Castle, was successfully sued by a developer on the basis of exclusionary zoning because it had allowed no multi-family housing whatsoever (*Berenson v. Town of New Castle* 1975). The court argued that the town failed to provide a variety of housing, thereby not sharing in a regional responsibility to provide adequate housing for all income levels. Bedford allows only a small amount of multi-family dwellings (less than 1 per cent of the land in the town) in a few locations where it does not threaten the more scenic of the town's landscapes and has thus been less vulnerable to such suits.

5 Although the county, regional planning associations, and large employers such as the Reader's Digest have produced studies to show the need for much more affordable housing in the area, a large majority of the residents, town officials, and planners we talked to were concerned only about housing for town employees such as school teachers, while a few thought that it was a shame that many of those who grew up in the town could not afford to remain there.

6 We conducted one questionnaire-based survey of 120 residents of Westchester County, including thirty people from each of four contiguous towns: Bedford, Mount Kisco, North Castle, and Somers. We also interviewed forty more people from Bedford and ten more from Mount Kisco. These interviews were more loosely structured and are not included in the percentages presented throughout this chapter. Quotations, however, are drawn for both sets of interviews.

7 The thirty respondents from each town in the more formal interview survey were chosen at random from three residential neighbourhoods identified on the basis of the socio-economic status of the residents. There are pockets of poor in Bedford and pockets of rich as well as a fairly large middle-class population in Mount Kisco; thus, despite significant overall differences in socio-economic characteristics of the two towns, it was possible to find respondents from both towns in all economic and occupational categories.

8 On the notion of distinction through the consumption of cultural goods and the role of taste in the formation of class identities see Bourdieu (1984, 1993).

9 There is a growing body of literature on the increasing interest in and commodification of heritage. See for example Hewison (1987, 1991).

10 On environmental preservation as an aesthetic ideology see Wilson (1992) and Oeleschager (1991).

11 In answer to the question 'Do you feel that you or someone like you could influence changes in any way?' the percentages of those who replied yes ranged from only 19 for those with less than a high school degree to 79 for those with a college degree and 87 for those with some graduate education. By occupation it ranged from 22 per cent for semi-skilled manual occupations to 88 per cent for professional managerial.

12 Here we use the term individualism in its broadest sense, pointing to the fact that individuals as individuals are seen as the primary influences in the public arena. What is thought to hold some back from achieving the ranks of the powerful are individual rather than structural factors. We use the term 'structural'

here as it is used in structuration theory (Giddens 1979, 1984). We do not subscribe to any form of structural determinism (see Duncan 1980).

13 Bedford proudly traces its roots back to New England as it belonged to the colony of Connecticut from 1680 to 1700. It should be noted that this nostalgic view of consensus is based on a myth as these communities tended to achieve consensus through the systematic repression of dissenting views.

14 This concept originated with Benjamin (1969) and members of the Frankfurt School. For recent discussions see Berman (1989: 27–41), Eagleton (1990: 366–417), and Harvey (1989: 31–5).

15 For empirical exemplifications of this see: Pratt (1981) and Duncan (1973), Duncan and Duncan (1988), Hugill (1986, 1989), Lowenthal and Prince (1965) and Wyckoff (1990). More generally on the symbolism of built form see Knox (1987, 1991), Ley (1987, 1993, 1995), Cosgrove (1984).

16 In using the terms 'discursive' and 'practical' consciousness here we point to Giddens's (1979) distinction between those causes, conditions, and consequences of their own actions which actors can articulate and those they cannot. Both have a bearing on political action and, more importantly, in this case, inaction.

17 There was a tradition in Bedford of tipping one's hat to its 'most venerable citizen', the Bedford Oak. A plot of land was bought around it by residents of the town in order to prevent any houses from being built anywhere near it. For a discussion of the mythology of the New England village see Wood (1991).

18 The aestheticization of nature is manifested in the scenic view which has tremendous monetary as well as aesthetic value. Wilson (1992: 42) makes this point in relation to the double meaning of the term 'scenic value'.

19 For discussions of this landscape model see Lowenthal and Prince (1965), Cosgrove (1984), and Daniels (1993).

REFERENCES

Barthes, Roland (1986) *Mythologies*, trans. A. Lavers, New York: Hill & Wang.

Benjamin, Walter (1969) 'The Work of Art in the Age of Mechanical Reproduction', in *Illuminations*, H. Arendt, ed., New York: Schocken.

Berman, Russell (1989) 'The Aestheticization of Politics: Walter Benjamin on Fascism and the Avant-garde', in M. Berman, *Modern Culture and Critical Theory*, Madison: University of Wisconsin Press, pp. 27–41.

Bourdieu, Pierre (1984) *Distinction: A Social Critique of the Judgement of Taste*, Cambridge, MA: Harvard University Press.

Bourdieu, Pierre (1993) *The Field of Cultural Production: Essays on Art and Literature*, New York: Columbia University Press.

Cosgrove, Denis (1984) *Social Formation and the Symbolic Landscape*, London: Croom Helm.

Cox, Kevin (1989) 'The Politics of Turf and the Question of Class', in *The Power of Geography: How Territory Shapes Life*, J. Wolch and M. Dear, eds, Boston: Unwin Hyman, pp. 61–88.

Daniels, Stephen (1993) *Fields of Vision: Landscape Imagery and National Identity in England and the United States*, Princeton: Princeton University Press.

Duncan, James (1973) 'Landscape Taste as a Symbol of a Group Identity: A Westchester County Village', *Geographical Review* 63: 334–55.

Duncan, James (1980) 'The Superorganic in American Cultural Geography', *Annals of the Association of American Geographers* 70: 181–98.

Duncan, James and Nancy Duncan (1984) 'A Cultural Analysis of Urban Residential Landscapes in North America: The Case of the Anglophile Elite', in *The City in Cultural Context*, J. Agnew et al., eds, Boston: Unwin Hyman, pp. 255–76.

Duncan, James and Nancy Duncan (1988) '(Re)reading the Landscape', *Environment and Planning D: Society and Space* 6: 117–26.

Duncan, James and Nancy Duncan (forthcoming) *Suburban Pretexts: Deconstructing History, Individualism and Nature in a Westchester County Town*, Baltimore: Johns Hopkins University Press.

Duncan, Nancy (1986) *Suburban Landscapes and Suburbanites: A Structurationist Perspective on Residential Land Use in Northern Westchester County, New York*, Ph.D. dissertation, Syracuse University, Department of Geography.

Eagleton, Terry (1990) *The Ideology of the Aesthetic*, Oxford: Basil Blackwell.

Giddens, Anthony (1979) *Central Problems in Social Theory*, London: Macmillan.

Giddens, Anthony (1984) *The Constitution of Society: Outline of a Theory of Structuration*, Cambridge: Polity Press.

Harvey, David (1989) *The Condition of Postmodernity*, Oxford: Basil Blackwell.

Hewison, Robert (1987) *The Heritage Industry*, London: Methuen.

Hewison, Robert (1991) '*The Heritage Industry* revisited', *Museums Journal* 91: 23–6.

Hugill, Peter (1986) 'English Landscape Tastes in the United States', *Geographical Review* 76: 408–23.

Hugill, Peter (1989) 'Home and Class among an American Landed Elite', in *The Power of Place: Bringing Together Geographical and Sociological Imaginations*, J. Agnew and J. Duncan, eds, Boston: Unwin Hyman, pp. 66–80.

Knox, Paul (1987) 'The Social Production of the Built Environment: Architects, Architecture and the Postmodern City', *Progress in Human Geography* 11: 354–77.

Knox, Paul (1991) 'The Restless Urban Landscape: Economic and Sociocultural Change and the Transformation of Metropolitan Washington, D.C.', *Annals of the Association of American Geographers* 81: 181–209.

Ley, David (1987) 'Styles of the Times: Liberal and Neoconservative Landscapes in Inner Vancouver, 1968–1986', *Journal of Historical Geography* 13: 40–56.

Ley, David (1993) 'Past Elites, Present Gentry: Neighborhood of Privilege in Canadian Cities', in *The Changing Social Geography of Canadian Cities*, Montreal: McGill-Queens University Press.

Ley, David (1995) 'Between Europe and Asia: The Case of the Missing Sequoias', *Ecumene* 2, 2: 185–210.

Lowenthal, D. and Hugh Prince (1965) 'English Landscape Tastes', *Geographical Review* 55: 186–222.

MacPherson, C. B. (1962) *The Political Theory of Possessive Individualism: Hobbes to Locke*, Oxford: Oxford University Press.

Oeleschager, Max (1991) *The Idea of Wilderness: From Prehistory to the Age of Ecology*, New Haven, CT: Yale University Press.

Parker, Tom (1979) *Westchester Magazine*, April: 52–9.

Pratt, Geraldine (1981) 'The House as an Expression of Social Worlds', in J. Duncan, *Housing and Identity: Cross Cultural Perspectives*, London: Croom Helm.

Reeves, Richard (1974) 'The Battle over Land', in *Suburbia in Transition*, Louis Masotti and Jeffrey Hadden, eds, New York: The New York Times Company, pp. 303–11.

Sennett, Richard and Jonathan Cobb (1973) *Hidden Injuries of Class*, New York: Vintage.

Wilson, A. (1992) *The Culture of Nature: North American Landscape from Disney to Exxon Valdez*, Oxford: Basil Blackwell.

Wood, Joseph (1991) 'Build Therefore, Your Own World: The New England Village as Settlement Ideal', *Annals of the Association of American Geographers* 81: 32–50.

Wyckoff, William (1990) 'Landscapes of Private Power and Wealth', in *The Making of the American Landscape*, M. P. Conzen, eds, London: Unwin Hyman, pp. 335–54.

THE SEXUALIZATION OF SUBURBIA

The diffusion of knowledge in the postmodern public sphere

John Hartley

Beyond the castle gates dinner was shared, as was love.[1]

VIRTUAL SUBURBIA

I thought about the dear old telly, and what an education it has been to one and all. I mean, until the TV thing got swinging, all we uncultured cats knew next to nothing about art, and fashion, and archaeology, and long-haired music, and all those sorts of thing.

(Colin MacInnes)[2]

This chapter is an account of the suburbanization and sexualization of knowledge in a world of popular media; it's about visions *from* rather than *of* suburbia. It is concerned with the knowledges that pertain to the development of what might be called a 'postmodern public sphere'; not so much knowledge of public affairs as traditionally defined, but new modes of knowledge which bespeak new ways of forming the public, and of communicating and sustaining what it means to be the public, in communities whose major public functions – the classical functions of teaching, dramatizing and participating in the public sphere – are increasingly functions of popular media, and whose members are political animals not in the urban forum but on the suburban couch; citizen-readers, citizens of media.[3]

In the twentieth century knowledge has dispersed and diffused, escaping and

exceeding traditional distinctions such as these:

formal : informal
intra-mural : extra-mural
public : private
universal : particular
factual : fictional
real : illusory

The nineteenth-century fantasy of being able to collect all the facts, data, and information from the world into a vast but ultimately coherent 'imperial archive', in Thomas Richards's phrase,[4] is no longer an incentive to revolutionary practices of scientific and literary innovation, but by now a nostalgic, reactionary impediment to understanding what's going on (however, it is still a fantasy encrypted into the rhetoric and practices of a good deal of modernist intellectual and academic work).

At stake in this chapter is the question of what has happened to the public sphere in a world of private media during this period of diffusion. My argument is that, like the imperial archive of knowledge, the public sphere is more real as fantasy, an ideal type, than as historical achievement. The critical pessimism of twentieth-century social theorists who lament the passing of an informed, rational public sphere and the rise of popular entertainment media has simultaneously overplayed the achievement and social extent of the Enlightenment public sphere, and also proved to be an impediment to understanding the role that the popular media do play in producing and distributing knowledge, visualizing and teaching public issues in the midst of private consumption, writing the truths of our time on the bodies of those image-saturated 'telebrities' whose cultural function is to embody, circulate, dramatize and teach certain public virtues within a suburban cultural context. The virtues in question are feminized, private, personal, consumeral (not consumerist for there's no formal ideology involved); I think that between them they are not only the virtues of suburbia, but also the future of democracy, for good or ill. However, they are hard to recognize within an intellectual tradition that tends, often unwittingly, to favour:

origins over destinations
producers over consumers
urban over suburban
male over female

the voice of authority over the *vox populi*
truth over desire
word over image
printed archive over popular screen

Contemporary suburbia is the physical location of a newly privatized, feminized, suburban, consumerized public sphere. But suburbia is itself a diffused and dislocated phenomenon (i.e. not tied to a regional location but generalizable even across continents). Nevertheless the home and suburb, together with their associated institutions (shopping centre, family, media) and practices (dressing and congregating; looking, listening and talking), constitute the place where and the means by which public, political knowledges are not only circulated and consumed but recreated, generalized and personalized. The postmodern (media) public sphere, which like suburbia itself is not a place at all, is the locus for the development of new political agendas based on comfort, privacy and self-building. I would argue that the major contemporary political issues, including environmental, ethnic, sexual and youth movements, were all generated *outside* the classic public sphere, but that they were (and are) informed, shaped, developed and contested within the privatized public sphere of suburban media consumerism. And so suburbia emerges from this discussion not as a place you can walk into (an oft-noted 'problem' of actual suburbs), but as an image-saturated space which is both intensely personal (inside people's homes and heads) and extensively abstract (pervading the planet). It's where personal, family, political and cultural meanings are reproduced – a place where people make themselves out of the semiotic and other resources to hand.

There is clearly a problem of method associated with the investigation of such a phenomenon, given both the irreducible particularity of certain images and places, and the abstract or 'virtual' character of the mediated public sphere of contemporary suburban citizenship. The problem is compounded by the poor reputation enjoyed by both suburbia and the media in Western intellectual traditions. But whether pessimism about popular culture is in fact inspired by a fear of losing control of the teaching, preaching and speeching functions enjoyed by the 'knowledge class'[5] since at least medieval times, and whether popular disengagement from regular politics is evidence of the demise of democracy, or instead, of its extension into areas previously hidden from what Ernesto Laclau and Chantal Mouffe have identified as its own 'logic of equivalence'[6] – these strike me as empirical questions, requiring observation and assessment of evidence. However, the form that 'empirical evidence' takes in this media-saturated,

textualized 'semiosphere' is itself discursive and textual, and it is personal as well as public life that needs to be explored. Of course this chapter doesn't pretend to solve these problems of method, but it does address them – from a 'textualist' perspective. En route it will tend to wobble without warning (but not without purpose) between two of this planet's most suburbanized cultures, Britain and Australia. It is part of my argument that the cultural boundaries of contemporary society are no longer confined, if they ever were, to the physical and territorial frontiers of localities like suburbs, or of spatial entities like nations. On the contrary, the cultural 'universe', and suburbia within it, is much better conceptualized using Yuri Lotman's suggestive, supple and comprehensive concept of *semiotic* space, the 'semiosphere', which (like its twin-concept of 'the biosphere') signifies a whole planetary unit within which all the immense variety and difference of meaning is organized, differentiated, cross-fertilized and related.[7] Lotman says of the semiosphere:

Humanity, immersed in its cultural space, always creates around itself an organized spatial sphere. This sphere includes both ideas and semiotic models and people's recreative activity, since the world which people artificially create (agricultural, architectural and technological) correlates with their semiotic models. There is a two-way connection: on the one hand, architectural buildings copy the spatial image of the universe and, on the other hand, this image of the universe is constructed on an analogy with the world of cultural constructs which mankind creates.[8]

Dialogue or translation between asymmetrical and binarily opposed spatialized areas, such as urban and suburban space, intellectual and popular knowledge, 'high' and media culture, even British and Australian suburbia, is incessant and creative, according to Lotman, who says that there is 'constant transcoding of spatial images into the language of other models. The result is the complex semiotic mechanism which is in constant motion.'[9] Such a dynamic, dialogic concept of meaning requires attention not only to the way suburbia appears in itself, but how it is connected to other semiotic, spatial, intellectual and architectural spheres; how meaning generates spatial arrangements (like actual suburbs), which then impinge on meaning; and how the virtual, semiotic sphere of culture both generates and cohabits within the physical, architectural space of suburbia.

HEDGEMONY

The most successful suburb was the one that possessed the highest concentration of anti-urban qualities: solitude, dullness, uniformity, social homogeneity, barely adequate public transportation, the proximity of similar neighbourhoods – remoteness, both physical and psychological, from what is mistakenly regarded as the Real World. . . . The suburban experience, with its pattern of commuting, its jealously tended gardens and its separating hedges, its tedium and its isolation, its cosiness and its dominating domesticity would become the normal mode of existence for the Londoner and the Englishman at large.

(Donald J. Olsen)[10]

Like the imperial archive of knowledge, and the media that popularize(d) it, suburbia is a Victorian, and therefore also an imperial invention,[11] leaving its mark from Poona to Purley, often in the apt domesticated-imperial form of the bungalow. As Georges Duby has noted, 'the idea of *privacy* . . . first emerged in the nineteenth century in England, at the time the society that had progressed furthest in the establishment of a "bourgeois" culture'.[12] Suburbia is therefore a phenomenon of modernism and realism, developed to solve the problem of what to do with large numbers of white-collar workers needed for petty control functions and professional, technical and clerical labour in the imperial capital of London, while providing (and providing for) a positive/progressive value system which put privacy, comfort, family life, self-development and stability above the attractions of urban or collective culture. From the start suburbia attracted hostile comment from all the usual sources, ranging from journalism to high theory:[13] social theorists, cultural commentators, professional planners, architects, aesthetes, philosophers, environmentalists, economists – no one seems to have had a good word for suburbia.

Politically, suburbia has been blamed for creating an apathetic, reactionary, conservative, conformist, status-conscious, petit-bourgeois class whose members are incapable of organizing anything for themselves, but who are prey to demagogues, propaganda and media influence, forming the bedrock of passive support for authoritarian, anti-democratic, even fascist politics.

Economically, suburbia is reckoned wasteful – an unproductive domain of pure consumption which contributes nothing to His Majesty The Economy (Althusser's phrase), or to the wealth of nations (Adam Smith's phrase), except the cost of housing itself, which formal economics dismisses as a non-productive sector anyway, unlike the macho sectors of manufacturing and primary industry.

Environmentally, the suburbs are vilified for sprawling all over the countryside,

filling it up with tarmac, cars, and concrete while encouraging its inhabitants to live lifestyles oozing with garbage, plastic, toxins and tins.

Socially, suburbia is the place where society falls apart into atomized individualist nuclear families, isolated from each other and from community co-operation.[14] As Thomas Sharp put it in 1940:

Now, Suburbia . . . is socially sterile. . . . It involves its inhabitants in a great waste of time and money and energy in journeying to and fro. . . . And especially . . . its spreading means the eating up of great areas of valuable agricultural land and the banishment of the countryside. Suburbia is essentially selfish and anti-social in this respect.[15]

Sexually, suburbia is where women's subjugation to the 'feminine career' is secured, tying them to housework, childrearing, and abuse;[16] it's also the site of sexual perversity, domestic violence, incest and anorexia.[17] Colin MacInnes put the case in 1959:

In Soho, all the things they say happen, do. . . . And what's more, although the pavement's thick with tearaways, provided you don't meddle it's really a much safer area than the respectable suburban fringe. It's not in Soho a sex-maniac leaps out of a hedge on to your back and violates you. It's in the dormitory sections.[18]

Suburbia is also where patriarchal men subside into boozy stupor in front of the television, never lifting a finger to cook, clean, or do childcare, doing a bit of DIY on a weekend, trimming the hedges to keep up appearances.

Aesthetically, suburbia is unstylish, twee, naff, genteel, dull, desolate, ugly, and getting more so, it seems. In 1925 P. G. Wodehouse wrote of 'the early morning patois of Suburbia, which is the English language filtered through toast and marmalade', while in 1967 McLuhan and Fiore wrote of 'darkest suburbia and its lasting symbol: the lawnmower' (*OED*). In 1992 Graeme Turner, who calls it 'Suburbia verité', says that *Sylvania Waters* (of which, more later) 'is often just plain ugly, because the ideologies which surface in "private" conversations and behaviours are unrepentantly consumerist, racist, xenophobic, homophobic, and sexist'.[19]

'Spiritually', Walter Murdoch, after whom Murdoch University is named, pronounced 'the suburban spirit' the 'everlasting enemy'. In 1921 (while living in Suburban Road, South Perth) he described 'the awful sameness of Melbourne's suburban streets, with their red-tiled houses, neat lawns, gravel paths, *Pittosporum* hedges, reflecting a uniformity of spirit, a complacency, a positive fear of originality or difference'.[20] Or, as T. W. H. Crosland put it in 1905, 'Man was born a little lower than the angels, and has been descending into suburbanism ever since.'[21]

Dramatically (yes!), here's the town-and-country planner Thomas Sharp again:

In any case, even if Suburbia had not the fatal faults that it so obviously has in its social sterility, its aesthetic emptiness, its economic wastefulness, where is the point in sacrificing the invaluable dramatic contrast of the two old utilities [of town and country] for one simple neutrality?[22]

Philosophically, in the best (i.e. classical) tradition of binary thinking – which (no matter how often it is criticized by professional philosophers) is still widely used in ordinary conversation, in media representations and popular social criticism alike to classify the world and thus make sense of it – the suburbs ought not to be there at all. They are an offence to binary logic, being neither city nor country. They're an in-between, both urban and not urban at once, a logical impossibility, being a third term in a two-term universe. As Lewis Mumford put it in 1922, suburbia is made of 'dormitories where . . . life is carried on without the discipline of rural occupations and without the cultural resources that the Central District of the city still retains' (*OED*).

Bereft of both 'discipline' and 'cultural resources', if suburbia does figure in any binary system of thought with wide currency and respectability in intellectual traditions, it is on the wrong side of the fence in a *hedgemonic* system of oppositions (if I may put it that way) which serves to separate the field of knowledge-production and social actions understood as 'free' from the field of information-consumption and social existence understood as 'manipulated', or at best 'produced'; for example, using some of the key terms of this chapter:

imperial archive : (mass) media
public sphere : suburbia
[good repute] : [no repute]

Suburbia is also, historically, the habitat of the social class with the lowest reputation in the entire history of class theory, the social class that attracts no love, support, advocacy or self-conscious organization; the petit-bourgeoisie, the lower middle class, the class for whom it seems hardest (certainly it's very rare!) to claim pride of membership. Scholars scarcely venture into suburbia except to pathologize it, despite the fact that by some accounts intellectuals themselves occupy a petit-bourgeois speaking position.[23]

DIVERSION: A SUBURBAN BUS TRIP

Even more unusual has been the development in London of what are perhaps the only really loved buses in the world.[24]

While suburbia hasn't fared well in formal intellectual and academic thinking, it has sometimes done better in government policy discourses. In Australia for instance it is a generation since Gough Whitlam was elected to office to lead a government which owed some of its electoral success and continuing reputation to the fact that Whitlam had developed policies specifically addressed to the suburbs – housing, education, health, infrastructure, sexual equality. An especially able academic theorist of suburban development is Hugh Stretton, whose radio Boyer Lectures in 1974 were entitled *Housing and Government*.[25] These ABC radio talks (the Australian equivalent of the BBC's Reith Lectures) were addressed directly to the Whitlam government while simultaneously broadcasting their message to an electorate listening at home (a good example of the mediated public domain at work), making suburban policy a matter of 'high' political debate at a critical period of cultural change. But somewhere along the line the plot was lost, and 'high' political commitment to fully theorized suburban culture slowly ebbed away.

However, the traffic may again be increasing, and it comes from rather an unexpected place. In Australia, as in other countries in the English-speaking intellectual semiosphere, there has been a continuing debate about the politics and utility of theoretical work in the humanities area of the academy, and specifically in cultural studies. One of the turns that this controversy has taken in the decade of the late 1980s and early 1990s is known in Australia at least as the 'cultural policy debate', associated with the work of Tony Bennett in particular. One aspect of this debate has been for those who are interested in the *utility* of cultural analysis to turn away from 'high theory', textual criticism, political critique of state apparatuses, and instead to analyse governmentality in its cultural mode, with a view to making theoretically informed but practical and pragmatic interventions in the development of social policy within the sphere of culture. Meanwhile, some writers, notably Ian Hunter, have focused a powerful critique on the ethics of academic humanities work itself, contesting the assumption of the mantle of the 'universal intellectual' by cultural critics, and suggesting more modest, bureaucratic aims and procedures for those of us who work in what are after all state/cultural institutions (universities). Others involved in the 'cultural policy debate' began to conduct an intense dialogue with the 'ideological state

apparatuses', becoming involved in the formulation of official policies in relation to broadcasting, the arts, multiculturalism, Aboriginal reconciliation and so on. It is in this rather superheated context, for the cultural-policy-wallahs were by no means uncontested within the intellectual community, that a new interest in suburbia began to develop among certain followers of the 'policy' camp. Colin Mercer, for example, Director of the Institute for Cultural Policy Studies which had been founded by Tony Bennett as the spearhead of the 'policy push', acted as a consultant for the new city of Joondalup in Western Australia to help it develop a cultural policy in relation to the design and orientation of its civic buildings (i.e. which way should a shopping centre face: inwards to the malls, or outwards to the street?). Suddenly, Foucauldian theories of governmentality met practical questions about where suburban developers should put the lamp posts.

Such an encounter was bound to end in bathos. But on the way, suburbia re-entered intellectual debate in the humanities. The 'policy moment' provoked Denise Meredyth, for instance, to lambaste what she saw as the hegemonic regime of 'universal intellectuals' in relation to academic cultural studies, and to argue for 'the mundane, laborious and often boring investigation of the actual composition' of the 'zones of social administration':

This kind of investigation may involve a descent from the peak of cultural critique and a willingness to explore the social spaces surrounding the arts faculty at ground level. It might also involve admitting that these areas stretch beyond the horizon of 'critical vision' and into the sprawling areas of public administration, social welfare, popular schooling and citizenship. Still, even if it may not suit the urbane tastes of the universal intellectual, there is a lot to look at on a bus trip to the suburbs.[26]

Her 'bus trip to the suburbs', then, is not a tourist but a works bus; taking planners, service-providers and the odd protesting cultural critic to those 'sprawling areas' of public administration, social welfare, popular schooling and citizenship. Despite her aim to redress the historic prejudice of 'critical vision' against everyday life, however, Meredyth's project retains a half-apologetic, half-truculent tone which does little to suggest why anyone *other* than bureaucrats would want to get on the bus in the first place. In fact, her purported attempt to retheorize suburbia in relation to cultural studies adds up to a desire to reinstate purely sociological categories and social-work priorities, and to cause 'universal intellectuals' to see the error of their ways from the vantage point of the 'bus trip to the suburbs'. That such a 'universal' critic as Meaghan Morris (to name but one) has been theorizing culture from the perspective of feminized suburbia and

ordinary life during her entire career seems to have escaped Meredyth's attention.[27]

But this encounter between cultural studies, cultural policy and suburbia is important, and of more than locally Australian significance (though of course any specific policy debates are bound to be localized), because what is at stake here is not only the future of suburbia itself as a policy-object, but also the future of cultural analysis. It is indeed important for cultural critics to take account of ordinary life (this is a position I've espoused in my own work), but equally it is vital that the agenda for such an account is not monopolized by the existing concerns of social planners and service-providers. One of the things that cultural studies can claim to have taken seriously is the existence and nuances of popular culture in all its amazing textual and performative variety, and this of course is the very culture that thrives so vigorously in suburbia. In short, cultural studies has been 'exploring the social spaces surrounding the arts faculty at ground level' for twenty years. In the context of a newly burgeoning 'policy' interest in suburbia in the humanities, then, it is important not to forget all this as we peer out of the window on our dreary bus-ride with the running commentary of 'public administration, social welfare, popular schooling and citizenship' dinning in our ears.

In fact I would propose not this fictional daytrip but a virtual one; not 'a bus trip to the suburbs', because that would show only the front gardens (an experience I can only describe as *lawnnui*), whereas, as everyone knows, the interesting bits of suburbia are round the back or inside the house, well out of sight of busloads of tourists, which is why such buses never go there. We need a different means of communication, one that might provide the sightseer with better visual evidence of the internal life therein; a means of communication which Terence Hawkes is bold enough to call art:

This is to see art as one of the major activities through which a society 'means'. . . . What, for instance, do we mean by 'man', by 'woman', by 'duty', by 'justice', by 'nation', by 'honour', by 'marriage', by 'love'? These are far from simple issues, yet our whole way of life depends on our answers to such questions: they give our culture its distinctive identity at a particular historical juncture.[28]

The art Hawkes himself investigates is popular drama, but such questions are posed by and within other media, both factual and fictional, especially popular journalism. To study the art of popular culture and the communications media is, in this view, to pose questions which are at once mundane (of everyday life) and of a high order of importance at the intersection of the personal (man, woman,

marriage, love) and the social (duty, justice, nation, honour). The challenge to this position is of course its person-centred humanism (its questions about 'man . . . woman'), and so even to ask such questions has been seen as inappropriate. For instance, Ian Hunter argues that the 'humanist' tendency to ask questions about the essence of the self in the tradition of the universal intellectual 'takes the principles of modern humanism far too seriously', resulting in a 'Kantian' defence of 'the humanities academy' as a 'timeless bastion of ultimate principles . . . as the voice of humanity demanding that the state live up to the principles on which it should be founded'. Instead of treating the humanities as the seat of 'principled opposition to the state', says Hunter, we should avoid 'moral grandiloquence' and 'resist the temptation to see further or deeper than the institutional forms'.[29] Instead, 'moral competence' for the job is, Hunter recommends, demonstrated by 'self-abnegation, strict adherence to procedure, and dedication to professional expertise'.[30]

Such an adherence to procedure may offer some guidance on the ethics of bureaucratic provision for suburbia, but it is hopeless as a means of finding out what suburban culture 'means' from the inside, and useless as a means to discipline the chorus of critics whose pejorative views on suburbia I have catalogued earlier. The no-nonsense, commonsense, down-to-earth approach is also quite unsuited to academic research where the object of the exercise is not to take suburbia at face value, or as a self-evident reproach to the wankers from the arts faculty, but to see whether something is going on there that we (academic cultural studies) *don't* already know about, something for which we *don't* have an existing 'procedure' or 'expertise' (a bus trip won't show us the semiosphere); in short whether the 'sprawling areas of social administration' have anything to offer academic intellectual inquiry in relation to Hawkes's questions about art. Meredyth and Hunter leave media, culture, even commerce entirely out of account in this 'zone', which is a pity, for considering what 'a society' means by such questions as those posed by Hawkes may turn out to be something quite different from residual Renaissance humanism, for the critical theorization of art since the 1960s (conducted by those much-maligned universal intellectuals) has radically destabilized any ideology of 'the essence of the self'. What's sauce for Derrida is sauce for suburbia, for it is here that media, culture, commerce and communication *produce* selves, and here that what contemporary 'society "means" by . . . man . . . woman . . . duty . . . justice . . . nation . . . honour . . . marriage . . . love' gets sorted out, or not, on a daily basis.

My alternative tour of suburbia, then, via popular media and images that are designed for suburban readerships, is a virtual voyage of exploration, looking for

evidence of meaning-formation that may previously have escaped the attention of cultural critics, be they universal or bureaucratic. I think I've found it too – evidence that, welling up within the medium of suburban popular culture itself, there is a different kind of public sphere (media readership), with a different kind of logic (the glance), with a surprising but simple mechanism for calling the public together (which I will emblematize as 'the frock' to signify the means by which meanings are conveyed through semiotic systems which are visual, bodily, social and manufactured rather than personal), and a secret weapon to overcome the prejudice of respectable critics (sexualization). At the outset of our trip, though, let it be said that none of this may be new; the convergence of sex and suburbia was noted right from the start, though naturally only to be denounced:

> The *Building News* in 1875 condemned the 'want of taste and frequent extravagance' in the architecture of the London suburbs: . . . 'It is the pushing to extreme the more sensuous elements of our architectural styles. . . . We see the same tendency in women's attire, and among the less educated tastes of every class of society.'[31]

After more than a century, in the place where houses are frocks and the 'tastes of every class' have escaped the discipline of education, it may be timely to look at things from the point of view of the 'more sensuous elements', whence it may be possible to glimpse the internal meanings and knowledges of suburbia.

PHILOSOPHIE

> 'Why do you ask me about Killee Minog? I don't care about Killee Minog.'
>
> (Vanessa Paradis)[32]

During 1991–2 two rather different images of Australian suburban culture suffused Australian suburban television screens: they were *Sylvania Waters* (ABC) and *Sex* (Channel 9). Both were documentary series, and they both illustrate a continuing dissolution of the supposedly rigid line between fact and fiction on television: *Sylvania Waters* was *generically* 'dirty' as a 'soapumentary' (and all the better for that); while *Sex* was formally much more straightforward, taking its place in the burgeoning 'lifestyle' genre (gardening, home, holiday . . . sex).[33]

Suburbia is quite common on television, but sex is not. Television sex is almost exclusively confined to fiction (and, until the shortlived *Chances* at any rate, restricted to movies rather than soapies), although even fictional sex is

traditionally signified by its absence.[34] Actual sex involving actual people – for example a documentary sexual encounter (even just kissing and holding) between ordinary suburban citizens – is very rare on television, and it is literally subversive, generically risky, because it undermines the division between fact and fiction, wherein we've become accustomed to the 'fact' that *characters* (fiction) can have sex but *people* (fact) can only talk about it. Interestingly, however, *Sex* turned out to be generically and ideologically straightforward, not to say suburban, showing and talking about sex across a wide range of people, practices and problems. But none of this affected the programme's reputation, which centred almost entirely on its presenter, Sophie Lee, who in turn came to *be* 'sex' for the Australian popular media during 1992 – '*Sex* with Sophie Lee' became the ho-ho headline of the year.[35]

Meanwhile, *Sylvania Waters*'s Noelene Donaher seemed to confirm some people's worst fears about suburban, petit-bourgeois social democracy: she was the Australian Dream incarnate, but was it a nightmare after all? Controversy raged in the media about both shows and both women, and while both received more than their share of criticism, both toughed it out, providing endless extra copy for the popular print media. They finally came together on the same page in the Christmas 1992 edition of *The Australian Women's Weekly*, which allowed them a Christmas wish. One of them – and I won't say which – wanted to shower her loved ones with gifts, the other wanted 'documentary makers to be more honest'.[36]

Although *Sylvania Waters* came as a shock to an unsuspecting Australian public in 1992, Sophie Lee was already a star. She grew up in suburban Newcastle, NSW, but her home would never have been chosen for the archetypal suburbanality of *Sylvania Waters*. The daughter of a professor of philosophy and a schoolteacher, she went without television throughout her childhood, a curious fact that the weekly magazines never tired of telling us, given that she made her name as presenter of a children's television show, *Bugs Bunny*. She attracted attention for doing nothing more revolutionary than wearing stylish clothes on the show, and very quickly she became a synonym for sexiness.

Sophie Lee appeared in most of the Australian popular print media within a year and was featured – often as cover girl as well – in *Woman's Day* (twice), *New Idea*, *TV Soap*, *TV Week* (three times), *Cosmopolitan*, *Dolly*, *The Dolly Rock Book*, *Who Weekly*, *Playboy*, *Cleo* and *The Australian Women's Weekly*. She also featured in extensive news copy,[37] in a Samboy Chips television commercial ('hit me slowly . . .'), and as celebrity gardener on *Burke's Backyard*. She was newsworthy not only as presenter of *Sex* and *Bugs Bunny*, but also in connection with the NSW Family

Figure 7.1 Sex and *Sylvania Waters* enter the national community. Sophie Lee and Noelene
Donaher make their Christmas wishes on behalf of a suburban readership

Source: Reprinted by courtesy of *The Australian Women's Weekly*

Planning Association's *Fact and Fantasy File* diary ('banned by the PM!'), as
saxophonist for The Freaked Out Flower Children (on the cover of *Playboy* as well
as *Dolly*), as an actor playing the character of Penny Wellings in *The Flying Doctors*
(and its successor *RFDS*), as a fashion model for *Cosmopolitan* and *Cleo*, and she was
also frequently reported as being a close friend of Kylie Minogue.

She may be better known to an international audience through her role in the
1994 suburban tragi-comedy film *Muriel's Wedding*, where she plays Tania, a
character whose sobbing, mascara-spattered, uncomprehending line, 'But I'm
beautiful!' (as if that should have guaranteed her a happy ending in line with
Hollywood mythology) when she literally loses the plot to the despised friend, the
ugly, fat, uncool Muriel of the title, sums up an Australian, ironic refusal of the
standard American teen plot where the good-looking juvenile lead always wins out
in the end.[38] That Sophie Lee herself is no fan of some aspects of suburban culture
shines through her too-perfect portrayal of the too-awful Tania. As Lee herself
commented in a later interview:

Figure 7.2 Sophie Lee: The 'frocks pop'

Source: *TV Soap*, November 1991. Reprinted with permission

I got her [Tania] from Newcastle [NSW]. It does not have the benefits of a big city where people tend to be more accepting of a wider variety of cultures. In a small town there is more of an accepted norm and people dangerously short of brains run around dictating what the norm is. Tania to me is a real suburban terrorist. Those girls try to be really tough with each other and really ugly and

Figure 7.3 Sophie Lee: Sexualization as popular critique

Source: *TV Soap*. Reprinted with permission

threatening – they have to be really sure no-one steps out of line. It's a power thing.[39]

In other words, within the constraints of possibility offered by her public persona, Sophie Lee is working against the grain of 'suburban terrorism', not uncritically endorsing or exploiting it, but offering glimpses of other possibilities than being 'beautiful' but 'dangerously short of brains'. Indeed, she uses her own beauty, brains, and opposition to the 'power thing' to talk *through* the expected stereotypes *to* the suburban Tanias, not to mention the men who were hooked on her *Bugs Bunny* persona: 'As Lee says: "Boys are dumb".' In short, she uses her visibility to teach the real Tanias and the boys, whom she knows so well, other possibilities than simply to be 'ugly and threatening' to each other.

Although it is quite possible for one person, a Rupert Murdoch or a Kerry Packer, say, to *own* such a multifarious collection of media outlets as Sophie Lee appeared in during her spectacular early career, it is unusual to find one person *appearing* in so many different sectors of the market simultaneously without regard to the usual generic boundaries between fact and fiction, actors and models, presenters and performers, men's and women's magazines, fashion glossies and supermarket weeklies, children's interests and sex. So among other things Sophie

Figure 7.4 Sophie Lee: The politics of the glance. 'Telebrity' private lives as the (suburban) public sphere

Source: *TV Week*, 16 November 1991. Reprinted by courtesy of Pacific Publications Pty Limited

Lee functions as a personalized visual marker of this crossover tendency in contemporary popular culture, and the thing that crossed all these boundaries with her was the subject of sex. Naturally, this remained the case whatever she might have thought or said about it, since her critical comments were duly reported in the very organs she was criticizing.[40] In fact the contradiction between her sexiness and her anti-sexism became an accepted part of a developing 'narrative image' in the media, which did however have the positive consequence that her forthright views got prominent billing in outlets not noted for political or social progressiveness.[41]

THE FROCKS POP

In *Nightmare Abbey*, Peacock makes his reactionary Mr. Flosky lament: 'How can we be cheerful when we are surrounded by a *reading public*, that is growing too wise for its betters?' . . . In 1828 a barrister told the Westminster magistrates that a forger owed his trip to Botany Bay to 'the march of

intellect,' and to this the magistrates (or some of them) responded with 'Hear, Hear.'

(R. K. Webb)[42]

Part of the problem addressed by this chapter is that of repute. As is the case for suburbia itself, and whole media like television and popular periodicals, it seems that whatever the 'telebrity' person actually does or says has little impact on his or her reputation, even when it would be seen as progressive or radical in other contexts. And part of the problem of repute is that popularity seems to bring with it a poor rather than a high reputation, at least among those in the 'knowledge class' whose cultural function it is to dispense repute (those for whom the phrase 'good television' is an oxymoron). Here the question becomes one of how to account for the power of reputation to determine whole reading practices (it's my view that reputation is a form of class-policing: the more popular the medium, whether it be television or Sophie Lee, the more virulent is its dismissal by belittlement and unfair criticism, no matter how good its content or actions; and because this discourse of dismissal emanates from respectable sources like academics, professionals, intellectuals and 'opinion leaders', it makes good copy for the popular media themselves, who thereby teach their own readers and audiences that their most popular symbolic engagements are the most to be despised). The question thus becomes one of how to account for the low repute of people who are, in their own words:

a mixture of I look alright, I can sing alright, I can dance reasonably well. People can relate to me because I'm not out of reach or unattainable. It's a kind of ordinariness. That sounds depressing, doesn't it?[43]

In other words, this investigation is not about looks, singing or dancing as such, but about the politics that makes 'ordinariness' 'sound depressing' – the *reputation* of phenomena that are, in Graeme Turner's words, 'so widely seen as *so* self-evidently bad', serving a 'culturally denigrated audience', via the medium of stars who are held to be '*more* fabricated, *less* talented, *more* "produced" and more of a brainless puppet than any other',[44] that in the end only one name encapsulates both the thing itself and the unanimous contempt in which it is held – and that name belongs to the mixture of 'ordinary alrightness' quoted above – Sophie Lee's friend Kylie Minogue.

Kylie Minogue is held by the best authorities to produce nothing worth disagreeing with,[45] presumably on the principle that bouncing cheerfully up and down to a dance beat is not something with which you *can* disagree.[46] Fair enough, but in the semiosphere it is not only statements which make propositions, but also

clothes which make statements. As fashion magazine *Mirabella* put it in relation to Gianni Versace's 1991 collection: '*This* is truly power dressing: not the tired symbolism of the padded shoulder in which women aped the bodies of men', but the power of 'confidence, wit, and above all, sexuality. "My ideal woman," he [Versace] says, "can have any type of body and be any age, but she must have the intelligence to adapt her figure and personality to the various proposals of fashion."'[47]

Kylie Minogue is by no means merely a singer, dancer, actor and model. She is also, like her friend Sophie Lee, a popularizer of certain 'proposals'. Given their pop-culture careers, popularization is the general cultural function of such entertainers as Kylie Minogue and Sophie Lee, but it does need to be remembered that popularization is always pedagogic, and that Kylie Minogue and Sophie Lee are teachers, if their performances are looked at from the point of view of their readership rather than from that of their reputation. Kylie Minogue's reputation allows critics to have fun at her expense, but her readership – the audience that is as 'culturally denigrated' as she is herself – is the thing that allows certain values, images, energies and changes to be circulated *so* widely that even though she is not a critic she is the bearer of meanings which do have a propositional – as well as a spectacular and bodily – component. Kylie Minogue and Sophie Lee are not the *vox populi*, the voice of the people (the thirty-second grab of anonymous opinion that performs the dialogue of a fictionalized democracy), but they are among those celebrities whose showy messages cling to them like a frock – often as a frock; in short they're the '*frox populi*'; visualizations of certain knowledges, truths and values, and every time they appear, their image, action, 'look' and performance become the idiom of popular pedagogy.

Like any other fashion garment the 'frocks pop' are an expression of their wearer's identity, but simultaneously they are quite obviously 'made up' by someone else. Just as a dress is created by couturiers and their staff, so the public personae of Kylie Minogue and Sophie Lee are created by managers and record companies, by editors, journalists and photographers of the popular media, and – to some extent – by Kylie Minogue and Sophie Lee themselves. Kylie Minogue's image is her own even while it is produced by others (this is a point she was constantly trying to get across in interviews), just as she can choose which outfit to wear without personally creating its fashion style.

From the perspective of the reader, 'frocks pops' are mixed and fragmented images, generating meanings that are well beyond the control of the 'telebrity' whose image they appear to be; Sophie Lee's likeness appears all over the public sphere (which in this case resembles not so much a sphere as a glitter-ball), but

no reader (other than the assiduous fan or trudging scholar) is expected to trace each little facet in order to construct a (wholly imaginary) 'real' Sophie Lee out of all the bits. In fact the reputation of popularizers like Kylie Minogue and Sophie Lee is based not so much on who they are or what they do, but on how they're reported and reputed, on how well they fit into the fashions of the season, and on how they look. Their 'speaking position' is determined by their audience (which comprises not only general readers but also journalists who 'read' them for gossip copy and celebrity pix), their value by their consumers. This is a fact of public life that has not been better put than by its first modern philosopher, Thomas Hobbes, writing in 1651:

The *Value*, or WORTH of a man, is as of all other things, his Price . . . and therefore is not absolute; but a thing dependent on the need and judgement of another. . . . And as in other things, so in men, not the seller, but the buyer determines the Price. For let a man (as most men do,) rate themselves as the highest Value they can; yet their true Value is no more than it is esteemed by others.[48]

It is interesting that Hobbes saw power and value (reputation) as commodities with exchange values, for he included among them natural attributes and abilities, including bodily beauty, which he calls 'Forme' (and, in the custom of the day, associates with men) – 'Forme is Power; because being a promise of Good, it recommendeth men to the favour of women and strangers.'[49] 'Forme' in Hobbes's time was a complex term but, applied to persons, it referred not only to the 'visible aspect of a thing', but also to 'beauty, comeliness', to 'style of dress, costume', and to 'an image, representation, or likeness'. It was 'a body considered in respect to its outward shape and appearance; *esp.* that of a living being, a person' (*OED*). However, as C. B. MacPherson has noted, Hobbes located power not in a person's natural abilities or attributes as such, but in their '*eminence*'; once more it is 'esteem by others' that determines the social value of even such natural gifts as 'Forme'.[50] This Hobbist conceptualization is the political theory of 'frocks pops' too; their contemporary 'power' and 'value' is also the 'eminence' of their 'form'; exactly the situation as described by Hobbes in the mid seventeenth century. They are significant not so much for their originality as for their destinations; not so much for their own speaking position as for that of their hearers; they are dedicated not to production, origin and identity, but to consumption, destination and exchange. Their meanings are social, communicative, cultural, not authorial or authoritative.

A SIDELONG GLANCE

To argue that women catch psychological disorders from watching television [i.e. eating disorders from seeing images of 'waif' supermodels Kate Moss (English) and Emma Balfour (Australian)] is to enter into an undemocratic infantilisation of women's everyday practices. The prevalence and power of this argument needs attention.

(Abigail Bray)[51]

Perhaps one of the lessons that the 'frocks pop' teach is that identity itself (subjectivity) is mixed, fragmented, dispersed and not entirely in the individual's control. Here they differ radically from the more celebrated Madonna, whose career is dedicated to preserving the fiction of individualism, and whose press coverage in this period (1991/2) was generally much more sympathetic than that given to Kylie Minogue and Sophie Lee, perhaps because commentators were lulled by her militant self-invention and her megalomaniacal manipulation of the public sphere into a false sense of ontological security; Madonna seemed to confirm all the old verities of authenticity, originality, creativity and self-identity, not to mention American superiority and the long-standing habit of presuming that New York is coterminous with the civilized world. Whether she turned into the things she parodied so well remained an open question, but few critics doubted that Kylie Minogue was copying her, an accusation which dogged her throughout the year.[52]

Certainly, what the 'frocks pop' teach is not confined to what they say, even though they are interminably interviewed, profiled and quoted (and much of the content of such copy is indeed straightforward advice, teaching sensible ideas). But in the main theirs is a performative and dramatic pedagogy, visual and vestimentary, and its message – precisely because it is not spelt out but per-formed as part of popular entertainment – can be read 'at a glance'. Kylie Minogue finds her possession of an 'ordinary' image that can be apprehended on first glance potentially 'depressing'. But she might take comfort from political and anthropological theory; not only is universal recognition a form of Hobbist 'Value' but – perhaps more surprisingly – the kind of glance on which her value depends has been claimed, by the American anthropologist Marshall Sahlins, as perhaps the very means by which society itself is constituted: 'It is by appearances that civilization turns the basic contradiction of its construction into a miracle of existence: a cohesive society of perfect strangers.'[53] What Sahlins calls 'la pensée bourgoise' is based on a '*coherence* of a specific kind'; on 'the possibility of apprehending others, their social condition, and thereby their relation to oneself

"on first glance"'. The condition of possibility for this 'pensée' is the glance, which turns out to be more than merely a 'brief or hurried look' (*OED*). The *OED* offers sufficient historical quotations to show that a glance is indeed a thing of power: it is used to cheat at cards (1591); to convey anger (1592); to fall in love 'with the first glance' (1606); to flirt (1667); to maintain and communicate power – 'in most courts . . . the glance of the monarch is watched, and every smile is waited for with impatience' (1728); to take in information (1828); to apprehend a landscape (1860); and to assess imminent danger (1874). The only entry that suggests that the glance may be flawed as a means of practical reasoning is one from 1799 that opts for the now-familiar privileging of the analytic gaze: 'This arrangement pleases at first glance, but soon fatigues the eye by it's [*sic*] uniformity.'

Sahlins suggests that 'a logic completely foreign to the conventional "rationality" is present in economic and social life', a 'practical reason' that pervades humanity. But far from being a mere epiphenomenon of more basic matters like the economy (material goods) and class (social relations), Sahlins argues that it is the cultural system of meanings based on appearance and the glance which enables the other components of 'civilization' to operate at all – the economy, modern, rational, productive and impersonal, is nevertheless 'totemic' in anthropological terms.[54] The 'miracle of existence' hinted at by Sahlins, a 'cohesive society of perfect strangers', is signified through such bearers of meaning as the clothing and fashion system, which is no less miraculous for being popularized by high-visibility personalities such as Sophie Lee and Kylie Minogue.

Kylie Minogue is the bearer of the logic of the glance; she is a member of what I've called elsewhere the 'smiling professions'.[55] It seems, as true professionals, the smilers can get fed up with their work – and their frocks:

'I'm reacting against the old days,' Kylie says, 'All the suits telling me "*This* would look nice, Kylie, why don't you put it on?" – all the silly old photographers from weekly magazines, telling me to smile, smile, smile.'[56]

Does this 'sound depressing', as Kylie Minogue herself fears? Perhaps so, but only for her, not for the system she personifies. According to the [London] *Independent on Sunday*, 'It is clear she frets about not being talented or extraordinary enough', and she 'lacks Madonna's burning belief in her own uniqueness'. She is in permanent danger of being superseded, even by her own sister:

With a younger sister, Dannii, currently in the process of throwing off Oz naffness (a lead role in *Home and Away*) in favour of Euro-hipness (pop songs and slinky dresses), Kylie has the predictability

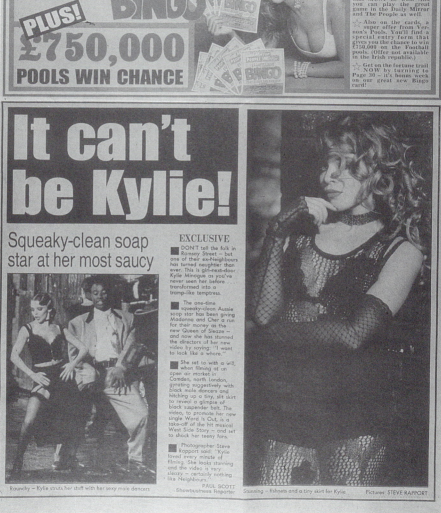

Figure 7.5 Kylie Minogue sends frock-waves around the world

Source: *Daily Mirror*

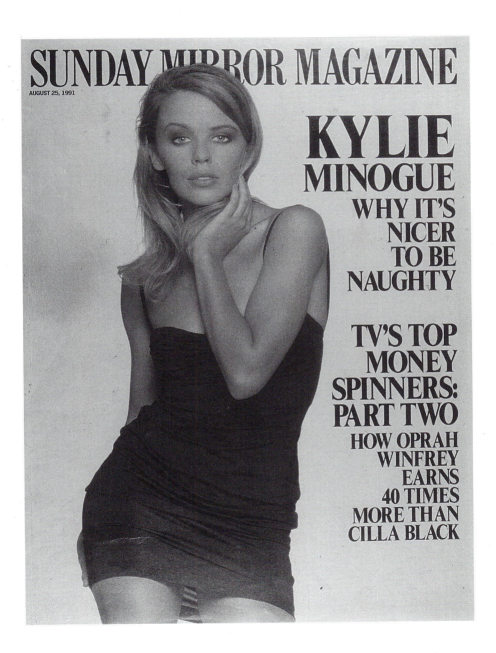

Figure 7.6 Popular couture: British and Australian magazines choose the same dress (but different meanings – see Figure 7.7)

Source: Sunday Mirror Magazine

Figure 7.7 Popular couture (Australian version)

Source: *Rolling Stone* (Australian edition), February 1991. Reprinted by courtesy of *Rolling Stone*

– and infinite repeatability – of her career placed in unusually harsh light . . . 'Of course I know that there will always be someone younger and more beautiful than me. Sometimes I ask myself, Why am I here? and I really don't know the answer.' Kylie crosses and uncrosses her skinny, black-stockinged legs and tugs at her whouffed-up blonde hair. 'There are,' she adds wonderingly, 'probably a million of me out there.'[57]

Figure 7.8 Kylie Minogue as covergirl for the sexualization of ordinariness

Source: Follow Me, December/January 1991

A million Minogues – and that's only at the production end; the number of people whose ordinary alrightness resembles hers at the consumption end is indeed a matter of economics (where a million Minogues = a million dollars). But it's a precarious kind of success, almost incomprehensible to current ideologies of artistic authenticity – it's not based on authorship, originality or uniqueness, but precisely on repeatability, on the anthropological glance rather than the analytic gaze, on distribution not copyright. The meanings that circulate around her body – 'dwarfishly ravishing – weirder-looking but also far more beautiful than her glamour shots convey'[58] – are not seen as her private intellectual property but precisely as 'produced', like the smile itself, and produced for suburban, domestic consumption at that.

THE BODY POLITIC

I am less interested in music or TV than I am in how these cut across and organize the various time-spaces in which the labor, as well and the pleasure, of everyday living is carried out by Australian women. This is why I do not think of 'tourist sites and sounds' as insignificant. . . . I think of them in the first place as political combat zones.

(Meaghan Morris)[59]

During 1991 Kylie Minogue underwent a surprising transformation. Just as Sophie Lee sexualized mainstream children's and lifestyle television, so Kylie Minogue, icon of pre-teen pop and Neighbourly homeliness, sexualized herself. She was literally unfrocked, brought into the realm of the profane, and – to the self-serving astonishment of the magazine media – made synonymous with sex. So surprising was this event, in fact, that it became news in real newspapers, from the highest (the Independent on Sunday) to the lowest brow (the Daily Mirror),[60] and its meaning was minutely analysed while Minogue's body was photographed from every conceivable angle, in glossy magazines, stylish and otherwise, and in popular media in at least two continents, for several months. Maybe the new image was contrived, maybe Kylie Minogue's 'practical reasoning' was a little too well-rehearsed. As the world's most stylish magazine remarked at the time: 'There are, of course, reasons to be suspicious.' But, despite itself, The Face devoted nine pages and a cover to the event, and concluded:

The strange thing is that it is working. Britain is entranced with Kylie in a way that it rarely gets entranced. . . . It's not just working for the public, but in her life. When most teen stars try to move

into more fashionable milieux, they are laughed at. . . . But fashionable London seems to like having Kylie around. She's the girl they talk about.[61]

Kylie Minogue and Sophie Lee, in Britain and Australia, were media through which the postmodern public domain was sexualized. I don't think that what was happening was merely a matter of sexualizing their bodies – this was the *tabula rasa* upon which social messages could be written. And I don't think they were mere products of commercial manipulation – Kylie Minogue and Sophie Lee were also professionals; troupers. Their 'moral competence' for their job was precisely that which Ian Hunter wants for arts academics: 'self-abnegation, strict adherence to procedure, and dedication to professional expertise'[62] – in short they were 'produced' to the extent that they were good at their job. They were sexualized and produced, certainly, but beyond that, and more important, was their cultural function as popularizers of meanings. In this sense their bodies and frocks *were* the public sphere, they were *spatial practices* in the semiosphere, a place that is as small as a photo and as large as suburbia. This is not space as classically conceived, but, after Morris's *Great Moments in Social Climbing*, it's hard to decide what constitutes space *as such*, never mind public space, but as she says, the real concern is 'with the problems of historicising particular spatial practices', not with space in general.[63] The particular spatial practice I am seeking to explain is the 'virtualization' of the public sphere, its relocation into the 'frocks pop.'

Once again in this context, it's worth noting that, as Elizabeth Wilson has reminded us, fashion has developed hand in glove with the public sphere of democratization and urban life ever since the nineteenth century: 'Fashion in the city served to signal to the other strangers in the crowded streets and public places the class and status of the individual, thus countering to some extent the social disorientation threatened by urban life.'[64] And so, it could be argued, as post-Frankfurt-School cultural theorists trace the history of what Richard Sennett entitles *The Fall of Public Man*,[65] it becomes ever more clear that 'man' is precisely the subject of the discourse of the public sphere from Hobbes onwards, and that, meanwhile, the shift from public to private domains, from political power to spending power, marks a contrary kind of history for women, one which can be read optimistically, as Wilson suggests:

So far as women are concerned – and fashion is still primarily associated with women – contemporary fashions arguably have liberatory potential (whether or not this is realized). . . . As fashion increasingly extends its ambiguous sway over both sexes . . . it creates a space in which the normative nature of social practices, always so intensely encoded in dress, may be questioned.

Fashion, as the most popular aesthetic practice of all, extends art into life and offers a medium across the social spectrum with which to experiment.[66]

The 'space' created by fashion not only draws our attention to the politics of the body, but also introduces a new space for the body politic, and perhaps, thence, 'a site from which to speak' for women and others, 'as opposed to the Western modernist male intellectual who believed he stood at the cutting edge of history'.[67] The popular aesthetic spatial practice of wearing clothes in public is also political, whether self-consciously, like the demotic avant-garde punk (called by Wilson 'a walking art object and performance', designed to collapse the boundaries between art and life),[68] or the more diffused emancipation of social democratic mass clothing, which functions not only to expand individual *difference* but also to make it impossible, for the first time in history, to 'know a woman by her dress' – an anonymity which is one of the historic attractions of popular culture, as Leslie A. Fiedler tried to get the critics of 'mass culture' to see as long ago as the 1950s.[69]

In my view (I don't think Wilson, as an avowed urbanist, would be a party to this extension of her argument), a further diffusion of the 'logic of equivalence' of democracy has extended the politics of fashion from urban to suburban locations; from boulevard and high street to shopping mall and home entertainment. If the tendency to feminize and sexualize the public domain continues, and if it is to be taken seriously by cultural analysts, then it follows that the prejudicial reputation of suburbia will also have to be rethought. The popular media, as is their wont, have begun to think through certain long-term, historical transformations via the 'calculating machine' of Kylie Minogue's and Sophie Lee's visual attractiveness (i.e. the hold of the 'telebrity frocks pop' at the point of contact between media and the public exemplifies, and is the focus of, larger trends towards the privatization, feminization and more recently the sexualization of the public sphere) – but the same cannot yet be said for the suburbs. Sexy they ain't (yet), despite the fact that this is where homes are traditionally set up by couples at the start of their sexually active careers, where children are begotten and where teenagers first learn about sex, in short where sex actually happens in Australian and other societies. So little are the suburbs associated with sex that noticing it has the force of a literary innovation. Robin Gerster notes, for instance:

Alan Wearne's verse-novel set in post-sixties Melbourne, *The Nightmarkets* (1985), is a contemporary text that explodes the myth of suburban deadness. In one scene, Sue Dobson, cynical veteran of the urban counter-culture, takes a friend to the family home deep in the suburbs as part of a tour of

the city. 'Take any normal street of average length and just consider all that fucking!' she advises her companion.[70]

Considering all that fucking may, however, produce other than pleasant visions of passion and fecundity. The quintessentially Australian 'class' which lives in 'the' suburbs is the petit-bourgeoisie, now for ever identified with *Sylvania Waters* and in particular with Noelene and Laurie. Sex, in this context, is challenging to the onlooker to say the least, surfacing startlingly on occasion to produce what for Graeme Turner 'gets my vote as one of the most embarrassing moments in Australian television', namely 'Noelene's expression of pride in her lust for a black stripper, a lust that is actually fuelled rather than undercut by her racism'.[71] In short, sexualizing suburbia may only increase the problem of its reputation.

In fact the unsexiness of suburbia in so many discourses of loathing suggests that in the semiosphere suburbs generally occupy the position of ugly sister; their negativity is required, as is that of personalizations like Noelene Donaher, as a rhetorical foil for whichever desirable *urbs* they *sub*tend.[72] However, as I've tried to show, the 'frocks pop' indicate that the story of Cinderella applies to the suburbs in another way: it's the 'ugly sisters' of urban decline who have tried to clothe themselves in the desirable garb properly belonging to the despised but beautiful 'other' sister working in the scullery. Perhaps her time has come for an 'outing'?[73]

I've argued that the classical public domain is fully fictionalized and rhetoricized in contemporary representative politics, and that the 'smiling professions' exist within the great institutions of government, education and the media to produce and circularize the Sahlinesque symbols that allow society to cohere at all (to the extent that it *does* cohere at all). Suburbia is just as fictional as the classical public domain. It too is rhetoricized. This can occur positively; for instance in the form of 'the' suburban family on the cover of *TV Extra*, where the 'family' turns out to be two local newsreaders and three not very feral kids (not their own) posing for a fake picnic outside the Telethon Home (publicizing a charity auction).[74] Or, negatively, suburbia can be made to symbolize the destruction of the classical body politic, as it was most tellingly in *Time* after the 1992 LA riots, putting to shame the democratic sentiments of the Woody Guthrie song: 'this land' (downtown) 'is your land' (black, poor, male); 'this land' (suburbia) 'is my land' (white, affluent, female) . . . the democratic vistas of America are divided, a social fact symbolized in *Time* by putting the images of downtown and suburbia on succeeding pages, requiring the reader to *enact* the 'two Americas'.[75]

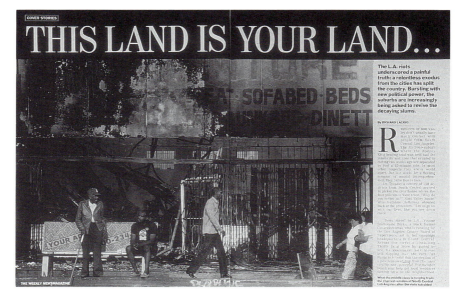

Figure 7.9 Suburbia as class war: Suburban culture ('our land') abandons the city
Source: *Time* (Australia)

Meanwhile, in what used to be the real public domain – the city centre – the only time crowds turn out in this forum nowadays is to come in from the suburbs to catch a glimpse of supermodel Elle Macpherson, whose tour of Australia to promote her 'own' brand of lingerie turned into the contemporary equivalent of a Royal Progress, lovingly recorded in the weeklies, and in Perth at least rating two consecutive front-page colour lead stories in *The West Australian*, the newspaper of record for that state. Rob Sitch, comedian and 'host' of the ABC's parody current affairs show *Frontline*, has been quoted in *Australian Fashion Quarterly* as saying: 'Women are attracted by power and success, and men are attracted by lingerie. . . . You have to worry about our priorities.'[76] He's right, especially as these two sets of priorities are now merged. Elle Macpherson, admired by women and men alike, pictured signing lifesized photographs of herself in lingerie, performs exactly the same function as Queen Victoria once did, the body politic now literally revealed *as* 'The Body', successfully symbolizing the 'dignified part' of the constitution even in her underwear, effortlessly uniting 'the people' around a figure which is clearly understood by the crowds (who fight each other for the right to get a glimpse of her) as the smiling professional *par excellence*, a representative of Australianness in a way that the actual Queen's actual

Figure 7.10 Suburbia recolonizes the city – with lingerie, consumers and hormones

Source: *The West Australian*, 10 October 1992

representative, the then Governor General Bill Hayden, could never hope to match.

NOTES

1 Caption to an illustration of the *Psalter* of Odbert, abbot of Saint-Bertin, AD 1000, in Boulogne Library, in Georges Duby, ed. (1988) *A History of Private Life. Vol II: Revelations of the Medieval World*, trans. Arthur Goldhammer, Cambridge, Mass.: Harvard University Press, 32.

2 Colin MacInnes (1959) *Absolute Beginners*, London: Allison & Busby, 143. After calling television a 'sort

of non-university education', the passage continues on a more cautionary note: 'The only catch – and of course, there always is one – is that when they *do* put on a programme about something I really know about – which I admit is little, but I mean jazz, or teenagers, or juvenile delinquency – the whole dam things [*sic*] seems utterly unreal. Cooked up in a hurry, and made to sound simpler than it is. Those programmes about kiddos, for example! Boy! I dare say they send the tax-payers, who think the veil's being lifted on the teenage orgies, but honestly, for anyone who knows the actual scene, they're crap. And maybe, in the things *we* don't know about, like all that art and culture, it's the same, but I can't judge.' Apart from being an unusually early (1958) example of *plus ça change* in the world of TV, it's also a clear instance of popular fiction performing a pedagogic function for its presumed readers, both teenage and otherwise; teaching the former that television is not all positive and the latter the reverse.

 3 I don't wish to burden the reader with credentials, but the argument of this chapter is developed in the context of a number of other studies in which its major themes are elaborated: see my *The Politics of Pictures: The Creation of the Public in the Age of Popular Media* (1992), London & New York: Routledge; 'Citizens of Media, Technologies of Readership', *Arena Journal*, New Series, 3 (1994), 93–113; 'Twoccing and Joyreading', *Textual Practice*, 8(3) (1994), 399–413; 'Suburbanality (in Cultural Studies)', *Meanjin*, 51(3), (1992), 453–64. The material in the second half of the chapter was first published as 'Frocks Pop: Sexualising Suburbia from Meaghan Morris to Sophie Lee', in David Bennett, ed., *Cultural Studies: Pluralism and Theory*, Melbourne: Melbourne University Literary and Cultural Studies, vol. 2 (1993), 245–71.

 4 Thomas Richards (1993) *The Imperial Archive: Knowledge and the Fantasy of Empire*, London: Verso.

 5 John Frow (1993) 'Knowledge and Class', *Cultural Studies*, 7(2), 240–82.

 6 Ernesto Laclau and Chantal Mouffe (1985) *Hegemony and Socialist Strategy: Towards a Radical Democratic Politics*, London: Verso.

 7 Yuri Lotman (1990) *Universe of the Mind: A Semiotic Theory of Culture*, trans. Ann Shukman, Bloomington: Indiana University Press, Part Two, 'The Semiosphere', 121–214.

 8 Ibid., 203.

 9 Ibid.

 10 Donald J. Olsen (1979) *The Growth of Victorian London*, Harmondsworth: Peregrine Books [first published 1976 by B. T. Batsford], 263, 297.

 11 See Olsen (1979), especially chapter 5, 'The Villa and the New Suburb'.

 12 Duby (1988), xi.

 13 For Australian perspectives (apart from Meaghan Morris), see Diane Powell (1993), *Out West: Perceptions of Sydney's Western Suburbs*, Sydney: Allen & Unwin; Katherine Gibson and Sophie Watson, eds, (1994) *Metropolis Now: Planning and the Urban in Contemporary Australia*, Sydney: Pluto Press; John Fiske, Bob Hodge and Graeme Turner (1987) *Myths of Oz: Reading Australian Popular Culture*, Sydney: Allen & Unwin, chapter 2. See also Craig McGregor (1984) *Pop Goes the Culture*, London: Pluto Press. For historical comparison, and a British perspective, see Geoffrey Crossick, ed. (1977) *The Lower Middle Class in Britain*, London: Croom Helm; and, for an unusual and tolerant insight into the original London suburbia (among other places) when it's really under stress, based on the data of Mass Observation and written by that organization's co-founder, see Tom Harrisson (1978) *Living Through the Blitz*, Harmondsworth: Penguin. As for links between British and Australian suburbias, how about this unguarded aside from Donald J. Olsen: '(King's Cross, the one significant specialized neighbourhood in all Australia, may arguably be a less important centre of Australian culture than Earl's Court)' Olsen (1979), 28.

 14 Cf. Deborah Chambers (1992) 'Women and Suburban Culture: Investigating Women's Experiences of the Transition from Rural to Suburban Living', in Brian Musgrove and Rebecca Snow-McLean, eds, *Signifying Others: Selected Papers from the Second Cultural Studies Association of Australia Conference*, Toowoomba: USQ Press, 121–9.

 15 Thomas Sharp (1940) *Town Planning*, Harmondsworth: Pelican Books, 53.

 16 On the 'cult of domesticity', for suburban women, and how it prepared the way for broadcast media, see Lynn Spigel (1992) *Make Room for TV: Television and the Family Ideal in Postwar America*, Chicago: University of Chicago Press.

 17 On media/anorexia see Abigail Bray (1994) 'The Edible Woman: Reading/Eating Disorders and Femininity', *Media Information Australia*, 72, 4–10.

 18 MacInnes (1959), 60. It may be appropriate that one of the most sustained and telling analyses of this

aspect of suburban life in recent times is not only written by a man but is also a novel – Peter Carey (1991) *The Tax Inspector*, Brisbane: University of Queensland Press.

19 Graeme Turner 'Suburbia Verité', *Australian Left Review*, (October 1992) 37–9.

20 John La Nauze (1977) *Walter Murdoch: A Biographical Memoir*, Melbourne: Melbourne University Press, 122.

21 T. W. H. Crosland (1905) *The Suburbans*, London: John Long, 80–3.

22 Sharp (1940), 54–5.

23 See especially Meaghan Morris (1988) 'Politics Now: Anxieties of a Petty-bourgeois Intellectual', in *The Pirate's Fiancée: Feminism, Reading, Postmodernism*, London and New York: Verso, 173–86; and Meaghan Morris (fall 1988) 'Things To Do With Shopping Centres', *Working Paper No. 1*, Center for Twentieth Century Studies, University of Wisconsin-Milwaukee.

24 Olsen (1979), 321. (This sentence can only have been written without an eye on the buses of South Asia, from Afghanistan to the Philippines.)

25 Hugh Stretton (1974) *Housing and Government*, Sydney: ABC. Stretton argues for the importance of the domestic economy (unwaged work) as well as the commercial one, and points out that not only do people use their homes for all sorts of productive and creative activities which are recognizably 'suburban', but also that 'formal culture' often originates in suburbia – writers, composers, painters and so on do their work at home, and their followers do much of the work of enjoying culture in the same place. 'That's where most people now hear most music, read most books, see and hear most drama, read and see and hear most of the world's news and most of the analysis and commentary on it.' Furthermore, Stretton points out that such energetic engagement in public culture does not confine people to their homes but propels them out, into the city and the country, where 'public community and city life' continues, supported by those whose interest is stimulated by home consumption (41).

26 Denise Meredyth (1992) 'Changing Minds: Cultural Criticism and the Problem of Principle', *Meanjin*, 51(3), 491–504. This article was part of the 'cultural policy' debate in Australian cultural studies that rumbled on through the early 1990s; at issue was the purpose of cultural studies (whether it should continue with high theory and criticism or 'talk to the ISAs' (Ideological State Apparatuses) in Tony Bennett's phrase), and also the position of intellectuals in social democratic polities. The edition of *Meanjin* that contains Meredyth's piece was partly devoted to the debate, with articles by me, Ian Hunter, Denise Meredyth, John Frow, Tom O'Regan, Stuart Cunningham, Meaghan Morris and Bronwen Levy, some of which are quoted below.

27 Meaghan Morris's work is, as she says, 'unrepentantly practised' as a 'theoretically specialized criticism' (i.e. she's a 'universal intellectual' in Hunter/Meredyth's terms), while at the same time she's centrally concerned with the realities – the culture – of petty-bourgeois, suburban and family life. Meaghan Morris (1992) 'A Gadfly Bites Back', *Meanjin*, 51(3), 545–51. See also Morris's (fall 1988) 'Things To Do With Shopping Centres'; Morris (January 1988) 'At Henry Parkes Motel', *Cultural Studies*, 2(1), 1–47; Morris (1992) *Ecstasy and Economics: American Essays for John Forbes*, Sydney: EMPress. The second essay in this book, 'On the Beach', contains a discussion of Hunter's position.

28 Terence Hawkes (1992) *Meaning by Shakespeare*, London and New York: Routledge, 5.

29 Ian Hunter (1992) 'The Humanities Without Humanism,' *Meanjin*, 51(3), 479–90.

30 Hunter (1992), 488.

31 Olsen (1979), 224.

32 Vanessa Paradis, 'France's Leading Cover Girl', quoted in 'Paris Passion – The New French Starlets', by Amy Raphael, *The Face*, no. 40, January 1992, 32–9.

33 See Cherise Saywell (1994/5) 'Post-Sacred *Sex*: Melodramatic Discourse and the Erect Penis in *Sophie Lee's Sex*', paper presented to *Intellectuals and Communities*, Conference of the Australian Cultural Studies Association, December 1994. Saywell argues that this documentary series' over-coding of emotion, visualization, feminization and the moral order places it in the tradition of melodrama, rather than current affairs.

34 Sex on television comes in three forms of absence: *metonym* – bits of bodies and movements associated with sex; *metaphor* – flowers/ocean waves/ceiling fans (etc.) plus music and a quick cut to the morning/cigarette after; *modification* – the evil MAO or 'Modified Adults Only' classification, which deletes even fully fictionalized sex from Australian commercial television screens for fear of offending someone, or more exactly some*thing*, namely the Australian Broadcasting Authority.

35 E.g. a full page ad for Channel 9 in The *West Australian* (13 August 1992) showing photos of Sophie

Lee and Elle Macpherson, captioned 'SEX WITH SOPHIE LEE 8-30 TONIGHT', and 'ELLE McPHERSON [*sic*] CALENDAR GIRL 9-30 TONIGHT'.

36 'All I Want for Christmas . . .', *The Australian Women's Weekly*, December 1992, 4–5. The spread featured a kind of 'Australian community' of different people, ranging from some worthy unknowns to Prime Minister Paul Keating, Olympic swimmer Kieren Perkins, author Elizabeth Jolley, Professor Fred Hollows and *Strictly Ballroom*'s star Tara Morice.

37 The most interesting story was about some advertisers' response to *Sex*, though it was misleadingly headlined 'Some *viewers* don't like "Sex"'. Despite high ratings, viewer approval, and a primary audience of the desirable 'females aged 16 to 39' demographic, some advertisers were unmoved: 'General Motors–Holden's advertising manager David Venticich said: "We choose to advertise on programs which are wholesome and *Sex* simply doesn't fit our bill in terms of being a wholesome program."' Luckily, Channel 9 had the good sense to stick with the show (and, with the increasing tendency for women to decide motor car purchases, GMH might have to reconsider their amazingly outdated notion of wholesomeness). See 'Some Viewers Don't Like "Sex"', Perth *Sunday Times*, 14 June 1992, 4.

38 See Tom O'Regan (1995) *Australia Cinema*, London: Routledge, chapter 10.

39 Sophie Lee, interviewed by Catharin Lambert in *Australian Style*, no. 12, 1995, 62–3.

40 For instance her cover-girl picture in *TV Week* (16 November 1991) is superimposed, in big red letters, with the headline: 'IT HURTS . . .'. On reading the story inside, it transpires that what has hurt her is sexism and gossip, the very things that *TV Week* displays and celebrates via Sophie Lee, and so the readers, if not Sophie Lee herself, can have their sex-and-gossip cake and critically eat it too.

41 As always, the uneditorialized voice of the readership is hard to trace, but one fan letter did show up – in *Playboy*. After asking 'What does Soph wear under her miniskirt?', a reader's letter (from one C. Marks, Sydney South, NSW) concludes: 'What better subject for some good old-fashioned cheesecake photography – subtle, tasteful, but all the more naughty – than the lady who has become the leading spokesperson for the safe sex campaign of Australia?' To which 'Ed.' appends a reply: '*Wow, that's one weird question! We also would have thought that the answer to what she wears under her miniskirt is pretty obvious: panties. Still, you're obviously after more detail. As far as a more revealing look at Sophie goes, you can rest assured that we are on the case – Ed.*' *Australian Playboy*, November 1992, 5. (Needless to say, Sophie Lee never appeared as a pin-up.)

42 Opening lines of R. K. Webb (1955) *The British Working Class Reader 1790–1848: Literacy and Social Tension*, London: George Allen & Unwin, 13.

43 'Kylie Comes Clean: Minogue on Sex, Drugs, and Naked Ambition', by Adrian Deevoy, *Cleo*, January 1993, 112–15, 153.

44 Graeme Turner 'Return to Oz: populism, the Academy and the Future of Australian Studies', *Meanjin*, 50(2), (1991) 19–31.

45 Meaghan Morris 'Responses to Graeme Turner', *Meanjin*, 50(2), (1991) 32–4. Turner and Morris were engaged in a dialogue in *Meanjin* as to whether or not John Fiske was the Kylie Minogue of Cultural Studies. Morris thought not, because unlike Fiske, Kylie Minogue did not produce work with which she could *disagree*.

46 Even Kylie Minogue's lyrics can be controversial, and have been subjected to close textual analysis, as in the case of her 1991 hit song 'Shocked'. According to an analysis in the opening paragraph of her *Cleo* profile, the lyrics go like this: 'I was shocked by the power, Shocked by the power of love, Yes, I was shocked, Fucked to my very foundations.' To which the typical bad-faith question immediately asked by *Cleo* (which either does, or does not, reckon 'pop kids' among its own readership), is this: 'Must we fling this filth at our pop kids?' *Cleo*, January 1993, 112.

47 'Power over Flesh', by Sally Brampton, *Mirabella* [UK], February 1991, 110–13.

48 Thomas Hobbes (1651) *Leviathan*, ed. by C. B. MacPherson (1968), Harmondsworth: Penguin, 151–2.

49 Hobbes (1651), 150–1.

50 Hobbes writes: '*Naturall Power*, is the eminence of the Faculties of Body, or Mind: as extraordinary Strength, Forme, Prudence, Arts, Eloquence, Liberality, Nobility' (150). See also C. B. MacPherson (1962) *The Political Theory of Possessive Individualism: Hobbes to Locke*, Oxford: Oxford University Press, 35–7.

51 Bray (1994), 9.

52 For example, on a planned Minogue book with nude poses, see *TV Week*, 21 November 1992, 22: 'A Leaf from Madonna's Book'.

53 Marshall Sahlins (1976) *Culture and Practical Reason*, Chicago: University of Chicago Press, 203–4.

54 Sahlins argues for an anthropology of meaning in which culture is understood both as a unified symbolic structure, and as a form of practical reasoning with material effects. He writes: 'Much of anthropology can be considered a sustained effort at synthesizing the original segmentation of its object, an analytical distinction of cultural domains it had made without due reflection, if clearly on the model presented by our own society. But the project was doomed from the beginning, because the very first act had consisted in ignoring the unity and distinctiveness of culture as a symbolic structure, hence the reason imposed from within on the relations to an external nature. . . . But it follows that a retotalization is not effected merely by considering material goods, for example, in the context of social relations. The unity of the cultural order is constituted by a third and common term, meaning' (205–6).

55 *The Politics of Pictures*, chapter 5.

56 'Kylie Evolved', by Zoe Heller, *The Independent on Sunday*, 27 October 1991. This interview was a promo for an upcoming concert at Wembley Arena, but it was headlined *FASHION* and accompanied photographs by Mark Lebon of Kylie Minogue dressed by John Galliano.

57 Ibid.

58 Ibid.

59 Morris (1992), 122. Along with three other interestingly titled books – *Fraud, Sin*, and *The Pleasure of Reading* – Morris's stylish book rated a review in *Vogue*, headlined 'The fantastical reality of others' lucid dreams', which brought cultural studies (or at least Morris's) into direct dialogue with the feminized public domain I've tried to describe herein (*Vogue Australia*, vol. XXXVI, no. 11, November 1992, 66). But of course Morris was there long before me: the author's photo on the back cover of *Ecstasy and Economics* shows her, a true professor of smiling, sitting outside a motel called, appropriately, The Forum.

60 27 October 1991 and 1 September 1991 respectively.

61 'In Bed With Kylie . . .', by Chris Heath, *The Face*, no. 37, October 1991, cover, 3, 46–53, 128.

62 Hunter (1992), 488.

63 Meaghan Morris (1992) *Great Moments in Social Climbing: King Kong and the Human Fly*, Sydney: Local Consumption Publications, 4–5. For Morris, such problems are associated with places well to the side of the traditional public domain (she lists Sydney Tower, three suburban shopping malls, a motel and a memorial park); apart from the beach, they are at least *buildings*.

64 Elizabeth Wilson (1990) 'These New Components of the Spectacle: Fashion and Postmodernism', in Roy Boyne and Ali Rattansi, eds, *Postmodernism and Society*, London: Macmillan, 209–36, this quotation 211.

65 Richard Sennett (1974) *The Fall of Public Man*, Cambridge: Cambridge University Press.

66 Wilson (1990), 233. See also her essay 'All the Rage', in Jane Gaines and Charlotte Herzog, eds (1990) *Fabrications: Costume and the Female Body*, New York and London: Routledge, 28–38, where she hints that the British radical (Fabian) dislike for fashion may have the same roots as suburbia itself, namely late Victorian lower middle-class respectability (29). If so, then the hip dislike of suburbia is understandable, but it is as outmoded as the radical dislike of fashion.

67 Wilson (1990), 232–3.

68 Ibid., 216.

69 See Leslie Fiedler's essay in B. Rosenberg and David Manning White, eds (1957) *Mass Culture: The Popular Arts in America*, Glencoe, Ill.: Free Press.

70 Robin Gerster (1990) 'Gerrymander: The Place of Suburbia in Australian Fiction', *Meanjin*, 49(3), 565–75.

71 Graeme Turner (1992), 39.

72 See Kathleen Mee (1994) 'Dressing up the Suburbs: Representations of Western Sydney', in Katherine Gibson and Sophie Watson, eds., *Metropolis Now: Planning and the Urban in Contemporary Australia*, Sydney: Pluto Press, 60–77.

73 While it may be time for suburbia to 'come out', both Kylie Minogue and Sophie Lee signed off 1992 in the popular picture papers by saying that they would (or would like to) disappear, by turning to study; in Sophie Lee's case this was enough to make front page news: 'It's back to school: Sophie swaps Sex for study!' squealed the cover of *TV Week*. The first benefit of study, we learn inside, is to avoid the *glance*: 'at the Actors' Centre in Surry Hills, Sydney, no-one gives Sophie a second glance' ('A Class Act!', by Di Stanley, *TV Week*, 12 September 1992, cover and 6–7). Meanwhile, 'Kylie has also recently admitted that she hopes one day to

FROM THEATRE TO SPACE SHIP

Metaphors of suburban domesticity in postwar America

Lynn Spigel

In 1956, a year before the Soviet launching of Sputnik, Shakespeare travelled to the planet of the Krel in the science fiction classic *Forbidden Planet*. An adaptation of *A Midsummer Night's Dream*, the film presents the fantastic tale of Mobius, an earthling who lands on an alien world where he builds a suburban dream house complete with modernist decor and the latest in robotic home appliances. As the film unfolds, this Technicolor version of suburban bliss becomes a stage not only for Shakespearean drama, but also for the darker side of suburban domesticity. The audience soon discovers that this marvellous space-age home contains a threatening underworld of perverse sexual pleasure. As it turns out, Mobius has an obsessive need to keep his daughter for himself by maintaining her innocence of sexual difference and desire – a need that is destroyed when a team of swarthy astronauts arrives on his planet and awakens the sexual longings of the girl. In his jealous state, Mobius begins to conjure up a series of threats to deter the advances of her suitor. But, as in Shakespeare's famous play, the father's stormy rage is placed in check when the young woman, now fully aware of her sexuality, embraces her astronaut lover and takes off on his rocket bound for earth.

As a film that restages Shakespeare's Oedipal drama in the better homes and gardens of outer space, *Forbidden Planet* is symptomatic of a transition in the language used to represent suburban family life during the postwar period. This transition entailed a shift from metaphors that presented domesticity as theatre – a stage on which predefined gender and generational roles were played – to a competing set of images that presented suburban family life in terms of space travel. As in the case of *Forbidden Planet*, the new metaphor of space travel was

typically quite ambiguous. On the one hand, it functioned to glorify the high-tech family utopias promised by the developers of the postwar suburbs; on the other, space travel offered an escape from the perverse homogeneity of suburban life and toward an imaginary elsewhere where difference (sexual and otherwise) was possible to sustain.

This conceptual shift certainly was not smooth or even. Instead, following Raymond Williams's classic formulation, I would argue that the metaphors of 'home as theatre' and 'home as space ship' are better conceived as dominant, residual, and emergent forms. These metaphors existed in a kind of parallel universe, and sometimes – as in the case of *Forbidden Planet* where domestic gender roles were performed theatrically in outer space – these worlds did collide. What interests me particularly here is the way these conceptions of suburban domesticity competed for cultural legitimacy during the late 1950s and through the 1960s. What was at stake in this discursive competition? And how did it relate to wider social and political attitudes about the ideal design for living during a decade marked by intense social change?

In asking these questions, I am not simply interested in the 'poetics' of suburbia or even just in describing an ideological shift. Thinking about suburban domesticity in terms of the language used to describe it is, I believe, a necessary step in understanding the way people have represented *and also lived* their social relationships. Criticism of the suburbs has generally been divided between the culturalists interested in 'meanings' and the structuralists interested in economic and political policy. More recently, the field of critical geography and suburban history has complicated this culture/structure split. Feminist historians such as Margaret Marsh and Elizabeth Wilson, and Marxist writers such as Mike Davis, have provided ways to see the connections between language systems and the structural policies the affect urban and suburban design. Cultural representations of the suburbs, I want to argue, were deeply implicated in the policies and practices of suburban social life. These metaphors were not merely symptomatic of those deep structures, but also helped to create a language for domestic and suburban space – a spatial language in which people lived their lives and through which economic and political struggles were also formulated.

STAGED DOMESTICITY: THE HOME AS THEATRE

In the American housing boom after the Second World War, the mass-produced suburbs provided a practical alternative to the rising costs and diminishing space in urban areas. Towns like Chicago's Park Forest and New York's Levittown offered urban Americans of the white middle (and sometimes working) class a new design for living, largely devoid of the extended families and ethnic ties in the city. These new mass-produced suburbs were funded by Federal Housing Administration (FHA) building loan starts, which included strict 'red-lining' zones that effectively kept these new neighbourhoods confined to whites of European descent (many of whom were second-generation immigrants). Because the FHA issued GI loans to returning soldiers, many of the occupants were young couples, poised to raise families. The architectural layouts of the homes as well as the neighbourhoods themselves were designed for this form of nuclear family life and thus tended to exclude the interests and lifestyles of people not living in such arrangements.

Most interesting for my purposes is the way these mass-produced suburbs were modelled on notions of everyday life as a form of theatre, a stage on which to play out a set of bourgeois social conventions. Since the Victorian period, the theatre served as a central organizing principle of domestic architecture. 'Upstage' and 'backstage' spaces (such as the front and back parlour) served to make the home a kind of stage where family members and visitors knew what kinds of roles to assume depending on which spaces of the home they inhabited. Archways between rooms approximated a sense of proscenium space, while the late Victorian penchant for ornate trim and excessive decor provided an aura of public grandeur to private rooms.

Moreover, during this period the theatre served as a compelling recreational form for domestic social occasions. In fact, at mid-century, bourgeois Victorians were so fascinated with theatricality that they literally turned their parlours into theatres, staging plays with friends and family members in their homes. As Karen Halttunen has observed, these 'parlor theatricals' were sold in books that people purchased and adapted for their own use at parties. Using their front parlour as a proscenium space and their back parlour as a backstage area, Victorians constructed theatrical spaces, even adorning entrance and exit ways in the home with curtains and other decorations. The plays themselves were often extremely self-reflexive in nature, including dialogue and actions that self-consciously

referred to the artifice of everyday life (for example, players often dropped out of their stage character to reveal themselves in their private characters). Analysing its social significance, Halttunen argues:

The parlor theatrical was itself a play within a play, an explicit theatrical performance taking place within the larger, implicit theatrical performance that was middle-class gentility. . . . Many popular private theatricals succeeded in collapsing the distinction between the overt theatricality of the play and the implicit theatricality of all parlor social conduct. The message of parlor theatricals was simply this: middle-class social life was itself a charade.[1]

The theatricality and self-reflexivity that Halttunnen discusses carried through to the twentieth century as numerous popular sources conceptualized domestic life as a kind of stage. Although the grandeur and scope of the Victorian home gave way to increased comfort, family life was still represented in terms of spectacle and theatre. Magazines and advertisements of the 1920s devised elaborate ways to depict the home as a showcase for glamorous commodity lifestyles, while manuals on architecture and interior decor adopted metaphors of theatricality when speaking about the home. In 1940, Louise Pinkey Sooy and Virginia Woodbridge's *Plan Your Own Home* began by asking female readers:

If all the world's a stage, what drama is being presented within your four walls? For what parts are the members of your family cast? As the director of production, are you, the homemaker, creating a backdrop against which the story of your family life may be sympathetically and beautifully portrayed?[2]

Postwar Americans – especially those being inducted into the ranks of middle-class home ownership – must, to some degree, have been aware of the artifice involved in suburban ideals of family life. For people who had lived through the Depression and the hardships of the Second World War, the new consumer dreams must have seemed somewhat pretentious. Leaving ethnic and working-class areas for mass-produced suburbs, these people must have been aware of the new roles they were asked to play in a prefabricated social setting. This perception is suggested by sociologists of the era, whose studies showed that people were sensitive to the theatrical quality of everyday life.

The strongest case was made in 1955 by sociologist Nelson Foote. In his article 'Family Living as Play', Foote claimed that 'family living in a residential suburb has come to consist almost entirely of play'. While he admitted that the 'popular recognition of this fait accompli is only partial', he went on to detail how 'the family home may be most aptly described as a theatre'. The members of the family, he argued, were all performers: 'The husband may be an audience to the

wife, or the wife to the husband, or the older child to both.'[3] If Foote used theatricality as a metaphor for family relations, other sociologists concentrated on the wider drama of social relations, showing how families transformed their homes into showcases for their neighbours. In his study of the mass-produced suburbs, Harry Henderson suggested that 'constant attention to external appearance "counts for a lot" and wins high praise from neighbors'. While residents decorated their homes in distinctive ways, none strayed far from the predictable standards exhibited in middle-class magazines – in fact, Henderson argued that 'what many [new home owners] sought in their furniture was a kind of "approval insurance"'.[4] Sociologist William H. Whyte described the social conformity of interior decor in the suburban home, noting one woman who was 'so ashamed of the emptiness of her living room that she smeared the picture window with Bon Ami; not until a dinette set arrived did she wipe it off'.[5] For this woman the picture window itself became a venue of theatrical display in which furniture took on the status of props.

Home manuals, magazines, and advertisements extended this emphasis on the home as showcase, recommending ways to create glamorous backgrounds on which to enact spectacular scenes. In *The House and the Art of its Design*, Robert Woods Kennedy claimed that the housewife needed 'an effective and glamorous background for her as a sexual being, commensurate with the amount of energy she expends on clothes, make-up, and society'.[6] Home magazines and their advertisements continually suggested this idea in illustrations that depicted housewives who were visually integrated into domestic backgrounds by colour, shape, and size. In 1949, one upper-crust, planned community in Great Neck, New York (the Kings Point Estates) took the house-as-showcase aesthetic to its logical extreme, basing the entire suburb around principles of theatrical design. Built by Homer Harmon, who had formerly been director of advertising and publicity at the Roxy Theater, the community was engineered by a production team that included Charles Bruton (designer of Paramount Theaters), Herbert Coe (who had once been on the executive staff of Columbia Pictures), and Arthur Knorr (the executive producer at the Roxy Theater). According to the Home section of *The New York Times*, the architects incorporated 'many of the unusual features of the homes of Hollywood stars . . . in a colony of theatrical and ranch style residences'.[7]

This theatrically inspired uppercrust landscape was matched at a more popular level by the depiction of the middle-class suburban home on the new medium of television. As I have detailed elsewhere, the theatrical quality of everyday life became a major organizing principle of the emerging television sitcom.[8] Family

sitcoms highlighted the performative nature of middle-class life on a weekly basis, and, like the Victorian parlour theatrical, such programmes were extremely self-reflexive in nature. By far the most self-reflexive was *The George Burns and Gracie Allen Show* (1950–8), whose entire premise revolved around a real-life couple (ex-vaudevillians George Burns and Gracie Allen) who played themselves playing themselves as real-life performers who had a television show based on their lives as television stars. If this is a bit confusing, it should be because the entire show was based on the paradox involved in transforming everyday life into a play for television. Designed to be the television version of *Our Town*, and set for most of its run in the *nouveau riche* suburb of Beverly Hills, the programme featured George Burns as part-time narrator/part-time character, who continually stepped out of his role in the family scene, reflecting on the stage business and the plot.

Although *Burns and Allen* was an extreme example, its self-reflexive theatricality was symptomatic of a general trend in domestic comedies. Sitcoms such as *The Adventures of Ozzie and Harriet* (1952–66), and *I Love Lucy* (1951–7) featured celebrity couples who seemed to be living their family lives on television. Furthermore, a cycle of 'showbiz family sitcoms', such as *I Love Lucy*, *The Danny Thomas Show* (1953–64), and *The Dick Van Dyke Show* (1961–6) worked much like the backstage musical as episodes revolved around families with careers in show business, ambiguously staging performances for a diegtic audience as well as the actual viewer at home.[9] One of the first such programmes, *The Truex Family*, dealt with a family of thespians headed by real-life actors Ernest Truex and Sylvia Field. Broadcast on New York's local station WPIX in 1949, the first episode detailed Truex's attempt to win a part in a play by impressing a wealthy producer whom he invited over to dinner. As in many backstage musicals, the performances were motivated by rehearsals – only here the rehearsals took place in Mr Truex's home as he read the script to his family. Eager to be in on the act, the entire family began pitching their talents to the producer who, in a case of mistaken identity, turned out to be an insurance salesman. In this and other showbiz family comedies, theatricality seemed to be a natural condition of domestic life.

In addition to the premises of all of these programmes, the family sitcoms developed formal conventions that presented the home as a proscenium, theatrical space where performances took place. In *Burns and Allen* the domestic space was often revealed to be a stage set as George walked out of the home setting (and his place in the story) in order to go on to a theatre stage where he addressed the camera in first person. Moreover, in numerous family sitcoms, the domestic set was often ambiguously a 'realist' element of the story world in which characters interacted and a theatrical stage on which star talents were featured. In suburban

sitcoms such as *I Married Joan* (1952–5) and *The Ruggles* (1949–52), the story was often completely derailed as the home was turned into a vaudeville performance space. For example, in a *Ruggles* episode entitled 'Charlie's Lucky Day', the domestic setting is suddenly transformed into a stage as numerous comedians, who play highly stereotyped roles reminiscent of stock characters in vaudeville sketches (a policeman, an inventor, and an insurance agent), knock on the door, enter the living room, and begin performing short sketches full of comic banter and broad physical humour. Even in the more 'folksy' naturalist comedy of *Ozzie and Harriet*, the interior space of the Nelson home served as a proscenium space in which the celebrity family performed their talents.

While such popular representations of the home as theatre seem most directly related to older forms of nineteenth- and early twentieth-century popular culture, by the postwar period a growing number of intellectuals began to formulate theories of everyday life that also took the theatre as a model of explanation. In France, Marxist historian Henry Lefebvre wrote his *A Critique of Everyday Life* (1947), which dealt philosophically with the problem of authenticity, concluding that life was better conceptualized through models of theatrical display than through appeals to human nature. In the United States, Erving Goffman's *The Presentation of Self in Everyday Life* (1959) offered a by now classic sociological account of everyday communication as a series of theatrical stagings with people assuming a variety of roles on and off stage. Later, at the University of Cambridge in his 1974 lecture 'Drama in a Dramatized Society', Raymond Williams argued that in the age of television, the dramatic form 'was built into the rhythms of everyday life', not only because drama has become more available through televised presentations, but also because there is a 'direct cultural continuity' between the enclosed domestic rooms staged by naturalist dramatists such as Ibsen and those enclosed rooms in which ordinary people now watch television.[10]

Meanwhile, in the early 1960s a new documentary movement emerged that was based on an epistomophilia of everyday life – a strongly charged desire to understand the nature of lived relations. The documentary practices of cinema verité should be seen as part of the intellectual as well as popular penchant for investigating the lines between authenticity and theatricality. Verité directors continually foregrounded the sense of 'upstage' and 'backstage' behaviours among their numerous subjects, supposedly to demonstrate the difference between social pretence and authentic expression.[11] For this reason, film-makers were particularly interested in performance and performers including famous subjects such as Jackie Kennedy (*Primary*) or Jane Fonda (*Jane*). But also, and more importantly for our purposes, they filmed ordinary people such as door-to-door bible

salesmen travelling through East Coast suburban neighbourhoods (*Salesman*) or the families of Muncie, Indiana (*Middletown*). Much as in the television sitcom, these last two documentaries reflect on the theatricality and artifice entailed in living out social roles in new suburbs and older towns. And while the audience for these documentaries was not as large as the sitcom audience, they were shown on network and/or public television, and they did have a relatively extensive nationwide viewership.

This 'direct cinema' aesthetic was taken to its logical extreme in 1973 with the broadcast of the PBS documentary *An American Family*, which documented the life of the Louds who lived in a suburban town. By setting cameras up in the home, the film-makers hoped to explore the lived experience of a typical American family. But as the film proceeded, it became clear that the domestic stagings of happy family life were a mere social pretence as the 'normal' American family disintegrated before the cameras (the parents divorced, and the son came out as a homosexual). In this way, *An American Family* can be seen as part of a longer tradition – co-extensive with the Victorian parlour theatrical – in which American audiences delighted in critical 'restagings' of the social conventions of middle-class family life.

THE VOYAGE HOME

As the case of the Loud family suggests, theatricality continued (and still continues) to serve as a metaphor for family life, but by the beginning of the 1960s another metaphor for domesticity began to have increased cultural currency. A perfect example of this transition is a 1959 episode of *Men Into Space* (1959–60) a popular science fiction anthology that was produced with the assistance of the Department of Defense. The episode begins as astronaut Captain Hale returns from the space lab to his suburban home and invites his wife Renza to join him on a voyage that will make her the 'first woman on the moon'. The excited housewife immediately wonders how many clothes she will be able to bring, how she'll live without her hairdresser, and whether she'll be able to fit the fancy china into the rocket's luggage compartment. As it turns out, her feminine imaginings aren't far from wrong. In fact, once on the moon Renza learns that she is not allowed to go out of the capsule, but instead must stay home and cook anti-gravity Yorkshire puddings for the boys. Isolated and distraught over her inability to get the pudding to rise, Renza finally breaks out on her own. When Captain Hale

discovers her moon-walking out of radio-control range he becomes enraged and rails, 'Your place is on earth at home.' While initially furious, the feisty Renza finally does return to the ship, at least after the couple metaphorically 'kiss' and make up by rubbing their space helmets together.

This episode is symptomatic of a shift in the language used to represent suburban domesticity. Now the home was depicted as a space ship that promised to carry occupants away from the conventional roles played in domestic space to the new and exciting frontiers of outer space. Even while this episode ends conservatively, with Renza accepting her role as space wife on the ship, the new metaphor of rocketry serves as a narrative vehicle through which Renza, and by implication the audience, can (at least temporarily) break loose into an imaginary elsewhere, beyond the boundaries of domestic (or in this case space ship) confinement.

The idea of the home and family life as a vehicular space was not entirely new. Certainly, as Raymond Williams has argued through the concept of 'mobile privatization', domesticity in industrial culture has always been linked to fantasies of being somewhere else while in the comforts of one's home.[12] Communication technologies have long provided this sense of mobile privatization, and in the postwar years television materialized these fantasies. So too, while Williams does not discuss it, the postwar suburb was itself constructed around the links between mobility and privacy; that is, suburban development was intimately connected to the development of high-tech freeway systems that allowed commuters to use private transportation systems (i.e. family cars) to move between jobs in the city and their detached single-family homes.

Since the 1920s, modernist designs for living – including housing, furniture, and appliance design – were fashioned on the related idea of what might be called 'privatized mobility'. Streamlined and aerodynamic styles presented a sense of the cruise ship or airline in the context of domesticity. In the postwar period, however, such designs became available at a mass-market level and they were associated foremost with space travel. Moreover, they took on a postmodern dimension as they were integrated firmly, and even in a cartoonish way, into the material culture of everyday life in suburbia rather than simply exhibited in museums, movies, or upper-crust homes. Outer-space façades turned family restaurants and suburban car washes into fantastic adventures while Tang, a sugary orange juice substitute promoted as 'the breakfast drink of astronauts', was the new wonder product at the supermarket. To borrow Mike Featherstone's phrase, these space-age make-overs added up to an 'aesthetization of everyday life', in this case predicated on the fantastic possibility of space travel as a new form of family and community relations.[13]

This transition from 'home as theatre' to 'home as space ship' was, I want to repeat, not smooth or even. Still, the idea of the 'home as space ship' gained popular currency during the late 1950s, and through the 1960s it served as a compelling metaphor for suburban family life. Its emergence can be seen in the context of a set of historical transitions, both at the micro-level of everyday life and the level of macroeconomics and politics.

By the end of the 1950s, utopian dreams for consumer prosperity and domestic bliss that the suburbs had once represented were revealing their limits in ways that could no longer be brushed aside.[14] Social criticism of suburbia had become a genre of its own. John Keats's *A Crack in the Picture Window* (1956) presented unflattering pictures of the new suburbanites, with characters like John and Mary Drone, whose lives were spent deciding how to buy washing machines and avoid their busybody neighbours. William Whyte's *The Organization Man* (1956) was a damning critique of the new company boys, whose willingness to conform to job expectations was mirrored by the peer-pressure politics of their suburban lifestyles. In *The City in History* (1961), Lewis Mumford criticized the new organization of social space and the homogeneous living arrangements it encouraged. Meanwhile, in women's culture, Betty Friedan's *The Feminine Mystique* (1963) indicted mass media and a host of other social institutions for forcing women to accept the role of 'occupation housewife'.

What Friedan perhaps didn't notice, however, is that the mass media had already been offering their own criticisms of postwar domesticity and suburban entrapment for women (and men). Science fiction novels such as Philip K. Dick's *Time Out of Joint* (1959) used the suburbs as a trope for the uncanny horrors of banality, while Hollywood genres from science fiction/horror to melodrama to social problem films presented suburbia as a paranoid, claustrophobic space where perverse social relationships reigned. In the suburban family sitcom, the housewife's enslavement became a common theme as female characters searched for roles outside the home. For example, an episode of *Father Knows Best* (1954–63) entitled 'Margaret's Vacation' shows wife Margaret fed up with her housework and wandering from the family home to a downtown club where she flirts with becoming a beatnik.

Such depictions of suburban domesticity continued throughout the 1960s and into the 1970s. Perhaps in this respect it is no surprise that a new cycle of television sitcoms which represented single girls and later 'new liberated women' did so largely by having them move to the city. For example, in *That Girl* (1966–71), the first single girl sitcom to picture a woman living alone, Ann Marie moves from her middle-class suburban town of New Rochelle to New York City.

On *The Mary Tyler Moore Show* (1970–7), which is generally seen to inaugurate a cycle of 'new woman' sitcoms, Mary Richards moves from her small town suburban life to Minneapolis where she chooses a career over marriage. Significantly, both of these shows (as well as several others of the genre) contained credit sequences that narrativized scenarios of female autonomy through a glorification of city life in which forms of transportation were central narrative vehicles. In *That Girl*, Ann Marie frolics through the streets of New York City as a bus drives by with a picture of her on it. And in the now famous credit sequence of *The Mary Tyler Moore Show*, Mary is shown driving her car to her new Midwestern metropolis as the lyrics remind us that she might just 'make it on her own'. A similar driving sequence is seen in the second season of *The Doris Day Show* (1968–73) when single mother Doris commutes from her small town to her job in San Francisco.[15]

The most literal critique offered by this new woman genre came in 1975 with *The Stepford Wives*. In this dystopian science fiction film, an evil husband moves his family out to a new suburban company town of Stepford, where unhappy housewives are systematically transformed into domesticated and blissfully subservient robot-replicants. Much as in the television sitcoms, the credit sequence prefigures this transformation by showing the family moving from their city apartment to the suburbs, with the wife (played by Katherine Ross) decidedly uneasy about the transition. The final sequence of the film displays the horrific outcome of suburban migration as Ross is shown restyled in her replicant form, strolling mindlessly through the aisles of a suburban supermarket and greeting other similarly vacant Stepford wives. Indeed, by the time of *The Stepford Wives*, popular culture had fully pronounced its own social critique of suburbia, presenting it as a decidedly inauthentic space where the social conventions of gender roles turned humans into artifacts.

As all of these 'driving' sequences indicate, the widespread disillusionment with suburban lifestyles that began to mount at the end of the 1950s gave way to a newfound fascination with the trope of transportation in popular media. At least at the level of fantasy, transportation offered a way out of the confines of suburban domesticity and into more exciting locales. Considering the fact that the postwar suburbs were themselves constructed around new transportation systems – i.e. freeways – this is no small irony. Now, in cultural fantasies the freeway system provided a great escape from the very suburban communities that were enabled and perpetuated by it.[16] It is in this context of transportation and its peculiar relation to the suburbs that we might begin to understand how domestic space came to be associated with rocketry over the course of the 1960s.

The translation of a 'metaphor' for a particular social fantasy into the 'hardware' of a scientific and technological agenda has been brilliantly documented by Donna Haraway, who shows how the ideologies entailed in patriarchal family life and species reproduction came to be expressed in the scientific experiments on primates.[17] Here I want to suggest that fantasies of suburban domesticity, as well as the escape from it, were translated into the hardware of rocket science during the period of America's space race.

That period, of course, was inaugurated with the advent of Sputnik in October 1957. The Russian launching of the rocket precipitated the most stunning technological embarrassment of the times. Cold War logic was predicated upon America's ability to prevail in all technological endeavours, especially those associated with national security. Thus, the advent of a Russian rocket soaring into orbit sharply contrasted with previous conventions for representing American relations with the Soviets. Sputnik quickly became a media panic, and two months later when America's own rocket, Vanguard I, fell to the ground, the media called it such derisive names as 'Flopnik', 'Kaputnik', and 'Stayputnik'.[18] More generally, critics expressed anxieties about the nation's technological agenda, claiming that American science had put its faith in consumer durables rather than concentrating on the truly important goals of national security. As Henry Luce of *Life* said, 'For years no knowledgeable U.S. scientist has had any reason to doubt that his Russian opposite number is at least his equal. It has been doubted only by people – some of them in the Pentagon – who confuse scientific progress with freezer and lipstick output.'[19] By using freezers and lipstick as examples, Luce not too implicitly suggested that America had put its faith in femininity and domesticity as opposed to the scientific arena more typically associated with men. This relationship among domestic appliances, femininity, and rocket science was echoed and discursively refigured in the famous 1959 'Kitchen Debates' between Vice-President Richard Nixon and Soviet Premier Nikita Khrushchev at the opening of the American National Exhibition in Moscow where the main attraction was a full-scale model of a six-room ranch house complete with labour-saving devices. Here, the two leaders argued over the relative merits of home appliances in both countries, and Nixon especially related this to the superior ease with which American housewives led their lives. As Elaine Tyler May suggests, at a time when the United States was vulnerable to the Soviets' military strength in rocket science, 'Nixon's focus on household appliances was not accidental.' Instead, 'Nixon insisted that American superiority in the Cold War rested not on weapons, but on the secure, abundant family life of modern suburban homes.'[20]

But outer space and domesticity were not discursively related simply as

binarisms in rhetorical manoeuvres of the Nixon kind; instead scientists and engineers found ways to integrate the two. In 1958, the same year that NASA was formed, America's premier space scientist Dr Wernher von Braun described the hardware of space rocketry through metaphors of domesticity. Von Braun told *Life* that 'missile building is much like interior decorating. Once you put it all together you may see in a flash it's a mistake – the draperies don't go with the slip covers. The same is true of missiles.' Eleven years later in 1969, just before Apollo 11's famous voyage, NASA engineer John C. Houbolt told the same magazine that a 'rendezvous around the moon was like being in a living room'.[21] Indeed, in this case the metaphors for family life and interior decor are turned into the hardware of space science. Beyond this specific case, the cultural symbolism of family life was used throughout the period to communicate the nation's goals in space.

It is in the documentary coverage of the space race that we can begin to see how the trappings of suburban family life came to be communicated through the new image of rocketry and outer space. This media coverage was key for the Kennedy administration, which typically positioned the United States investment in space in ideological rather than scientific/military terms. In the context of his general 'New Frontier' rhetoric, Kennedy attached great ideological importance to scientific knowledge, promising that our nation of homebodies would get off their easy chairs and on to the moon by the end of the decade. In 1961, President Kennedy sent Congress his new budget, which poured billions of dollars into NASA. Faced with numerous Congress people sceptical of his agenda, he continually sought ways to convince them and the general public of the symbolic – if not strategic – significance of space exploration for the nation. In particular, he argued that the space race provided America the opportunity to show the world that, as opposed to the Soviets, America would not censor coverage of the launchings, regardless of how disasterous or embarrassing they might be.[22] Distinguishing the flight of Alan Shepard from the Soviet flights before it, he told the 39th annual convention of the National Association of Broadcasters:

no secrecy surrounded the launching of our first astronaut. We did not conceal the anxious hours of waiting, the dangers of uncertain adventure, the possibilities of failure. On the contrary, the members of your association and the members of the press carried the news of each moment of tension and triumph to an anxious world.[23]

Whether or not the people of other nations believed this 'free world' rhetoric, the imagery of space travel obviously captured the attention of the American public. The A. C. Nielsen rating service estimated that the average home was tuned in for five hours and fifteen minutes of the ten-hour coverage of John

Glenn's orbital flight on 20 February 1962. This was, according to A. C. Nielsen, 'by far the largest audience ever tuned to daytime TV'; even at its 'low' moments the programme reached '5 million more homes than typically tuned to the highest-rated network [prime-time] program, WAGON TRAIN'.[24] Presumably, the public's fascination with the new frontier had far surpassed its passion for the old.

It is perhaps no coincidence that the rocket launchings served as an exciting replacement for the quintessial form of televised images of family life – the daytime soaps. Indeed, more generally, the Kennedy administration's notion of satisfying news coverage tended towards family melodrama rather than scientific data. The 'documentary' coverage of the space race gave way to an intensive exploration of spectacularized family life with astronaut stars and their wives appearing on the airwaves, in newspapers, and on the covers of national consumer magazines. In these media spectacles, ideals of suburban domesticity and the fantastic voyage to outer space were intricately bound together.[25]

The discursive merger between domestic and outer space found its standard form in *Life*'s biographical essays, which presented technical information alongside multi-page spreads depicting family scenes and life histories of the astronauts. In the 18 May 1962 issue, Scott Carpenter was pictured with his wife Rene on the cover, while the inside story showed family photos of Scott as a child with his grandfather, his pony, his friends, and his modern-day wife and children. The snapshots showed them as the ideal American family: playing at home, enjoying a family vacation, and finally, in the last pages of the essay, saying their farewells just before the space flight. In this way, the photographic narrative sequence suggested that Scott Carpenter's flight to the moon was one more in a series of 'everyday' family activities.[26] This became the conventional narration of *Life*'s astronaut profiles in the years to come.

In a practical sense, this essay format allowed the magazines to appeal to diverse audiences because it conveyed technical, scientific information in the popular format of family drama. Discussions of domesticity made space familiar, offering a down-to-earth context for the often abstract reasoning behind space flights. When astronaut John Young went into space in 1965, this merger of science and domesticity was taken to its logical extreme. *Life* reported his flight by telling the story of his wife and children, who witnessed the event on television while sitting in their suburban home:

The Youngs watch. In John Young's home outside Houston, the astronaut's family sits at the TV set as the seconds crawl toward launch time. Barbara Young fidgets, Sandy fiddles with a bit of string

and Johnny, still getting over chicken pox, stares unsmiling at the screen. At lift off Mrs. Young hugs Sandy. 'Fantastic,' she crows . . . as ship soars skyward.[27]

The accompanying photographs show the Young family sitting before their television set in their suburban home, much as other Americans would have done that day. Here as elsewhere, the 'fantastic' is communicated through the domestic, and space technology is itself mediated through the more familial technology of television.

Other media also presented suburban domesticity in the context of space science. Drawing on an older tradition of song lyrics that tied romance to the moon, a new spate of space songs emerged with titles like 'Space Ship for Two' and 'Sputnik Love'.[28] Women's home magazines included recipes for 'blast-off' space cakes, promoted 'space-age homes', and suggested building 'space platforms' instead of porches.[29] Designers and advertisers, eager to employ popular meanings, used space-age imagery to glorify family-oriented products. Furniture companies offered new space-age-inspired kitchen dinettes that played with earlier modernist furniture designs. For example, a 1969 ad for Style Setter dinettes shows a couple on the moon dressed in NASA space suits, embracing each other as they sit on their space-ship-inspired bucket seat chairs (the NASA landing capsule was in the background). Just in case this visual link between outer space and domesticity had not registered in the mind of the consumer, the caption read, 'At Home in Any Atmosphere'.[30] Earlier in the 1950s, car companies had already made the link between the motor age and the space age by modelling cars to look like rockets. In one advertisement, for example, Ford showed a little boy dressed in a space suit, exploring his brand new Fairlane family sedan and telling consumers that ' Ford interiors are . . . out of this world'. Meanwhile, the family vacation had also become a medium suited for metaphors of space travel.[31] The link was forged most emphatically in 1955 at Disneyland in a space-age-inspired section of the theme park known as Tomorrowland. In the early 1960s, with the official space race under way, the Seattle and New York World's Fairs opened their gates to families who wandered about peering at Ford's hundred-passenger space ship and the NASA exhibit. A 1958 article in *Look* showed a more low-tech variation on the space-age theme vacation; it depicted a family relaxing on Florida's Cocoa Beach and watching for 'imminent missile launchings' as they 'take in the sun and sights at the same time'.[32]

While the merger of science fiction fantasies and domesticity often served to make outer space seem familiar, it also accomplished the opposite purpose of making the familiar seem strange. As Fredric Jameson has argued, science fiction

tends less to imagine the future than to 'defamiliarize and restructure our experience of our own present'.[33] While Jameson is speaking about literary and filmic texts, we can apply the same rule to other forms of material culture, including the geographical and domestic spaces of the suburbs. The redecoration of suburban towns with 'outer-space' architecture and building ornamentation, as well as the new penchant in furniture design and home decor for the space-age look, suggests a profound reorganization of the familiar through the strange. This estrangement of domesticity worked as the central propeller for a model of suburban family life that took transportation – and space travel in particular – as its central metaphor.

Within this new symbolic regime, television's portrayal of family life also looked to the planets. Like Captain and Renza Hale in *Men into Space*, numerous television families were renegotiating their roles through the fantastic possibilities of space science. Programmes such as *My Favorite Martian* (1963–6), *It's About Time* (1966–7), the cartoon sitcom *The Jetsons* (1962–3), and the more 'family-drama' oriented (by now cult classic) *Lost in Space* (1965–8) were part of a genre cycle of fantastic family sitcoms in which the suburban family sitcom and science fiction fantasy (or sometimes horror) were joined into a hybrid form.[34] This collision of two unlikely forms gave rise to the moment of 'hesitation' which Tzvetan Todorov identifies as the 'fantastic'.[35] According to Todorov's account, the fantastic often occurs at the point at which the hero or heroine doubts the credibility of the narrative situation (can this be happening, or am I dreaming this?). In addition to this hesitation within the mind of a character, the fantastic also makes the reader uncertain about the status of the text. The story calls its own conventions of representation into question and makes the reader wonder whether the narrative situation is possible at all. In the fantastic family sitcom, the elements called into question are not the supernatural elements of the story (we are never made to question whether genies or Martians exist). Rather, the moment of hesitation takes place in the realm of the natural. We are, in other words, made to question the 'naturalness' of middle-class suburban ideals, especially as those ideals had been communicated through the genre conventions of previous suburban sitcoms such as *Ozzie and Harriet* or *Donna Reed*. In place of the suburban sitcom's friendly next-door neighbours and heterosexual nuclear family, the programmes offered neighbourhood snoops and unconventional couples like a talking horse and his master (*Mr. Ed*, 1961–5) or a man and his mother who had been reincarnated as a car (*My Mother the Car*, 1965–6).

The sitcoms with outer space themes were equally unusual. *My Favorite Martian*, for example, was premised on the idea of a Martian who landed in the yard of

a young man's suburban home. The Martian took on the double identity of earthling Uncle Martin, moved in with young man, and hid his true Martian self from suspicious folks around the neighbourhood. This premise not only allowed for a comedic exploration of the social conformity demanded in suburban neighbourhoods, it more specifically can be seen as a programme that worked through nagging anxieties about bachelors, especially bachelors who lived with other men. Uncle Martin was constantly thwarting the advances of his overzealous landlady, who could not understand why he preferred bachelorhood to her womanly ways.

As a companion piece for *My Favorite Martian*'s homophobic nervousness about single men in suburbia, *I Dream of Jeannie* presented anxieties about the single girl. Based on the exploits of astronaut Tony Nelson, who finds a beautiful genie (named Jeannie) after crashing his rocket on a beach, this programme also dealt with the closeted sexuality that suburban social conventions demanded. When Tony brings Jeannie back to his suburban home, he has to hide his live-in supernatural girlfriend from the boys at NASA. But while he tries literally to bottle up Jeannie's powers, she typically escapes the rational logics of masculine science by using her feminine supernatural power to wreak havoc at home and at the space lab. And unlike NASA, which spends billions to get men up to the moon, Jeannie is able to wish her way there in a matter of seconds. The programme thus functions as a contradictory mix of contemporary discourses on swinging singles (with Jeannie as the ultimate playmate who lies around in harem garb and calls her live-in boyfriend 'master') and the emerging discourses of women's liberation (with Jeannie as a supernatural and superpowerful woman).

Anthologies such as *The Twilight Zone* (1959–65), *The Outer Limits* (1963–5), and *Science Fiction Theater* (1955–7) also presented stories that linked suburban domesticity to space travel.[36] A central theme was the paranoid fear of difference in suburbia, played out (as in much science fiction of the times) through the figure of the alien. At the height of the Cold War and anti-communist sentiments, *The Twilight Zone*'s 'The Monsters on Maple Street' depicted a suburban town where citizens suspected someone in their midst to be a space alien, while the premiere episode of *The Outer Limits*, 'The Galaxy Being', showed how suburbanites demonized a kindly extraterrestrial whose only wish was to communicate peacefully with them. And in a period when FHA building policies were predicated on keeping racial 'others' out of white suburbs, *Science Fiction Theater*'s 'The People from Planet Pecos' presented a space scientist whose suburban home was located next door to a family suspected of being from another planet. Such liberal cautionary tales about interplanetary race relations often included didactic

narration that encouraged audiences to question the more familiar acts of racism and xenophobia (as well as other types of social exclusion) in their own everyday suburban towns.

If these mainstream television programmes used tropes of the fantastic to present liberal commentary on the racism in suburbia, they were a weak cry in a world that was bent on conserving the red-lining policies that had excluded people of colour from the suburban dream. Indeed, despite the 'progressive' imagery of Kennedy's space age new frontier, the idea that suburbia was changing was mostly the stuff of science fiction fantasy. Back on earth, the suburbs were still grounded in their tried and true Jim Crow building policies. Despite the passing of the Civil Rights Act in 1964, 'from 1960–1977 four million whites moved out of central cities, while the number of whites living in suburbs increased by two million'. And 'During these same years, the inner-city black population grew by six million, but the number of blacks living in suburbs increased by only 500,000 people.'[37]

Most interestingly in this regard, African American critics often used the space race as a launching pad for criticism not only of the racism at NASA, but also of the racist policies of suburbia.[38] This is well demonstrated in the black middle-class magazine *Ebony*, which reported on the rise and fall of the first black astronaut-candidate Edward J. Dwight. Much like the astronaut essays in *Life*, when *Ebony* first presented Colonel Dwight, it used metaphors of suburban family life, showing him at home reading books to his children and wife.[39] But when NASA dropped Dwight from the space programme, *Ebony* reported this defeat by focusing on the fact that Colonel Dwight was also in the middle of a divorce. In this way, the African American broken family was ultimately connected to the black man's inability to serve as a symbol of heroic space travel. But unlike much of the white majority that would have blamed the black male for the whole incident, *Ebony* connected Dwight's divorce both to the '"anti-Negro" attitude and social ostracism the Dwights faced at [the] California base' and to the housing discrimination they experienced in the suburbs:

In an effort to make a home for his wife and family, he tried to rent a good-sized house near Wright-Patterson AFB, instead of settling on one of the barrack-type housing projects set aside for military personnel. Despite his Air Force uniform and silver captain's bars, he faced the same problems as other Negroes seeking homes in white neighborhoods.

Finally, a Catholic layman who had seen Dwight's picture on the cover of a Church publication offered to rent him a house in Huber Heights, a Dayton suburb. Soon after the Dwights moved in, the harassment began. . . . Shouts of 'niggers go home!' met the family almost every day. . . . Not long thereafter, Dwight's marriage went on the rocks.[40]

This story, then, inverts the myth of the ideal, white, suburban space age family by presenting instead a failed black family whose break-up is caused by discrimination both in the space programme and in the white suburbs.

Dwight's story was told time and time again in black America, as black critics continually pointed to the paradox of their situation. While whites were busy with the space project and all the wondrous imagery it entailed, blacks were living in decidedly undecorative housing projects. This opposition between outer space and inner cities was nowhere better stated than in a 1969 issue of *Ebony* which had this to say about the moon landing:

Especially to the nation's black poor, watching on unpaid-for television sets in shacks and slums, the countdowns, the blastoffs, the orbitings and landings had the other-worldly alienness – though not the drama – of a science fiction movie. From Harlem to Watts, the first moon landing in July of last year was viewed cynically as one small step for 'The Man,' and probably a giant step in the wrong direction for mankind.[41]

More generally, as I argue elsewhere, the connections between space travel and the politics of housing on earth repeated the familiar metaphors of 'white flight' that had surrounded the suburban migration that took place in the 1950s.[42] Now these white flight metaphors took on literal meaning, as the segregated suburban communities re-dressed themselves in the material culture of outer space. In this regard, it is worth pointing out that despite the 'futurism' of rocketry and space race rhetoric, the 'home as space ship' metaphor did not serve, *a priori*, a more progressive function than its Victorian-based predecessor did. Instead, both the metaphors of 'home as theatre' and 'home as space ship' provided discursive opportunities for their publics – opportunities to think progressively, conservatively, regressively, or any combination thereof. It is, as Michel de Certeau reminds us, the act of speaking within the language system that makes the political difference in everyday life.

A CAUTIONARY TALE FOR CYBERNAUTS

Today, as everyone is caught up in the electronic sublime of cyberspace and the postmodern communities it proposes, it seems especially useful to consider the way suburban living and community space has been imagined in modern times. In one utopian sense, these metaphors of theatricality and space travel have come to stand for the dream places people wish to inhabit; in another way these

metaphors have been used to defamiliarize the 'lived' suburban spaces that are oppressive in their homogeneity and rigid social expectations; and finally these metaphors have been deployed in blatantly racist, classist, homophobic, and sexist ways to keep the suburbs clean of those 'aliens' that won't or can't play the 'roles' required of them.

In this regard, the newer metaphor of cyberspace and the technical hardware that accompanies it repeats these familiar signs. As so many 'blue sky' scenarios suggest, cyberspace can potentially create a better world by expanding our sense of place, community and communication, and by breaking down the rigid identities (the races, the sexes, the nationalities, the classes) experienced historically in 'mundane' space. Cyberspace is clearly also accompanied (or, more to the point, preceded) by defamiliarizing cyberpunk fictions – most notably those written by cyber-guru William Gibson who has largely staked out the territory for all social criticism. Moreover, while Gibson often says he knows nothing about computers, his stories have served as an inspiration for the engineers and technocrats who produce the systems; in other words, his metaphors of cyberspace are literally being turned into hardware. Finally, cyberspace is also subject to the same kind of racism, sexism, and class bias that have accompanied metaphors of theatricality and space travel. Indeed, as other critics have suggested, the computer technology needed to occupy this territory is developed by and available to mostly white, First World men. This kind of white privilege is nowhere better seen than in the myriad of contemporary ads for home theatres and computer 'net' systems geared at the consumer market. The images used are blatantly white and overwhelmingly familial.

Moreover, while many of the cybernauts are busy enthusing over the utopian possibilities for social reformation in cyberspace, the politics of housing, community planning, and family life are not improving. In 1993, 86 per cent of suburban whites still lived in areas with a black population below 1 per cent.[43] This situation is especially ironic given the fact that the idealized version of white suburban family life is itself no longer available to most Americans, even those in the white middle class. As sociologist Judith Stacey argues, we are now living in the age of 'virtual family values', a time when the idea of a nuclear family living in a shiny, happy suburban town is no more tangible than the compelling illusions of cyberspace.[44]

Hopefully, however, it is by now clear that my point is not that everyday life is distinct from the images used to describe it. Instead, the metaphors by which we live our lives often result in the structures we build to contain them. The metaphors of suburban domesticity that circulate in popular culture serve as a

foundational myth for the housing policies and community designs in which we live or cannot live.

Despite the fact that these metaphors are often used in ways that conserve property values at the expense of human justice, there is a positive side to thinking about social life in terms of language. After all, metaphors, as Haraway has taught us, are 'software'. As such, with some imaginative play, they can be recast and turned into rhetorical tools that we might use to dismantle those very community planning and building policies that have often rendered suburbia a hostile and alienating terrain. From this point of view, thinking about the poetics of suburbia is not merely a literary critic's pastime. Instead, by understanding the language used to represent domestic and community space, we might be able to refashion the cultural myths that organize those spaces. In so doing, we might begin to build more joyous environments in which to lead our everyday lives.

NOTES

1 Karen Haltunnen, *Confidence Men and Painted Women: A Study in Middle-Class Culture in America, 1830–1870* (New Haven: Yale University Press, 1982), pp. 184–5.

2 Louise Pinkey Sooy and Virginia Woodbridge, *Plan Your Own Home* (Stanford: Stanford University Press, 1940), p. 1.

3 Nelson Foote, 'Family Living as Play', *Marriage and Family Living*, 17:4 (November 1955), pp. 297, 299.

4 Harry Henderson, 'Rugged American Collectivism', *Harpers*, November 1953, p. 81 and 'The Mass Produced Suburbs, Part II', *Harpers*, December 1953, p. 27.

5 William H. Whyte, Jr, *The Organization Man* (1956: reprint, Garden City, NY: Doubleday, 1957), p. 133.

6 Robert Woods Kennedy, *The House and the Art of its Design* (Huntington, NY: Robert E. Krieger Publishing Company, 1953), p. 42.

7 'Theatrical Designers Assist in Planning New Colony of Residence at Great Neck', *The New York Times*, 2 October 1949, sec. VIII and IX, p. 1.

8 Lynn Spigel, *Make Room for TV: Television and the Family Ideal in Postwar America* (Chicago: University of Chicago Press, 1992).

9 *Ozzie and Harriet* and *The Dick Van Dyke Show* were set in the suburbs. *The Danny Thomas Show* was set in a penthouse apartment in Manhattan. *I Love Lucy* was set in the city but moved to the suburbs in the 1956–7 season, a move which was symptomatic of the family sitcom form in general as most were set in suburbia by the end of the 1950s.

10 Henri Lefebvre, *Critique of Everyday Life, vol. I*, trans. John Moore (1947: reprint, London: Verso, 1992); Raymond Williams, 'Drama in a Dramatized Society', Inaugural Lecture, University of Cambridge, 29 October 1974, and published in Alan O'Connor, ed., *On Television: Selected Writings* (London: Routledge, 1989), pp. 3–13; Erving Goffman, *The Presentation of Self in Everyday Life* (New York: Anchor, 1959).

11 While the films were often intended to minimize the 'artifice' of classical documentary techniques, they paradoxically served to beg the question of authenticity itself (filmed or otherwise). For example, even while the film-makers used hand-held cameras and natural diegetic sound to portray events, they also employed more classical narrative techniques of invisible editing and sound-overs.

12 Raymond Williams, *Television: Technology and Cultural Form* (New York: Schocken, 1975), p. 26. See too Jean Baudrillard who, like Williams, speaks about domestic communications in metaphors of drama and mobility. He argues that new communication technologies of the postwar period have reconfigured the home from the space of a Freudian 'scene' to a vehicle in orbit (a space of the 'disease'). See his 'Ecstasy of Communication' in *The Anti-Aesthetic*, ed., Hal Foster (Port Townend: Bay Press, 1983), pp. 126–34.

13 Mike Featherstone, 'Postmodernism and the Aestheticization of Everyday Life', in *Modernity and Identity*, eds, Scott Lash and Jonathan Friedman (Oxford: Blackwell, 1992), pp. 265–90.

14 Certainly, postwar suburbia had always had its discontents; at the beginning of the decade *Harpers* published Harry Henderson's two-part study that provided a revealing critique of the social homogeneity and conformity exhibited in the new suburban towns. See Henderson, 'Rugged American Collectivism' and 'The Mass Produced Suburbs'.

15 *The Doris Day Show* is almost a laboratory experiment in how important the trope of the city was to the representation of liberated women at the end of the 1960s. In its first season, the show was about a single mother who moved from the city to a rural town in northern California. When this premise didn't work, the producers changed the programme in the second season so that Doris now commuted from her small town to a job in San Francisco. Finally, in the third season, the producers completely changed the programme and had Doris move with her two sons to an apartment in San Francisco.

16 These female road narratives have an interesting relation to the male version made famous by Beat poet Jack Kerouac's *On the Road*. Kerouac used the road as a trope for freedom, and this Beat aesthetic was popularized on television in the programme *Route 66* (1960–4). Whereas the Beat's road is the cross-country highway 'route' that stretches expansively and aimless from east to west (and is thus connected to frontier mythology), in the case of women characters and the sitcom form the road is the more functionalist and purposeful freeway that leads from the city to suburbs, but never just anywhere.

17 Donna Haraway, *Primate Visions: Gender, Race, and Nature in the World of Modern Science* (New York: Routledge, 1989). She uses this phrase as the main title for Part II, chapter 9.

18 See a discussion of this media panic in Walter A. McDougall, . . . *the Heavens and the Earth: A Political History of the Space Age* (New York: Basic Books, 1985), pp. 141–56. It is clear that Kennedy's administration continued to be interested in the popular media's representation of NASA because the president's files contain clippings of cartoons on the subject which date from 8 December 1957 (two days after the Vanguard I failure, and before he took office) to March 1960. (These dates, of course, suggest that Kennedy had his staff do historical research into the media's portrayal of Sputnik.) Almost all of these cartoons derive humour out of making women the butt of the joke or else likening women's sexuality to rockets. For example, a cartoon from the 10 January 1960 issue of *The Denver Post* titled 'Snow White and the Seven Astronauts' depicts Snow White as a dormant rocket lying in bed (with the words 'U.S. Space Program', written on her dress) and the astronaut dwarfs trying so to speak, to 'get her up'. See Cartoon Clippings, 8 December 1957–21 March 1960, Box 362: Folder, Space Program General, np.

19 Henry Luce, 'Common Sense and Sputnick', *Life*, 21 October 1957, p. 35. Soviets took the occasion to suggest this as well. For example, McDougall cites Leonid Sedov's condemnation of America's fixation on consumer durables: 'It is very obvious that the average American cares only for his car, his home, and his refrigerator. He has no sense at all for his nation' (p. 137). The criticisms voiced by American journalists grew out of and reinforced a more general dismay with consumer capitalism that was voiced over the course of the postwar years. Science fiction writers Cyril Kornbluth and Frederik Pohl told of a future dominated by advertisers in the popular book *The Space Merchants* (1953), while non-fiction books like Vance Packard's *The Hidden Persuaders* (1957) and John Kenneth Galbraith's best-seller *The Affluent Society* (1958) made similar cases. Such concerns were fuelled by the recession of 1957–8, which created more general doubts about the consumer economy. Private debt increased from $73 billion to $196 billion during the 1950s, so, when the Eisenhower administration suggested that the recession could be overcome by increased consumer purchases, not all Americans took solace in the buy now/pay later recovery plan.

20 Elaine Tyler May, *Homeward Bound: American Families in the Cold War Era* (New York: Basic Books, 1988), pp. 16–17.

21 'The Seer of Space', *Life*, 18 November 1957, pp. 134–5; 'How an Idea that No One Wanted Grew UP to Be the LEM', *Life*, 14 March 1969, p. 22.

22 For more on this see 'White Flight', in *The Revolution Wasn't Televised: Sixties Television and Social Conflict*,

Lynn Spigel and Michael Curtin, eds (New York: Routledge, 1996).

23 Office of the White House Press Secretary, 'The White House Address of the President to the Opening Session of the 39th Annual Convention of the National Association of Broadcasters, Draft of Speech', 9 January 1961–25 May 1961, President's Office Files/Speech Files, Box 34, John Fitzgerald Kennedy Library, p. 1.

24 Erwin H. Ephron, A. C. Nielsen Company Press Release, 'News Nielsen: 40 Million Homes Follow Telecast of First U.S. Orbital Flight', White House Central Staff Files, Box 655: File 054, c. 21 March 1962, John Fitzgerald Kennedy Library, p. 1.

25 It should be noted here that the television coverage itself was often extremely tedious so that the only parts that offered variation were the comments by and about the families. In the *On the Road with Charles Kerault* documentary discussed herein, one man comments on how boring the moon landing was when he said, 'You got a lot of suspense going for you when they get there . . . and then it's a big nothing.'

26 Loudon Wainwright, 'Comes a Quiet Man to Ride Aurora 7', *Life*, 18 May 1961, pp. 32–41.

27 Miguel Acoca, 'He's On His Way . . . And It Couldn't Be Prettier', *Life*, 2 April 1965, pp. 36–7.

28 By 1958, there were at least three hundred such songs, and one music publisher even called his company 'Planetary Music'. See Gorden Cotler, 'Songwriters Blast Off', *The New York Times Magazine*, 16 February 1958, pp. 19, 21. It should be noted that popular songs about outer space, the moon, and romance have been popular since the nineteenth century. However, this constituted a new cycle.

29 *American Home*, September 1964, p. 54; *American Home*, December 1962, p. 121; *House Beautiful*, June 1963, pp. 129–30.

30 *Good Housekeeping*, September 1969, p. 232.

31 *Life*, 24 May 1963, pp. 54–5.

32 'The Strange Boom at Cocoa Beach', *Look*, 24 June 1958, p. 24.

33 Fredric Jameson, 'Progress vs. Utopia: Or Can We Imagine the Future?', *Science Fiction Studies* 9:27 (1982), p. 151.

34 See my 'From Domestic Space to Outer Space: The 1960s Fantastic Family Sitcom', in *Close Encounters: Film, Feminism, and Science Fiction*, edited by Constance Penley, Elizabeth Lyon, Lynn Spigel, and Janet Bergsrom (Minneapolis: University of Minnesota Press, 1991), pp. 205–35.

35 Tzvetan Todorov, *The Fantastic: A Structural Approach to a Literary Genre*, trans. Richard Howard (Ithaca, NY: Cornell University Press, 1970).

36 For more on *The Outer Limits* see Jeffrey Sconce, 'Static and Stasis: Electronic Oblivion in *The Outer Limits*', *Sixties Television and Social Conflict* (New York: Routledge, 1996).

37 George Lipsitz cites these statistics in 'The Possessive Investment in Whiteness', *American Quarterly* 47:3 (September 1995), p. 374.

38 Even while people of colour often spoke out about racism in NASA, space travel still provided compelling fantasies of progress and liberation from the problems back on earth. In *Ebony*, outer space was often used in articles and advertisements to promote the progressive and fantastic possibilities that products offered black consumers. See my essay 'White Flight', in *The Revolution Wasn't Televised: Sixties Television and Social Conflict*, Lynn Spigel and Michael Curtin (New York: Routledge, 1996).

39 See, for example, Louie Robinson, 'First Negro Astronaut Candidate', *Ebony*, July 1963, pp. 71, 747–81.

40 Charles L. Sanders, 'The Troubles of "Astronaut" Edward Dwight', *Ebony*, June 1965, p. 35.

41 Steven Morris, 'How Blacks View Mankind's "Giant Step"', *Ebony*, September 1970, p. 33. See also commentary that compares the moon landing to Columbus's 'rape' of America in 'Giant Leap for Mankind?', *Ebony*, September 1969, p. 58.

42 Spigel, 'White Flight'.

43 Lipsitz, 'The Possessive Investment in Whiteness', p. 374.

44 Judith Stacey, 'Social Science and the Politics of Virtual Family Values', unpublished paper, U. C. Davis, California, 1995.

NEGOTIATING THE GNOME ZONE

Versions of suburbia in British popular culture

Andy Medhurst

There was something depressing, Deirdre felt, in a place that had grown up within living memory. She would have liked to live in the heart of London or deep in the country.

Barbara Pym, *Less Than Angels* (1955)

Now that you've found your paradise
This is your kingdom to command
You can go outside and polish your car
Or sit by the fire in your Shangri-La.

The Kinks, 'Shangri-La' (1969)

When I was young, suburbia was what stood between me and pleasure. Many a suburban child has said the same, recollecting the childhoods where they counted the days until they could escape from the semi-detached, gnome-guarded prison where their parents had well-meaningly incarcerated them, but I was not a suburban child and I mean that opening sentence not metaphorically, but quite literally. Growing up in inner London, suburbia was not a cultural system that oppressed me, a topography of conformity that denied me independent self-expression, but a very concrete, very solid somewhere that I had to pass through, fidgeting in the back seat of the car, to reach the pleasure zones of the countryside or the seaside. The strongest emotion suburbia produced in me was impatience – we had Brighton to get to, but would Croydon never end?

Elsewhere, in more elevated circles than my Uncle Frank's Vauxhall Cresta, impatience would have been a mild response indeed to the cultural problem suburbia was deemed to represent. What has struck me most while researching this chapter has been the sheer vitriol which cultural practitioners and

commentators have felt compelled to pour over the suburbs. Architects committed to modernism, for example, damned suburbia as 'a kind of scum churning against the walls of the city', 'the slums of the future', 'an urbanistic folly', 'an inefficient fringe', 'a squalid antechamber of the city' and 'one of the greatest evils of the century' (see Oliver et al. 1994: 40–6). From a different but equally vituperative quarter, literary critics such as Cyril Connolly and Q. D. Leavis asserted that 'middle-class suburbs are incubators of apathy and delirium', and that suburban culture was 'inflexible and brutal . . . it has no fine rhythms to draw on and it is not serious . . . it is not only formed to convey merely crude states of mind but is destructive of any fineness' (see Carey 1992: 51; Leavis 1965: 210–11), while in that most canonically modernist of poems, *The Waste Land*, T. S. Eliot gazed down with unmitigated contempt at suburban commuters arriving for work in central London:

> Under the brown fog of a winter dawn,
> A crowd flowed over London Bridge, so many,
> I had not thought death had undone so many.
>
> (Eliot 1963: 65)

Such attitudes were not confined to elite culture: the whole of Dennis Potter's celebrated television drama series *Pennies From Heaven* was predicated on the assumption that suburbia was a trap, offering nothing but drab conformism and frigid respectability. Potter also subscribed to another frequently recurring characterization of suburbia in British culture, by depicting that conformism, that respectability, as feminized. In *Pennies*, the suburbs are women's domain, housewives' territory, personified in the shape of Joan Parker, the nagging, emasculating wife of Potter's hero Arthur. This gendered model – men who dream of escaping routine and rut, women who unquestioningly accept or even, at worst, embody them – will appear in many of the texts analysed in this chapter.

A writer with more ambivalent feelings towards suburbia was John Betjeman. He could be as anti-suburban as any modernist when required, though his hostility had a profoundly different origin. For modernism, suburbia was not contemporary enough, for Betjeman it was too contemporary by half. In poems like 'Slough' and 'Middlesex' he launched swingeing critiques of suburban lives and landscapes, contrasting what he saw as their inauthentic, manufactured quality with the more meaningful rural culture they had supplanted. Yet his later television documentary *Metroland*, which traces the suburbs that rose in the wake of the Metropolitan Line from central London to Buckinghamshire, seems to offer a mellower, less damning

perspective. Far from lambasting suburban crassness, *Metroland* is an exercise in enthralled camp. Betjeman totters through Neasden, Wembley, Pinner and Ruislip, relishing the personal, cultural and architectural oddities he finds along the way. It is a classic parade of suburban iconography – Sunday-morning car-washing, lawnmowing, golf, tennis, horse riding – as if to bring to life Willmott and Young's image of what made suburbia qualitatively different from urban life: 'East End children do not trot their ponies along forest paths wearing velvet hunting caps . . . there are no golf courses near the docks' (Willmott and Young 1960: 1). It seems as though Betjeman has given up sending poison-pen letters to the suburbs and wants to kiss and make up – but there is a sting in the tail. The programme ends at Verney Junction, a station that was never completed because the money ran out, thus ending the Metropolitan's, and suburbia's, progress, and the last words of the programme are: 'The houses of Metroland never got as far as Verney Junction. Grass triumphed, and I must say I'm rather glad.' So despite the curatorial pleasure Betjeman has taken in showing off his gallery of suburban eccentrics, he reverts to type: suburbia is an encroachment, a bricks-and-mortar fungus creeping through the green fields of England. It has its diversions, its pleasures, it is certainly seen as preferable to urban deprivation, but it deserves no higher praise. The last verse of 'Slough' –

> Come, friendly bombs and fall on Slough
> To get it ready for the plough.
> The cabbages are coming now;
> The earth exhales.

> (Betjeman 1970: 24)

– and the victory of the fields at Verney Junction manifest the same fundamental belief in the innate superiority of the rural. Betjeman was prepared to chronicle the foibles of the suburban classes, and they loved him for it, making him Britain's best-selling poet and an icon of middlebrow taste, but the most charitable feeling he could offer suburbia in return was amused toleration.

The aim of this chapter is to consider representations of suburbia in British cinema and in the two central genres of British popular television, situation comedies and soap operas. My reading of those texts will, inevitably, be inflected through my own understanding of what suburbia means, and the predominant image of the suburbs I carry remains the one I learned in childhood, which means the suburbia of south-east London. These were districts I did not live in, but travelled through and studied in, that were in my life though I was never part of them. There was Bromley (already elected the suburb of suburbs by Roger

Silverstone in the Introduction to this book), where there used to be a plush department store called Medhurst's that prompted many a fervent dream of long-lost rich relatives, Beckenham, with its Art Deco Odeon queening it over the local shops, Hayes, with its woods and common helping it to imitate a village more convincingly than most, Sidcup, Eltham, Mottingham, Bexleyheath, Petts Wood, Crystal Palace, Forest Hill, Dulwich and Blackheath, where my pretentious suburban grammar school admitted a few working-class inner London boys in order to knock our culture out of us, show us the error of our ways and introduce us to the subtler contours of the suburban path.

My gut feeling that these were not just any suburbs but paradigmatic suburbs is supported by historical fact. South-east London was the site of the first-ever commuter railway, to Greenwich, and without easy commuter transportation suburbia could never have come into being. It is still, crucially, the railway, as opposed to the Underground system, which characterizes the area to this day. Apart from a few tentative stations near the Thames, south-east London has no tube service, making it somehow even more purely suburban than the capital's other outlying quarters. This isn't a matter of speed – a fast train from Bromley to London Bridge will take far less time than a tube from Ealing Broadway to Tottenham Court Road – but a question of symbolic geography. Ealing is on the tube map, that iconographic fiction which masquerades as a true picture of London, giving it an umbilical link to the metropolitan centre poor Bromley can never hope to equal (for an excellent account of the history and meanings of this map, see Forty 1986: chapter 10). So my early exposure to suburbia was exposure to a particularly potent strain: south-east London, beyond the mythically inclusive space of the Underground network, is quintessentially, irredeemably suburban – it was the starting point, after all, of the daily journeys made by those commuters so loftily despised by T. S. Eliot.

SUBURBIA AND BRITISH CINEMA

Representations of suburbia in British cinema occur with surprising infrequency. Paul Oliver, the architectural historian who is suburbia's most partisan champion, sees this as a deliberate cultural slight. British cinema, he insists, could

have shown something of Dunroamin's life and people, who supported the film industry by paying for a substantial proportion of the thirty million seats every week. Instead, there is scarcely a glimpse

of suburban life. . . . Every upper-class hero had his comic cockney counterpart, but Dunroamin's middle-class England was virtually absent from the screen.

(Oliver et al. 1994: 130–1)

Such a claim, however, mistakenly assumes that audiences necessarily want to see versions of themselves in the texts they enjoy, and grossly underestimates the importance of fantasy and escape in popular cinema. The suburbanites of the 1930s, the decade Oliver is particularly concerned with, were far happier luxuriating in the gloss and glamour of Hollywood musicals or the imperial adventuring of Korda's costume pageants; why should they pay money to see a fictionalized account of what they saw for free in their everyday lives? Oliver does speculate that one Hollywood genre might have had particular resonance for the cinemagoers of Bromley and Ruislip: the Western, which he describes as concerned with 'migrants, settlers, newly established townships . . . bonded by the railroad' (1994: 133) and thus offering a parallel for the expansion of suburbia. This is neat, but over-ingenious; after all, the pioneers of Pinner did not have to genocidally drive out an indigenous population before putting down roots, and the Piccadilly line to Bounds Green and Cockfosters lacks just a little of the mythic mystique of the Atchison, Topeka and Santa Fe. Oliver makes a similar blunder in his attack on the newsreels of the period for their neglect of suburbia and their implication through doing so that 'news happened elsewhere' (1994: 131). Yet surely that is one of the founding attractions of the suburbs, one that estate agents milk shamelessly, since what one might call the *newslessness* of suburbia is a cornerstone of the vision of tranquillity that sold the suburban dream.

However misplaced Oliver's answers are, the question remains a crucial one: just why was suburbia so frequently absent from British cinema screens? A key reason lies in the factor of genre. Many of the core genres of British cinema – costume melodrama, vulgar comedy, gothic horror, the war film – had no place for suburban iconography as a result of either their period setting or their location. Even a genre like the family melodrama, in theory just right for a suburban treatment, rarely placed itself on unequivocally suburban terrain. An instructive film here is *They Were Sisters* (1945), which tells of the lives and relationships of three middle-class sisters between 1919 and 1937. All marry, and the film schematically dispatches one to a life of brittle urban sophistication, one to village bliss, and one, whose marriage to an insurance salesman (an occupation emblematic of suburbia) is clearly signalled as a step down the social ladder, to suburban drudgery. Unsurprisingly, marriages one and three end in tears while it

is the second sister who flourishes, living with a husband who describes his ideal house as 'old and calm, it stands on a village green overlooking one of those parks where the oaks look like bits of English history'. What chance did suburbia stand against such deep reservoirs of bucolic fantasizing?

There is, however, one film from the same period which does take the very unusual step of making suburbia central, indeed of making a suburban family stand for the nation as a whole. *This Happy Breed* (1944), adapted from Noel Coward's successful stage play, is a love letter to ordinariness (albeit an ordinariness that now looks rather contrived and condescending), a slice of wartime propaganda designed to reinforce a sense of unified national characteristics and purpose. The suburbia of the film is not the expansive semi-detached bourgeois suburbia of the outer London fringes, but the inner suburbia lived in by upwardly mobile families in the process of crossing that critical if evanescent line between upper working class and lower middle. *This Happy Breed*'s gambit is to elect the Gibbons family as Britain in miniature, draping them in the qualities of resilience, acceptance and persistence that a wartime audience would want to recognize and applaud. As Frank Gibbons, head of the family, says at one point 'It's up to us ordinary people to keep things steady.'

The character in the film who resists ordinariness and despises steadiness is Frank's daughter Queenie. 'I hate living here,' she spits, 'I hate living in a house that's exactly like hundreds of others. I hate coming home from work on the tube. I hate washing up and helping Mum darn Dad's socks. . . . And what's more I know why I hate it. It's because it's all so common.' Queenie, recklessly and ungratefully, has ideas above her station, ideas for which the film punishes her before allowing her back into the suburban, familial fold. *This Happy Breed* is a celebration of social stasis, and as such perhaps rather disingenuous coming from Coward, who had elevated himself from a suburban childhood in Teddington to a life of moneyed ease, but as his most recent biographer has said, 'Although Coward had managed that remarkable leap, he was not about to encourage further social acrobatics' (Hoare 1995: 302). The message is implacable: steadiness is the Gibbons' way, the suburban way, the British way.

This was eagerly lapped up by the film's original audiences. C. A. Lejeune, film critic of *The Observer*, wrote that:

this film about the suburbs has gone out into the suburbs, and the suburbs have taken it to their hearts. All the Gibbonses of Greater London have flocked to see themselves on the screen. Women in fish queues, fruit queues, cake queues, bus queues, and queues for queues, have passed the word to each other over their baskets; we have been amused, touched, entertained and edified by the film. It has gone straight to our address: or, as we say genteely in our suburb, Chez Nous. Nor is the

enthusiasm for the film confined to Metroland. The Gibbonses are a large family; they are found all over the British Isles. There are plenty of Gibbonses, too, serving in Normandy, Italy and the Middle East.

<div align="right">(Lejeune, 1947: 116–17)</div>

In other words, the film fully achieved its project of extrapolating a hegemonic vision of national endurance and fortitude from a hymn of praise to quiet suburban pluck.

The success of *This Happy Breed* might be seen as endorsing Paul Oliver's point that suburban audiences were crying out for recognizable cinematic versions of themselves, but any such verdict would need three modifications: firstly, the context of wartime cinema was significantly different from the prewar era; secondly, the film is set between the two world wars and thus is a historical fiction not a depiction of contemporary life; and thirdly, the efforts the film makes to mythologize its subject matter are far from disguised. Lejeune noted and approved of this mythologization, praising 'the special quality of Mr Coward's film; a film that finds in a house in a row the symbol of a nation; daring to call itself *This Happy Breed* instead of, say, *17 Sycamore Road*' (1947: 118). None the less, for all its insistence that the suburbs were the resilient, steadfast heart of the nation, *This Happy Breed* still contains seeds of doubt. Queenie may be humbled by the narrative, but her invective against suburban conformity still electrifies the film (would it be too fanciful to suggest a certain identification between the queeny writer who did escape suburbia and Queenie the character who tries but fails?), while at the end of the story her parents are leaving their suburb for the retirement in the countryside they had always dreamed of and planned, and the last image of the film is a panoramic shot of London, the urban centre rather than the suburban fraction. Such clues suggest that while *This Happy Breed*'s anatomy of Englishness boldly argues that suburbia must be seen as typical, it cannot bring itself to insist that suburbia is ideal.

Lejeune's point that *This Happy Breed* would have been so much more limited if it had been called *17 Sycamore Road* is confirmed by the release, a year later, of an immeasurably less interesting film which actually was called *29 Acacia Avenue*. Stilted, mundane and justifiably forgotten, this film deserves mention for only two reasons. Firstly, for the words which appear on screen at the end of the titles:

If you take the first on the left and the second on the right when you leave home, you will find yourself in Acacia Avenue, even though your local council has been careless enough to give it a different name. To all the residents in all the Acacia Avenues, this film is affectionately dedicated.

None of the characters in this film is entirely imaginary and some resemblance to people you know
is quite unavoidable.

What follows is a dim-witted romantic farce that even for a British B-picture tries
the patience, but those on-screen words are rather remarkable, since they
constitute a bald, direct acknowledgement of the argument *This Happy Breed* chose
to make through flagrant mythification, that the British audience was now a
predominantly suburban one. The second reason *29 Acacia Avenue* merits attention
is that it is a comedy, and from this point onwards in British film history suburbia
and comedy become indissolubly intertwined. There are exceptions to this rule
– for example the Ealing Studios police drama *The Long Arm* (1955), which makes
a point of stressing the typically suburban home life of its Detective Inspector and
the inconvenience it causes him to have to travel to Scotland Yard all the way from
(this book's favourite suburb) Bromley – but in the late 1940s and throughout the
1950s, if suburbia is the setting, then comedy is almost invariably the genre.

There are precedents for this. In his evocative 1909 book of social reportage
The Condition of England, the Liberal politician C. F. G. Masterman devoted a
whole chapter to 'The Suburbans', and wrote about them in a way refreshingly
untainted by anti-suburban rhetoric. The inhabitants of suburbia are too often
omitted from cultural representation and political debate, he argued: 'They are
easily forgotten: for they do not strive or cry; and for the most part only ask to
be left alone. They have none of those channels of communication in their
possession by which the rich and the poor are able to express their hostility. . . .
They only appear articulate in comedy' (Masterman 1960: 56). Masterman goes
on to state that suburbanites primarily feature in comedy to be laughed at by more
sophisticated audiences, and in terms of the immediate historical context of his
book that may well have been the case (there was, for example, a short comedy
film called *The Suburbanite* made in the United States as early as 1904, while the
British comedy *A Suburban Pal* dates from 1914), but his insight holds true for later
eras too, when the primary impulse behind suburban comedy was not to offer up
suburbia for condescending laughter but for laughter stemming from shared
experience. Gentle domestic comedy seemed to be the one genre in post-1945
British cinema which found suburbia an amenable location and which found itself
recognized and welcomed by suburbanites as an acceptable fictionalization of their
lives – appropriately so given that gentle domesticity was at the heart of suburbia's
fantasies about itself.

Consider, from 1948, *Here Come the Huggetts*, the first in a series of films to
feature the Huggetts, who, like Noel Coward's Gibbonses, live in that stretch of

inner suburbia where the class lines are still somewhat blurred. Their Tudorbethan house is part of an interwar terrace, in a road defined by clipped privet hedges and neat little front gardens. It's comfortable but not plush, the first house they've bought now Dad has been promoted to foreman at the factory. There are three daughters in the family – it's worth noting that in British suburban film comedies daughters hugely outnumber sons, often making Dad the only man in the house and facilitating the joke-generating clash between his patriarchal expectations and the domestic world of suburban femininity – who all speak with much more middle-class voices than their parents and either have or can expect to have white-collar jobs. For the Huggetts, the step into suburbia is a step away from working-class origins into a more middle-class world, a journey many in the audience had made or were hoping to make. This can cause complications; in *Vote for Huggett* (1949), Dad's decision to stand for the local council forces his deferential wife to mix with much more securely middle-class women, one of whom mistakes Mrs Huggett for the cleaner. Along such anxious faultlines of status and position, these suburban comedies told their tales.

Another key trope in such films was respectability. *The Big Money* (1955) is a one-joke comedy, the joke being that a family who on the surface are the epitome of respectable semi-detachment are in fact a gang of crooks. The film has some moderate fun with standard codes of industriousness and dependability – 'it took me twenty-five years to get where I am today', says the father about his highly polished pickpocketing skills – while another suburban staple, the expulsion of the deviant individual, is comically inverted as the family reject the oldest son for his failure to thieve successfully. Comedy and crime are also combined in *The Green Man* (1956), where the indistinguishability of suburban villas aids an attempt to conceal a murder (house names are swapped to fool the police); the joke here again hinges on the juxtaposition of utmost respectability and foul nefariousness. One baffled resident protests that murder can't happen here, 'not in Turnham Green'.

A street called Acacia Avenue returns in *As Long As They're Happy* (1955), where the calm order of a suburban family is disrupted by the behaviour of its three daughters (no sons, just like the Huggetts). The youngest invites an American pop star to stay, the other two return from overseas with unsuitable husbands, one a beatnik artist (who, in the film's smartest gag, has been living in Avenue des Acacias, Montmartre), one a Western rodeo rider. When the latter arrives, parading down Acacia Avenue on horseback, the family's affronted father can only splutter 'This is Wimbledon, not Dead Man's Gulch.' The intrusion of all these un-English activities serves to underline the equation the film seeks to make between national identity and suburban sensibility. The youngest daughter tries to

justify her undying love for the pop singer by pointing out that Romeo and Juliet were only fourteen; she is put in her place by the response: 'They were foreigners.'

In *Please Turn Over* (1959), humour and chaos arise when the teenage daughter of a suburban family publishes a scandalizing novel, *Naked Revolt*, which consists of her daydreamed fantasies of the secret lives of both her family and the wider suburb's inhabitants. The central section of the film is a 'dramatization' of the novel, opening with an authorial voiceover:

I come from a suburb, a place where respectability is built in with the plumbing, a street where nothing out of the ordinary ever happens. . . . A typical suburb: respectable, contented and home-loving . . . kindly and conventional . . . full of innocent healthy fun . . . people cut from a suburban pattern, leading placid respectable lives.

This is followed by a spoof exposé, wherein these placid, conventional types are shown to be adulterers, embezzlers, cheats and drunks. The inverted suburb joke can, of course, only work if the audience has no shred of doubt about the rightness of traditional suburban values. Such a joke offers a safety-valve, a what-if fantasy – wouldn't it be exciting if suburbia truly was this sordid – but there is never any danger that order, placidity and respectability will be overthrown. Suburban lives might be dull and circumscribed, but they none the less offer security, a security textually mirrored by the safely predictable narratives of these comedies.

There are a few films which hint at a deeper disquiet. *Meet Me Tonight* (1952) is made up of three short Noel Coward plays, one of which, *Fumed Oak*, takes the same raw material as *This Happy Breed* but turns it inside out, producing a vicious attack on suburbia in place of the earlier film's salute to it. Accurately subtitled 'an unpleasant comedy', *Fumed Oak* revisits, with venomous misogyny, the equation between suburbia and femininity. Henry Gow, a downtrodden clerk who works in a dull job to support his all-female family – shrewish wife, meddling mother-in-law, adenoidal daughter – returns from work one evening to announce that he has been secretly saving money in order to finance his escape. His parting shot is a torrent of abuse: he labels his wife 'mean, cold and respectable' (an exceptionally rare use of that last word as an insult), hits his mother-in-law ('I liked slapping you just now, it was lovely'), and rants about their nagging and ingratitude. Suburbia can be transcended, then, but only at the cost of the comedy, which curdles into sheer malice in Henry's hideously bitter tirade, and only if you're male.

The film version (1949) of H. G. Wells's novel *The History of Mr Polly* (1910) follows a similar path, though it adopts a far more benign tone. Mr Polly is perhaps

the originating archetype of the suburban little man, the clerk with dreams who figures so often in the texts discussed in this chapter. These are dreams of escaping from social realities, from everyday drudgery, and from women, unless they are welcoming, subservient archetypes like the buxom pub landlady Mr Polly discovers in his rural idyll, the South Sea Island maidens Henry sails in search of in *Fumed Oak*, or the sexually generous country girl Arthur Parker finds in *Pennies From Heaven*. Contrasted with these are those women who embody the shackles of suburban constraints, like the coven of grotesques Henry leaves behind, or Mr Polly's sharp-tongued, demanding wife. A recent film that offered a less simplistic version of the Mr Polly archetype was *Howards End* (1991), an unusually politicized text from the Merchant–Ivory stable of costume films, where the Polly-ish Leonard Bast begins to realize some of his dreams through associating with the middle-class Schlegel sisters, only to find himself embroiled in, betrayed by and finally killed for the sake of class and gender hierarchies way beyond his control. In this inflection of the story of the clerk with dreams, his mild transgressions are not rewarded with comedic fulfilment but punished with tragic brutality.

The Rebel (1960), the first feature film built around the talents of the radio and television comedian Tony Hancock, takes the established device of the dreaming clerk but adds a new twist, what might be called the Gauguin manoeuvre. Hancock sustains himself through the numbing repetitions of commuting ('journey number six thousand, eight hundred and thirty three, arriving Waterloo 8.32 excepting Bank Holidays, religious festivals, Saturday mornings and strikes') by delusions of being a great artist. Tired of his job and his nagging landlady (there's always a nag in these narratives) he moves to Paris, perhaps to live in Avenue des Acacias, Montmartre. The bulk of the film is a series of swipes against modern art, but, however ridiculous the 'art' becomes, it is always seen as a livelier, more meaningful alternative to the tedium of suburban conformity.

The need for men to escape, to resist the closing, feminized jaws of domestic containment, also runs through another body of films roughly contemporary with Hancock's work. The social realist, or 'kitchen sink' films, such as *Saturday Night and Sunday Morning* and *A Kind of Loving* are the only cycle of non-comic texts in British cinema in which suburbia plays a substantial role. Such a claim might sound odd, since it was these films' adherence to a naturalistic rendition of northern working-class life that won them acclaim – indeed the very term 'kitchen sink film' signifies their iconographic commitment to a mise-en-scène of impoverished domesticity, whereas in suburban comedies the kitchen sink was something attended to, even in the late 1950s, by the domestic help. None the less, suburbia does figure in the social realist cycle, if only as a largely unseen threat, a feared

destination where the aggressively masculine protagonists are liable to end up once their proletarian defiance has been tamed through marriage (see Geraghty 1995).

This tension is most memorably played out in *A Kind of Loving* (1962), where Vic's reluctant marriage to Ingrid sees him moving from the cramped warmth of his parents' home in run-down Fountain Street to her mother's impeccable, heartless suburban semi in Windemere Crescent. Ingrid's mother is houseproud to the point of mania, a Tory, a bigot, a nag and a prude – another variant of Joan Parker. The film presents her conflict with Vic in shamelessly one-sided terms, encouraging the audience to loathe this suburban harpy. At the end of the film, as he tries to mend his broken marriage, Vic confides to his father that he's worried Ingrid will want 'a semi like her mother's', to which his father's reply, reasserting working-class patriarchal mastery in the face of such soft, suburbanizing dangers, is 'She'll live where she's bloody well put.' Men must be men, it seems, and a semi is no place for that.

Billy Liar (1964) has often been seen as the last of the kitchen sink films; more pertinently for the concerns of this chapter it is also the only one of the cycle to be both primarily comic and to be based in suburbia. Billy Fisher is another of Mr Polly's heirs, taking his dreams of escape to the extreme of inventing a whole fantasy country in which he prefers to live, a world where he can forget his predictable clerking job, his dull and conformist semi home, and the smothering girlfriend who has the seeds of a nag inside her. The chance of genuine escape comes in the return of an old girlfriend, with whom Billy plans to run away to London, but his courage deserts him and he stays trapped in suburban predictability. Alexander Walker has argued that Billy's failure to move south marks a transition between the kitchen sink films of the early 1960s and the Swinging London cycle which supplanted them (see Walker 1974); viewed through a slightly different lens this becomes not just a question of regionality, but one of suburban versus urban, with Billy's choice relegating him to the familiar category of suburban dreamer, forfeiting his chance to participate in the new Pop vibrancy of big-city life. Once Billy had failed this test, suburbia all but vanished from British films. Like him, it stayed home, happier on the smaller, domestic screen, finding a snug, congenial niche amid television's abiding concern with what the American television playwright Paddy Chayefsky once called 'this marvellous world of the ordinary' (quoted in Willis 1959: 8).

SUBURBIA AND BRITISH SITCOM

Since comedy dominates British cinema's depiction of the suburbs, it should come as no surprise that the television genre which above all others has centred its attention on suburbia is the sitcom. C. F. G. Masterman's prescient anatomy of suburban culture is again relevant here, his account of how in the suburbs the apparently trivial can become profoundly important containing this example: 'into a feud with a neighbour about a disputed garden fence . . . will be thrown force and determination which might have been directed to effort of permanent worth, in devotion to one of the great causes of the world' (Masterman 1960: 65) – which is as good a plot summary of the more banal suburban sitcoms as you could wish to read.

The roots of British television sitcom lie in radio, film and music hall (see Medhurst 1985, 1986), and it is the last of those, with its traditions of broad, physical, vulgar, often risqué comedy, which the suburban sitcom has sought most strenuously to renounce. The suburban sitcom represents British comedy's most sustained attempt at embourgeoisement, its plots often concerned with the maintaining of genteel values against threats from outside or below. Many series used as their initial narrative motor the idea of suburbia suddenly having to accommodate the 'wrong' kind of people, so in *George and Mildred*, for example, a working-class couple move to the suburbs, in *Love Thy Neighbour* a black couple do the same, in *The Good Life* two previously well-integrated residents betray the suburban ethos by turning a manicured garden into an agricultural smallholding – and in each case comedy is generated by the clash between established suburban protocols and the shock of the new.

There is another strand of suburban sitcom, markedly less interesting because it forgoes the rich possibilities of social warfare in favour of remaining entirely within the suburban class itself, including such self-satisfied tales of mild familial conflict as *Not in Front of the Children*, *And Mother Makes Three*, *Rings on Their Fingers*, *Bless This House* and *No Place Like Home*, whose very titles drip with the suffocatingly normative contentedness that formed their ideological project. These programmes will not be the focus of this section, though mention should be made of *Terry and June*, the 1970s/80s sitcom about a middle-aged married couple from Purley which out of sheer longevity (it ran, in two differently titled incarnations, for a total of thirteen years) established itself as *the* television benchmark for safe suburbanism. Its dogged refusal even remotely to acknowl-edge the contemporary complexities of life (best instanced, perhaps, by June

attempting to scandalize Terry by dressing as a punk rocker in 1987 – a full decade after punk was any kind of threatening iconography) ensured it a kind of immortality: if future historians want to know how delighted to be backward-looking the British suburban sensibility could sometimes be, *Terry and June* is the text they'll need to consult (see Medhurst 1987).

The sitcoms I do want to focus on here are those which added a little grit to the suburban blancmange, which interrogated suburban values rather than taking them for granted, though it must be remembered that the circular, cyclical, change-resistant narrative structures of sitcom make sustained social criticism difficult. None the less, some sitcoms have at least raised the possibility that suburban lives might be restricted lives, petty lives, lives that prompt thoughts of escape. Tony Hancock's dreams of abandoning the drab repetitions of suburbia have already been discussed briefly in the context of *The Rebel*, but his most important work was in sitcom. First on radio in the 1950s, then continuing on television through into the early 1960s, the Hancock character lived at 23 Railway Cuttings, East Cheam, an address which situated his social standing with shrewd precision. It is redolent of the suburbs, but not the nicer ones. It sounds a little too close to the station, and 'Cuttings' implies terraced houses rather than the more imposing semis of high suburbia. As for the fictitious district of East Cheam, it can only be an impertinent upstart trying to clothe itself in the respectability and classiness of Cheam proper. So Hancock lurks on the fringes of suburbia, close enough to see the lifestyle he aspires to, but always outside, always excluded, never really 'one of us'. Many episodes of *Hancock's Half Hour* play on this – he joins a local literary society, for example, keen to acquire culture as his passport up the social scale – but all conclude with him back where he started. Aspirations cannot be satisfied, because if they were the comedy would be over.

Much later, a 1970s sitcom took a distinctly Hancockian stance towards suburbia, but was able to go much further through its utilization of non-naturalistic visual and narrative codes. *The Fall and Rise of Reginald Perrin* begins with its hero at the start of another crushingly familiar day: same breakfast, same farewell to the wife, same walk to the station, same train, same fellow passengers, same predictable job. This is all very familiar from *The Rebel*, but Reggie has a different strategy to Hancock's: not literal escape to foreign parts but an escape based on fantasy and subversion at home. He becomes a middle-aged Billy Liar. 'From now on', he declares in the first episode, 'I'm going to do everything differently', and this difference ranges from mentally depicting other characters as he'd really like them to be to a complete overhaul of his job, relationships and lifestyle. The series touches on dark, risky areas rarely seen in sitcom – Perrin

gives every impression, when not laughing, of having a nervous breakdown, with a number of episodes concluding with his agonized roar of rage, and his own liberation is bought at the cost of considerable emotional pain to those around him. The genre seems scarcely up to the task of conveying these emotions – drastic change, wild anger and palpable distress are hard to accommodate within sitcom parameters.

Perrin causes chaos by shaking the certainties on which suburbia depends. He becomes unpredictable, capricious, selfish, irresponsible, pleasure-seeking, truth-telling – each of which inverts a cardinal suburban value. He leaves work early, prompting his wife to respond, perplexed, 'But you usually come home at the usual time', a line which with beautiful economy summarizes the routinization of suburban existence. Raymond Williams has written of 'the suburban separation of "work" and "life" which has been the most common response of all to the difficulties of industrialism' (Williams 1961: 211) and it is this separation, with all the alienating dissatisfactions it trails in its wake, that Reggie determines to abolish, going so far as, in the last of the three series of *Perrin*, to set up an altruistic commune light years away from the predictable business world in which he was first seen. Note, though, that this was the final series, further proof that the boundaries of sitcom are not infinitely expandable.

I would not want to suggest that *Perrin* was a wholly radical text. Its sexual politics would deny it any such status, since Reggie's fantasies belong to that tradition of self-indulgent male visions of escape in which women are arche-typalized ciphers with no life of their own. One of Reggie's recurring dream-images is of making love to his secretary, while, tellingly, the first visual fantasy he has in the series is of his mother-in-law as a hippopotamus; the easy music-hall laugh won by this image means it is frequently repeated, particularly when the general tone of the programme becomes gloomy and in need of lightening. His wife Elizabeth shoulders the burden of so many suburban wives – she tends to his needs, tolerates his waywardness and never gives even the slightest hint that she too might find suburbia stifling. If she ever did, Reggie's trajectory would be fatally problematized: his wish to escape is fundamentally predicated on her unquestioning obedience to suburban codes and conventions, she has to stand for that which he must repudiate. *The Fall And Rise Of* Elizabeth *Perrin* is simply inconceivable, because the only ones permitted to dream of alternatives to suburbia are, in this brand of fantasy, men.

The sitcom which most systematically challenged that patriarchal assumption was Carla Lane's *Butterflies*, which did ask the question that *Perrin* and its kind found unthinkable: what if it's the suburban woman who finds life intolerable?

That question gained extra weight through the casting of Wendy Craig as the central character Ria, since Craig's persona had hitherto been linked, seemingly indissolubly, to those tirelessly cosy home-and-family sitcoms I berated at the beginning of this section. Ria lives in comfortable material security; she is, in her own words, 'happily married but not excitingly married' to a dentist; and they have two lanky, randy, coltish teenage sons, whose casual and varied sex life is held up throughout the series as a permissive foil to the staled relationship of their parents. Ria, in classic suburban-dreamer fashion, is bored – she doesn't even, like the Arthur Parkers and Reggie Perrins, have a job to take her outside the home, having been informed by her husband that her job is maintaining the home and servicing male needs. So she stays bored, and faced with such familial thanklessness her thoughts turn elsewhere, the significant difference being that while all the Perrins dreamed of escape from suburbia with a little illicit love thrown in as spice, Ria's dreams put romance first and geographical relocation nowhere. Her restlessness is rooted in the interpersonal rather than the sociological; her desires are for romantic and sexual satisfaction, but she still conceives of them taking place in the suburban context. She wryly speculates on how shocked the neighbours would be if she acquired 'naked gnomes and a rude door-knocker', but fleeing the gnome zone entirely is not on her agenda. 'I want to pull life through the letterbox,' she says, but such a wish only underlines how immured she is within conventional domesticity, how stuck she is in what she calls 'a hut in a suburban jungle with dust delivered daily'.

A way out materializes in the shape of Leonard, a businessman she meets by chance and then proceeds (in a plot modelled without much disguise on Noel Coward's *Brief Encounter*) to not quite have an affair with – the ramifications of this provide the central narrative thread of the series but, while it does enable Ria to question her allotted role, it only goes to reinforce her dependence on men. The only way out of a dull marriage is to move sideways into something that might originally appear to offer more, but would doubtless slide into similar conformity before too long. Any sympathy Ria might earn from our recognition of her plight is, however, undermined by the way the series depicts Ruby, her cleaner. Ruby (again just like the parallel characters in Coward's film) is wheeled on as lower-orders comic relief, counterpointing the rounded complexity of the middle-class characters with her patronized Cockney simplicity. Her existence also severely dents one of *Butterflies'* core meanings, since Ria's protestations about housework look a little hollow once the viewer realizes it is actually Ruby who will be undertaking most of it. The programme's tentatively feminist critique of suburban domesticity is thus undercut by its hugely retrogressive presentation of class.

Butterflies, like *Perrin*, is able to establish a partial exposure of suburbia's flaws, but any steps it timidly takes towards radicalism are more than balanced by the conservatism of other discourses in the text.

Another pair of examples might help to illuminate further the range of suburban representations available to British sitcoms. *The Good Life* and *Ever Decreasing Circles* were both written by John Esmonde and Bob Larbey and both starred Richard Briers (like Wendy Craig, an actor often associated with the blander end of the genre), yet their differences are much more noteworthy than their similarities, a fact attributable to their different historical contexts, which could be very crudely differentiated as pre-Thatcher and high-Thatcher. *The Good Life* centred on the decision of a suburban couple to join the then-current vogue for self-sufficiency, giving up paid work to turn their house and garden into an economically viable self-contained unit. In short, out with the gnomes, in with the pigs, chickens and vegetable patch. Pottering in the garden is a suburban staple (Mr Huggett did it all the time), but the Goods took it further, flouting the ordered, nine-to-five, commuting culture of the suburbs.

The comedy of the series sprang from two sources: Tom and Barbara Good's teething troubles in shifting from affluent consumers to neo-peasants, and (far more rich, memorable and ideologically resonant) the response of their neighbours, Jerry and Margo. Suburban snobbery incarnate, pillar of the local Operatic Society, Margo treats her cleaner and gardener with all the conviction of one who believes that people have a station in life, and is horrified to see children from a nearby council estate coming into The Avenue. Once more, suburbia's reactionary, hierarchical conformism is rendered feminine. Margo regards Tom and Barbara's crusade with a mixture of incomprehension and disdain, but she is prepared to assist them in times of crisis. She runs to fetch brandy to help save the life of an ailing piglet, though not before asking, in perhaps the ultimate Margo line, whether it should be 'Remy Martin or Hine VSOP?'. As the most memorable figure in the series, Margo demonstrates the ambivalent status of suburbia in *The Good Life* – she is the butt of most of the jokes, suburban pretentiousness ceaselessly ridiculed, but her monstrousness became lovable, her certainty enviable, while the camp excessiveness of her commitment to normative proprieties prevented her from being relegated to the status of background or feed (she was no Elizabeth Perrin). Like suburbia itself, despite all its critics, she persisted.

The rest of the central quartet were dwarfed by the shadow of her ultra-suburban rectitude. Her husband Jerry had only the occasional qualm about continuing to take part in the rat race Tom had escaped, mostly he was glad not

to be knee-deep in pig dung. 'London Bridge in the rush hour suddenly seems terribly attractive,' he once remarked, neatly refuting T. S. Eliot's condescension in the process. As for the Goods themselves, they were suburban dreamers who had the rare success, denied to the Polly/Hancock/Billy Liar school, of achieving their goal. Yet turning their Surbiton garden (a couple of miles from Reggie Perrin's Norbiton) into a miniature farm was merely the act of eccentrics, not radicals, and suburbia, as *Metroland* showed, can always accommodate a few eccentrics. They add to the Englishness of the place – and if Betjeman had turned up to immortalize the Goods no one would have been more pleased than Margo. Tom and Barbara were only amiable dabblers in deviance, never any kind of real threat – clinching proof of this coming from the fact that when the self-styled 'alternative comedians' of the 1980s sitcom *The Young Ones* wanted to target a previous programme as embodying all the safe, respectable niceness they saw themselves as replacing, it was *The Good Life* that they singled out for abuse, even placing a gnome in the centre of their parodic version of the Goods' garden.

Ever Decreasing Circles was a sitcom of a different order. It might, indeed, be seen as *The Good Life* inverted, with the benevolent antics of the 1970s series replaced by a 1980s tone of bitterness, sourness and bile. In *Ever Decreasing Circles* the title describes the trap, the suburbs are the site of petty status-seeking, unimaginative repetition and a ferocious hostility to difference. Leaving the affable Tom Good way behind, Richard Briers's Martin Bryce is suburban man *in extremis* – pedantic and pernickety, a humourless fusspot stuffed full of seething neuroses. He is the kingpin of the cul-de-sac, running every conceivable club and society (things which definitively signalled suburbia for the likes of Willmott and Young), a man who makes the noises one might associate with orgasm only when surrounded by his filing system.

The central conflict of the series is between Martin and his new neighbour Paul, who is not only relaxed, suave, sexually confident and witty, thus throwing Martin's deficiencies into sharp relief, but strikes up a flirtatious friendship with Martin's wife Ann. 'I want to break the pattern,' Ann tells Martin. 'Why?', he answers, investing that single syllable with all the puzzlement, frustration and fear of a man whose world has been turned upside down. Martin likes patterns, he fetishizes lists, change petrifies him. When it looks likely that Paul is moving away, Martin is incandescent with joy at the prospect of the return of order and calm; he hopes Paul's house will be bought by 'Proper people, people who only say "Good morning" or "Good evening" for the first year or so'.

Martin is the inversion of the suburban dreamer: he couldn't be happier with the status quo, and escape is a language he simply doesn't speak. His only reliable

friends are Howard and Hilda, a married couple so devoted to each other and to the suburban pursuit of static sameness that they always dress in his-and-hers versions of the same clothes (looking not unlike betrothed garden gnomes as a consequence). Martin fights long and hard against Paul's encroachments, because he isn't just guarding his own slice of suburbia but the suburban principle in general, and, by extension, a particular construction of Englishness founded on stability, hierarchy and staunched emotions. Such Englishness leads Martin to refer to overt sexual suggestiveness as 'that Mediterranean business', and makes him shudder when Howard puts his arm around his shoulder: 'We don't want to start slipping down the Parisian slope.' Conversely, the code word he and Ann use for sex, since it reminds them of a particularly satisfying past encounter, is 'Kidderminster'.

This series remains the most sustained attack British sitcom has yet made on traditional suburban values. Thanks to the sharpness of the writing and acting, Martin is never allowed to become a Margo-like lovable monster – he is pitiable, certainly, but too accurate an image of the damage suburbia can wreak to ever be liked. *Ever Decreasing Circles* revealed his limitations with an almost surgical precision – at its best it was that rare thing in British sitcom, *viciously* funny – yet even this memorable series eventually went limp; its extended final episode showed the neurotic suburb symbolically transformed, via a summer fete, into a sweetly bucolic village and packed Martin and Ann off to start a new life in a country town. A disappointing retreat yet, within the tight boundaries of sitcom, only to be expected. The conclusion I had hoped to see, Martin driven by a mania far greater than Perrin's to hang himself in the garden while Paul and Ann copulate ecstatically in the shadow of the swinging corpse, would have been within the text's narrative logic, but far beyond the genre's representational repertoire.

Nothing in the 1990s has matched *Ever Decreasing Circles*, though *One Foot in the Grave* has come close. Its protagonist, Victor Meldrew, spends most of his time dispatching fusillades of invective against petty bureaucracy, the idiocy of his neighbours and the predictabilities of suburban life in general. *One Foot in the Grave* also has a daring and healthy tendency to abandon naturalism, introducing plots full of outrageous coincidences, visual gags that go beyond standard generic confines and moments of real and affecting pathos, all of which distinguish it from cosier representations of the suburbs. None the less, despite Victor's irascible soliloquies, suburbia is still a given. Nothing really changes, however much Victor might not believe it. One episode, however, did offer a brief, delirious glimpse of something darker. Owing to the kind of clerical error that always provokes his wrath, Victor received a delivery of 263 garden gnomes. These had to be stored

in the house, so that whichever room Victor or his wife entered, a gaggle of gnomes was present – the image, brilliantly milked throughout the programme, was an irresistible one of suburbia taken to insane extremes. The episode concluded with their next-door neighbour stepping up his ongoing feud with Victor by gunning down the whole gnome phalanx. It was a moment to treasure: suburbia's inhabitants finally cracking, turning in a Peckinpah-like frenzy on their own most revered, most ridiculed cultural symbol.

Sadly, a more typical and infinitely more conservative suburban sitcom of the 1990s is *Keeping Up Appearances*, wherein the semi-detached dragon Hyacinth Bucket (Margo from *The Good Life* squared, then coarsened) bosses her spouse, friends and neighbourhood into supporting her delusions of cultural grandeur. The key joke here is that Hyacinth has distinctly down-market working-class origins which are always threatening to erupt (literally so in the shape of her corpulent and voracious extended family) to expose and shame her. This sitcom casts an unequivocal vote in favour of maintaining class hierarchies: we are left in no doubt that Hyacinth should abandon thoughts of social climbing, and leave suburbia to its true, securely bourgeois guardians. The suburban sitcom, clearly, is open to being mobilized for a whole range of competing ideological agendas, but despite occasional glimmers of dissent the predominant message (for if the likes of *Ever Decreasing Circles* is the exception, *Keeping Up Appearances* is most certainly the rule) is firm and terse: know your place.

SUBURBIA AND BRITISH SOAPS

In analysing the global role television plays in the shaping of everyday experience, Roger Silverstone has argued that the soap opera, with its stress on quotidian domesticity and its fostering of curiosity about one's fellow citizens, is the most quintessentially suburban, and suburbanizing, of televisual genres (Silverstone 1994: chapter 3). While such a claim, like all totalizing gestures, offers the soothing comforts of certainty, it is impossible to sustain convincingly when considering the more specific case of British television soaps through the humbler lens of textual analysis. Any textual study of those series leads to one unassailable conclusion: they do not flourish in suburban soil. This does not mean that British audiences have no appetite for soap in the suburbs, as is evidenced by the popularity of the Australian serial *Neighbours*, as suburban a text as one could wish for, but that we prefer to see it done by somebody else. It's true that *The Grove*

Family, a mid-1950s BBC series that is one of the precursors of today's soaps, had a suburban location, to the point where one whole episode was given over to advice on how to secure your suburban semi against housebreakers ('dirty brass is a sure sign of absence, especially in a nice house like this' an avuncular policeman warned the grateful Groves); but *The Grove Family* was, in today's terms, as much sitcom as soap, the family themselves drawing heavily on the Huggetts. Of the four British television soaps currently being broadcast nationally in prime time, *Coronation Street* and *EastEnders* are set in working-class inner-city districts, *Emmerdale* is centred on a rural village, and only *Brookside* takes place in what could pass for suburbia.

The scepticism suggested by that last phrase may seem odd: surely *Brookside*'s cul-de-sac of owner-occupied houses, situated a considerable distance from the centre of Liverpool, is unarguably suburban. The fact that *Neighbours*' Ramsay Street was reputedly modelled on the layout of Brookside Close only adds weight to that case. Yet *Brookside* does not *feel* suburban, its governing structure of feeling is Liverpudlian, its primary axis is regional rather than residential. All successful British soaps are rooted in tropes of regionality first, constructions of communality second – hence *Coronation Street*'s Mancunian wit and warmth, *EastEnders*' Cockney ebullience and dodginess, *Emmerdale*'s Yorkshire bluffness and plain speaking. (Outside England, Scotland's *High Road* and the Welsh-language soap *Pobol Y Cwm* use similar strategies – and neither concerns itself with the suburbs.) *Brookside* has undoubtedly bought itself a plausibly wider range of characters thanks to its setting on the edge of town – unlike the more urban soaps, middle-class residents do not feel like untrustworthy incomers – but it lacks a truly suburban sensibility.

The one bold generic gamble *Brookside* made in its early years was to deny itself the easy option of a communal space where all the characters could interact, a role typically played in British soaps by the local pub. Such a gamble was made under the rubric of realism, since those pubs are more often narrative conveniences than naturalistically convincing (would *Coronation Street*'s Mike Baldwin, Percy Sugden and Liz MacDonald, for example, all frequent the same pub 'in real life'?), but this condemned *Brookside* to running parallel plots rather than intertwining ones, and it is the latter which are the lifeblood of the genre. The atomized nuclear families of the serial, each one churning out plot developments within their own four walls, may have been credibly suburban, but they were not satisfyingly soapy enough. Subsequently, *Brookside* caved in, sprouting shops, a petrol station, even a nightclub, where people and storylines could intersect (these marked a significant advance on the pillar box on the corner

of the Close, for so long the only legitimate meeting point that the residents seemed to be writing an awful lot of letters).

In any case, the communal spaces of soap are nothing to do with realism (however one chooses to define that treacherous word). Their function is to foster the myth of communality on which such texts depend, and in British popular culture communality is inextricably linked with working-class milieux. As Christine Geraghty rightly says, 'the settings of *Coronation Street* and *EastEnders* refer to an architecture of the past which, because of its smaller scale and layout, has connotations of a lost neighbourliness and community of interest' (Geraghty 1991: 93). This neighbourliness may be suffused with nostalgia and bear scant resemblance to contemporary urban life, but the audience figures these soaps continuously accrue underline the deep emotional pull such myths exert. Suburbia can hardly compete, so when it does appear in British working-class soaps it either signifies a threat or sets itself up to be mocked.

EastEnders' Sharon Watts, for example, having grown up with an adoptive family in Albert Square, decided to seek out her biological parents – that the search was doomed to end in heartbreak was evident from the way Sharon's teenage East End blowsiness looked so out of place in the neat suburban street where her original mother lived. At other times in the same soap, Nigel's fight for the custody of his stepdaughter and Kathy's determination to confront the man who had raped her have led to similarly unsettling trips into the suburban hinterlands. Typically inflecting such incongruities through a more comic mode, *Coronation Street* once mischievously gave Curly Watts a fiancée whose parents were such delicious caricatures of sherry-drinking, greenhouse-worshipping suburbanites that no regular viewer could fail to guess the unhappy outcome. One of the *Street*'s main comic storylines of 1995 centred on the campaign by the pretentiously aspirational Wiltons to convince both themselves and their neighbours that their house, on the posher side of Coronation Street, was a suburban dwelling. They signalled this by buying (what else?) a pair of garden gnomes, dubbed, with a sly dig at suburban attempts to 'speak for England', Arthur and Guinevere.

Such pretensions could not go unchallenged, and the Wiltons reeled as the Duckworths, the programme's embodiment of unreconstructed proletarian gusto, planned to move across the Street and next door to them. The two sides of Coronation Street summarize in an architectural nutshell the resistance to suburbia which is intrinsic to British soaps. The old side, made up of small nineteenth-century terraced houses, is the emblematic side, the side that features in the programme's credit sequence, in its lucrative memorabilia, in the hearts

and minds of the watching millions. It *is* The Street. Opposite stand a row of houses built in the 1980s to replace a factory, dinky-sized versions of suburban houses which, even though they are now home to some long-running characters, could be blown away in a typhoon tomorrow without even slightly damaging the fundamental ideological fabric of the text. The Duckworths' plan to cross this great divide – in effect to suburbanize themselves – plunged the Wiltons into wailing dismay. Such a transgression could only demonstrate how small and easily bridgeable the gulf was, and hence how preposterous the Wiltons' airs and graces (gnomes, classical music, continental food) truly were. As the Duckworths stood on the lawn behind the house they hoped to make their own, Mavis Wilton was finally driven, in hysterical self-defence, to call out to them 'this is supposed to be a pleasant suburban back garden.' The S-word had been spoken, the unthinkable was out in the open, the Wiltons' folly was laid bare. *Coronation Street* knows what its viewers know, that on British television suburbia belongs primarily to comedy; and if it strays into soap, it's liable to be laughed at.

Conclusive proof of the irreconcilability of suburbia and British soaps came in the shape of *Castles*, a BBC serial that ran for just twelve weeks in the summer of 1995. Centred on three generations of a north London family who had worked their way out from a grimy, industrial zone of the capital to its leafy fringes, *Castles* wore its suburban trappings unashamedly, spelling out its title in the kind of decorative stained glass that adorns windows throughout suburbia. That title itself threw out multiple resonances: the family's surname was Castle, castles connote security, tradition and rootedness, many suburban houses have pseudo-medieval ornamentations, perhaps someone involved in devising the series knew of J. M. Richards's *The Castles on the Ground*, one of the few books ever published in Britain to defend suburban tastes and lifestyles (Richards 1946). If so, that was a more ironically apposite reference than could have been intended, since *Castles* stayed on the ground, resolutely refusing to take off. Its world of mock-Tudor exteriors, stripped pine interiors, white-collar jobs, precocious children, wives who garden and husbands who have affairs might well have worked in another format (the 1970s series *The Brothers*, for example, mined similar territory very successfully for years as a once-weekly, fifty-minute-episode programme) but the mixture of unequivocal suburbia and unmistakable soap failed to gell. British audiences like their home-grown soaps a little rougher around the edges. However, that taste may in time be modified by *Hollyoaks*, the second British soap to be launched in 1995 and the first British teenage soap to follow the Australian model pioneered by *Neighbours*. It is set in the north of England, in Cheshire, but has chosen to foreground age rather than regionality as its defining characteristic, suggesting

perhaps that for younger British soap audiences an unabashedly suburban setting presents no barriers – indeed it might, for tastes weaned on *Neighbours*, be taken as the norm. At the time of writing, however, the series has been running for only a month, so its full impact cannot yet be assessed.

The only lasting contribution made by *Castles* was to reinforce that curious and revealing homology between suburban texts and the telephone. The Castles seemed perpetually on the phone to each other – plausible enough in the sense of a geographically disparate extended family keeping in touch with each other and, crucially, being kept within the same plot strand, yet most of the calls were (for good melodramatic reasons) engaged in furthering deceit and duplicity, while truth-telling and honest revelations were reserved for face-to-face conversation. This contrast extends across a wide range of texts – in working-class soaps, most characters see each other regularly, so telephoning almost always suggests news from outside the core community, and *anything* from outside the core community is liable to be troubling. Telephone calls allow for secrecy, for betrayal, for illicit affairs and suspect plans; making them should be an activity conducted by the far-flung diaspora of the suburbs, not the interconnected inhabitants of an urban soap. Both *EastEnders* and *Brookside* have taken this even further recently by introducing the up-to-date device of an unwanted fax message (from a secret lover and persistent ex-wife respectively) as a threat to domestic harmony and thus to communal stability. In such soaps, communicating in ways other than speaking in the street, shouting up the stairs, or chatting in the shop or pub is too underhand, too evasive, too polite, too suburban; you can't natter in the launderette in suburbia, because everyone has their own washing machine. Similarly, in other genres, sitcom monsters like Hyacinth Bucket and Martin Bryce place inordinate emphasis on telephone etiquette, while an early scene in *Here Come the Huggetts* deals with Mrs Huggett's panic when two men come to install the phone. This is partly the vehicle for some tired jokes about a woman's inability to master machinery, but on another level Mrs Huggett might, somewhat speculatively, be seen as a resistance fighter against the suburbanization implicit in the acquisition of a telephone. She's a believer in compact and knowable communities, a soap matriarch before her time, and she's much happier with gossiping over the garden wall – one of the oldest communication technologies of them all.

CONCLUSION

Rather than, as is common with conclusions, wearily reiterate all of the above in summarized form, I want instead to shed a differently angled light on the issues by offering some brief thoughts on one further area of British popular culture and its relationship to the suburban – popular music. Pop's images of suburbia have been a crucial component of the British popular cultural picture since the mid-1960s: it is unlikely that any text prominently featuring the word 'suburban' has ever reached a wider audience than The Beatles' 'Penny Lane'. That song's exuberantly nostalgic evocation of 'blue suburban skies' marks it out as a rare creature indeed, a text prepared to celebrate the suburban with unalloyed delight, but such a reading might need to be moderated in the light of its exact cultural context, 1967, when the influence of drug culture warns against any naive, over-trusting interpretation. Ian MacDonald, in his peerless study of The Beatles, describes 'Penny Lane' as 'subversively hallucinatory . . . [d]espite its seeming innocence' (MacDonald 1994: 179), and this should indicate how pop's suburbias must always be carefully contextualized in just the same way as the suburbias of film and television.

'Penny Lane' aside, British pop records of the 1960s tended to approach suburbia through exactly the same predominant frameworks deployed in the culture at large: comedy and contempt. If pop had its own distinctive role to play, it was in combining the two. Thus The Kinks, the group who spent the most time productively exploring the possibilities of suburban imagery, produced 'A Well-Respected Man', which scathingly sketched the portrait of an unquestioningly conformist suburbanite whose 'world is built round punctuality . . . doing the best things so conservatively'. An analogous attack by Manfred Mann on a similar individual had such an impact it even found itself used as a reference point in the dour confines of a sociology textbook, which in search of an evocative and student-friendly image spoke of 'the spacious but dreary monotony of the semi-detached suburban Mr James' (Lambert and Weir 1975: 24). As part of their shrewd 1990s reworking of 1960s British pop, it's not surprising that the group Blur have frequently satirized the suburban milieu, their song 'Ernold Same', for example, delineating the same kind of soullessly repetitive commuter's life familiar from so many other texts surveyed in this chapter.

Pop of the 1960s loathed suburbia because it was the antithesis of Swinging London: nobody, at least according to the media, swung in Penge or Ongar. Suburbia was Acacia Avenue not Carnaby Street, it oozed unfashionability. Pop

was about the neon buzz of the urban night, those pleasures Billy Liar was too timidly suburban to embrace, or, in the hippiefied late 1960s, the back-to-the-land vibe of rural bliss – and as always, suburbia could find no place in that binary. The irony here, of course, was that most of the groups who castigated the suburbs did so because they knew them all too well from the inside. Ray Davies of The Kinks could identify and mock suburban values with such accuracy only because he had grown up in Muswell Hill. Attacks on suburbia from pop culture originated in the rebellious, almost Oedipal wish to disavow one's parent culture, and the suburban audience for pop, all those teenagers skulking in the bedrooms of Hendon and Beckenham, latched on to this as a sign that escape was possible, that glamour was attainable once suburbia had been transcended. As Pat Kane has perceptively put it, 'pop music, in Britain, is so often the dream that makes suburbia survivable' (Kane 1995).

Some pop writers even overcame their hostility towards the suburbs that had spawned them and produced more reflective songs about the suburban experience. The Kinks moved on from the invigorating spite of 'A Well-Respected Man' to the tragi-comedy of 'Shangri-La', a song which feelingly describes the situation of people who have worked hard for years to secure a suburban lifestyle but, having attained it, find it hollow, repetitive and unsatisfying. Such a position is not, in some ways, far from Q. D. Leavis's stinging condemnation of 'the emptiness and meaningless iteration of the suburban life' (Leavis 1965: 211), but The Kinks perform with compassion and empathy, emotions which take the song into areas unreachable from Leavis's perch of withering, mandarin condescension. Her attitude to suburbia was more in keeping (though she would have been gratifyingly mortified to hear this) with that of the punk groups of the late 1970s. Many of them came from suburban backgrounds – one of the most famous gangs of early London punks was known as the Bromley Contingent – and the shock tactics of punk style (swastikas, piercings, torn clothes) were shrewdly calculated to offend the semi-detached folks back home.

Punk's response to suburbia was characteristically ruthless – it was the enemy – but then this was only a response in kind, since the devotees of punk (often sexually unconventional individuals) had long been on the receiving end of what Roger Silverstone has identified as suburbia's 'capacity to exclude those who did not fit into the tightening strait-jacket of the suburban ideal' (Silverstone 1994: 172). Eloquent testimony confirming Silverstone's point comes from the autobiography of Boy George. A south-east Londoner, at one time star-struck on the fringes of the Bromley Contingent, George's undisguised homosexuality ensured his unhappiness in the suburbs, but pop offered a way out. In a

carnivalesque inversion of the millions of respectable commuting journeys made along the railway lines of south-east London, George and his cronies fled at night to the centre of the city, seeking out punk clubs, gay clubs, any subcultural space where the respectabilities of suburbia could be temporarily forgotten by immersion in the delights of loud music, cheap drugs and easily available sex. The railways that invented the suburbs, the railways that carried the workers so loathed by T. S. Eliot, the railways that criss-crossed the geography of my own childhood, the railways that open the television adaptation of Hanif Kureishi's *The Buddha of Suburbia*, were gleefully appropriated in this act of scandalous bricolage, forced to service not the needs of dutiful wage-slaves but the thrills of suburbia-defying hedonists. George's book includes a photograph of himself in full, outrageous, parent-shocking New Romantic garb, subtitled with impeccable cheek 'A subtle little number for travelling on the train from Woolwich'.

And unlike those trapped suburban dreamers of films and sitcoms, all the Perrins and the Pollys and the Rias and the Queenies, George actually got away. As if to prove J. M. Richards's 1940s point that only 'a minority of freaks' could fail to appreciate the joys of suburban life, George decamped from commuterland to live in a succession of city-centre squats, bang in the middle of his new playground with no need to worry about the last train home. Pop culture and queer culture (the two, as ever, inextricably coiled around each other) flourished in the urban centre, so that was where George needed to be. Though a full consideration of this point lies outside the scope of this chapter, it is perhaps sexual dissidents who are the most rigorously policed victims of the suburban cult of conformity. Of all the hegemonies of suburbia, it is the hegemony of heterosexuality that cuts deepest, bites hardest, and the reason is evident: 'The family is crucial both to the decision to move to the suburbs and to the whole suburban way of life' (Thorns 1972: 111). Every sociological study of the suburbs, every media text depicting them, unerringly concurs on this point, so it's little surprise that suburban homosexuals either flee such smothering familialism for the centres of cities – for what is gentrification but the assertion of gay taste? – or keep fearfully quiet about their sexual lives (for a study of gay men struggling to cope in American suburbia, see Lynch 1992). In matters of sexuality – which, being queer myself, I tend to prioritize – the suburbs are so deadly that I almost find myself siding with the architects and literary types I quoted at the beginning of this chapter.

Yet it isn't that simple. For all the constricting safeness of suburbia, for all its cruelly small-minded inability to deal with difference and diversity, its contribution to British culture has been vast and indelible. Some (mostly writers of bad

sitcoms and readers of worse newpapers) revel in that fact; I have come to acknowledge it warily, with a fascinated ambivalence; and there are still those who persist in responding to it with just the same kind of astringent, bilious snobbery that has been in circulation since the first villa went up in Southgate or Bromley. While preparing the final draft of this chapter, I noticed an article in *The Guardian* commenting on plans to landscape the road that leads from Heathrow Airport to central London. This road was described as currently resembling

A Terry and June theme park with a skyline punctuated by Rupert Murdoch's satellite dishes – all tastefully displayed in a row of fake tudor houses. Welcome to Britain. Welcome to the A4 corridor – the first impression visitors get when travelling into London from Heathrow . . . the corridor does pass some of the most beautiful green sites in London, like Kew Gardens and Osterley Park. Unfortunately, there are so many fake tudor houses and satellite dishes in the way it is impossible to see either of them.

(Younge 1995: 2)

It's all still there: suburbia as inauthentic, banal, repetitive, tasteless, duped, a blot covering nature, fit only for (what I'm pleased to note is the inevitable genre) sitcoms. The old myths won't die – but perhaps there is a way of turning them on their head and making them serve a different purpose. Perhaps the maligned suburban sprawl of the A4 corridor is *exactly* what should be there as a first glimpse for visitors, a promise of what's in store. Suburbia, to conclude with a pun, is where the nation resides: England wouldn't be England without it.

ACKNOWLEDGEMENT

I'd like to thank Marc O'Day, who survived an upbringing in suburban Surrey, for a number of conversations which were invaluable in helping to shape the insights of this chapter.

REFERENCES

Betjeman, John (1970) *Collected Poems*, London: John Murray.
Boy George with Spencer Bright (1995) *Take It Like a Man*, London: Sidgwick & Jackson.
Carey, John (1992) *The Intellectuals and the Masses*, London: Faber.
Eliot, T. S. (1963) *Collected Poems 1909–1962*, London: Faber.
Forty, Adrian (1986) *Objects of Desire: Design and Society 1750–1980*, London: Thames & Hudson.

Geraghty, Christine (1991) *Women and Soap Opera*, Cambridge: Polity.

Geraghty, Christine (1995) 'Albert Finney: A Working-Class Hero', in Pat Kirkham and Janet Thumim, eds, *Me Jane: Masculinity, Movies and Women* London: Lawrence & Wishart.

Hoare, Philip (1995) *Noel Coward: A Biography*, London: Sinclair-Stevenson.

Kane, Pat (1995) 'In The Key Of Life', *New Statesman and Society*, 29 September.

Lambert, Camilla and David Weir, eds (1975) *Cities in Modern Britain* London: Fontana.

Leavis, Q. D. (1965 [1932]) *Fiction and the Reading Public*, London: Chatto & Windus.

Lejeune, C. A. (1947) *Chestnuts in her Lap*, London: Phoenix House.

Lynch, Frederick R. (1992) 'Non-ghetto Gays: An Ethnography of Suburban Homosexuals', in Gilbert Herdt, ed., *Gay Culture in America: Essays from the Field*, Boston: Beacon Press.

MacDonald, Ian (1994) *Revolution in the Head: The Beatles' Records and the Sixties*, London: Fourth Estate.

Masterman, C. F. G. (1960 [1909]) *The Condition of England*, London: Methuen.

Medhurst, Andy (1985) 'A History of Sitcom', in Cary Bazalgette, Jim Cook and Andy Medhurst, *Teaching T.V. Sitcom*, London: British Film Institute.

Medhurst, Andy (1986) 'Music Hall and British Cinema', in Charles Barr, ed., *All Our Yesterdays: Ninety Years of British Cinema*, London: British Film Institute.

Medhurst, Andy (1987) 'Heart of the Middle Country', *The Listener*, 3 September.

Oliver, Paul, Ian Davis and Ian Bentley (1994 [1981]) *Dunroamin: The Suburban Semi and its Enemies*, London: Pimlico.

Pym, Barbara (1980 [1955]) *Less Than Angels*, London: Panther.

Richards, J. M. (1946) *The Castles on the Ground*, London: Architectural Press.

Silverstone, Roger (1994) *Television and Everyday Life*, London: Routledge.

Thorns, David C. (1972) *Suburbia*, London: McGibbon & Kee.

Walker, Alexander (1974) *Hollywood England: The British Film Industry in the Sixties*, London: Michael Joseph.

Williams, Raymond (1961) *Culture and Society*, Harmondsworth: Pelican.

Willis, Ted (1959) *Woman in a Dressing Gown and Other Television Plays*, London: Barrie & Rockliff.

Willmott, Peter and Michael Young (1960) *Family and Class in a London Suburb*, London: Routledge & Kegan Paul.

Younge, Gary (1995) 'That Long And Doleful Road', *The Guardian*, 11 November.

THE SUBURBAN SENSIBILITY IN BRITISH ROCK AND POP

Simon Frith

INTRODUCTION

The suggestion that British pop sensibility is essentially suburban is hardly new. I have previously traced the suburban thread that runs through England's musical Bohemia from jazz to blues to rock, while Jon Savage has explored the suburban secrets of punk and Sarah Thornton described the suburban routes of rave. In England suburbanism is, it seems, equally implicated in folk revival and indie ideology, and what is the Last Night of the Proms if not a celebration of a suburban night out?[1]

I don't want to repeat these histories here, but pop's suburban sensibility is worth revisiting for three overlapping reasons.

First, because the working class remains so significant in the mythology of British pop culture. To cite an example to hand, in her MacTaggert Lecture to the 1995 Edinburgh Television Festival, Janet Street-Porter drew her media audience's attention to the contrast between the tired ideas of the middle-class middle-aged men of television and the vibrant creativity of the streetwise young people of pop. There is, in fact, very little difference between the class profiles of the television and music industries, and street wisdom is more a rhetorical than a material quality, but Street-Porter was only voicing common sense here – the common sense of both academic and media sociologists. Pop culture does seem different from television culture, and what interests me about this is not the gap between myth and reality but the way in which the myth – the rhetoric of class and street and grit – is itself the product of suburban dreams, suburban needs.

The resulting aesthetic confusion was apparent in the 1995 summer 'war' between Blur and Oasis. This was the first time since the 1960s that such a sales battle (whose new single would top the charts?) had interested news reporters and the narrative was quickly cast in 1960s terms – the north versus the south; working class versus middle class; rocker versus mod. But the analogies began to break down when more explicit comparisons were made: Blur versus Oasis as the Beatles versus the Stones. The problem here was both musical (Oasis are as obviously influenced by Lennon/McCartney as by Jagger/Richard) and social (it was the Beatles who were northern working class; the Stones southern petit bourgeois), and listening to the records made other comparisons seem more obvious (Blur as The Kinks; Oasis as Status Quo), and other precedents more telling – Blur work obviously and comfortably with the suburban sensibility that has always defined Britpop; Oasis work obviously and comfortably on the suburban awe that has always puffed up the proletarian lout. Both groups and their music, both groups and their Britishness, have to be understood in terms of the ideology of pop rather than the realities of class.

The second reason for exploring pop's suburban sensibility further is because it blurs distinctions that are otherwise taken for granted in sociological common sense – between high and low culture, art and pop, mass market and subculture. In this respect British pop ties in, perhaps unexpectedly, to another defining British cultural institution, the BBC. Again, it is hardly startling to point to the importance of the BBC to British identity, but it is worth stressing the essential suburbanity of this identity – in terms of both the domestic placing of the listener and viewer and the offered spectacle of the city: *In Town Tonight!*[2] And if cultural categories are therefore blurred – in the figure of the middle-brow – such blurring depends, in turn, on marking out other sorts of boundaries – regional, racial, social. Suburban culture, whether shaped by pop or the BBC, is white culture, white English culture, white south-eastern English culture; it describes, in the end, an urban phenomenon, the media domination of London, the concentrated site of both political and cultural power. The sub-urban sensibility with which I am concerned is sub-London sensibility. From this media perspective other English cities (and even Scottish, Northern Irish and Welsh cities) are themselves effectively suburban. The point about Oasis (and the Beatles), that is to say, is not that they are, in fact, from the north, but that they are seen and heard (from south of Watford) to be 'northern'.

And there is here a third reason for paying attention to pop sensibility, as a particularly fantastic account of the suburban experience. If suburban culture *tout court* seems essentially middle-brow, that is, in part, because the literature of

suburbia has been essentially middle-brow, in the no-nonsense poetry of
Betjeman, Larkin and the mocking Stevie Smith; in the plain fiction legacy of
Bennett and Wells; in the genre *grande guignol* of an Ian McEwan or Ruth Rendall;
in the comfortable humour of Richmal Crompton's William books. In mass
cultural terms, while suburban mores do pervade the television screen, they do
so in the bloodless terms of the sitcom and the commercial. In the last thirty years
at least it has been pop music more than any other form that has articulated
suburban pretension, suburban claustrophobia, suburban discontent. British pop
draws on both the ironies and the secret desires of suburban literature but gives
them a more grandiose setting, using rock, a musical form which is, after all, the
sound of the metropolis. As Jon Savage puts it,

Pop (and rock's) rhetoric is of the inner city, but scratch the surface of most English pop stars, and
you'll find a suburban boy or girl, noses pressed against the window, dreaming of escape, of
transformation.[3]

And it is hardly surprising that the most incisive suburban fiction of recent
times, Hanif Kureishi's *Buddha of Suburbia*, is driven by rock not literary dreams.

SUEDE: SNARES AND THICKETS

Does you love only come, does your love only come,
Does he only come in a Volvo?

('Breakdown')

The most significant suburb in British pop history is probably Bromley, setting for
Kureishi's novel, home of the quintessential suburban star, David Bowie, and the
quintessential suburban fans, the Bromley Contingent (from whom later emerged
both Siouxsie and the Banshees and Billy Idol). I don't want to rewrite the
Bromley story here, but two aspects of Bowie's version of progressive rock and
the Bromley Contingent's version of art-school punk are worth noting. First, both
involved self-consciously aesthetic gestures (and pervasive references to such
iconic art figures as Rimbaud and Baudelaire, Warhol and Wilde), gestures
stylized less for their intrinsic artistic qualities than as a mark of social *difference*
– this was art being used to irritate the philistine and to worry the conformist.
'I hated Bromley,' says Siouxsie.

I thought it was small and narrow-minded. There was this trendy wine bar called Pips, and I got

Berlin to wear this dog-collar, and I walked in with Berlin following me, and people's jaws just hit the tables. I walked in and ordered a bowl of water for him, I got the bowl of water for my dog. People were scared![4]

What was at stake here was what one might call *Bohemia in a bedroom*: an alternative lifestyle practised at home, and displayed as a kind of performance art at the bus stop and railway station, in select club backrooms and parents-are-away-for-the-weekend parties. (No wonder London's suburban art schools, ringing the capital like the outposts of a metropolitan mission, have been so important as pop hang-outs, safe havens for trying things on.)

The second aspect of the Bromley aesthetic I want to emphasize is the lure of the city – the metropolis at the end of the local railway line, a metropolis not to occupy but to visit, to visit as a matter of routine, at the weekend, for the occasion, in a gang. In pop terms London is a peculiar place. While they certainly offered the glimmering promise of sex and drugs and rock'n'roll, London's key music clubs, whether the Flamingo for mods in the 1960s or the Roxy for punks in the 1970s, whether Blitz for New Romantics in the 1980s or Shoom for raves in the 1990s, have actually been settings for the suburbanization of the city, as local obsessions and alliances were mapped on to Soho streets and basement dance floors. Suburban sensibility here concerns the enactment of escape (rather than escape itself) and the domestication of decadence. The affinity of suburbia with camp is obvious. As David Bowie has always understood, a suburban pop sensibility means a camp sense of irony, a camp knowingness, a camp mockery, a camp challenge: *do they really mean it?*

In recent pop history this question has been posed most interestingly by the group Suede. Suede emerged from a group initially formed in Haywards Heath around 1983 by Bowie obsessive Brett Anderson and bassist Mat Osman. In 1989, while they were university students in London, they recruited guitarist Bernard Butler (from Leyton) and drummer Simon Gilbert (from Stratford-upon-Avon). Musically, Suede stabilized around the classic singer/guitarist, lyricist/composer, front-man-sex-star/backroom-musical-genius-axis of Anderson and Butler, but emotionally Suede's key component was Anderson and Osman's teenage friendship. Even before they met,

'I knew of him,' Osman says. 'It's a small enough place that anyone who's slightly out of the ordinary is pretty well known. I met him at parties, when he used to look like a young stockbroker, with a striped shirt and tie-pins. You had this room full of people with huge bushes of hair, and Brett had this little block flick, a yellow suit: he looked like Tommy Steele's son.'[5]

The intended effect was David Bowie's *Let's Dance* look. As Jon Savage comments,

Now in their mid-20s, Osman and Anderson were teenagers in the early '80s: time of New Romantics, post-punk. . . . Both went wholesale for pop: 'You recreate yourself as an outsider,' says Osman. 'Because you know you're not going to have fun as the centre of the gang, you're immediately drawn to people like David Bowie. When you live in an environment where there is nothing elegant, nothing lasting, you're bound to be drawn to someone like that.'[6]

This sense of being on the margins of youth culture (and Osman's words here echo those of Berlin, remembering the Bromley Contingent in Jon Savage's study of punk culture, *England's Dreaming*) remained even as Suede became commercially successful. The group came to fame by playing on the media possibilities at each end of the Southern Line (Suede was first signed to a little label in Brighton; first got attention on London radio stations and in the metropolitan pop press). Suede was a *Melody Maker* cover story before a Suede record was released; the group became the national rock sensation of 1992–3 with a debut album, *Suede*, that charmed London critics and won the Mercury Music Prize. The second album, *Dog Man Star*, released in 1994, was equally effective (if rather more grandiloquent) but even before it reached the shops Bernard Butler had left the group, citing, as ever, 'musical differences'.

As a suburban success story Suede's pop career is familiar. The first non-cognoscenti knew of the group was probably from the billboard campaign for their debut album. It featured a blow-up of the cover picture, a photograph by Tee Corinne of an intense kiss – the lovers' nakedness is apparent; the lovers' gender is not. (The couple are, in fact, women but the casual passer-by was as likely to assume the advert featured two young men.) The image is artistic (rather than pornographic) – an elegant study of tenderness and inwardness not of lust and titillation – but shocking anyway, a glimpse of a sexuality not usually seen in the high street. Suede's hoarding claim to decadence was revealing in two ways: firstly, the picture worked as an artistic *representation* of the 'perverse' and not as the real thing (this was not a photo of Brett and Bernard kissing); secondly, the image was obviously romanticized, airbrushed, soft focused. As an advertising poster and CD cover it seemed less a picture of real life in the sexual twilight zone than a picture taken from a Book of Favourite Photographs in Brett's bedroom, and by the time *Dog Man Star* was released he was claiming 'Sleeve Concept and Art Direction' for himself. The *Dog Man Star* cover used another found gallery photo (by Joanne Leonard): a young man lies naked, arse up, on a bed beneath an open, tree-filled window; a sexual pose but (as male gay imagery goes) soft

not hard. What the picture reveals is less Suede's sexual tastes than their aesthetic preferences, their ability to appreciate difference as art.

This message was reinforced by the other strands of the promotion process: the interviews (dominated by Brett) in which he proclaimed himself gay in spirit if not yet in the flesh; the look (emaciated, black garbed, floppy haired); the manners (nervy, awkward, laconic). Suede were sold as slightly dour, pretentious, intense and thus, in suburbia, as the boys next door.

In musical terms the most obvious reference point was David Bowie (*Dog Man Star* sounds like a Bowie title) in terms of both the songs' melodic construction (a kind of laconic melodrama) and Brett Anderson's tone of voice: pushing up against the pitch, shifting register, vocal self-regard, gloriously purple passages. Suede turned out to be the careening vehicle of expression for a narcissist; the line that comes through the rock beat and the guitar drive is, pathetically, 'Won't someone give me some fun?'

Lyrically, this means a vague romanticism, mood created through metaphor and simile not plot and character (like, say, Blur). Suede sing songs of feeling, but the feelings are derived from the lyrical images rather than imposed upon them, as if Anderson (as lyricist) is letting his life be shaped by the pop songs that rush around his head. Youth is thus an image of both possibility ('I'm 18!') and gloom (describing a quality that by its nature won't last); the youthful protagonists of Suede's songs are stuck in a vain attempt to stop time passing, and the essential boredom of suburbia becomes, oddly, a kind of utopia, a place where there's nothing to do except dream of other places. In the words of one of Suede's instant biographies,

For years, Brett, who claims that growing up in Haywards Heath excluded him 'from anything remotely interesting', dreamed of escape, a recurrent theme in Suede songs. He wanted to go somewhere glamorous and exciting where he could dress as he pleased without being victimised. The place was London.[7]

But Anderson's lyrics suggest a continuingly ambiguous attitude to the city, which is described less as a real place than as something made up in suburbia itself and imagined, inevitably, in media imagery, through Hollywood scenarios and sci-fi cartoons. The city, London, is not a place in which to live but a backcloth against which to imagine living. In this sort of suburban sensibility the twin engines of rock'n'roll power, sex and the motor car, are as much threat as pleasure. In Suede songs every sensual move is always already choreographed, a gesture in a pornographic video or pin-up, and the car stands as much for restraint as movement, windows closed against true life. Each moment of sexual satisfaction

becomes a measure of the finitude of fantasy, and in this narrative the Wild Ones, far from driving dramatically into suburbia never get to leave it, never lose the sense that whatever is happening is happening elsewhere.

Suede, in short, celebrate (and their music is celebratory) suburban alienation, the sense of lives going nowhere, of activity reduced to 'lying in my bed, lying in my head'. This pop world is decidedly male – the footloose girl (Julie Christie in *Billy Liar*) remains the romantic icon – and determinedly adolescent: from Suede's perspective days don't pass but hang there, interminably; night means life but fleetingly; and 'home' is the term most riddled with unease.

ALWAYS ON MY MIND

Suede's sensibility is familiar enough in recent British social history. We can hear echoes in their songs of suburban jazz fans' longing for real life in the 1930s and 1940s and suburban blues fans' reveries of dirty sex in the 1950s. And Suede's fans are obviously still engaged in the 1960s mod pursuit of elusive metropolitan pleasures and the 1970s punk rejection of buttoned-up cultural conformity. The group know this very well, dressing up their attitude self-consciously – as gesture, as style, as art.

It is not difficult to explain such suburban music sociologically. Reading backwards, that is to say, from music to society, from aesthetic to material circumstances, one can find a number of obvious sociological themes: mobility, difference, habitus. But then British suburbia is as much a product of pop as British pop is a product of suburbia. In articulating the suburban experience so powerfully over the last thirty years or so, rock musicians have developed a coming-of-age narrative which is convincing to teenagers wherever they live.

Simply as a matter of pop imagery 'suburbia' describes a way of living with a number of commonsense components. Suburban dwellers move there from somewhere else; suburban housing is designed for the small family; suburban lives are lived behind closed doors. There's no sense of excess here; no spill-over of cousins, aunts and uncles; no massing on street corners. These are single-class communities: people don't know each other but they know what they're like. Neighbours nod across the street, compare cars, keep their salaries to themselves. Suburbia is a place where people live but don't work; rest but don't play (the real jobs, the real shops, the real pleasures, are elsewhere). Geographically, suburbia is, in effect, an empty sign, a series of dots on the map from which people travel

– to the office, to the fleshpots, to the city. Suburban living is characterized by what it lacks – culture, variety, surprise – not by what it offers – safety, privacy, convenience.

What I'm outlining here is a pop fancy, of course – suburban communities are no more classless, genderless or cultureless than anywhere else in contemporary Britain – but the significance of suburbia in song is as an account of the situation of suburban youth; what is sociologically persuasive is the suggestion that to live in the suburbs is a different experience for children than for their parents. To grow up in suburbia is, indeed, to grow up *in* suburbia. Adults may go off each morning to work, each evening to play, but their children's world is the suburban world, the mother's world, the world of the play group, the park, the walk, the school. For teenagers the home is the place to escape from, not to retreat to, and if parents can live to all intents and purposes anonymously (with no obvious reason to know their neighbours at all), their children cannot: they've been in and out of each other's houses since kindergarten, gone through school in adjoining desks, staked out the locality in a grid of friendships and disdain. What may seem homogenous from the outside – the rows of identical residences; the shared commuting lifestyle; a kind of cultural blankness – is marked from the inside (where the children live) by the recurring problem of fine difference. And what was built to signify security – not least for the family: bring your children up in safety! – is, from these children's own point of view, an illusory edifice. The one thing they know for sure is that some day they'll have to leave, to make something of – for – themselves.

From another perspective, what sells suburbia to grown-ups – its stability as a place to go out from and return to – is precisely what is oppressive to the young: they can't just jump in the car. Except in the imagination, of course: it is suburban youth, more than anyone, who depend on the media as a window on the world that adults seem to occupy; it is the suburban teenager, more than anyone, for whom media dreams seem real, whether on screen or on record. It is not surprising, then, that rock and pop, as youth forms, should be obsessed with suburbia, nor that suburban experience should be, in its mass mediated form, defined by teenage mores.

This is the context in which British popular music has developed a distinctive account of time and a particular sense of space. At the heart of all youth pop lurks boredom – a state of mind which apparently defines both teenage experience and teenage talk about that experience. Boredom ostensibly refers to an absence of activity – nothing's happening; I've got nothing to do – but in suburbia it describes a more complex state: not only is nothing unexpected happening, but

I sense, uneasily, that I don't really know what it means for something to 'happen' anyway. On the one hand, then, boredom is a way of discounting suburban routine (as the repetition of everyday life is transmuted into the repetition of a 4:4 beat); on the other hand, boredom can only be abated by excitement, in an intensity of feeling, with a shock. In their songs, suburban pop artists like David Bowie and suburban pop groups like Suede move constantly between the mundane and the apocalyptic. And because teenage experience is still grounded in the home, the boredom/excitement axis is focused, narcissistically, on the most immediate adolescent anxieties. Sexuality, for example, becomes the site for fantasies of *going to extremes*, and it is taken for granted that the most intense sensations (sex and drugs and rock'n'roll) are those enjoyed furtively, fearfully, kept hidden from the family – the suburban Gothic, a form that describes not only the classic English detective novel and the horror novels of Stephen King but also a genre of teen movie, is familiar too in rock, in the music of, say, Siouxsie and the Banshees or The Cure.

Music is the art form most concerned with time, most interested in detaching us from the inevitability of time passing and from the dismay that time is standing still. Music imbues time, one might say, with both turbulence and grace. If suburban pop is conceived in boredom, then – as music in which routine becomes exciting – it is also written against the inexorable process of growing up/moving on/settling down. There's a distinctly nostalgic strain in the music (from The Kinks to Blur), an oblique longing for a kind of lost local innocence (the Village Green, the Ford Cortina) which in emotional practice seems to stand for childhood, for an idealized neighbourly life, for home.

Home operates here as the implicit term of comparison with the electric space of most suburban rock: the metropolis, the metropolis as both real city – a place at the end of a tube or train or bus ride – and mythical backcloth, with its neon-lit streets and shadowy alleys of adventure, exchange and disaster. London is central to suburban sensibility as being both accessible (the place where parents work and elder siblings play) and imaginary (the place which dreams are made of). London, after all, gives suburbia its social meaning – as a dependent community; and pop's suburban musicians (Suede, Blur) clearly have a different sensibility from their northern provincial equivalents (The Smiths, Pulp). For the former, London is, really and mythically, part of the locality; for the latter London is, resentfully and day-trippingly, somewhere else.

And for the suburban teenager too the distinction between public and private spaces is blurred: to grow up suburban is to use public spaces, to get out of the house and into the park, the railway station, and now, I guess, the multiplex and

the mall; but such spaces are in effect occupied, marked out by a subcultural determination to draw boundaries against 'the public'. It is this way of taking over territory that is reflected in the suburban teenage use of London itself, in the weekend gatherings in clubs and on dance floors that have marked musical movements from Mod onwards.

In her book on music-making in Milton Keynes (a suburban settlement, to be sure) Ruth Finnegan suggests that sociologists should move away from describing people in occupational terms (what they do at work defines how they are at play) and take seriously cultural activities and interests as determining people's 'social pathways' through life (including, perhaps, their jobs).[8] From this perspective what is important about the suburban sensibility in British pop and rock is not the way it reflects the class structure but the way it maps out distinct attitudes, ways of culture (the Bohemian *versus* the conformist), that make sense simultaneously in terms of taste and sociability (musical tastes define friendship groups and vice versa) and which mark out divisions *within* a broadly shared class position.

These divisions are not easily categorized either in terms of high or low culture. If suburbia is, in itself, a product of the mass media (dependent culturally on radio and television and records, on newspaper and magazines) as well as mass planning, it is also the setting in which art is most important as a mark of social difference. The suburban pop dream (as is obvious for Suede) is to become a big star as a misunderstood artist; to turn suburban alienation into both aesthetic object and mass cultural commodity. And it could be argued (in defence of all these ridiculous pop boys) that because suburbia lacks a grand theorist (the proletariat can make sense of their lives with Marx, the bourgeoisie with Freud), youth pop, as *the* suburban art form, has filled the gap, feeding airwaves around the world with the sounds of boredom, grandeur, longing.

NOTES

1 See Simon Frith and Howard Horne, *Art into Pop*, London: Methuen, 1987; Simon Frith, 'Playing with Real Feeling', *New Formations* 4 (1988); Jon Savage, *England's Dreaming*, London: Faber & Faber, 1991; Niall Mackinnon, *The British Folk Scene*, Milton Keynes: Open University Press, 1993; Sarah Thornton, *Club Culture: Music Media and Subcultural Capital*, London: Polity, 1995.

2 See Simon Frith, 'The Pleasures of the Hearth', in *Formations of Pleasure*, London: Routledge, 1983, and 'The High, the Low and the BBC', in Wilf Stevenson, ed., *All Our Futures: The Changing Role and Purpose of the BBC*, London: BFI Publishing, 1993.

3 Jon Savage, 'Suede', *Mojo* 3, January/February 1994.

4 Savage, *England's Dreaming*, pp. 183–4.

5 Savage, 'Suede'.

6 Ibid.

7 Chris Charlesworth, ed., *Suede*, London: Omnibus Press, 1993, p. 13.

8 Ruth Finnegan, *The Hidden Musicians*, Cambridge: Cambridge University Press, 1989.

THE WORST OF ALL POSSIBLE WORLDS?

Vicky Lebeau

> Johnny's upstairs in his bedroom / Sitting in the dark
> Annoying his neighbours with his Punk Rock electric guitar.
> (The Members, 'The Sound of the Suburbs', 1979)

> The 9.25 train from Liverpool Street was almost empty . . . [T]he train racketed through the urban sprawl of the eastern suburbs; rows of drab houses with blackened bricks and patched roofs from which sprang a tangle of television aerials, frail crooked fetishes against the evil eye; layered high-rise flats smudged in a distant drizzle of rain. . . . This drab no man's land was part of everyone's mental topography.
> (P. D. James, *Innocent Blood*, 1980)

I have borrowed the title for this chapter from Phil Cohen's 'Subcultural Conflict and Working-class Community', first published in *Working Papers in Cultural Studies* in 1972 and subsequently extracted in 1980 as a key chapter on ethnography and cultural studies in the collection of essays from the Birmingham Centre for Contemporary Cultural Studies, *Culture, Media, Language*. Cohen's immediate point of focus is the effects – economic, familial, psychic, cultural – of what he describes as the 'state of crisis' of the working class of the East End of London, a crisis derived from the restructuring of the local economy since the 1950s and the postwar housing policy of slum clearance and relocation of families on suburban housing estates on the outskirts of London where they had 'the worst of all possible worlds' (Cohen 1980: 80–2). For Cohen, the transferral of this crisis from one generation to the next is the key to any understanding of the subsequent development of subcultural forms: in his now famous conclusion, the 'latent function of subculture' is the 'magical' expression and resolution of the conflicts which remain hidden in the parent culture (1980: 82). In other words,

the crisis endured by the parent culture is re-enacted through the different subcultures it 'produces' and, equally, a parent culture 'in crisis' is likely to be very productive of subcultures.

What remains, for me, most striking about Cohen's work is its bringing together of an analysis of the formation of subcultures with a sociological account of the postwar development of the suburbs. On the one hand, this is an attempt to give an account of subcultural forms which would articulate a Marxist analysis of class antagonism with the 'family romance', with the dynamics of the Oedipal conflict which has so often dominated psychoanalytic thinking about both individual and collective forms of fantasy. While subcultures are viewed as the privileged products of the working class – 'From my point of view,' Cohen writes, 'I do not think the middle class produces subcultures, for subcultures are produced by a dominated culture, not by a dominant culture' (1980: 85) – they are also cast as symptoms bearing the traces not only of their own unconscious desires and conflicts but of the desires and conflicts of the parent culture: a form of transgenerational inheritance that it may be difficult, in fact, to confine within class terms. On the other hand, Cohen examines the role played by suburbaniza-tion in a type of intra-class upheaval: the transformation of the urban environment through the postwar slum clearance programme in London and other major cities and a subsequent split between the families who remain, for this example, in the East End and those who move out.

That axis – the fantasmatic structures supporting subcultural forms, the psychopolitics of the suburbs – is, I want to suggest, essential to any understanding of the iconography of suburbia which has been so central to the self-imaging, as well as to the commercial packaging and repackaging, of one of the most pervasive and elusive of the postwar subcultures: punk. In his history of English punk, *England's Dreaming*, Jon Savage makes the general point that 'the dreamscape of suburbia has a powerful and unrecognised place in England's pop culture' (Savage 1991: 145). To take one example: *The Sound of the Suburbs*, a compilation of punk rock classics from between 1977 and 1981, borrows its title from The Members' single, 'The Sound of the Suburbs', first released in 1979. The sleeve design for *The Sound of the Suburbs* is itself a testament to the cognitive efficiency of one distinct imaging of the suburbs (Figure 11.1). The front cover is divided – or 'torn' – into three horizontal sections. Contained between the tower blocks and Victorian remnants of a (probably) London cityscape at the top of the sleeve and the uniform monotony of the terraced housing of a (probably) council estate at the bottom, a visual cliché of the country-in-the-city runs through the middle: an aerial view of the semi-detached,

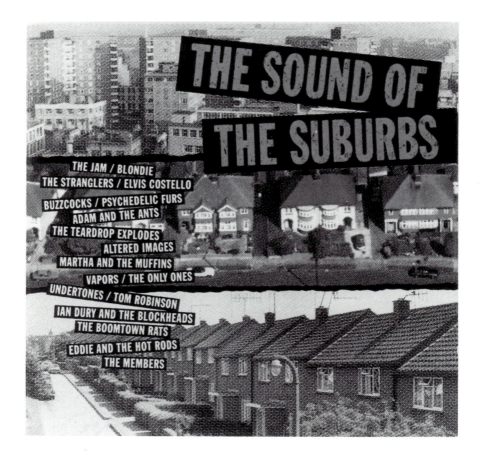

THE SOUND OF THE SUBURBS

THE JAM / BLONDIE
THE STRANGLERS / ELVIS COSTELLO
BUZZCOCKS / PSYCHEDELIC FURS
ADAM AND THE ANTS
THE TEARDROP EXPLODES
ALTERED IMAGES
MARTHA AND THE MUFFINS
VAPORS / THE ONLY ONES
UNDERTONES / TOM ROBINSON
IAN DURY AND THE BLOCKHEADS
THE BOOMTOWN RATS
EDDIE AND THE HOT RODS
THE MEMBERS

Figure 11.1 Record sleeve, *The Sound of the Suburbs*
Source: Courtesy of Sony Music Entertainment (UK) Ltd

semi-individualized suburban comfort of bay windows and front and back gardens. Plastered over the front cover, fracturing these images, are the typically 'punk' title graphics: the cut and paste anonymity of 'ransom note' lettering (Hebdige 1979: 112).

The images trafficked by *The Sound of the Suburbs* take for granted an association between these different representations of suburbia and a music most famous for its disaffected aggression – an aggression which so often presented itself as a reaction to and exposure of the latent violence and perversity of the suburbs. Think of Jordan, the 'first Sex Pistol' and one of the most public images of punk, commuting every day from Seaford (in Sussex) to the Kings Road to work at

Malcolm McLaren and Vivienne Westwood's Sex: '"And whatever I wore at work, I wore on the train and I didn't wear a coat. . . . Sometimes I'd get on a train and all I had on was a stocking and suspenders and a rubber top, that was it. Some of the commuters used to go absolutely wild, and they loved it"' (Jordan, cited in Savage 1991: 93–5). Or Siouxsie of Siouxsie and the Banshees: '"I hated suburbia . . . I hated the street we lived in, bordering on middle class. More puritanical than proper middle class in a way, almost spiteful"'; '"The only thing that was looked down on was suburbia. I hated Bromley: I thought it was small and narrow-minded"' (Siouxsie Sioux, cited in Savage 1991: 146; 183). Or Jon Savage, commenting on Siouxsie and the Banshees' 'Suburban Relapse':

'I was minding my own business when my string snapped . . .' ('Suburban Relapse') their most fully realised mix. Very English: paraquat parties behind the privet hedges, the pebble-dash prisons that keep the occupants *in* just as much as they keep the outside world out. English emotional and physical isolation turning ever inwards into psychosis, unnameable perversions in deep closets.

(1991: 485).

It is difficult not to hear a note of panic in this by now familiar vision of the suburban asylum. As itself a form of cultural critique, a certain 'punk' – which includes the punk historians of its cultural history – reinflects as malicious banality the famously residential stability or, more strongly, inertia, which makes a certain version of the suburb identifiable, typifiable, somehow – wearily – known.[1] The insistence that there is something rotten in the state of suburbia remains central to the reception in the 1980s and 1990s of whatever it is/was that is/was punk culture in the 1970s – and the lure of punk in recent youth and pop culture immediately exposes the mythic and fictional elements of any attempt to document the history of such a moment.[2] At the same time, to understand punk as an attempt to expose the madness and perversity of the suburbs is to highlight punk's encounter with suburban boredom. One very convincing – or at least seductive – way of telling the history of punk is to put the punk ideologues (usually, Malcolm McLaren, Jamie Reid, Vivienne Westwood, John Lydon) into a more or less self-conscious dialogue with a situationist sloganeering against boredom as a means of cultural domination: 'Boredom is always counterrevolutionary.' According to Greil Marcus, for example, Malcolm McLaren turns that situationist declaration into a question: 'What are the politics of boredom?' (Marcus 1989: 49). To which we can add: Where are the politics of boredom? Where does punk locate boredom?

Quite simply, quite often, in the suburbs. Running through Savage's *England's Dreaming* is the figure of the punk as a refugee from boredom: from Burnt Oak,

from Bromley, from Croydon, as well as from the notably less demarcated category of 'the estates'. But, for Savage at least, the boredom of the suburbs remains ambivalent, at once fatal and strangely enlivening. His sleeve notes for *The Sound of the Suburbs* make a statement about the always contested origins and development of punk: 'Punk presented itself as the ultimate Sound of the City [this is the title of a second punk compilation released in 1992], but it picked up its first fans in the suburbs' (Savage 1991a).[3] Canvey Island, Woking, Harrow, Ealing, Bromley: here, outside London but not that far, punk was generated and sustained by the emptiness, the blankness, of the suburbs: 'Space is all important to the suburbs, that interwar ideal of the country in the city. There's nothing to do there, nothing to grab hold of except fantasies of self-recreation. Think of the suburbs as a blank state' (ibid.). Such an investment in the monotony of the suburbs as a resource for dreaming, for a fantasmatic reprocessing of what Savage calls the 'information overload' of the city, presents suburbia as something like an anarchic dreamscape, as a site of resistance in its very conformity: Savage finds a reason to be different in a place where, again quite simply, there is nothing else to do. To dream the suburbs is to distort, to defamiliarize and to make strange what has become too ruthlessly familiar – so that punk becomes a way of staving off the intolerable ordinariness which is the constant threat carried through the 'noise' of living in the suburbs: 'The sound of the suburbs / Driving me mad' (The Members). Whether on the streets, through the public visibility of punk self-fashioning – the dog collars, chains and rubber T-shirts invested as an antidote to the sadomasochistic unconscious of Bromley – or in the bedroom, breaching the boundaries of the 'pebble-dash prison' by listening to a different 'sound of the suburbs' – 'Johnny's upstairs in his bedroom / Sitting in the dark / Annoying his neighbours with his Punk Rock electric guitar' – the work of punk dreaming is to construct an adequate defence against an ill-defined, but passionately felt, threat of going mad.

However familiar the discontents of suburbia, there seems to be no obvious precedent for this gesture of cultural retrieval of the banality of the London suburbs in either the pre- and interwar suburban ideal of the 'best of both worlds' of country and city for the middle classes or the postwar version of the 'worst of all possible worlds' of the reluctant suburbs: the overspill estates for the urban working classes (Silverstone 1994: 59; Cohen 1980: 82). In this sense, punk belongs to, cannot be thought outside of, the confines of the suburbs at the same time as it undertakes to destroy them from within. In this sense again, what both *England's Dreaming* and *The Sound of the Suburbs* suggest is that the genealogy of punk as a cultural phenomenon is closely bound up with the postwar development

of the suburbs as a state of mind as much as a built environment. To put this another way: a punk culture which locates itself as 'suburban', as the 'sound of the suburbs', can be put into dialogue with a cultural studies which takes as its object a shift in the geographical and psychical space of the suburbs: a punk iconography of suburbia finds itself closely bound up with what has been described as the transgenerational crisis of suburbanization.

Look once more at the images used to market *The Sound of the Suburbs*. On one reading, this musicological imaging of the suburbs contains a condensed visual history of the destruction and transformation of the cityscape since 1945: the urbanism of the tower blocks collides with both the suburban affluence of the country-in-the-city and the drab rows upon rows of the housing estate. Punk, it seems, can emerge from any and all of these conditions – and is thus carefully coded as both a middle- and a working-class cultural phenomenon. It may be that as a youth culture, trading on generational rather than – or as much as – class conflict, punk manages to articulate both sites of the suburban. Certainly, there are times when punk has invoked a 'working-classness and "common sense"' (Savage 1991: 397) which recalls nothing so much as the discursive investments in working-class lifestyle so prominent from the 1950s through the 1960s and early 1970s, a lifestyle associated, predictably enough, with the inarticulate but gritty social realism which is apparently inseparable from the representation of working-class 'life'. But, the class fantasies circulating through punk culture and politics aside, there is a difference showing through these images, a difference between, for example, living under the surveillance encoded in that aerial shot of privately owned residences in the avenues and suffering the brutal tedium of the municipal estates. That class difference is, however, almost immediately erased by the banality supposed to subsume both categories of the suburban in Savage's decisive reinflection of the suburb as the prestigious site both of and for oppositional critique.

The history of that division, or collision, within the suburbs has been told and retold through the different sociological, literary and cinematic accounts of postwar English culture. Such accounts can be used to examine both the class difference which starts to show up through these images, which announce, albeit retrospectively, the new sounds of a suburban punk culture, and, tentatively, one possible transgenerational dynamic supporting a punk recasting of the suburbs. Take the following lines from 'The Children', the final story included in Nell Dunn's *Up the Junction*, first published as a collection of short stories in 1963 and made into a teleplay by Ken Loach in 1966:

Over the mud and rubble, they go to where the crane smashes down the slum clearance houses. . . . Through the white-tiled alley with its millions of messages scrawled in pencil and lipstick – RUSSIA IS BEST – to where the new flats tower above them and onto the playground.

(Dunn 1966: 121)

As Adrian Henri suggests in his Introduction to the recent Virago reprint of *Up the Junction*, what Dunn's naturalistic attention to Battersea as locale records here is the transformation of the cityscape of South London, 'a particular moment in English social history: the destruction of large areas of inner-city housing, and with it a whole way of life' (Henri 1988: xi). Similarly, the following few lines from 'The Deserted House' document a sad and familiar story of sexual pursuit and the failures of London transport in the suburbs: '"I go up there Monday nights for a giggle – Continental dancing – but you offer to take a bird home and most of them live right out in the suburbs, so you find yourself walkin' home twenty miles if you haven't got a bike"' (Dunn 1966: 34).

On the one hand, the 'love affair between the classes'[4] for which Dunn's fiction is most famous suggests that the girl who lures the youth twenty miles away from home may belong to 'a better class of people', to a class for whom, as Peter Willmott and Michael Young observe in *Family and Class in a London Suburb*, published in 1960, the 'move outwards is also a move upwards' (Willmott and Young 1960: 3). In this case, the girl in the suburbs would be, like Dunn's upper-class narrator, the type of 'decent girl' consistently addressed as an object of desire by the young working-class men of *Up the Junction*: '"You must think I'm slow. I don't know what to say to a decent girl. If you was an old slag, I'd just say, 'Come 'ere . . .'"'; '"You smell as if you never sweated in your life . . . I don't want a girl who's bin through all what I've bin through"' (Dunn 1966: 13–14; 35–6). On the other hand, the long walk back to Battersea can be read as just one of the effects of the demolition of the slums and the extensive relocation of their inhabitants on the purpose-built municipal housing estates outside of the city. The 'birds' in the suburbs, then, belong not to the 'better class of people' but to the families who have moved, or have been moved, from inner London to the outskirts of the city, and beyond. Thus Dunn's allusion may not so much confirm an inter-class love-affair as reference the intra-class upheaval described by Phil Cohen, a split, between those who stay or are left behind and those who move out. At least one of the effects of that class disturbance is then registered in Dunn's passing reference to the girls who, stuck twenty miles outside of London, make the motorbike such an essential object of consumption for the young working-class men who continue to meet them in the dance-halls of London's West End.

At the same time, the indecision sustained by Dunn's narrative when the class identity of the suburbs is in question depends on the postwar shift in the notion of the suburb itself, on a difference within the outside of the city. A key text through which to examine that difference is Michael Young and Peter Willmott's now classic *Family and Kinship in East London*, first published in 1957 (and one of the sources for Cohen's analysis of subcultural forms). 'The middle classes', the authors conclude, 'led the exodus into the inner suburbs; the working classes of London and other large cities followed by jumping over the earlier settlers into the outer ring of the municipal estates' (Young and Willmott 1986: xxv). In a new Introduction to their book in 1986, Young and Willmott set out the double aim of postwar housing policy in London: 'to improve conditions in the older districts and to halt the unplanned spread of suburbs into the countryside' (1986: xvi). Inside London, the London County Council and, in Young and Willmott's example, the Metropolitan Borough of Bethnal Green replaced the abolished slums with blocks of flats; outside London, the LCC had developed a number of large housing estates (including Debden and Buckhurst Hill). Apart from those rehoused because their homes were due for demolition, families who considered themselves to be in housing need could register with either or both authorities 'but they stood a better chance with the LCC – as long as they agreed to move to an estate outside London' – a 'better chance' which obviously prompts a question about the compulsive element of the choice to leave the slums for better housing elsewhere (1986: xvii).

The movement out from London, then, suspends the concept of the suburb somewhere between the privileged inner circle of an outer London and what, taking our key from the rhetoric of the exodus, could be described as the exile of the municipal estates. Both can fall within the category of the suburban: Young and Willmott refer to the fictitiously named 'Greenleigh' where so many of their Bethnal Green respondents are rehoused as a 'suburban housing project' (1986: xiv). Equally, both carve out a set of distinctions not only between the middle and the working classes, not only between an inner London working class and the working-class inhabitants of the outer London new towns and estates but also between the promised land of the 'interwar ideal of the country in the city' (Savage 1991a) and the postwar territorial compromise necessitated by the resistance put up by those already dwelling in the promised land to any invasion of their ideal by the human overspill from the city slums. Note the language of war here. Far from evoking Dunn's love-affair between the classes, Willmott and Young's study of *Family and Class in a London Suburb* maps out the suburb as a site of class conflict; more specifically, their record of local responses to the influx of

the former East Enders into Woodford (the suburb of the book's title) suggests that the history of the differences within the suburb is the history of a virulent fantasy of persecution:

'This place was like fairyland when we first came. It was so beautiful before they brought in the people from the slums.'

'It's bringing the Central line out here that's made all the difference. You get a different class of person here from what you used to get before the war.'

'It's not like Cromer Gardens used to be with all these East Enders in the road. The noise and the ice-cream papers and the wireless on all day.'

(Willmott and Young 1960: 8; 119; 121)[5]

And no doubt the noise of those motorbikes in the middle of the night. Taking advantage of London transport this time, the 'scum of the earth' (1960: 4) have got on the tube and come 'out here', bringing their noise, their litter, their chaos, with them – a chaos, an ugliness, which has no place in 'fairyland'. This is not to overstate the class repulsion which is so very much in evidence through *Family and Class in a London Suburb* and has at least something to do with a sense of the middle-class suburban ideal as a fragile one, constantly vulnerable to the debasement carried by those who, in their class difference, breach its boundaries and drive out its old residents – those privileged figures in the suburban landscape of private ownership of one's dwelling: '"On both sides they're recent, and on both sides from the East End. That's what has really made us decide to retire to Worthing. You can't talk to those people, we just don't speak the same language"' (1960: 121).

By contrast, implicitly refuting the voices from Woodford which tell us that the East Enders have destroyed the suburbs, Cohen's influential account of the postwar crisis in working-class community suggests, as we've seen, that the lure of the suburbs has been instrumental in undermining working-class collectivity. In other words, if there is violence here it is suffered at least as much by the aspiring or displaced East Enders as it is by the anxious residents of suburbia. In *Family and Kinship in East London* that violence is further clarified by Young and Willmott's analysis of the way in which the historically new development of the working-class suburban housing estate in the late 1940s and 1950s effected an essential change in the structure and function of what is presented as the prototype of the working-class communal tie: the working-class family. 'We were least prepared for what we found in the borough [Bethnal Green],' they note in their

original Introduction to *Family and Kinship in East London*: 'We were surprised to discover that the wider family, far from having disappeared, was still very much alive in the middle of London' (Young and Willmott 1986: xxv; xxvi). Their research into the kinship network integral to the wider social structure of Bethnal Green suggested that extended families (with extensive 'neighbourly' networks between them) had lived, often for some generations, within a very small area, sometimes no more than a few streets, of the borough. The ambiguously coerced move away from Bethnal Green, then, was in no sense simply a geographical relocation. The lifestyle generated through a set of kin, work and friendship relations developed within densely populated and ruthlessly familiar boundaries was irreplaceable and irretrievable elsewhere.

It was a lifestyle that, in the different literary, cinematic and sociological investments in working-class 'community' of the 1950s and 1960s, could be invoked against, variously, the intrusions of a compensatory and anomic mass media, the privatized individualism of a paradoxically conformist middle class and, most relevant here, the disfiguring effects of the housing policies implemented in London and other major cities after 1945.[6] That is, just as the supposed authenticity – even the glamour – of working-class collectivity could come as a surprising and unexpected source of value, of resistance and identification, it was in the process of being transfigured by the disturbance analysed by Young and Willmott as early as the 1950s (and documented, albeit incidentally, by Nell Dunn in 1963). In particular, Young and Willmott pay a nuanced attention to what their respondents had to say about the experience of moving out of Bethnal Green without necessarily moving up. In Greenleigh, the authors suggest, the 'busy sociable life' of Bethnal Green 'is now a memory' (1986: 132); Greenleigh 'was built in the late 1940s on ground that had been open fields before. The nearest substantial settlement, a few miles away at Barnhurst, is the antithesis of East London, an outer suburb of privately-owned houses' (1986: 151). And, of course: 'The distance between the estate and its neighbour is magnified by the resentment, real and imagined, of the old residents of Barnhurst at the intrusion of rough East Enders into the rides of Essex' (1986: 151). In 1957, Young and Willmott say nothing more about the responses of the residents of Barnhurst but turn instead to the 'kind of thoughts harboured by the ex-Bethnal Greeners' about the inhabitants of the middle-class suburb: '"People at Barnhurst look down on us. They treat us like dirt. They're a different class of people. They've got money"'; '"It's not so easy for the girls to get boys down here. If people from the estate go to the dance hall at Barnhurst they all look down on them. There's a lot of class distinction down here"' (1986: 151).

Again, the (gendered) limits of the love-affair between the classes send the young, single women on the Greenleigh estate back to the London dance-halls. Thus the journey from Bethnal Green to Greenleigh is presented as a move from a profoundly familial and recognizable urban space to the 'emptiness' of a suburban estate unmarked by memory, thoroughly strange and estranging. For reasons which never become entirely clear through this analysis — and above and beyond the more than predictable class tension — there is a crisis of friendship on the estate, a withdrawal within four walls which characterizes the way of living in Greenleigh and suggests nothing so much as a form of intra-class repulsion mirroring the sense of persecution across the classes. 'Usually the troubles are shadowy affairs which have happened to people other than oneself', the authors note and, as they continue in a footnote, this is a loneliness and hostile retreat which has been noticed elsewhere in other estates (1986: 148–9):

Mrs Harper knew no one when she arrived at Greenleigh and her efforts to make friends have not been very successful: 'I tried getting friendly with the woman next door but one,' she explained, 'but it didn't work.'

Mr Young told his wife – 'When I walk into these four walls, I always tell her, "Don't make too many friends. They turn out to be enemies."'

[O]ne experience had turned Mr Yule into a recluse. 'We don't mix very well in this part of the estate. . . . I had £20 pinched from my wallet. Now we don't want to know anyone – we keep ourselves to ourselves.'

'We're friendly,' says Mr Wild in the usual style, 'but we don't get too involved, because we've found that causes gossip and trouble. . . . Now we keep ourselves to ourselves.'

Mr Stirling summed it up by remarking – 'I don't mind saying hello to any of them or passing the time of day with them, but if they don't want to have anything to do with me, I don't want to have anything to do with them. I'm not bothered about them. I'm only interested in my own little family. My wife and my two children – they're the people I care about. My life down here is my home.'

(1986: 132; 148; 149)

And so it goes on. On the one hand, it is as if the bewilderment at the difference between the 'busy sociable life' of Bethnal Green and living out at Greenleigh has generated a desire to talk, to complain, to put a certain misery on the record collected by these investigators into working-class community. And the speech produced by that anxious desire appears to have been experienced by Young and Willmott as a binding demand to reproduce what has been said to them. Introducing the anecdotes of life on the estate in 'Keeping themselves to themselves', the authors acknowledge the perhaps surprising willingness of the ex-Bethnal-Greeners to speak to them: 'Our informants were so eager to talk

about their neighbours and generally about their attitude to other residents on the estate, that we feel bound to report them' (1986: 147). 'We feel bound to report them': the responsibility for one of the most painful chapters of *Family and Kinship in East London* appears to lie with the privileged objects of a book which, of course, turns the bewildered unhappiness of those living on the Greenleigh estate into 'sociology'; *Family and Kinship in East London* transfers, passes on, what has now become an apocryphal narrative of the loneliness and desolation of the suburban estate, citing the Greenleigh respondents as the authenticating source of what remains one of our most powerful narratives of working-class suburban living.

On the other hand, we can hear another note of panic in the insistent representation of the others on the estate as hostile *first*, as the cause of the hostility that Young and Willmott's respondents then demonstrate all too clearly through their own accounts of a way of speaking to one another which maintains friendliness without making friends; a friendliness, defined in terms of the avoidance of enmity, which cannot tolerate knowledge: '"You stop friends if you don't get to know them too well"' (1986: 148). Again, it is as if the constant repetition of these phrases is there to ward off a world become suddenly and unbearably opaque, to stereotype and so to contain what should be familiar but isn't: '"They all come from the East End but they all seem to change when they come down here"' (1986: 147). Such disorientation, such defamiliarization, recalls Savage's investment in the suburb as a dreamscape but then casts dreamscape as nightmare: 'It's like a strange land in your own country' (1986: 154).[7] These statements also recall one of the most prevalent metaphors through which we currently explore what Anthony Vidler describes as the 'fundamentally unlivable' modern urban condition: the Freudian uncanny, 'the fundamental propensity of the familiar to turn on its owners, suddenly to become defamiliarised, derealised, as if in a dream' (Vidler 1992: x; 7). At issue on the working-class suburban estate, however, is the disruption of an expectation of familiarity which, precisely, belonged to the urban slums – at least as they are now remembered on the estate.

That disruption plays its part in the shift from what Young and Willmott describe as a 'people-centred to a house-centred existence', to a co-existence 'infused with . . . bitterness' amidst other Londoners all the more strange in their similarity (Young and Willmott 1986: 154). The implicit point of comparison is always the 'friendliness' of Bethnal Green. The familial reclusiveness, the more or less violent refusal to recognize anyone outside of the four walls of the home – '"I'm not bothered about them"' – comes, at least in part, in response to the loss of the wider kinship network in Bethnal Green through which the urban space

was used and recognized. Against that loss and the uncanny world of the estate, the bonds within the nuclear family are drawn tighter. The immediate family – husband, wife, children – is cast as an asylum, as a source of compensation for and protection against the outside world: '"I'm only interested in my own little family. My wife and my two children – they're the people I care about"' (1986: 149). Living in Greenleigh itself is sometimes presented as a sacrifice performed in the name of that familial ideal; bigger houses, indoor bathrooms, hot running water and large gardens to say nothing of the 'fine schools' the children can now attend: '"You've got to put up with things if you want a place for your children. Your children come first, I say"' (1986: 146; 121). Further, a sense that the move away from Bethnal Green has reinflected the familial tie in a way that might be described as autistic – a withdrawal back into the protective shell of the nuclear family, a refusal to engage with the world outside 'these four walls'[8] – is reinforced by the description of the way in which these families make use of the new mass cultural phenomenon of television. There were, according to the GPO statistics cited by Young and Willmott, almost twice as many television sets per hundred households on the Greenleigh estate as in Bethnal Green: 'In Bethnal Green there is one pub for every 400 people, and one shop for every 44 (or one for every 14 households). At Greenleigh there is one pub for 5,000 people, and one shop for 300' (1986: 142). On the estate, instead of an extensive network of family and neighbourhood acquaintances, there is, according to one ex-Bethnal-Greener, the '"television most nights and the garden in the summer"' (1986: 132), a comment which links the popularity, or necessity, of television decisively to the wider demographic shift. As Young and Willmott put it:

Instead of going out to the cinema or the pub, the family sits night by night around the magic screen in its place of honour in the parlour. In one household the parents and five children of all ages were paraded around it in a half circle at 9 p.m. when one of us called; the two-month-old baby was stationed in its pram in front of the set. The scene had the air of a strange ritual.

(1986: 143)

Thus a difference in the mode of consumption of television measures the distance from the slums to the housing estate. The father of this family insisted on the pivotal role of the television in forging familial cohesion: '"The tellie keeps the family together. None of us ever have to go out now"' (1986: 143). Or, in the words of another respondent: ' "[T]he tellie is a bit of a friend down here" ' (1986: 149). A member of the family, a friend: what Young and Willmott associate so seductively at this point is the absence of family, friends and 'community' and the overwhelming presence of that so-called death threat to the

collective: television. But if television is a threat to the collective on the estate it is because it supplies whatever it is that is felt to have gone missing in the present of Greenleigh but is still remembered from the recent past of Bethnal Green. It's not even clear from these statements if it matters what the family is watching. What matters is the television as a focal point for a shared looking which somehow binds the mutilated family back together again. Like a prosthesis, the television allows the displaced family to function in the absence of the matrix which had, until recently, governed it, compensating for the loss of family and friends by becoming nothing less than a member of the suburban kinship network.[9]

Is this the logic – one possible logic – through which the dysfunction of the family becomes so intimately associated with a generation (if not by now two generations) made derelict by a televisual compensation for the loneliness of the suburban estates? One of the most compelling questions raised by *Family and Kinship in East London* is what happens when the children of these estates grow up? – compelling especially if we read across from Young and Willmott's insistence, in 1986, that the 'collective madness' of postwar housing policy created the conditions for the 'anomie and violence' of Britain in the 1980s (1986: xx–xxi) to Cohen's allusion to the fantasmatic expression and resolution of parental misery in the formation of subcultures. That anomie and its violence is thus brought into contact, for example, with the unforgettable image of the children 'paraded' around the television screen, caught up in a ritual of familial reparation in which, as the cause of parental sacrifice, of their unhappy move from Bethnal Green to the suburbs, they may have such a crucial part to play. In this context, too, it is difficult to forget Jacques Lacan's characteristically miserable warning against the aggression latent to any such apparently self-sacrificial altruism, the demand internal to the reminder that 'I am doing this for you' – and, concomitantly, the aggression which is provoked in all but the most saintly of beneficiaries.[10]

It is worth pointing out here that, in his research into youth subcultures, Dick Hebdige argues that punk, in fact, shows up the limitations of Cohen's psychopolitics which, in its concern to underline the importance of class, tends to overstate the links between postwar youth and adult working-class culture:

We should be hard pressed to find in the punk subculture, for instance, any symbolic attempts to 'retrieve some of the socially cohesive elements destroyed in the parent culture' . . . [T]he punks seemed to be parodying the alienation and emptiness which have caused sociologists so much concern . . . celebrating in mock-heroic terms the death of the community and the collapse of traditional forms of meaning.

(Hebdige 1979: 78–9)

Hebdige's unease may be derived from the residual functionalism in Cohen's appropriation of the psychoanalytic concept of the symptom (an appropriation which derives, I think, from an Althusserian reading of Lacan, or a culturalization of Lacan's concept of the imaginary): why assume, after all, that the symptom 'works'? Contrasting the skinheads' 'fetishization' of their class position with punk 'dislocation' from its parent cultures, for example, Hebdige is able to position punk 'on the outside: beyond the comprehension of the average (wo)man in the street', the evocation of working-classness in punk culture itself being understood as a form of symbolic disfigurement of the 'exact origins of individual punks' (1979: 120–1). In other words, punk steps up the aggression, it inflates, rather than attempts to repair, the collapse of the culture against which it protests. But what if such a dislocation, such a confusion of origins, was precisely the overwhelming experience of the parent culture? What if punk 'style' is there both to aggravate and to acknowledge – Hebdige's parody? – the dilemmas of a parent culture which itself took refuge in isolationism and aggression, turning the family into the site of both suburban sacrifice and solace? How might we start to speculate about the relationship between the prototypical forms and occasions of punk rhetoric and the narratives of disaffection which have helped to structure sociological knowledge of life on the working-class suburban estates – the estates invoked by the *Sound of the Suburbs* as one of the sites of and for punk intervention. Could we understand the relation to the world embedded in the 'fuck you, who cares?' of the punk refugee as, at least sometimes, an inflation of the violent uninterest manifest in the stereotypical phrases that may have governed the lives of his or her newly suburbanized parents on the estates in the 1950s: 'I'm not bothered about them'? What would it mean to think of the cultural purchase of punk's onslaught on familial convention in terms of an enforced enclosure within the nuclear family and the loss of an extended family network? And who, after all, are the neighbours being annoyed by the sound of Johnny's/The Members' 'Punk Rock electric guitar'? The 'residents' of Woodford or the ex-Londoners who might have been on the estate now (1979) for over twenty years? Or both?

The noise of that punk guitar and the insolence of punk lyrics are, I want to suggest, implicated in the differences within the suburbs that I have tried to trace through this chapter – whatever the banality that, no doubt, characterizes both forms of suburban living. Certainly what Young and Willmott are sketching through *Family and Kinship in East London* is *one* way of telling the difference between the two images of suburbia with which we started: the 'drab no man's land' that, as P. D. James puts it, is 'part of everyone's mental topography' has to be located in relation not only to the suburban idyll but also to the devastated

inner-city scape against which one parental culture, at least, measures the extent of its loss. In other words, in so far as we understand the cultural genealogy of punk as also a genealogy of what has happened in the suburbs, we can start to trace the transgenerational dynamics of punk culture. This is, finally, to tell the story of suburbia as a family romance – a romance which promises to reintroduce into our histories of popular culture the class dimension of the 'blankness' and the 'madness' embedded in a punk iconography of the suburbs.

ACKNOWLEDGEMENTS

My first thanks to John Shire for his sometimes belligerent, and always properly biased, knowledge of punk as well as his comments on this paper. Thanks also to Cyril Simsa (for discussions as well as archival tendencies) and to D. S. Marriott and Christine Blake for their reading and commentary. The artwork and sleevenotes to *The Sound of the Suburbs* are reproduced by courtesy of Sony Music Entertainment (UK) Limited.

NOTES

1 There is an intriguing coincidence between a punk representation of the suburbs and a critique of the latent violence of suburbia which runs through postwar women's writing. Marilyn French's exposé of the sexual and social viciousness of the American suburb in *The Women's Room* (1978) is only the most obvious example and the book could be read as a literary version of Betty Friedan's *The Feminine Mystique* (1964) which first locates 'the problem that has no name' in 'a suburban development fifteen miles from New York' (Friedan 1964: 15. See Rachel Bowlby's fascinating discussion of Friedan in Bowlby 1992.). Doris Lessing's 'To Room Nineteen' (1951) also anticipates the 'problem with no name' in a story about a woman whose room of her own at the top of a large and comfortable house in Richmond is not enough to prevent her from succumbing to the indefinable sense that there is something wrong in this most opulent version of the suburban lifestyle (Lessing 1951: 306). And, finally, a search through what literature there is on the history of punk turned up Greil Marcus's remarkable 'Johnny Rotten and Margaret Drabble', first published in *Rolling Stone* in 1977. Whatever the differences between the twenty-one-year-old member of the Sex Pistols and the middle-aged celebrated novelist, he insists, 'both are scared, and both are responding to an overwhelming sense that their culture – political, economic, and aesthetic – has collapsed around them' (Marcus 1993: 18).

2 It could be said that the 'story of punk' has been the story of the struggle to tell the story of punk; that is, what punk exposed was that there was no place outside of such a fictioning or fashioning of punk. See Savage (1991), Temple (1979), Hebdige (1979).

3 The obsessive debates about the origin and death of punk seem to be an essential aspect of its narrativizing. During the course of writing this paper, a correspondence in *The Guardian* returned to the interminable question of the role played by the New York Dolls (etc.) in the development of punk. The debate seems to have been regenerated by the screening of Savage's production for the Arena programme on BBC2,

Punk and the Pistols shown on 20 August 1995. The question of whether punk is dead or not may well have been there at its inception. Just one example: 'Things Your Mother Never Told You' (interview by 'Hutch' with Electric Chairs) appeared in *Allied Propaganda*, issue 2, July/August 1979: 'J. J. continues: "We want to find new alternatives because it's 1979, we're related to the punk movement but thats [*sic*] dying now and we want to move on." That sort of statement invariably leads to long boring arguments about the meaning of "Punk" and its relevence today etc. . . . enough said?'

4 One contemporary reviewer for the *New Statesman*, which had previously published a number of her short stories, defended Dunn against the charge that she was slumming it through her fiction: 'She has been reworking a national literary tradition, the love-affair between the classes' (*New Statesman*, 22 November 1963). Compare this literary love-affair with the following 'lonely heart' advertisement, taken from the *Bristol Evening Post* and featured in the 'This England' section of *New Statesman* in April 1963: 'Attractive widow, 45–50 desires gentleman's companionship, agricultural interests; working class need not apply.'

5 The representation of class prejudice in a fictional New Town in Christopher Fowler's recent *Psychoville* (1995), described by its publishers as a 'suburban nightmare', is enough to give the lie to any sense that the attitudes voiced by the residents of Woodford are now merely of historical interest.

6 In *Working Class Community*, Brian Jackson summarized his sociological project as follows: 'I shall be asking a series of familiar questions. Questions about the clash between established working-class values and established middle-class values; about those older working-class values and their encounter with the mass media; and most of all, whether the new world of relative affluence inevitably means the total end of the old styles of living' (Jackson 1968: 3). Margaret Drabble's recent assessment of Dunn's fiction as a discovery of, and identification with, the 'lives of working-class women' so different from her own – 'Battersea was different. It offered friendship, community, passion, warmth, instead of respectability and reserve' (Drabble 1988: ix–xi) – effectively asks us to read both *Up the Junction* and Dunn's later novel, *Poor Cow* (1967), as literary versions of the postwar sociological research which provided the crucial framework for the development of the research into 'culture' and social change associated with the development of Cultural Studies over the last two or three decades. In this sense, and, again, very schematically, what Dunn is said to have found in Battersea seems also to have been discovered in Bethnal Green (by Michael Young and Peter Willmott) or Huddersfield (by Brian Jackson), or, more recently, in northern England (Richard Hoggart).

7 This rhetoric is also remarkably close to that which has dominated what Young and Willmott describe as the 'rank prejudice against newcomers' over the last two or three decades of more or less violent racial harassment and discrimination against the Bangladeshi families who, since the 1950s, have moved into the East End (Young and Willmott 1986: xiii). Is that racial violence itself – so often linked to the issue of housing by local politicians as well as the inhabitants of the East End – bound up with the dislocation described by Young and Willmott?

8 This tentative insight depends on Frances Tustin's work on autism. 'The over-use of autistic objects', she suggests briefly – tantalizingly – 'brings tragedy to the societies in which we live' and the 'outstanding characteristic of autistic objects is that they are not used in terms of the function for which they were intended' (Tustin 1992: 120; 112). Tustin is clear that autism is a very contemporary problem – certainly not confined to those recognized as 'suffering' from one of the autistic syndromes – but she does not expand on these points.

9 Cf. Gunter and Svennevig: 'Television today is an integral part of the family household – almost another member of the family' (cited in Silverstone 1994: 32). Young and Willmott's account of the use of television in Greenleigh supports one of the key arguments of Silverstone's *Television and Everyday Life*: that television is essentially a suburban cultural form.

10 See 'Aggressivity in Psychoanalysis': 'Only saints are sufficiently detached from the deepest of the common passions to avoid the aggressive reactions to charity. . . . In any case, such reactions should hardly surprise us analysts; after all, do we not point out the aggressive motives that lie hidden in all so-called philanthropic activity' (Lacan 1977: 13).

REFERENCES

Bowlby, R. (1992) *Still Crazy After All these Years*, London: Routledge.

Cohen, P. (1980) 'Subcultural Conflict and Working-class Community', in Stuart Hall, Dorothy Hobson, Andrew Lane and Paul Willis (eds) *Culture, Media, Language*, London: Unwin Hyman.

Drabble, M. (1988) Introduction to N. Dunn (1967; reprinted 1988) *Poor Cow*, London: Virago Press.

Dunn, N. (1966) *Up the Junction*, London: Pan Books.

French, M. (1978) *The Women's Room*, London: André Deutsch.

Friedan, B. (1964) *The Feminine Mystique*, New York: Dell Publishing Co.

Hebdige, D. (1979) *Subculture: The Meaning of Style*, London: Methuen & Co.

Henri, A. (1988) Introduction to Dunn's *Up the Junction*, London: Virago.

Jackson, B. (1968) *Working Class Community: Some General Notions Raised by a Series of Studies in Northern England*, Harmondsworth: Penguin.

Lacan, J. (1977) *Ecrits: A Selection*, trans. A. Sheridan, London: Tavistock.

Lessing, D. (1951; reprinted 1978) *To Room Nineteen: Collected Stories*, volume I, London: Jonathan Cape.

Marcus, G. (1989) *Lipstick Traces*, London: Secker & Warburg.

Marcus, G. (1993) *In the Fascist Bathroom*, New York: Doubleday.

Savage, J. (1991) *England's Dreaming*, London: Faber & Faber.

Savage, J. (1991a) Sleevenotes to *The Sound of the Suburbs* (see discography).

Silverstone, R. (1994) *Television and Everyday Life*, London and New York: Routledge.

Temple, J. (1979) *The Great Rock 'n' Roll Swindle*, UK. Available on Virgin VIRV001A.

Tustin, F. (1992) *Autistic States in Children*, London: Routledge.

Vidler, A. (1992) *The Architectural Uncanny*, Cambridge, MA: Massachusetts Institute of Technology.

Willmott, P. and M. Young (1960) *Family and Class in a London Suburb*, London: Routledge & Kegan Paul.

Young, M. and P. Willmott (1986) *Family and Kinship in East London*, Harmondsworth: Penguin.

DISCOGRAPHY

The Sound of the Suburbs (MOODCD18), Sony Music (UK) Ltd.

POSTSCRIPT

Bombs away in front-line suburbia

Homi Bhabha

When we first moved to Hyde Park in Chicago the streets were plastered with posters that screamed out at you: 'Bomb the Suburbs.' The graffiti-style lettering of this call to arms made me think it was publicity for a new rock or rap group, definitely something in the music business.

Leah, my seven-year-old, took a more apocalyptic view: she was quietly convinced that there was a war raging on the outskirts of the city and whenever the suburbs were mentioned she looked up wanly to ask what things were like on the battlefront, was the bombing really bad?

Some time later I discovered that 'Bomb the Suburbs' was in fact the title of a rambling manifesto, written by the son of a philosophy professor at the University of Chicago. The author, William 'Upski' Wimsatt, had identified himself with the counter-culture of the 'Black' southside of the city: rap music, hip-hop, and above all, the convoluted calligraphic art of graffiti that emblazon subway stations and freight trains, sending coded messages to other underground artists down the line.

Something of a streetwise philosopher himself, Upski has declared total war on the suburbs which he describes as 'an unfortunate geographical location, [an] unfortunate state of mind. It's the American state of mind, founded on fear, conformity, shallowness of morals, and dullness of character.'

Without quite knowing it, my daughter Leah was right. There is a culture war going on that seeks to 'suburbanize' the soul of America. Its agenda is traditional and conservative; its buzz words are predictable – 'family values', 'opportunity society', 'individual responsibility', 'free-market', 'the work ethic'. But the crusading spirit of the campaign is most powerfully conveyed through its negative

rhetoric: anti-social-welfare, anti-intellectuals, anti-universities, anti-public-funding for the arts and humanities, anti-minorities. Upping the anti, as the phrase has it, in this heated national debate is Newt Gingrich, the Leader of the House, who succinctly defines his role in what he describes as 'this genuine revolution': 'I am a cultural not a political figure. I don't care about the politics. I try to change the culture.'

Gingrich tries to change the culture by playing with the future – the press frequently refers to him as a 'futurist' politician. For instance, his belief in the economics of space travel once led him to suggest that the building of a lunar colony, complete with Hilton and Marriott hotels, would make possible $15,000 honeymoons on the moon using third-generation space-shuttles. More recently Gingrich hinted at tax-breaks that would allow the poor to buy lap-top computers and speculated on a $500 bonus for children with precocious reading skills. Even for someone named after an amphibian, Newt seems remarkably wet behind the ears.

Those of us who have experienced the Granny of Grantham's snatch at the soul of Britain in the 1980s know only too well the problem with politicians who have a blind faith in their own visions. The public spectacle of heroic struggle for a nation's spirit – with lofty rhetorical appeals to Tradition and Civilization – is often no more than a party political ploy aimed at ascendancy in moments of social crisis.

In the Age of Newt, the New Right campaign 'to renew American civilization' is more like a return to the state of nature, where, in the words of his own majority whip, 'Newt's as big a barracuda as they come.'

What's all this fearsome animal imagery, this jungle fever, got to do with the much publicized Republican 'contract with America'? This is where our Hyde Park hip-hop graffiti sage Upski has a point: the conservative suburban attitude is founded on the fear of difference; and a narrow-minded appeal to cultural homogeneity. It is a kind of national paranoia that draws the boundary between what is acceptable and unacceptable ever more tightly around the norm of the 'known' – for which the Chicago suburbs provide an appropriate metaphor.

The homes may vary from the gorgeous seafront mansions of Evanston to the more modest bungalows of Beverly; from the exotic boutique malls of Glencoe to the 'brand name' plazas of Skokie. But each suburb is carefully banded by class, race and ethnic community. The irony lies in the fact that the current conservative revival is increasingly founded on one of the oldest conformist arguments in the annals of America's cultural history – the link between Puritanism and philistinism: the association of Anti-American guilt and punishment with anything

that smacks of sex, pleasure, desire, experimentation or creativity – whether in art, or in life.

To grasp this suburban culture of paranoia we have to move from the newfangled Newts – cloning at an alarming rate – to the more traditional bloodhounds of the conservative establishment, such as the baleful presidential hopeful Bob Dole who is obsessed with 'family values'. What are family values? If they represent a concern with fidelity within marriage, as ex-Vice-President Dan Quayle's wife Marilyn once glossed the term, then family values are doing quite well.

According to the latest 1994 nationwide sex survey conducted by a team at Chicago University, between 70 and 80 per cent of married men and women are faithful within their marriages: marriage remains the great leveller – so what's the problem? Well, if family values are modelled on a legally married heterosexual couple cohabiting in the same house with children under eighteen, then only a quarter of American households follow this pattern. And if that's the case, then maybe the very norm of the American family is changing.

For instance, the latest AT&T phone-sell campaign has already changed its perspective on the all-American family. The advertisement is narrated from the point of view of divorced or estranged couples, living in different cities, who need the phone to communicate on issues concerning joint parenting: 'Be a good parent. . . . Install an extra phoneline' may be the new slogan, as bedtime stories go cellular, and goodnight kisses come curling out of the fax machine.

If that is the reality of family life, then what in the world do family values actually stand *for*? Very little, except that they stand *against* abortion rights, gay rights and all forms of affirmative action, a term that covers the great unwashed, migrants, minorities and the poor. We are back with Upski's notion of suburbanite fear and loathing turning into a national state of mind.

But why, it can be asked, do issues concerning minority rights in the public sphere have to be 'domesticated', turned into a matter of family values? Well, Barbara Bush, the previous First Lady, had the answer to this: 'When we speak of families we include extended families, we mean the neighbours, even the community itself.' But, as a journalist on the *New York Times* pointed out mischievously, the Bush family values were certainly underscored when, at the Houston Republican Convention, the entire Bush clan gathered for the cameras and the music accompanying this image of familial solidarity and marital bliss just happened to be 'The Best of Times' from the classic gay musical *La Cage Aux Folles*.

It is precisely in the arts – in the off-off-off Broadway equivalents of *La Cage*

Aux Folles, or artists whose work offends the pieties of American everyday life – that the suburban spirit finds its *bêtes noires*. Politicians play the populist card in their arguments against government sponsorship of the National Endowment for the Arts and Humanities, echoing the British Tory Party MP, the late Geoffrey Dickens, who once suggested cutting the Covent Garden subsidy because it represented a whole lot of incomprehensible Italians poncing around. Newt grabbed the headlines when he suggested that arts patronage should be stopped 'because it is funding for avant-garde people who are explicitly not accepted by most of the tax payers'.

But for anyone who wants to play the populist suburban scourge, the fiscal argument is weak and disingenuous. Taxpayers provide only one-tenth of 1 per cent of the arts budget – a small price for a nation to pay for what it gets in return on an international scale. America is, and has been, the world's crucible for artistic innovation and experimentation. The great revolutionary Latin American muralists did their best work here; Chagall's mystic blue landscapes reached a new pitch here; more recently, Andy Warhol gave postwar America its historic icons in his great portraits of Chairman Mao and Marilyn Monroe right here, while providing the disposable commodity culture with more Brillo boxes than it could handle.

And none of these works that America now proudly displays in its national museums and claims as its cultural heritage comes out of the suburban sense of 'family values'. Which is not to say that public taste is not offended and churchgoers are not insulted when art displays its cutting edge. One of the most controversial recent *causes célèbres* concerned an HIV-positive gay performance artist called Ron Athey whose ritual enactments included body-cutting, scarification and skin penetration with acupuncture needles. His successful performance at the prestigious Walker Art Centre in Minneapolis caused a furore in Congress, although only $150 of its endowment grant went towards the performance. There were renewed calls for the dismantling of the National Endowment of the Arts – a strong possibility at this moment, a good year after the Athey show.

Quite coincidentally, I saw a video of Athey's work in London, as a member of the advisory board of the ICA. My own reactions were complex. I entered the auditorium with a measure of fear, though without the virulent loathing associated with 'family values'. The intensity of the performance allowed me to empathize with Athey's quest to come to terms with a body and a mind that had been violated by a violent father, lacerating lovers and unforgiving, oblivion-seeking syringes. Seen in this context Athey's ritual of self-controlled bodily scarification seemed like a retributive and healing act, and I found myself no more fearful or

offended than I am when Oedipus tears out his eyes at the end of that Greek tragedy.

Still, how do you deal with issues that clearly offend 'family values' but engage your sympathy and admiration? The conservatives have a derogatory phrase – they call it being 'politically correct'. It is an ill-defined term loosely used to finger subversive, left-leaning liberals or radicals who, it is claimed, show excessive concern for the rights of disadvantaged minorities.

For instance, to argue as I have done in favour of Ron Athey's attempts to come to terms with his past as an abused gay person would immediately be labelled 'politically correct'. I would be accused of straying so far from everyday suburban norms, from the concerns of most heterosexual couples and their children in the supposedly workaday world, that my empathy for Athey would be deeply suspect. Political correctness is now fading as a term of common use and abuse: it is yielding to the rhetoric of 'family values'. But as it slips away, could one perhaps link the two terms and ask, judged by their own standards how politically correct are the crusaders for American civilization?

Recent press stories linking slimy Newt and baleful Bob are much to the point. Dole recently attacked Hollywood movie-makers for using too much violence and sex, for ignoring the time-worn American respect for wholesome family entertainment – the ball game, grade-school romances in the suburbs, great neighbourly acts of friendship, that sort of thing.

Then somebody revealed that Senator Dole regarded Arnold Schwarzenegger's movie *True Lies* as family fun. Family what? asked an op-ed piece in the *New York Times*, observing that 'Arnold Schwarzenegger slaughters whole battalions of [Arabs] to keep America laughing.' Bob Dole is not laughing; he naturally denies having ever said anything about *True Lies*.

But that's not the last laugh. Here's one about Newt's new steamy suspense thriller *1945*, which was recently sent to a Hollywood scriptwriter for consideration. The scriptwriter happened to be Hollywood's most famous and expensive scribe, Joe Eszterhas. He wrote the script for *Basic Instinct*, where, it might be remembered, Sharon Stone opens and closes her knickerless legs once too often . . . once too long. Well, Eszterhas has turned down the script. In a letter to Bob Dole he explains that the opening scene which describes the President's chief of staff as 'a pouting sex kitten sitting athwart his chest' is far too un-American for him to script. Would Bob please persuade Newt to mend his non-familial deviant imagination?

'Calls to Gingrich's office weren't returned' the *Chicago Tribune* reports. Shhh . . . don't disturb him. Newt's got the American revolution on his mind. Or . . .

perhaps . . . could it just be that another flimsily clad bit of fiction is riding the barracuda?

He who laughs last . . . laughs best.

INDEX

Adorno, Theodor 18
Adventures of Ozzie and Harriet, The 222–3,
 232
advertising 87–8, 132, 172, 220–1, 271,
 300
aesthetic ideology 19–20, 163–4, 170–4,
 176
aggression 24, 282, 293–4
alienation 27, 58, 132, 144, 154, 165,
 275, 278
amenities 3, 92–3, 95, 101, 111, 162–3
American Family, An 224
appliances 96
Archer, John 14, 26–53
architectural significance of bungalow 56,
 58–9, 64–75
Arts and Crafts movement 57–8, 64–5,
 74–5
arts patronage 300–1
As Long As They're Happy 248
Aslet, Clive 65
asylum, suburbia as 283, 292
Athey, Ron 301–2
Australia: bungalows in 16, 56, 58, 76–81;
 sexualization of suburbia 187–210;
 women and suburban development 16,
 86–106
authenticity 223, 227
authority, seat of 51

autonomy 111
Ayckbourn, Alan 63

Baedeker, Karl 55
Bakke, E. Wight 120
Baldock, C. 99–100
barbecues 140–1
bartering 16, 92, 96–7, 105, 145
Basu, Susan Neild 45
Batavia, Indonesia 15, 28, 31–41, 48, 52
Bath of Psyche, The (Leighton) 61–2
BBC 270
Bedford Village, Westchester County, NY
 19, 161, 163, 166, 168–75
Beijing, China 81–2
Bellagio estate, Surrey 64–6
Benjamin, Walter 20
Bennett, Tony 187–8
Bentley, Ian 116
Berger, Bennett 111
Berman, Marshall 4
Betjeman, John 241–2, 257
Bhabha, Homi 12, 298–303
Big Money, The 248
Billy Liar 251, 275
Blacktown, Sydney 89–90, 95–7, 99
Blur 264, 270
Blussé, Leonard 33
boredom 23–4, 276–8, 283–4

bourgeoisie 3–7, 9, 11–12, 14–15, 17, 27, 35, 39–40, 44, 51, 53, 65, 108, 110, 115, 132, 164, 184, 186, 209, 219, 245, 252, 259

Bowie, David 23, 271–4, 277

Boy George 23, 265–6

Bray, Abigail 200

Brewerton, G. H. 70

Briers, Richard 256–7

Briggs, Robert Alexander 55, 64–7 70, 74

Britain: bungalows in 15–16, 57–76; popular culture 240–67; rock and pop 269–78; weekend 119–22, 124

Bromley 1–4, 23, 240–1, 265, 271–3, 284

Brookside 260–1, 263

Bruijn, Cornelis de 35

Buddha of Suburbia, The (Kureishi) 266, 271

bungalow 15–16, 55–82, 110, 119, 184

Bungalow, The (Horner) 16, 59–64

Butterflies 254, 256

Calcutta, India 28, 47–52

California bungalow 77

camp and suburbia 23, 272

Canary Wharf, London 13

capitalism 8

Carey, John 14–15

Carpenter, Scott 230

carpentry 115–16

Castles 262–3

Certeau, Michel de 235

Chagall, Marc 301

Chambers, Deborah 7, 16–17, 86–106

Charnock, Job 47

Chayefsky, Paddy 251

Chicago, USA 298–9

Chinese: in Australia 77; integration of 28, 33

choice 164, 167, 169

Choultry Plain, Madras 15, 42, 44–5

Chowringhee, Calcutta 15, 47–8, 51

church 99

cinema, British 22, 243–51, 266

Clarke, Alison J. 7, 18–19, 132–56

class, socio-economic: bungalows and middle 57, 60–1, 65, 75; democracy and 162–3; depoliticization 170–1; domesticity and 219–22, 224, 232, 236; music and 23; popular culture and 242, 245, 248, 250, 259, 261, 263, 269–70, 278; relations and suburbia 87; relocation and working 9, 284–91, 293–4; segregation 22, 91–2, 162, 176, 299; subcultures 280–1; suburban weekend and 109–16, 119–20, 122–4, 126; suburbia and 186, 275; Tupperware and 145, 156; values 95; working in Sydney 89, 91; zoning 168

Cohen, Phil 24, 280–1, 287–8, 293–4

colonialism 5, 15; Asian suburbs 26–53; bungalow and 56–60, 63–5, 75–7, 81

comedy 247–52, 262, 264

community: class and 280, 288–90, 292; sense of 16, 24–5, 86, 89, 92–3, 99–103, 105, 120, 164, 167–8, 185, 299

commuting 39–40, 45, 47, 110–11, 113, 117, 243, 276

compounds 48, 51

conformity 9, 23, 33, 240–1, 246, 250, 255–6, 266, 271, 284, 299

consciousness 26, 40–1, 143, 165, 175

conservatism 12, 112, 256, 299–300, 302

consumerism 6, 8–9, 14, 18–19, 74–5, 87, 95–6, 100, 110, 117–18, 120, 123, 125–6, 170, 182; Tupperware and mass 132–56

contrapositionality 15, 27, 33, 45, 51–2

Coronation Street 260–2

Coward, Noel 245–6, 249, 255

Craig, Wendy 255

criticism, social 181, 226–7, 236, 253
Crosland, T. W. H. 185
Cross, Gary 17, 26, 108
culture: change 86; colonial spaces and 15, 26–8; material 133–4, 136–7, 144, 145, 150, 152–3, 155, 225, 232, 235; political 165–6; representation 218; studies 9, 187–91; sub- 24, 280–1, 293–4; suburban 5–8, 11, 18; war 298–300, *see also* popular culture
cyberspace 235–7

Daendels, Governor of Jakarta 40
Davidson, G. F. 39
Davies, Karen 117
Davies, Ray 265
Davis, Mike 218
decadence 109, 272–3
decentralization 9, 113
decoration, interior 221, 231–2
democracy in Westchester County, New York 161–77
democratization 110, 208
Depression 119
detached houses 90
Dick, Philip K. 226
Dickens, Geoffrey 301
differentiation, social 27–31, 170
distinction, ideology of 163, 170–3, 175
diversity 266
division of labour 116–17, 121
do-it-yourself movement 18, 115–17, 122
documentaries 191, 223–4, 229–30, 241–2
Dole, Bob 302
domesticity 7, 11, 16, 18, 87, 95, 99, 114, 116, 122, 124, 133, 135, 142, 145–6, 148, 154, 185, 247, 255; in postwar USA 217–37
Donaher, Noelene 192–3, 209
Donaldson, Scott 143–4

Douglass, Paul 117
drama 189, 223, 241
dualisms 8, 52, 181, 186
Duby, Georges 184
Duncan, Nancy and James 19, 161–77
Dunn, Nell 285–7, 289
Durant, Ruth 120
Dutch East India Company 31–5, 52
Dwight, Edward J. 21, 234–5

East India Company 15, 28, 41, 44, 47, 51–2
EastEnders 260–1, 263
Ebony 234–5
economy: dependency on city 15, 27, 31, 34, 39–41, 65, 184; domestic 140, 141, 156; moral 154, 155
edge cities 12–13
education and pluralism/elitism 165–8
egalitarianism 87, 92, 105
Eliot, T. S. 241, 243, 257, 266
elitism 29, 39, 44, 165–6, 174–6
Emmerdale 260
empowerment 7, 100, 176
England's Dreaming (Savage) 281, 283–5
environment and suburbia 184–5
escape 5, 17, 88, 109–11, 113, 272, 274, 276
Esmonde, John 256
Eszterhas, Joe 302
ethnicity 29, 91, 143–4, 156, 299
Ever Decreasing Circles 256–7, 259
exclusion 161–3, 170, 174, 176, 219, 223–6

fact/fiction 191–2, 195, 209
Fall and Rise of Reginald Perrin, The 253–4
familialism 108–9, 112, 115, 120, 266
family: planning 98; values 299–302
Family and Class in a London Suburb (Willmott and Young) 286–8

Family and Kinship in East London (Young
 and Willmott) 287–91, 294
fashion 201–9
Featherstone, Mike 225
Federal Housing Administration 219, 233
feminism 19, 116, 133–4, 142, 156, 218,
 255; non-radical 146–50
feminization of suburbia 7, 12, 188, 208,
 241, 248, 250, 256
Fiedler, Leslie A. 208
Finnegan, Ruth 278
Fishman, Robert 5–6, 9
Foote, Nelson 220–1
Forbidden Planet 217–18
Friedan, Betty 132–3, 145, 226
Frith, Simon 23, 269–78
frocks pop 20, 191, 196–200, 207–9
Fumed Oak 249–50

Game, A. 87
garden city movement 111
garden houses 41–2, 44–5, 48
gardening 87, 92, 110, 114–16
Gelber, Steven 115
genre, British film and television 22–3,
 244, 247, 252, 254, 256, 258, 263
George Burns and Gracie Allen Show, The 21,
 222
Geraghty, Christine 251, 261
Gerster, Robin 208
Gibson, William 236
Gingrich, Newt 299–300, 302
Ginzberg, Eli 120
glamour 133, 148, 150–6, 220–1
glance 20, 191, 200–6
Glenn, John 230
globalization 77
gnome zone, suburbia as 240–67
Goffman, Erving 223
Good Life, The 256–7
Gordon, Elizabeth 137

governmentality 187–9
graffiti 298–9
Grandpré, Louis de 44
greenbelt areas 89
Green Man, The 248
Grossmith, George and Weedon 1
Grove Family, The 260
Guthrie, Woody 209

Habermas, Jürgen 11
Hall, Stuart 55
Halttunen, Karen 219–20
Hamilton, Capt Alexander 42
Hancock, Tony 250, 253
Haraway, Donna 228, 237
Hardwick, A. Jessop 70
Harmon, Homer 221
Hartley, John 12, 20, 180–211
Hawkes, Terence 189–90
Hayden, Bill 211
Hayden, Dolores 116
Hebdige, Dick 293–4
Henderson, Harry 221
Here Come the Huggets 247–8, 263
heritage 104–5, 163, 172–3
hierarchy: of city and suburbs 27, 33, 41,
 52; social 87, 109
Hine, Thomas 123
history, ideology of 171–6
History of Mr Polly, The 249
Hobbes, Thomas 199, 207
Hobson, J. A. 76
holidays 115, 120, 123, 231
Hollyoaks 262
home rule 162–3, 167
homogeneity 7, 15, 28–9, 91, 144, 218,
 236, 276, 299
homosexuality 265–6
horizontality of bungalow 56, 60, 66,
 74–5
Horkheimer, Max 18

Horner, Fred 16, 59–60
Houbolt, John C. 229
Howards End 250
humanism 190
Hunter, Ian 187, 190, 207
hybridity, suburban 7–12, 66

identity: British 270; collective 29, 41;
 colonial 15; consumerism and 164,
 170; feminine 132–3, 150, 154, 156;
 fragmented 200; heritage and 172;
 masculine 121; personal 115, 118,
 124, 175; self 28, 31, 41, 44–6,
 51–2
ideology 7, 22, 87, 95, 133, 144, 228–9,
 270; democracy and 162–9
image: of frocks pop 198, 206; of suburbia
 182, 190–1, 217, 275, 281–2, 285,
 294; of women 132
immigration 5, 89, 101–2
'imperial archive' 181, 184, 186
in-between, suburbia as 186
income 96, 116, 121–2, 124–5
individualism 27, 51, 53, 200; possessive
 19, 163–9, 172–6
industrialization 113
inferiority 32, 110
instantaneity 7
isolation, social 10, 17, 93, 95, 101, 105,
 132, 144, 185, 290–1, 293–4

James, P. D. 280, 294
Jameson, Frederic 231–2
Jones, G. Stedman 113
Jordan (Sex Pistol) 282–3

kampongs 15, 32–4
Kane, Pat 265
Kaplan, W. 66
Karskens, G. 103
Keat, John 226

Keeping Up Appearances 259
Kelly, Barbara 123
Kennedy, John F. 229–30
Kennedy, Robert Woods 221
Khrushchev, Nikita 228
Kind of Loving, A 250–1
King, Anthony D. 15–16, 55–83
Kinks, The 240, 264–5
kinship 288–9, 291, 293
kitchen sink drama 22, 250–1
knowledge, modes of 180–2
Kureishi, Hanif 266, 271

Lacan, Jacques 293–4
Laclau, Ernesto 182
Lancaster, Osbert 111
landscape change 161, 164–6, 168–72,
 175–6
landscaping 31, 35–6, 40, 47
Lane, Carla 254
language systems and domesticity 217–18,
 225, 235, 237
Larbey, Bob 256
Leaf, Michael 55
Leavis, Q. D. 265
Lebeau, Vicky 23–4, 280–95
Lee, Sophie 21, 192–8, 200–1, 206–8
Lefebvre, Henri 223
Leighton, Sir Frederic 61–2
leisure: Asian suburbia 35–6, 40, 46, 48;
 bungalows and 66; labour and 5, 7,
 17–18, 31; theatre and 219; weekend
 and 111–17, 120, 122–6; women and
 102–3
Lejeune, C. A. 245–6
Levittown, Australia 6
liberal humanism 164, 175
Liepmann, Kate 120
Light, Alison 6
Linder, Staffan 125
Lloyd George, David 119

Loach, Ken 285
localism 19, 115, 163–4, 167, 176
London: domination of 23, 40, 270, 272, 274, 277–8; relocation from 280–1, 287, 290
Long Arm, The 247
Lotman, Yuri 183
Loudon, John Claudius 29
Luce, Henry 228

MacDonald, Ian 264
MacInnes, Colin 180, 185
MacPherson, C. B. 199
MacPherson, Elle 21, 210–11
Madonna 200–1
Madras, India 15, 32, 40–6, 48, 52
magazines 116, 192, 210, 220–1, 230–1
mall, shopping 8
Manfred Mann 264
Marcus, Greil 283
marginality 5, 21, 23, 93
Marsh, Margaret 116, 121, 218
Marxism 218, 281
Mary Tyler Moore Show, The 227
Masterman, C. F. G. 247, 252
May, Elaine Tyler 228
Medhurst, Andy 22–3, 240–67
media, popular 6, 9–10, 180–1, 184, 189–92, 206–8, 295, 297
medical care 98
Meet Me Tonight 249
Meikle, J. 136
Members, The 280–1, 284, 294
Men Into Space 224–5, 232
Mercer, Colin 188
Meredyth, Denise 188–90
metaphors of domesticity 21, 217–37
Metroland 241–2, 257
metropolitan/peripheral 29
Meyerowitz, Joanne 145, 148
Miller, Daniel 19, 137, 144

Minogue, Kylie 21, 193, 197–9, 200–8
mobile privatization 225
modernism 4, 10, 13–14, 18, 109–10, 133–8, 144, 151–4, 156, 176, 184, 225, 241
morality 10, 42, 44, 135
Morris, Meaghan 188, 206–7
mortgages 119, 121
Mortland, Elsie 141
Mouffe, Chantal 182
Mount Kisco, Westchester County, NY 162–3, 166–70
multicultural suburbs 55–82
Mumford, Lewis 143, 186, 226
Murdoch, Walter 185
Muriel's Wedding 193–5
music, popular 23–4, 231, 264, 269–78
My Favorite Martian 232–3

nature, ideology of 173–5
neighbours 92, 101–2, 110–11, 120, 145, 221, 275, 290–1
Neighbours 259–60, 262–3
networking 86, 92, 97, 99–102, 105, 165–6, 288–9, 291–3
New Right 299
Newall, C. 61–2
newsreels 244
Nieuhof, Johannes 34
Nixon, Richard 228–9
nostalgia 88, 98, 115, 277

Oasis 270
occupation and pluralism/elitism 165–8
Oliver, Paul 116, 243–4, 246
Olsen, Donald J. 184
One Foot in the Grave 258–9
ordinariness 9, 197, 200, 206, 245, 251, 284
Orwell, George 111
Outer Limits, The 233

ownership 19–20, 56, 77, 87, 113, 116, 119, 122–4, 163–4, 174

Paradis, French Captain 42
Paradis, Vanessa 190
Parkes, Don 112
parlour theatricals 219–20, 222, 224
Party Plan and Tupperware 19, 133, 138–46, 150, 156
pastoral 173–6
patriarchy 17, 87, 103, 150, 185, 228, 248, 254
Pennies From Heaven 241, 250
'Penny Lane' 264
Penrith, Sydney 89, 92, 94, 97–9, 102
Phoa Bingam 34
Pitt, Thomas 41
planning 11, 17; Sydney 86–106
Plassey, Battle of (1757) 28, 47
plastics 136–7
Please Turn Over 249
pluralism 165
political correctness 302
politics: dependency on city 27, 31, 40–1, 65; networks 93, 100; suburbia and 12, 20–1, 184
popular culture 9, 182–3, 189, 191, 196, 198, 223, 227, 236, 240–67, 269–71, 278, 281, 283, 285, 295
population explosion 17, 89, 101, 104
postmodernism 6, 13–14, 175–6, 180, 182, 207, 225, 235
Potter, Dennis 241
power 12, 20, 112, 121, 165–6, 176, 207
praxis, human 26
prefabricated cottages 91
preservation 20, 163, 173–4, 176
Pringle, R. 87
privacy 5, 8, 11, 48, 87, 109–10, 115, 118–20, 122–3, 168–9, 173, 184, 276
private/public worlds 7, 11, 41, 113, 137,

141, 152, 181–3, 186, 277
privilege 29, 44, 51, 53, 108, 236
productivity 31, 108–9, 113, 117–18, 124
progress, suburbia as 17, 94, 103–4
property values 12, 27, 56, 162–3, 170, 237
public sphere and media 199, 207–8, 210
punk 4, 6, 24–5, 265, 271, 281–5, 293–5
Pym, Barbara 240

Quayle, Dan 300

Rach, Johannes 35–6
racism 22, 63, 234–6
radial dispersion, suburbs as 34, 40, 48
radicalism 133, 135, 256
Raffles, Sir Thomas Stamford 28
railways 3, 64, 92, 242–3, 266, 272
ranch house 57
readership of popular culture 198–9
realism 184
reasoning, practical 201, 206
Rebel, The 250, 253
reclamation of Batavia 34
relocation 9, 24, 280–1, 286–7, 289
representation, suburban 14
reputation 182, 186, 197–9, 209
residential enclaves 15, 27, 29, 31, 39–42, 45, 47, 49
respectability 110–11, 241, 248–9
retreat, suburbia as 35–6, 39–40, 42, 44, 46, 87, 120, 170, 276
Richard, Thomas 181
Richards, J. M. 262, 266
Richards, Lynn 125
Riesman, David 111
rights 162, 300, 302
Robinson, Percy 75
role: gendered 125, 217–18, 220, 224–7; of mass consumption 154–5; of men 115, 121; social 112; of space 26; of

women 116–17, 132–3, 143, 146, 152, 154; of women's organizations 100
Roosevelt, F. D. 119
Ruggles, The 223

sabbatarianism 114, 118, 125
Sahlins, Marshall 200–1
Said, Edward 57, 59–60
Savage, Jon 269, 271, 273, 281, 283–4, 291
Schreuder, Jan 35
Schwarzenegger, Arnold 302
science fiction 226–7, 231–2, 234
Science Fiction Theater 233
Scott, Baillie 66, 74
security 4, 15, 35–6, 39, 42, 48, 104, 249, 266, 276
segregation: class 22, 91–2, 162, 176, 299; racial 28, 32–3, *see also* exclusion
self-esteem 87, 149, 151
self-reflexivity 219–20, 222
semi-detached houses 122
semiosphere 20, 183, 187, 197, 207, 209
Sennett, Richard 207
sensibility, suburban 269–78
sewerage 96
Sex 191–2, 194
sexism 236
sexuality 273–4, 277
sexualization of suburbia 20, 180–211
Sharp, Thomas 185–6
Shepard, Alan 229
shopping 8, 92–3, 97, 103–4, 118, 125–6
showcases 110, 220–1
Silverstone, Roger 1–25
Singapore 28–30
Siouxsie (and the Banshees) 271–2, 283
Sitch, Robert 210
sitcom 22, 221–4, 226–7, 232, 242, 252–60, 263, 266–7, 271

size: of family 98; of plots 16, 89–91, 161–2, 169
sleeve designs 273, 281–2
slum clearance 9, 280–1, 286–7
soap operas 10, 22–3, 230, 242, 259–63
social change 104–5
social meanings: of bungalow 56–61, 74; of weekend 115–23
social relations 111, 185, 221, 289; Tupperware 132–56
socialization 7, 135, 145
Soja, Edward 13
Sooy, Louise Pinkey 220
Sound of the Suburbs, The 281–2, 284–5, 294
space: bungalow and change of 56, 60–1; change in Australian suburbs 86, 104–5; of modernity 26–53; weekend and 108–9, 111–13, 117, 119, 123–6
space travel and domesticity 21, 217–37
Spigel, Lynn 21, 217–37
Spivak, Gayatri 57
Sputnik 217, 228
Stacey, Judith 236
status: domesticity 145; seeking 110–13, 115; social 152, 155, 170; Tupperware and 137, 150
Stepford Wives, The 227
stereotyping 132–3
Street-Porter, Janet 269
Stretton, Hugh 187
structuralism 218
subordination 32, 52–3, 133, 176
Suede 23, 272–5, 277–8
summer use 67
Sylvania Waters 185, 191–2, 209

telebrities 181, 197, 208
television 9–11, 21–2, 191, 221–7, 231–2, 234, 241–2, 251–2, 269, 271, 292–3

Terry and June 252–3
Thames Valley 40, 42
That Girl 226–7
theatricality, suburbia and 21, 217–37
They Were Sisters 244
This Happy Breed 245–7, 249
This Land is Your Land 209–10
Thompson, F. M. L. 7
Thornton, Sarah 269
Thrift, Nigel 112
time, weekend and 109, 111–15, 117–19, 123–5
Todorov, Tzvetan 232
trade 5, 15, 27, 33, 35, 39–41, 45–6, 52
transport 92–3, 98, 101, 108–9, 119, 121, 225, 227, 232, 243, 286, 288
True Lies 302
The Truex Family 222
Tupper, Earl Silas 18, 133–5, 137, 146, 150–1, 155
Tupperware 7, 18–19, 132–56
Turner, Graeme 185, 197, 209
29 Acacia Avenue 246–7
Twilight Zone, The 233

unemployment 119–20
Up the Junction 285–6
Upjohn, Aaron 47
USA: bungalows in 56–7, 64; democracy in Westchester County 161–77; theatricality of suburbia 219–37; Tupperware 132–56; weekend 110, 119, 122, 124–6
utilitarianism 134, 137

Valentia, Lord 45
van Outhoorn, Willem 35
Versace, Gianni 197–8
Victoria, Queen 210
Vidler, Anthony 291
villa 3, 15, 31, 36, 40–1

violence: latent 282, 291, 293; physical and symbolic 6
voluntary work 99–100, 105
von Braun, Wernher 229
Voysey, C. F. A. 66

Walker, Alexander 251
Wandersee, Winifred 121
Warhol, Andy 301
Waterlooplein, Batavia 15, 40
Wattel, Harold 111–12
wealth 53, 111, 117, 125
Webb, R. K. 196
weekend 7, 17–18, 66–7, 108–26
Wells, H. G. 249–50
Westchester County, New York 19, 161–77
Westerns 244
Whitlam, Gough 187
Whyte, William H. 11, 221, 226
Williams, Raymond 10, 218, 223, 225, 254
Wilmott, Peter 24, 110, 112, 116, 123, 242, 257, 286–8, 289–94
Wilson, Elizabeth 207–8, 218
Wimsatt, William 'Upski' 298–300
Wise, Brownie Humphrey 18, 133, 138, 144–8, 150, 151, 154
Wodehouse, P. G. 185
Wolff, Janet 62
women: employment 12, 95, 97, 105, 114, 121, 124–5, 142, 145; experience of suburbs 16–17, 86–106; role 116–17
Wood, Captain Mark 47
Wood, Robert C. 144
Woodbridge, Virginia 220
working day 113–16, 122
Working Papers in Cultural Studies (Cohen) 280–1
Wright, Frank Lloyd 57

Young, John 230–1
Young, Michael 24, 110, 112, 116,
 123, 242, 257, 286–8,
 289–94
Young Ones, The 257

Younge, Gary 267

Zerubavel, Eviater 112
zoning 161–3, 166–71, 174, 176, 219
Zunz, Olivier 113